Aisthesis

Aisthesis

Scenes from the Aesthetic Regime of Art

Jacques Rancière

Translated by Zakir Paul

VERSO
London • New York

This work was published with the help of the French Ministry of Culture – Centre National du Livre

First published in English by Verso 2013
Translation © Zakir Paul 2013
First published as *Aisthesis: Scènes du régime esthétique de l'art*
© Editions Galilée 2011

1 3 5 7 9 10 8 6 4 2

Verso
UK: 6 Meard Street, London W1F 0EG
US: 20 Jay Street, Suite 1010, Brooklyn, NY 11201
www.versobooks.com

Verso is the imprint of New Left Books

ISBN-13: 978-1-78168-089-6

British Library Cataloguing in Publication Data
A catalogue record for this book is available from the British Library

Library of Congress Cataloging-in-Publication Data
Rancière, Jacques.
[Aisthesis. English]
Aisthesis : scenes from the aesthetic regime of art /
Jacques Rancière ; Translated by Zakir Paul. – [First
English edition].
pages cm
Includes index.
ISBN 978-1-78168-089-6 (hardback : alk. paper)
1. Aesthetics, Modern. I. Title.
BH151.R3413 2013
111'.85–dc23
2013004995

Typeset in Caslon by MJ & N Gavan, Truro, Cornwall
Printed in the US by Maple Vail

Contents

Acknowledgments

Previous versions of chapters 2, 4 and 11 were delivered as the Gauss Lectures at Princeton University in October 2009, at the invitation of Daniel Heller-Roazen, and translated into English by Zakir Paul. I also discussed chapters 2 and 4 with the scholars of the Sonderforschungsbereich 626, 'Ästhetische Erfahrung im Zeichen der Entgrenzung der Künste', at the Freie Universität in Berlin, where I was invited by Armen Avanessian in September 2009. I would like to thank all those who participated in these discussions.

Thanks also to Danielle for her attentive reading and comments on the chapters throughout, to Yuri Tsivian, who was kind enough to locate copies of the *Kino-fot* issue on Chaplin and Ismail Urazov's booklet on *A Sixth Part of the World*, and to P. Adams Sitney and the staff at the Anthology Film Archives, who made Dziga Vertov's films available to me.

A preliminary version of Chapter 11 was published in vol. 65 of *Trafic* (Spring 2008).

Prelude

This book deals with the same topic in fourteen scenes. This topic is announced by its very title: *Aisthesis*. For two centuries in the West, 'aesthetics' has been the name for the category designating the sensible fabric and intelligible form of what we call 'Art'. In my other works, I have already had the opportunity to argue that, even if histories of art begin their narratives with cave paintings at the dawn of time, Art as a notion designating a form of specific experience has only existed in the West since the end of the eighteenth century. All kinds of arts and practices existed before then, to be sure, among which a small number benefited from a privileged status, due not to their intrinsic excellence but to their place in the division of social conditions. Fine arts were the progeny of the so-called liberal arts. The latter were distinguished from the mechanical arts because they were the pastime of free men, men of leisure whose very quality was meant to deter them from seeking too much perfection in material performances that an artisan or a slave could accomplish. Art as such began to exist in the West when this hierarchy of forms of life began to vacillate. The conditions of this emergence cannot be deduced from a general concept of art or beauty founded on a global theory of man or the world, of the subject or being. Such concepts themselves depend upon a transformation of the forms of sensible experience, of ways of perceiving and being affected. They formulate a mode of intelligibility out of these reconfigurations of experience.

The term *Aisthesis* has designated the mode of experience according to which, for two centuries, we perceive very diverse things, whether in their techniques of production or their destination, as all belonging to art. This is not a matter of the 'reception' of works of art. Rather, it concerns the sensible fabric of experience within which they are produced. These are entirely material conditions – performance and exhibition spaces, forms of circulation and reproduction – but also modes of perception and regimes of emotion, categories that identify them, thought patterns that categorize and interpret them. These conditions make it possible for words, shapes, movements and rhythms to be felt and thought as art. No matter how emphatically some may oppose the event of art and the creative work of artists to this fabric of institutions, practices, affective modes and thought patterns, the latter allow for a form, a burst of colour, an acceleration of rhythm, a pause between words, a movement, or a glimmering surface to be experienced as events and associated with the idea of artistic creation. No matter the insistence with which others oppose the ethereal idealities of art and aesthetics to the very prosaic conditions of their existence, these idealities still provide the markers for the work with which they try to demystify them. Finally, no matter the bitterness others still express at seeing our venerable museums welcome the works of the darlings of the market, this is merely a distant effect of the revolution constituted by the very birth of museums, when the royal galleries open to the public made visible popular scenes that German princes taken with exoticism had bought from dealers in the Netherlands, or when the republican Louvre was stacked with princely portraits and pious paintings looted by the revolutionary armies from Italian palaces or Dutch museums. Art exists as a separate world since anything whatsoever can belong to it. This is precisely one of the arguments of this book. It shows how a regime of perception, sensation and interpretation of art is constituted and transformed by welcoming images, objects and performances that seemed most opposed to the idea of fine art: vulgar figures of genre painting, the exaltation of the most prosaic activities in verse freed from meter, music-hall stunts and gags, industrial buildings and machine rhythms, smoke from trains and ships reproduced mechanically, extravagant inventories of accessories from the lives of the poor. It shows how art, far from foundering upon these intrusions of the prose of the world,

ceaselessly redefined itself – exchanging, for example, the idealities of plot, form and painting for those of movement, light and the gaze, building its own domain by blurring the specificities that define the arts and the boundaries that separate them from the prosaic world.

Art is given to us through these transformations of the sensible fabric, at the cost of constantly merging its own reasons with those belonging to other spheres of experience. I have chosen to study these transformations in a certain number of specific scenes. In this sense, a distant model guides *Aisthesis*. Its title echoes Erich Auerbach's *Mimesis*, which focused on a series of short extracts, from Homer to Virginia Woolf, to study the transformations in the representation of reality in western literature. *Mimesis* and *Aisthesis* undoubtedly take on different meanings here, since they no longer designate categories internal to art, but rather regimes of the identification of art. My scenes are not only taken from the art of writing, but also from the visual and performance arts, and those of mechanical reproduction. They do not show the transformations belonging to any given art. Instead, they show the way in which a given artistic appearance requires changes in the paradigms of art. Each one of these scenes thus presents a singular event, and explores the interpretive network that gives it meaning around an emblematic text. The event can be a performance, a lecture, an exhibition, a visit to a museum or to a studio, a book, or a film release. The network built around it shows how a performance or an object is felt and thought not only as art, but also as a singular artistic proposition and a source of artistic emotion, as novelty and revolution in art – even as a means for art to find a way out of itself. Thus it inscribes them into a moving constellation in which modes of perception and affect, and forms of interpretation defining a paradigm of art, take shape. The scene is not the illustration of an idea. It is a little optical machine that shows us thought busy weaving together perceptions, affects, names and ideas, constituting the sensible community that these links create, and the intellectual community that makes such weaving thinkable. The scene captures concepts at work, in their relation to the new objects they seek to appropriate, old objects that they try to reconsider, and the patterns they build or transform to this end. For thinking is always firstly thinking the thinkable – a thinking that modifies what is thinkable by welcoming what was unthinkable. The scenes of thought collected here show how a mutilated statue

can become a perfect work, an image of lousy children the representation of the Ideal, somersaulting clowns a flight in the poetic sky, a piece of furniture a temple, a staircase a character, patched overalls a princely garb, the convolutions of a veil a cosmogony, and an accelerated montage of gestures the sensible reality of communism. These metamorphoses are not individual fantasies but the logic of the regime of perception, affection and thought that I have proposed to call the 'aesthetic regime of art.'

The fourteen episodes that follow are so many microcosms in which we see the logic of this regime being formed, transformed, incorporating unexplored territories and forming new patterns in order to do so. Their selection might give rise to some surprise; the reader will seek in vain for landmarks that have become unavoidable in the history of artistic modernity: no *Olympia*, no *Suprematist Composition: White on White*, no *Fountain*, nor *Igitur* or *The Painter of Modern Life*. Instead there are reviews of Funambules and the Folies Bergère written by poets who have fallen into the purgatory of literary anthologies, talks by thinkers or critics who have fallen from grace, sketchbooks for stagings rarely performed … There are surely reasons for this choice, even if, like all good reasons, they are discovered belatedly. Influential histories and philosophies of artistic modernity identify it with the conquest of autonomy by each art, which is expressed in exemplary works that break with the course of history, separating themselves both from the art of the past and the 'aesthetic' forms of prosaic life. Fifteen years of work have brought me to the exact opposite conclusions: the movement belonging to the aesthetic regime, which supported the dream of artistic novelty and fusion between art and life subsumed under the idea of modernity, tends to erase the specificities of the arts and to blur the boundaries that separate them from each other and from ordinary experience. These works only create ruptures by condensing features of regimes of perception and thought that precede them, and are formed elsewhere. The degrees of importance retrospectively granted to artistic events erase the genealogy of forms of perception and thought that were able to make them events in the first place. The scenographic revolutions of the twentieth century are difficult to understand without mentioning the evenings spent at the Funambules or the Folies Bergère by poets that no one reads any more: Théophile Gautier and Théodore de Banville. One would

be hard pressed to perceive the paradoxical 'spirituality' of functionalist architecture without referring to Ruskin's 'gothic' reveries – or even write a somewhat precise history of the modernist paradigm while forgetting that Loïe Fuller and Charlie Chaplin contributed to it far more than Mondrian or Kandinsky, or that the legacy of Whitman is as influential as that of Mallarmé.

One could thus consider these episodes, if so inclined, as a counter-history of 'artistic modernity'. However, this book has no encyclopaedic goals. It is not concerned with surveying the field of the arts during two centuries, but only aims to capture the occurrences of certain displacements in the perception of what art signifies. It does follow chronological order from 1764 to 1941. Its point of departure is the historical moment, in Winckelmann's Germany, when Art begins to be named as such, not by closing itself off in some celestial autonomy, but on the contrary by giving itself a new subject, the people, and a new place, history. It follows a few adventures of the relations between these terms. But it has not linked these adventures together; instead it develops a number of overlapping points and elaborations. Nor has it sought to lead them towards some apotheosis or end point. It could surely have come closer to our present. It could also include other episodes, and perhaps it will some day. For now, it seemed possible to me to end it at a significant crossroads: a time when, in James Agee's America, the modernist dream of art, capable of lending its infinite resonance to the most minute instant of the most ordinary life, was shedding its last light, the brightest yet, while this very era had just been declared over by the young Marxist critic Clement Greenberg and the monument of retrospective modernism was raised. Failing to found any important art, the latter would however succeed in imposing the golden legend of the avant-gardes and rewrite the history of a century of artistic upheavals to its advantage.

This book is thus both finished and incomplete. It is open to future development, but also allows for the construction of different narratives, which could link these isolated episodes together. By following the path that leads from the Belvedere Torso, the expression of a free people, to sharecroppers' barracks in Alabama, stopping by Murillo's beggar boys, the oil lamps of the Funambules, the urban wanderings of a hungry vagrant, or the nomads filmed by the Kinocs on the frontiers of Soviet Asia, readers will be able to

recognize so many short voyages to the land of the people, to which I have devoted another book.[1] From the mutilated Belvedere statue to the broken china rabbit belonging to the sharecropper's daughter, via the distorted bodies of the Hanlon Lees brothers, Loïe Fuller's unlocatable body, Rodin's limbs without bodies and bodies without limbs, and the extreme fragmentation of gestures assembled by Dziga Vertov, they will be able to construct the history of a regime of art like that of a large fragmented body, and of a multiplicity of unknown bodies born from this very fragmentation. They can also follow the multiple metamorphoses of the ancient that the modern feeds upon: how the Olympian gods transform into children of the people, the antique temple into a piece of salon furniture, or into a practicable theatre prop, the painting of a Greek vase becoming a dance celebrating American nature – and still more metamorphoses.

Among these stories, one always imposed itself with greater insistence as the book progressed: the history of the paradoxical links between the aesthetic paradigm and political community. By making the mutilated statue of Hercules the highest expression of the liberty of the Greek people, Winckelmann established an original link between political freedom, the withdrawal of action, and defection from the communitarian body. The aesthetic paradigm was constructed against the representative order, which defined discourse as a body with well-articulated parts, the poem as a plot, and a plot as an order of actions. This order clearly situated the poem – and the artistic productions for which it functioned as a norm – on a hierarchical model: a well-ordered body where the upper part commands the lower, the privilege of action, that is to say of the free man, capable of acting according to ends, over the repetitive lives of men without quality. The aesthetic revolution developed as an unending break with the hierarchical model of the body, the story, and action. The free people, says Schiller, is the people that plays, the people embodied in this activity that suspends the very opposition between active and passive; the little Sevillian beggars are the embodiment of the ideal, says Hegel, because they do nothing; the novel dethroned drama as the exemplary art of speech, bearing witness to the capacity of men and women without quality to feel

1 Jacques Rancière, *Courts voyages au pays du peuple* (Paris: Le Seuil, 1990), transl. James B. Swenson as *Short Voyages to the Land of the People* (Stanford: Stanford University Press, 2003).

all kinds of ideal aspirations and sensual frenzies. But it did so at the cost of ruining the model of the story with causes and effects, and of action with means and ends. The theatre itself, the ancient stage of 'active men', in order to draw itself closer to art and life, comes to repudiate action and its agents by considering itself a choir, a pictorial fresco, or architecture in movement. Photography consecrates the triumph of the gaze over the hand, and the exemplary cinematic body turns out to be the one that is constantly bombarded by events, none of which are the result of its intentions. The aesthetic paradigm of the new community, of men free and equal in their sensible life itself, tends to cut this community off from all the paths that are normally used to reach a goal. No doubt this tendency towards suspended action is constantly resisted. But this very struggle incessantly reproduces the inertia against which it rises up. In their search for an active theatre or ballet, Diderot and Noverre had to find models in pictorial composition. The same Rousseau who opposed the activity of the civic celebration to the passivity of the spectator in the theatre celebrated the *farniente* of reverie, and with *The New Heloise* inaugurated the long series of novels without action, devoted to what Borges later called the 'insipid and idle everyday'. Wagner wanted a living poem that acted instead of describing, but this living poem, made to welcome the figure of the free hero, instead gave way to the figure of the god who turns away from action. The renovators of dance and theatre freed bodily movements from the shackles of a plot, but the emancipation of movement also distanced it from rational, intentional action directed towards an end. Vertov's film, which sought to replace the plots and characters of yesterday with the living links of activities that formed the sensible fabric of communism, begins and ends in a cinema where the evening's spectators seem to play with images that present them to themselves as the daytime actors of communism. Emancipated movement does not succeed in reintegrating the strategic patterns of causes and effects, ends and means.

Hasty minds will undoubtedly see this as the sign of an irremediable breach between aesthetic utopia and real political and revolutionary action. Instead, I recognized the same paradox in it as the one I encountered in the practices and theories of social emancipation. Emancipated workers could not repudiate the hierarchical model governing the distribution of activities without

taking distance from the capacity to act that subjected them to it, and from the action plans of the engineers of the future. All these workers could easily have opposed the militants of the Saint-Simonian religion reinstating work, who came to recruit soldiers for the new industrial army, with the ingenuous words spoken by one of them: 'When I think of the beauties of Saint-Simonism, my hand stops.' The fullest expression of the fighting workers' collective was called the general strike, an exemplary equivalence of strategic action and radical inaction. The scientific Marxist revolution certainly wanted to put an end to the workers' reveries, along with utopian programmes. But by opposing them to the effects of real social development, it kept subordinating the end and means of action to the movement of life, at the risk of discovering that this movement does not want anything and does not allow any strategy to lay claim to it. Soviet critics responded to the filmmaker, who presented them with a vision of communism realized as the symphony of linked movements, that his so-called communism was doomed to an endless oscillation between pantheistic adoration of the irrational flux of things and pure formalist voluntarism. But what else could they oppose to this double defect except the return of artists to the old functions of moral illustration, whose inanity Rousseau and Schiller had exposed a century and a half earlier? Was the filmmaker effectively doing anything other than giving his judges a mirror in which they could recognize the dilemma of their science? Social revolution is the daughter of aesthetic revolution, and was only able to deny this relation by transforming a strategic will that had lost its world into a policy of exception.

1. Divided Beauty

Dresden, 1764

Abused and mutilated to the utmost, and without head, arms, or legs, as this statue is, it shows itself even now to those who have the power to look deeply into the secrets of art with all the splendor of its former beauty. The artist has presented in this Hercules a lofty ideal of a body elevated above nature, and a shape at the full development of manhood, such as it might be if exalted to the degree of divine sufficiency. He appears here purified from the dross of humanity, and after having attained immortality and a seat among the gods; for he is represented without need of human nourishment, or further use of his powers. No veins are visible, and the belly is made only to enjoy, not to receive, and to be full without being filled … In this position, with the head turned upwards his face probably had a pleased expression as he meditated with satisfaction on the great deeds which he had achieved; this feeling even the back seems to indicate, which is bent, as if the hero was absorbed in lofty reflections. In that powerfully developed chest we behold in imagination the breast against which the giant Geryon was squeezed, and in the length and strength of the thighs we recognize the unwearied hero who pursued and overtook the brazen-footed stag, and travelled through countless lands even to the very confines of the world. The artist may admire in the outlines of this body the perpetual flowing of one form into another, and the undulating lines which rise and fall like waves, and become swallowed up in one another. He will find that no copyist can be sure of correctness, since the undulating movement which he thinks he is following turns imperceptibly away, and leads both the hand and the eye astray by taking another direction. The bones

appear covered with a fatty skin, and the muscles are full without superfluity, and no other statue can be found which shows so well balanced a plumpness; we might indeed say that this Hercules seems to be the production of an earlier period of art even more than the Apollo.[1]

This description of the *Belvedere Torso* figures, alongside ones about *Laocoön* and the *Belvedere Apollo*, among the memorable passages in *The History of Ancient Art* published in 1764 by Johann Joachim Winckelmann. He was certainly not the first to praise a statue that belonged to the Roman pantheon of Greek sculpture and whose perfection Michelangelo had extolled two centuries earlier. This admiration however was not free of paradox. Here is a statue of Hercules, the victor of the Twelve Labours, the athlete and wrestler par excellence, the one whom another illustrious sculpture, the *Farnese Hercules*, represents as a colossus leaning on his club and carrying the pelt of the slain Nemean lion. Now, what this one shows is a seated body deprived of every limb capable of performing any action requiring force or skill. Hence different artists tried to complete the figure by imagining the action accomplished by the hero: a reduction added a club, another a bow; a drawing by Hans Baldung Grien had placed Omphale's distaff in its hands.[2] Winckelmann took this tradition backwards. Instead of compensating for the lack, he transformed it into a virtue: there is no action to imagine. The mutilated statue represents the hero welcomed by the gods at the end of his labours, when they are nothing but a subject of joyful recollection and meditation. Yet you still need a head to recall and meditate. This *Hercules* is lacking that too: he is nothing but pure thought, but this concentration is only indicated by the curve of a back that assumes the weight of this thought, by a stomach that seems unfit for any digestive functions, and by muscles that do not

1 Johann Joachim Winckelmann, *The History of Ancient Art*, vol. II, transl. G. Henry Lodge (Boston: James R. Osgood and Company, 1880), pp. 264–5. [Translator's note: Wherever possible, I quote the published English translations for passages cited from texts in languages other than English. At times, I have silently modified the quotations from these published translations. Otherwise, all translations are my own.]

2 See Francis Haskell and Nicholas Penny, *Taste and the Antique: The Lure of Classical Sculpture, 1500–1900* (New Haven: Yale University Press, 1981), p. 313.

tighten for any action, but whose outlines flow over each other like the waves of the sea.

Winckelmann thus carries the paradox to its extreme point. The accidental lack of the statue manifests its essential virtue. The apex of art is the mutilated statue that represents the greatest active hero miscast in the total inactivity of pure thought. Moreover, this pure thought only stands out as its exact opposite: the radical impersonality of a material movement very similar to immobility: the perpetual oscillation of waves on a calm sea.

The meaning of this radicalization remains to be understood. For there is a way of understanding this praise of calm a little too simply. Winckelmann had a polemical intention in publishing his *History*. He wanted to remind his contemporaries of the true models of beauty, drawing them away from the excesses of modern sculpture – that is to say, in his time, baroque sculpture: excessively extended or twisted bodies, faces distorted by the will to express extreme pleasure or pain. For him one sculptor embodied this perversion of art that our age, on the contrary, celebrates as the embodiment of baroque genius: Bernini. No more is needed to relegate Winckelmann to a certain role: he is made the retrograde guardian of a classical ideal of divine impassibility and beauty residing in pure lines and harmonious proportions. He would thus be the father of the neoclassical sculpture triumphant during the Napoleonic era, embodied by Canova's frigid marble figures. Above all, he would be the father of the academic Greece of 'calm grandeur' and 'noble simplicity', frozen far from its own soil in Roman museums and in the minds of German philosophers. It was against this Greece that Nietzsche's disciples, like Aby Warburg, raised a savage and tragic Hellas, making art, contrary to all glyptotheque Apollonianism, the manifestation of obscure energies that support and convulse the rituals and monuments of civilization at the same time.

But in order to oppose Dionysian energy to Apollonian calm, a certain Greece must already be constituted, far from all simple adoration of serene perfection. Winckelmann himself constituted its singularity by placing this torso, part of a body whose entire figure we will never be able to appreciate, above the divine form and proportion of the *Belvedere Apollo*. A mutilated statue is not only a statue lacking parts. It is a representation of a body that cannot be appreciated any longer according to two main criteria used by the

representative order: firstly, the harmony of proportions – that is to say, the congruence between parts and the whole; secondly, the expressivity – that is, the relation between a visible form and a character – an identity, a feeling, a thought – that this visible form makes recognizable in unequivocal traits. It will be forever impossible to judge whether the arms and legs of the *Belvedere Hercules* are in material harmony with the torso of the hero, forever impossible to know whether his face and his limbs are in spiritual harmony with the traits with which the myths represent him. More radically, it will be forever impossible to know whether it is indeed Hercules who is shown by this statue lacking all the attributes that would make him recognizable. Yet Winckelmann nonetheless confirmed the opinion that the statue represents the hero of the Twelve Labours, and does so in optimal form, translating the highest degree of perfection of Greek art. Posterity did not miss the chance to take him to task for this: his successors made this ideal Greek statue into a late Roman reproduction, and one of them even transformed his Hercules seated among the gods into a suffering Philoctetes. But assuming there was an error about the identity of the person, it was not the result of naivety, but a coup. The exceptional fate reserved for this mutilated body does not betray a naive allegiance to an outdated ideal of perfection. Rather, it signifies the revocation of the principle that linked the appearance of beauty to the realization of a science of proportion and expression. Here the whole is lacking just as much as expression. This accidental loss corresponds to the structural breakdown of a paradigm of artistic perfection. Attacking baroque excess does not amount to defending the classical representative ideal. On the contrary, it shatters its coherence by marking the gap between two optima that it claimed to match together: the harmony of forms and their expressive power.

No doubt the declaration of this gap is not absolutely new. It is also the assessment of a long history. For nearly a century, artists, critics and academicians were confronted with the problem of how to match the ideal of the noble harmony of forms, formulated in the seventeenth century by theorists like Bellori or Félibien, with the expression of passion notably illustrated, at the end of the same century, by Le Brun's physiognomic models. This was primarily a technical problem for students: How was it possible to imitate both the forms of studio models and the passions felt by characters to

whom they lent their features, but which they had no reason to feel themselves? One must leave the studio to study the way passions are inscribed on bodies elsewhere. This elsewhere, for some, was the privileged artistic stage for expressing the passions – the theatre. But others objected that, in the best acting, painters would only find 'grimaces, forced attitudes, and artfully arranged expressive features, from which feelings are excluded'.[3] On the contrary, the street or the workshop allowed one to better observe the common man, not yet moulded to expressive conformity by worldly conventions. But how was one to reach bodies expressing the nobility of forms corresponding to beauty? The academicians responsible for establishing 'the prize for expressive heads', founded in 1759 by the Comte de Caylus, determined that one could not find models among men whose 'baseness in outside habits and in their facial character made them incompatible with the study of beautiful forms that must remain inseparable from expression in this contest'.[4] And the very Diderot who urged students to abandon the academies to observe real movements of the body at work, or praised the expressive attitudes of Greuze's domestic tragedies, denounced the 'ignoble' faces the same Greuze gave his Septimus Severus and Caracalla in his 1765 Salon. Grand painting could not tolerate the living expression of a sly prince and an irascible emperor. Some had already solved the dilemma: the knowledge that neither theatrical convention nor the 'naturalness' of the common man could provide should be sought instead in the Ancients. For, like the sculptor of the *Laocoön*, they knew how to endow the same face with contradictory expressions never present in reality, except by unpredictable accidents, which the hand always arrives too late to copy. Winckelmann established the superiority of ancient models over 'natural' models, but he did not find it in the capacity to put the

3 Pierre-Jean Mariette, *Abecedario*, quoted in Thomas Kirchner, *L'Expression des passions: Ausdruck als Darstellungsproblem in der französischen Kunst und Kunsttheorie des 17. und 18. Jahrhunderts* (Mainz: P. von Zabern, 1991), p. 137. The artist Mariette is attacking is Coypel. Winckelmann similarly denounces figures with outraged expressions like antique masks meant to be legible for the spectators in the back rows. *The History of Ancient Art*, vol I. transl. G. Henry Lodge (Boston: James R. Osgood and Company, 1880), p. 365.

4 'Article du règlement du prix', quoted in Kirchner, *L'Expression des passions*, p. 199.

maximum amount of different emotions on the same face. *Laocoön's* beauty does not come from the multiplicity of passions it expresses; it comes, instead, from their neutralization in the sole tension of two opposite movements: one that welcomes the pain and the other that rejects it. *Laocoön* offers the complex form of the formula, which takes its simplest form in the radical insufficiency of the *Belvedere Torso*: beauty is defined by indeterminacy and the absence of expressivity.

Such a response deserves attention. It effectively seems to go against the current of watchwords developed in the same era by innovators of theatre and dance. They wanted to elevate the truthful expression of thoughts and passions above formal principles of harmony and proportion. Four years earlier, the *Letters on Dancing and Ballet* by Jean-Georges Noverre had appeared in another German capital, Stuttgart. They targeted the tradition of court ballet, which, according to Noverre, was meant only for the demonstration of aristocratic elegance and the mechanical skill of the artist. This art of steps and entrechats was opposed to an art of physiognomy and gesture fit to tell a story and express emotions. At the time, the model for this art was provided by ancient pantomime, in which another theorist of dance, Cahusac, had recently saluted a language of gestures capable of expressing all tragic and comic situations.[5] Two years earlier, Diderot's *Conversations on the Natural Son* had also pleaded for the resurrection of pantomime, and opposed the emotional potential of the tableau vivant to the artifice of the *coup de théâtre*. What Noverre and Diderot proposed – and end of the century reformist dramatists, musicians, and actors, from Calzabigi and Gluck to Talma, would take up once again – was a revolution in representative logic, playing upon its internal contradiction. They opposed the organic model of action as body, ideal proportion, and the entire system of conventions linking subjects to

5 Louis de Cahusac, *La Danse ancienne et moderne ou Traité historique de la danse* (Paris: Desjonquères, 2004 [1754]). The essentially pantomimic character of ancient dance had already been affirmed by the Abbé Dubos in his *Réflexions critiques sur la poésie et la peinture*, but for him it was a matter of opposing this rudimentary art to the perfection of modern dance. Cahusac and his heirs reversed the perspective by opposing the expressive perfection of a language of gesture to the formal conventions of courtly art. The first example of such reversals, which continued to feed the discourse on artistic modernism.

genres and modes of expression, with the bare principle of *mimesis* as the direct expression of emotions and thoughts. To the conventions of the theatre and elegance of the ballet, it opposed an idea of art in which every bodily gesture and every grouping of bodies tells a story and expresses a thought. Noverre's dancer-turned-actor and Diderot's actor-turned-mime must display an art of total expression on stage, identical to the manifestation of an entirely motivated language of signs and gestures:

> When dancers are animated by their feelings, they will assume a thousand different attitudes, according to the varied symptoms of their passions; when, Proteus-like, their features and glances betray the conflicts in their breast … stories will become useless, everything will speak, each movement will be expressive, each attitude will depict a particular situation, each gesture will reveal a thought, each glance will convey a new sentiment; everything will be captivating, because it will all be a true and faithful imitation of nature.[6]

The analysis of the *Torso* seems to go precisely against the current by setting a counter-revolution of suspended expression against a total revolution in expression. However, these two opposite revolutions share a common principle: the destruction of what lies at the heart of representative logic – namely the organic model of the whole, with its proportions and its symmetries. It is already significant that the art Cahusac, Noverre and Diderot considered to be a model of finally living theatrical action was painting. 'Any truly theatrical situation is nothing other than a tableau vivant', Cahusac declared.[7] Diderot opposed such composition of theatrical tableaus to the *coup de théâtre*. For Noverre, ballet masters must learn from painters to give each figure its own expression and to break the conventional symmetry that makes them place six fauns on one side and six nymphs on the other. This individualization of expressive figures and the natural way bodies are grouped together, according to the demands of each situation, provides the model for *vivacity*, which counts more than the effective mobility of bodies. The multiplicity of gestural and physiognomic events, which they demand,

6 Jean-Georges Noverre, *Lettres sur la danse et sur les ballets* (Stuttgart/ Lyon, Aimé Delaroche, 1760), p. 122; *Letters on Dancing and Ballet*, transl. and ed. Cyril W. Beaumont (London: Dance Books, 1966), pp. 52–3.

7 Cahusac, *La Danse ancienne et moderne*, p. 234.

shares at least one common point with the radical inexpressivity of the *Torso*, which is meant to gather an entire series of actions and a whole world of thought within itself. Both models undo the supposed conjunction of formal beauty and living expression. Both offer a form of inscription of life on bodies in rupture with the old organic paradigm that dominated the way discourse and the work were thought.

Discourse, according to Plato, must take the image of a living being, given all the elements that make up an organism, and only those; beautiful architecture, Vitruvius taught, took its norms from the proportions of the human body. Dürer's texts and drawings had renewed this principle of the mathematical proportions of the ideal body. This mathematics of beauty was strongly contested at the time. Artists like Hogarth and philosophers like Burke opposed its rigidity with the charm of the curved and sinuous line that also emblematized the new design of English gardens. Winckelmann was a stranger to their polemic, but he, too, opposed the continuous curved line to sharp angles. And the image that he used to characterize the *Torso*'s perfection is not accidental: muscles melt into one another like waves in the sea. This is the image of highest beauty, which the mutilated *Torso* embodies, like the Apollo with its head and all its limbs intact, but also mute, petrified Niobe, represented in 'a state such as this, in which sensation and reflection cease, and which resembles apathy' that 'does not disturb a limb or a feature'.[8] The beautiful statue is one whose muscles are not stretched by any action, but melt into one another like waves whose perpetual movement evokes the smooth and calm surface of a mirror. When Europe discovered the Parthenon reliefs half a century later, critics opposed their living movement to the poses of statues that Winckelmann admired. But they did so in the name of a criterion of perfection, which he had fixed himself: '... a principle of fusion, of motion, so that the marble flows like a wave'.[9] It was

8 Winckelmann, *History of Ancient Art*, vol. II, p. 122.

9 William Hazlitt, *Flaxman's Lectures on Sculpture* (*Collected Works*, vol. 16, p. 353), quoted by Alex Potts, 'The Impossible Ideal: Romantic Concepts of the Parthenon Sculptures in Early Nineteenth Century Britain and Germany', in Andrew Hemingway and William Vaughan, eds, *Art in Bourgeois Society, 1790–1850* (Cambridge: CUP, 1998), p. 113.

not simply nature's sinuous lines that were opposed to the right angles imposed by the minds of artists and princes. Rather, one nature was being substituted by another. On this point, the admirer of the immobile Hercules agrees with the philosopher who loved sentimental scenes like those in Greuze: nature, the guarantor of the beautiful, is to be found no longer in the proportion of parts, or the unity of expression of a character, but in the indifferent potential of the whole that endlessly mixes elements together by leaving them perpetually at peace. Forty years later Kleist explored the radical consequence of the rupture implied by the praise for the *Torso*. He opposed the movement of the marionette, whose 'soul' coincides with its centre, to the Bernini-like contortions imposed on the expressive body of the dancer to reach this very centre. A century after him, dance established itself as an autonomous art by exploit- ing all the possibilities of movement offered by the body freed from the obligation to tell a story, to illustrate a character, or to embellish music with images. These artistic transformations are certainly not inscribed ahead of time on the undulating surface of the *Torso*'s muscles. But this surface stretched between the memory of the tasks executed by the functional body of the hero and the indifference of the waves that rise and fall is already a surface for converting one body into another. The tension of many surfaces on one surface, of many kinds of corporality within one body, will define beauty from now on. The art announced by the praise for the mutilated *Torso* is not the art dreamt of by Kleist – an art of well-calculated automatisms meant to maximize an effect. Rather, it is an art of the plural compositions of movements freed by the dissociation of form, function and expression. Winckelmann inaugurates the age during which artists were busy unleashing the sensible potential hidden in inexpressiveness, indifference or immobility, composing the conflicting movements of the dancing body, but also of the sentence, the surface, or the coloured touch that arrest the story while telling it, that suspend meaning by making it pass by or avoid the very figure they designate. This revolution is perhaps more profound than the one Diderot and Noverre announced in their manifestos. No doubt Rudolf Laban saluted Noverre and his '*ballet d'action*' as a precursor of modern dance. But he saluted even more the revolution brought about by Isadora Duncan's dance, which aimed to show the identity between movement and rest that came to question the primacy of

'achievements through willpower'.[10] Now she sought her means of expression by observing the immobile figures on Greek friezes and urns. Free movement, movement equal to rest, only frees its expressive power once the links that oblige bodily positions to signify fixed emotions are undone. 'Expressive dance' celebrated in the twentieth century assumes the dissociation between sign and movement carried out by the analysis of the mutilated *Torso*. It assumes the breakdown of models of voluntary action and the legible tableau that still guide the '*ballet d'action*'.

By separating beauty and expression, Winckelmann also separated art into two. He dissociated the beauty of forms from their science. To appreciate this beauty liberated from expressive convention, one must stop examining it for a precise and functional muscular outline, which allows one to recognize the artist's anatomical knowledge and his capacity to translate it into the production of forms. The *Torso* reduced to a mere muscular outline, similar to waves, is still closer to the great era of art than the *Apollo*, in which divine majesty must be displayed on a face. Yet the *Apollo*, with its lines melting into one another, prevails in beauty over the *Laocoön*, forced to show both the pain of the bite and the greatness of the soul that resists it, even though the latter prevails in scientific terms, through the precise outline of its tense muscles and its facial expression, over the inactive and inexpressive *Apollo*. Kant summarized the separation between the beautiful form and the work of science in the thesis that our students know by heart, but whose unthinkable violence towards representative canons they have forgotten: the beautiful is that which pleases without a concept. It is necessary to realize what this break consists of. Surely, representative logic was familiar with the *je ne sais quoi* and the touch of genius that had to be added to the most learned application of the rules of art. Partisans of the Ancients even used it as a weapon to repel the criticism of the Moderns. And this is the reason Boileau excavated the treatise *On the Sublime*, attributed to Longinus. Some of our contemporaries have sought to locate the ruin of the representative model and the watchword of modernity in sublime disproportion. But this is a misunderstanding to say the very least, for the sublime was not discovered by champions of modernity. The defenders of the 'Ancients'

10 Rudolf Laban, *Modern Educational Dance* (London: Macdonald & Evans, 1948), p. 6.

made the sublime the secret of the superiority of the old masters and the keystone of the representative system. Genius, the power of the sublime, was the supplement of nature that sent art's rules and savoir-faire back to their living source, and thus allowed them to verify their agreement with the affects of sensible being in general. The sublime supplement sanctified the supreme principle of representative logic: harmony, at the heart of one and the same nature, between the abilities implemented in the productions of the arts and the affects of those for whom they were destined. This presumed harmony between *poiesis* and *aisthesis* gave *mimesis* the space necessary for its deployment, and the mimetic operation guaranteed it in return. The Kantian theorization of beauty without a concept breaks with the idea of the supplement because it first breaks with the idea of this correspondence. But with the mutilated statue, petrified *Niobe* or idle *Apollo* that Winckelmann celebrated, it is no longer a matter of addition, but of subtraction. It is less a question of adding an expressive flame to the rules of art. The less learnedly expression is reproduced, the more beauty there is. This calls for division, not completion: the *sensorium* belonging to the appreciation of the beautiful is no longer calibrated following any rules to the *sensorium* of making art. To bridge the gulf between the two, Kant would say, requires the power of genius and aesthetic ideas. But this genius is no longer the supplement checking the agreement between the rules of art and the affects of sensible beings. Henceforth it is a hazardous bridge thrown between two heterogeneous kinds of logic – the concepts that art implements, and the beautiful without a concept. It is the power, which remains obscure to the artist, of doing something other than what he does, of producing something other than what he wants to produce, and thus giving the reader, the spectator or the listener the opportunity to recognize and differently combine many surfaces in one, many languages in one sentence, and many bodies in a simple movement.

But the violence of the paradox does not stop here. For one must add that this very separation between the reasons of art and those of beauty make art exist as such, as its own world, and not simply as the skill of the painter, sculptor, architect or poet. The singularity of the analysis of the *Torso* cannot be dissociated from the singularity of the genre to which Winckelmann's book lays claim: not a history of the sculpture, monuments or paintings of antiquity, but

a *History of Art in Antiquity*. A 'history of art' assumes that art exists in the singular and without any qualifiers. For us this is obvious. But Winckelmann was one of the first, if not the first, to invent the notion of art as we understand it: no longer as the skill of those who made paintings, statues or poems, but as the sensible milieu of the coexistence of their works. Before him, the possibility of a *history of art in antiquity* was barred because its elements belonged to two separate histories: the history of artists and the history of antiquities. On the one hand, there were the lives of artists whose genre had been created by Vasari, modelled on Plutarch's *Parallel Lives*. These *Lives* took on meaning within a universe where the arts – forms of savoir-faire – were divided into 'liberal' arts practised and enjoyed by men of the elite, and mechanical arts, devoted to useful tasks practised by men in need. In this context, they were destined to justify the entry of painters and sculptors into the world of liberal arts. Hence anecdotal tales and moral lessons were given as much room as the analysis of works. The genre had been elevated since then, notably by the *Vite de pittori, scultori et architetti moderni* (*Lives of Modern Painters, Sculptors and Architects*), published in 1672 by Bellori. These were situated within a polemic concerning the principles of the art of painting. Bellori sought to show how these principles, brought to perfection by Raphael, then corrupted by Michelangelo's mannerist heirs, had been restored in the seventeenth century by Carraci and the Bolognese, and developed by the Roman school and Poussin. This argument required the genre of lives to be displaced towards the analysis of works. Yet Bellori and his French emulators did not attach these artists' lives to the general concept of a history, nor did they associate the art of any given painter or sculptor to the idea of Art as a proper sphere of experience. Such an idea was equally foreign to the work of those who used to be called 'antiquarians'. They brought fragments of antiquities from Italy and published detailed catalogues of medals, cameos, busts and other sculpted stones thus collected. For them these objects were 'monuments' – that is to say, testimonies of ancient life in addition to those found in texts. The Benedictine monk Bernard de Montfaucon formulated the principle: the monuments of arts 'like a painting' represented a good part of what the ancient authors had described, and moreover taught 'an infinite number of things that the Authors did not' about the uses and ceremonies of ancient

peoples.[11] No doubt this kind of history had been displaced, by the passion of artist–collectors, from simply functioning as a textual supplement to the consideration of objects themselves, their materials, and their modes of production. The *Recueil d'antiquités égyptiennes, étrusques, grecques et romaines* ('Catalogue of Egyptian, Etruscan, Greek and Roman Antiquities'), published in Paris in 1752 by the Comte de Caylus, shows the detailed attention to materials and techniques that makes historians of archaeology pay homage to 'antiquarians' of his kind.[12] But Caylus's inventory went against any will to 'art history': in his passion for antiquity, Caylus primarily took interest in the testamentary value of objects, stronger in the 'tatters' of useful objects than in the cold statues of Apollo or Venus;[13] he described these objects one after another, refusing to constitute their collection into an autonomous totality, just as he refrained from any extrapolation from these fragments 'that would fail to indicate the totality from which they are taken'.[14]

In order to provide a *history of art in antiquity*, it was not enough simply to unite the divergent interests of theorists of ideal Beauty and collectors of antiquities. Above all, it was necessary to extract the concept of Art from the dual limitations of those who studied the art – that is, the conception and the savoir-faire – of any one artist, and of those who studied *the arts*, that is to say, the knowledge and the techniques that produce objects and draw the portrait of a civilization. It was necessary to break down the separation between the singularity of 'the life of the artist' and the anonymity of the development of the arts, by revoking the social separation between the liberal and mechanical arts. A concept carried out this work – history. History does not come to take the constituted reality of art as its object. It constitutes this reality itself. In order for there to be a history of art, art must exist as a reality in itself, distinct from the lives of artists and the histories of monuments, freed from the old

11 Bernard de Montfaucon, *L'Antiquité expliquée et représentée en figures* (Paris: Firmin Delaulne, 1719), p. iii.

12 See Alain Schnapp, *La Conquête du passé: aux origines de l'archéologie* (Paris: Carré, 1993).

13 Charles Nisard, ed., *Correspondance inédite du Comte de Caylus avec le Père Paciaudi, théatin (1757–1765)* (Paris: Firmin–Didot, 1887), p. 9.

14 Comte de Caylus, *Recueil d'antiquités égyptiennes, étrusques, grecques et romaines* (Paris: Desaint et Saillant, 1752), p. 3.

division between mechanical and liberal arts. Yet reciprocally, for art to exist as the sensible environment of works, history must exist as the form of intelligence of collective life. This story must emerge from the narrative of individual lives modelled on the exemplary lives of antiquity. This story must therefore involve a temporal and causal scheme, inscribing the description of works into a process of progress, perfection and decline. But this scheme itself implies that the history of art should be the history of a collective form of life, the story of a homogenous milieu of life and of the diverse forms it brings about, following the model Montesquieu developed for political regimes. History thus signifies a form of coexistence between those who inhabit a place together, those who draw the blueprints for collective buildings, those who cut the stones for these buildings, those who preside over ceremonies, and those who participate in them. Art thus becomes an autonomous reality, with the idea of history as the relation between a milieu, a collective form of life, and possibilities of individual invention.

The historicist concern is surely shared by all those who want to break with the conventions of the representative order. Ballet, according to Noverre, and theatrical performance, according to Talma, must teach the life and the mores of the peoples that make history far more than the glorious acts of a few individuals. But there is something more radical about the history of art as practised by Winckelmann. It is not merely a matter of accurately represent-ing the ways of life and expression of people from the past. What matters instead is to think about the co-belonging of an artist's art and the principles that govern the life of his people and his time. A concept captures this knot in his work: the concept of 'style'. The style manifested in the work of a sculptor belongs to a people, to a moment of its life, and to the deployment of a potential for col-lective freedom. Art exists when one can make a people, a society, an age, taken at a certain moment in the development of its col-lective life, its subject. The 'natural' harmony between *poiesis* and *aisthesis* that governed the representative order is opposed to a new relation between individuality and collectivity: between the art-ist's personality and the shared world that gives rise to it and that it expresses. The progress of primitive sculpture up to its classical apogee, then its decline, thus follows the progress and the loss of Greek freedom. The first age of a collectivity massively subjected

to the power of aristocrats and priests corresponds to the rigidity of forms, due both to the awkwardness of art in its infancy and the obligation of following codified models. The golden age of Greek freedom corresponds to great and noble art with 'flowing lines'. The retreat of this freedom translates into the passage to an art of grace, where style gives way to manner – that is to say, to the particular gesture of an artist working for the particular taste of a narrow circle of art-lovers. This history of art, understood as a voyage between the two poles of collective absorption and individualistic dissolution, was destined for a very long future. During the revolutionary period, it would nourish dreams of the regeneration of art, recast in the antique model of the expression of collective freedom. Yet, more discreetly and more durably, it would also organize the historical arrangement according to which museums still present works of art today. It would also dominate all the thinking about art in the romantic period, and be systematized by Hegel as the passage from symbolic art to classical art, and from classical form to its romantic dissolution. Many of our contemporaries still see this as an historicist 'derailing' of art. But this 'derailing' is nothing other than the route through which the concept of Art as its own world came to light. Art exists as an autonomous sphere of production and experience since History exists as a concept for collective life. And the person who formulated this conjunction was no sociologist spitefully trying to cut down the sublimities of art to the prosaic conditions of their production. He was a hopeless lover of ancient sculpture, hoping to provide it with the most suitable sanctuary for its veneration.

It is true that this love itself is suspicious, and the argument is easily reversed. If Winckelmann is easily exonerated for having codified neoclassical frigidity, it is only to accuse him, on the contrary, of giving rise to the mad fervour of romanticism and German idealism. According to this accusation, his *History* invented a German Greece, an ideal land where art was born from the soil and expressed the very life of the people. This German Greece, sister to the Rome dreamt of by French revolutionaries, nourished the utopia of art's destiny, which destined it to negate itself in order to become what it used to be once again: the fabric of sensible forms of a people's life. It would feed the 'totalitarian' dream of identification between the life of art and of a people celebrating its unity.

However, how can one ignore the paradox that places the supreme embodiment of this Greece in a statue lacking its head and limbs? How can one ignore the mode of adoration it excites? It is in the past, Hegel would teach, that art *will have been* the manifestation of the life of a people. But Winckelmann already claimed he had followed the destiny of Greek art 'just as a maiden, standing on the shore of the ocean, follows with tearful eyes her departing lover with no hope of ever seeing him again, and fancies that in the distant sail she sees the image of her beloved'.[15] A torso for a body, the uniform movement of the waves for every action, a sail for the lover whom the ship carries away: the Greek body Winckelmann bequeathed to posterity is a definitively fragmented body, separated from itself and from every reactivation. Quite a different body, then, from the chorus of Spartan warriors, old men, and ephebes that Rousseau invoked during the same period in his *Letter to d'Alembert on the Theatre*. Rousseau's polemic attacked the coherence of representative logic differently. Winckelmann ruined the presupposition of a harmony between expressive capacity and formal perfection. Rousseau displaced the question onto ethical territory, in the proper sense of the term. *Ethos* means 'way of being', and Rousseau's polemic can be summed up as follows: theatre's way of being, comprising actions and emotions fictively experienced on stage, is contradictory with its pretention to positively educate the population's ways of being. For theatre gathers crowds only to dispossess them of the virtues that form a community. It takes the form of 'these exclusive entertainments which sadly close up a small number of people in a gloomy cavern, which keep them fearful and immobile in silence and inaction'.[16] Separation and passivity are the proper, antisocial features of the performance stage. Rousseau opposes this to the festival in which everyone participates, where all become actors and communicate emotions to each other, which the stage transformed into its simulacra. This was what continuous Spartan festivals were like, according to him. And this is what the civic festivals of modern

15 Winckelmann, *History of Ancient Art*, vol. II, p. 364.

16 Jean-Jacques Rousseau, *Lettre à d'Alembert*, in *Œuvres complètes*, vol. V, *Écrits sur la musique, la langue et le théâtre* (Paris: Gallimard, Bibliothèque de la Pléiade, 1995), p. 114; *Letter to D'Alembert and Writings for Theatre*, vol. 10, transl. and ed. Allan Bloom, Charles Butterworth and Christopher Kelly (Lebanon, NH: Dartmouth College, 2004), p. 343.

republics could resemble, seeds of which were contained in the pastoral and nautical pastimes of Genevans. Such were the great dreams of performance turned into collective action that would later inspire the celebrations of the French Revolution and flourish once again at the beginning of the twentieth century: the staging of *Orpheus and Eurydice* in 1913 in Hellerau with Appia's set design and the choirs trained in Émile Jaques-Dalcroze's rhythmic gymnastics, mixing the children of the European artistic elite with those of the workers from the 'German Workshops for Art in Industry', founded by a philanthropist and modernist industrialist; Romain Rolland's *Quatorze Juillet*, planned to end in a civic festival leading the theatre hall into collective action; Meyerhold's performances mixing the telegraphic news from the civil-war front with the Soviet war slogans at the turning points of plays performed, and so forth. No doubt these forms of collective mobilization in the name of art and revolution are far from the 'innocent' entertainments Rousseau promoted. Marx, Wagner and Nietzsche have left their mark here. Yet it is the same logic transforming ways of being that they oppose to representative logic: one must destroy the passivity of those who attend a show, separated by the performance from their individual and collective potential; they must be transformed into direct actors of this potential, acting together and sharing the same affective capacity. I call this alternative to representative logic 'ethical' – one that proposes to transform represented forms into collective ways of being.

But Winckelmann did not dedicate his history of art to such a resurrection of the collective festival. He opposes representative mediation not to ethical community, but instead to aesthetic distance. Separation and inaction – the two vices condemned by the *Letter to d'Alembert* – are, on the contrary, the paradoxical virtues of the mutilated statue, according to him. Not that he is less a lover of ancient virtue than Rousseau. The path that leads Greek statuary towards perfection, and then away from it, is strictly synchronous with the progress and decline of this freedom. But the way he saw this freedom embodied is strictly the opposite: it is not a matter of making the spectator active by suppressing the passivity of the performance. On the contrary, what matters is to negate the opposition between activity and passivity within the very figure of the god or the superhuman hero. Democratic Greece emerges through this negation. It does so retrospectively, of course. Modern republicans,

relying on their reading of the Stoics, invent such freedom, symbolized by a god or a hero who does not do or control anything. And Greece thus restaged is only present in the form of a lack. The impulse that leads to its embodiment in the new ceremonies of the republican people is strictly opposed to the metonymy of the sail that disappears from the lover's eyes. This sail takes the place of both the loved object and the ship carrying him away. It makes antique marble a figure in the double meaning of the word: a sensible presence that embodies the power that forged it, but also a deferral of this presence. The force of the whole is no longer in the gathering of a functional and expressive body. It is in the contours that melt into one another. It is everywhere and nowhere on the surface that withdraws what it offers. Figure is presence and deferral of presence, a substitute for lost presence. Winckelmann's statue has the perfection of a collectivity which is no longer there, of a body that cannot be actualized. The beautiful inactivity of the god of stone was the product of the free activity of a people. From now on, the indifference of the statue alone lends a figure to this free activity.

Indifference means two things: first, it is the rupture of all specific relations between a sensible form and the expression of an exact meaning; but it is also the rupture of every specific link between a sensible presence and a public that would be its public, the sensible milieu that would nourish it, or its natural addressee. Rousseau wanted the people to regain control of its sensible potential for action, emotion and communication, alienated in the distance of representation. But Winckelmann's Greek freedom is entirely enclosed in a block of stone. If the latter represents this for us, it is in its distance from its nurturing milieu, in its indifference towards any particular expectation from any specific public. The head of the *Juno Ludovisi* Schiller praised thirty years later was as follows: a head separated from any body, but also from everything a head is normally supposed to express: a will pursuing an end and commanding an action, a concern altering pure features. For him this expressionless head embodied free appearance presented for the enjoyment of pure aesthetic play, separated from any cognitive appropriation as well as any sensual appetite. But it did so as a thing of the past, a product of an exemplary art that can no longer be recreated. Moreover, he characterizes this art as 'naive' poetry: poetry that does not try to be

poetic, but expresses an immediate agreement between a collective, lived universe and singular forms of invention; an art that is not an art, not a separate world, but a manifestation of collective life. This is indeed what the mutilated *Torso*, the indifferent *Niobe*, or the will-less head of the *Juno Ludovisi* bear witness to. But they only bear witness by establishing an exactly opposed sensible configuration: by becoming works of art, lent to a 'disinterested' gaze, enclosed in the separate universe of museums. Art and History in the singular are born together by repudiating the division of the arts and the empirical dispersal of histories in the same movement. But they are born together in the form of this contradictory relation. History makes Art exist as a singular reality; but it makes it exist within a temporal disjunction: museum works are art, they are the basis of the unprecedented reality called Art because they were nothing like that for those who made them. And reciprocally, these works come to us as the product of a collective life, but on the condition of keeping us away from it. The Hegelian history of art forms would be the long demonstration of this constitutive divide. Art exists in the very difference between the common form of life that it was for those who made the works and the object of free contemplation and free appreciation that it is for us. It exists for us in the divide between the power of art and the power of beauty, between the rules of its production and the modes of its sensible appreciation, between the figures that regulate it and the ones it produces.

History is not the dreadful totality to which art was surrendered as a result of its break with classical harmony. It is a two-faced force itself: for it separates as much as it joins together. It is the potential of community that unites the sculptor's act with the practice of craftsmen, the lives of households, the military service of the hoplites, and the gods of the city. But it is also the power of separation that provides the enjoyment of ancient art – and the enjoyment of art in general – to those who can only contemplate the blocks of stone where the potential of community was saved and lost simultaneously. It is because it is divided itself, because it excludes at the same time as it gathers, that it lends itself to being the place of Art – that is, the place of productions that figure the division between the artist's concepts and beauty without concept. The mutilated and perfect statue of the inactive hero thus gives way to the complementarity of two figures. The head without will or worry of

the *Juno Ludovisi* emblematizes the existence of art, in the singular, as a specific mode of experience with its own sensible milieu. The *Torso*'s inexpressive back reveals new potentials of the body for the art of tomorrow: potentials that are freed when expressive codes and the will to express are revoked, when the opposition between an active and a passive body, or between an expressive body and an automaton, are refuted. The future of the *Torso* is within museums that make art exist as such, including and above all for their detractors; but it is also in the inventions of artists that will now strive to do the equivalent of what can no longer be done, by exploring the differences within bodies themselves and awakening the hidden sensible potential in inexpressivity, indifference, or immobility. The very dreams of a total work of art, of a language of all the senses, a theatre given over to collective mobilization, art forms identical to the new forms of life – all these dreams of ethical fusion following representative distance are possible only on the basis of a more intimate separation. The history of the aesthetic regime of art could be thought similarly to the history of the metamorphoses of this mutilated and perfect statue, perfect because it is mutilated, forced, by its missing head and limbs, to proliferate into a multiplicity of unknown bodies.

2. The Little Gods of the Street

Munich–Berlin, 1828

In the like sense, the beggar boys of Murillo (in the Central Gallery at Munich) are excellent too. Abstractly considered, the subject-matter here too is drawn from 'vulgar nature': the mother picks lice out of the head of one of the two boys, while he quietly munches his bread; in a similar picture two other boys, ragged and poor, are eating melon and grapes. But in this poverty and semi-nakedness, what precisely shines forth within and without is nothing but complete absence of care and concern, which a dervish could not surpass, in the full feeling of their well-being and delight in life. This freedom from care for the external, this inner freedom in the external is what the concept of the Ideal requires. In Paris there is a portrait of a boy by Raphael: his head lies at rest, leaning on an arm, and he gazes out into the wide and open distance with such bliss of carefree sat-isfaction that one can scarcely tear oneself away from gazing at this picture of spiritual and joyous well-being. The same satisfaction is afforded by those boys of Murillo. We see that they have no wider interests and aims, yet not at all out of stupidity do they squat on the ground, rather content and serene, almost like the gods of Olympus; they do nothing, they say nothing; but they are people all of one piece without any surliness or discontent; and since they possess this foundation of all capacity, we have the idea that anything may come of these youths.[1]

1 Hegel, *Aesthetics: Lectures on Fine Art*, ed. T. M. Knox, vol. I (Oxford: OUP, 1988), p. 170.

These lines appear in the first book of the *Lectures on Aesthetics* published after Hegel's death, based on his students' notebooks. And we read them willingly as a happy improvisation, an example opportunely chosen by the professor in order to explain this 'ideal' whose sensible realization constitutes the artistically beautiful. For in this section devoted to elaborating the concept of the beautiful that is the object of artistic production and aesthetic reflection, the professor willingly illustrates his argument with contemporary examples: the latest salon where a new school of painting ends up giving a caricatural aspect to ideal beauty, a polemical work in which a connoisseur opposes ideal theories with the exigencies of sensible matter and the technique that transforms it. Here two paintings from the Munich Gallery and a painting from the Louvre illustrate the argument. Two Murillos and one Raphael, or at least a painting attributed to Raphael. In the period when Hegel saw it, the portrait of the young dreamer with the velvet beret that posterity alternately attributed to Parmigianino and to Correggio was still attributed to Raphael. The correction of the attribution matters little here. What deserves attention is the coupling of the two names: Raphael and Murillo. For them to be associated in this way, for one to recall the other, an abyss needed to be crossed in the hierarchy of painters. In the tradition of Vasari, renewed by Bellori and Félibien, Raphael is the master par excellence, the one who nourished himself in Rome on the monuments of antique art and knew how to transpose their noble simplicity onto the pictorial surface. In the prize list of painters compiled by Roger de Piles in 1708, he was the undisputed master in the fields of drawing and expression, equalled only by Guerchin and Rubens in composition. Colour alone, of which Titian and the Venetians were the recognized masters, constituted his weak point. But even this weakness contributed to his supremacy for all those who considered drawing the directing principle of the art of painting, and colour its simple servant.

Murillo was very far from deserving such homage. *Beggar Boys Eating Grapes and Melon* probably entered the collection of the Prince Elector of Bavaria as early as the late seventeenth century, and a few English travellers brought some of the Sevillian master's works back to their country in the eighteenth century. But one would search in vain for his trace, and that of his compatriots, in the surveys that learned eighteenth-century Europe compiled of its

great painters and schools of paintings.[2] Undoubtedly there is an empirical reason for this. The religious works created for Spanish convents and the royal family portraits did not leave Spain at all. And even there, the visitors complained about the unwillingness to allow them to be seen. An English traveller, who hoped to see the Murillos at the Hospital de la Caridad, in Seville, recalled his desperate attempts to overcome the ill will of the lazy monks in order to access the chapel where the paintings were covered with a black veil that was lifted only a few days each year.[3] The Napoleonic armies satisfied the curiosity of these amateurs in their own way: there were eight paintings from the Caridad among the paintings seized by the general Soult, whose raids forced Spanish painting to enter the patrimony of universal painting. But the 'balance' of painters and Schools, as it was practised, excluded the idea of such a patrimony. The distribution of Schools was a distribution of criteria of excellence: Florentine drawing and Venetian colour, Italian modelling and Flemish chiaroscuro, and so on. A new national school could only take its place if it seemed to incarnate a specific excellence. And it was admitted that colour, the only praiseworthy element in the Spanish, came to them from the Flemish who had themselves inherited it from the Venetians. For a new 'national' painting to become visible, the idea of art as patrimony needed to impose itself: art as the property of a people, the expression of its form of life, but also as a common property whose works belonged to this common place now called Art, and that materialized in the museum.

Surely, the seizures of the French armies in the occupied territories constituted quite a peculiar form of 'common patrimony'. An extreme example can be found in the cynicism with which Soult collected misappropriated 'gifts', through armed force, for his private collection. Yet the very pillaging of the convents in Seville implied a new value attributed to their content. And one can readily smile

2 Some of the dictionaries of painting in use in the eighteenth century mention three Spanish painters – Velasquez, Murillo and Ribera – but none includes a Spanish School. For details, see Ilse Hempel Lipschutz, *Spanish Painting and the French Romantics* (Cambridge, MA: Harvard University Press, 1972).

3 Maria de los Santos Garcia Felguera, *La Fortuna de Murillo: 1682–1900* (Seville: Diputación Provincial de Sevilla, 1989), p. 48.

at the naivety or the impertinence of this French officer announc-
ing the arrival of a convoy of Flemish masterpieces in Paris: 'The
immortal works left to us by the brushes of Rubens, Van Dyck and
the other founders of the Flemish school are no longer in a foreign
land. Reunited with care at the orders of the people's represent-
atives, they are today deposited in the holy land of freedom and
equality, in the French Republic.'[4] But among the patriots who were
outraged by the thefts committed in Spain or Holland, in Italy or
Germany, more than one art lover recognized the benefit claimed
by the looters: having made paintings 'that were absolutely unfit to
be seen due to the smoke, grime and old oils with which they were
covered'[5] visible to all art lovers. One thing is certain in any case: the
revolutionary event, the new declaration of ancient freedom, and
the spoils of war of the 'armies of freedom' vertiginously accelerated
the movement that, with the progressive opening of princely col-
lections to the public since the middle of the eighteenth century,
made the works of the painters and Schools enter into this new
milieu of 'liberty' and 'equality' called art. In this sense, commen-
taries elicited by the return of the works to their country in 1815
are significant, such as this speech a Berlin journalist ascribed to
a Memling *Resurrection*, attributed to Van Eyck at the time: 'I am
only truly famous since the sorrows of war led a great number of
people to flock to Paris ... This was like a resurrection, and now
that I am presented to the eyes of all, here, in my country, I am
astonished to see how the way people see me has changed.'[6] The
very brutality of the operation accentuates the constitutive paradox
of art's new place: on the one hand, the works that enter it do so
as expressions of the life of their people, themselves belonging to
the patrimony of human genius. It accounts for why new 'schools'

4 *Le Moniteur Universel*, 3 vendémiaire an III, 1842, reprint, vol. XXII,
pp. 26–7.

5 *Notice des principaux tableaux recueillis dans la Lombardie par les
commissaires du gouvernement français dont l'Exposition provisoire aura lieu
dans le grand salon du Muséum les Octidis, Nonidis et Décadis, à compter du
18 pluviôse jusqu'au 30 prairial an VI* (Paris, Imprimerie des Sciences et des
Arts, 1798), p. ii.

6 *Berlinische Nachrichten*, 26 October 1815, quoted by Bénédicte
Savoy, 'Conquêtes et consécrations', in Roberta Panzanelli and Monica
Preti-Hamard, eds, *La Circulation des œuvres d'art, 1789–1848* (Rennes:
Presses Universitaires de Rennes, 2007), p. 85.

can appear there: the distribution of schools is not regulated by the distribution of criteria of academic excellence, but rather by their embodiment of the freedom of a people. But, inversely, it is because works henceforth express a collective belonging that it becomes possible to individualize them, to subtract them from classifications, and to draw the work attributed to the most sublime representative of the great 'Roman' school and the genre paintings of little Sevillian beggars closer to one another.

For, according to Hegel, what had been ruined was not only the hierarchy of schools, but also the hierarchy of genres. He does not compare a Madonna by Murillo to Raphael's Sistine Madonna, which he saw in Dresden. The Munich Gallery does not possess any. He compares the young man with the beret with two of these five paintings of children which ended up in Munich through a very specific path: via Dutch merchants. This is how Murillo's five *bodegones* entered, directly or indirectly, into the princely collection. In a way, it is as Flemish genre paintings that the little beggars of Seville are presented to Hegel's gaze in a gallery that possesses an important collection of 'little' Dutch or Flemish painters, like Teniers or Brouwer, who devoted themselves to painting domestic scenes, tavern fights or village festivals. And it is within a passage devoted to Dutch genre painting that their example occurs to him. The status of the artistic ideal is in effect linked to the evaluation of this kind of painting – that is to say, to the questioning of the hierarchy of pictorial genres. It had been a long time indeed since aristocratic collectors became infatuated with these popular scenes and Teniers's sale value reached reputable figures. Nevertheless, they were ranked at the bottom of the ladder throughout the eighteenth century: a great painting required a great subject. In scenes of domesticity, villages and the cabaret, one could certainly admire the dexterity of the painter (Teniers receives the same grade in composition as Leonardo da Vinci in Roger de Piles's classification) and allow oneself to be seduced by the art of shadow and light. But these merits equally amounted to signs of baseness: 'Some inferior dexterity, some extraordinary mechanical power, is apparently that from which they seek distinction', was Joshua Reynolds's verdict, in the 1770s, on these paintings and the genre that they embodied.[7]

7 Joshua Reynolds, *Discourses on Art* (New Haven: Yale University Press, 1988), p. 130.

The representation of vulgar scenes and people could only match the skill of an artisan, not the ability of an artist.

The museological and revolutionary constitution of artistic patrimony was evidently bound to overthrow this hierarchy. It was their capacity to translate freedom – of genius and of the people – which now had to define the value of paintings, rather than the distinction of the people represented. But this upheaval did not come without problems. No doubt the organizers of the revolutionary Louvre forcefully declared the end of

> ridiculous distinctions of *story*, or *genre*, or *landscapes*, or *history* … nature having told no-one that a village dance was out of place in the gallery of a people who imposed upon itself the duty to honour the values of the countryside, and to prefer its pleasures; nature having told no-one that it only breathes under Alexander's tent and ceases to revel in the nooks of an enchanting site.[8]

It remained unclear how the potential for freedom could be recognized on a canvas, and how what could be seen in the works of patrimony could incite the virtues of a free people. The revolutionary redactor emphasized this: even if nature did not know genres, one still needed to distinguish between its products. This is where the break from the ancient hierarchy quickly posed a dilemma: what education of a republican people could one expect from the tavern scenes preferred by genre painters? At first, Northern painters were only admitted for some edifying paintings. Thus the redactor of the *Décade philosophique* was able to oppose the 'historical flatteries' and 'the lies eternalized by Rubens and Lebrun' to the 'works of mercy' symbolized by the *Return of the Prodigal Child* by Teniers or *The Dropsical Woman* by Gérard Dou.[9] For the most part,

8 'Rapport du Conservatoire du Muséum national des arts, fait par varon, un de ses membres, au Comité d'Instruction publique, le 26 mai 1794', in Yveline Cantarel-Besson, ed., *La Naissance du Musée du Louvre: la politique muséologique sous la Révolution d'après les archives des musées nationaux: [procès verbaux des séances du Conservatoire du Muséum national des arts]* (Paris: Editions de la Réunion des Musées nationaux, 1981), vol. 2, p. 228. The allusion to Alexander's tent refers to a painting by Lebrun long considered a masterpiece of historical painting.

9 Pierre Chaussard in *La Décade Philosophique*, year VIII, first trimester, p. 212, quoted by H. Van der Tuin, *Les Vieux peintres des Pays-Bas et la critique artistique en France de la première moitié du XIXe*

popular Dutch or Flemish scenes offered no legible instruction to the republican people. The task thus fell upon great painting, upon the painting of great subjects, to provide this education. But what were these great subjects? What did the works of the great masters represent if not biblical episodes, mythological scenes, portraits of sovereigns and their royal favourites? In short, their subjects bore testimony only to religious superstition and oppression. The same report emphasizes that 'long centuries of slavery and shame' had turned art away from its 'celestial origins'. All of its works were 'stamped with superstition, flattery and *libertinage*' to the extent that one was 'tempted to destroy all these baubles of delirium and deceit'.[10] Winckelmann could still sigh like a grief-stricken lover before the freedom withdrawn from the world and preserved in antique stones. The curators of the republican museum had to confront this paradox brutally: the patrimony of freedom was there, in their crates, in the heart of the capital of the republican world, but this patrimony was composed of works that were the product and the consecration of servitude. Was it necessary to destroy all these 'baubles' and cover the walls of the Louvre only with paintings celebrating the great scenes of antique history and the heroism of revolutionary armies? But even when the subject of the action would not give rise to controversy, a deeper split affected the edifying value that could be given to painting. One now presumed to know: painting could not find perfection by representing an action. It only truly excelled at representing movement at standstill. This is the reason history painting with a message was perfected in *The Intervention of the Sabine Women* by David: the painting of an action interrupting military action. The positive message of peace could be identified through the calm lines, but not without a strange feeling summed up by a commentator: for him the most beautiful figure of the painting was a squire whose 'juvenile and admirable forms breathed the ideal'.[11] But this ideal figure seemed indifferent to the action. The squire was turning his back to the warriors as well as the women who were separating them.

siècle (Paris: J. Vrin, 1948), p. 58.

10 Rapport de Varon, quoted in Cantarel-Besson, *Naissance du musée du Louvre*, p. 228.

11 P. Chaussard, *Sur le tableau des Sabines par David* (Paris: C. Pougens, 1800), p. 17.

It was thus impossible to base the education of freedom on the subject of the painting. Only one solution was available to those drawing testimonies of 'long centuries of slavery and shame' out of the crates: to nullify the content of the paintings by installing them in art's own space. It was the placement of the paintings on the walls, the 'air of grandeur and simplicity' of the whole, and the 'severe choice' of the works that had to 'draw respect'.[12] The arrangement of art's place and the singular potential of artists would have to teach free people what represented subjects could not be expected to teach them. The republican display of educational painting had the paradoxical yet logical consequence of training a gaze detached from the meaning of the works. How was one to expose the cycle painted by Rubens to the glory of Marie de Medicis, the scheming widow of the 'tyrant' Henri IV to the republican people? The chosen solution was to extract the two paintings that were the least immediately legible, the most allegorical: two paintings devoted to the reconciliation of the queen mother with her son, the young Louis XIII. These paintings became pure representations of general concord. The queen, seen in profile in the background, was partially masked by Mercury and by two figures of Peace that left the foreground to an enigmatic character, partially nude with bulging muscles. These detached fragments became unintelligible as historical scenes, and forcefully solicited a 'disinterested' gaze on the pictorial idealness of the figures: 'Removed from their narrative sequence, the dense allegories of the scenes rendered them illegible except as figurative paintings and as examples of Rubens's brush; the nude foreground figures became all the more prominent as signifiers of the Ideal.'[13]

The revolutionary declaration of the equality of subjects and the institution of the museum alone could thus not suffice to ensure the overthrow of the hierarchy. The addition of a supplementary but also a contradictory element was necessary. It was thus the revival of the art market, corresponding to the decline of the Revolution, which consecrated the little Flemish and Dutch works by opposing the 'immortality of sales' to the 'immortality of biographies'.[14]

12 Cantarel-Besson, *Naissance du musée du Louvre*, p. 228.

13 Andrew McClellan, *Inventing the Louvre: Art, Politics, and the Origins of the Modern Museum in Eighteenth Century Paris* (Cambridge: CUP, 1994), pp. 110–11.

14 Charles Lenormant, *Les Artistes contemporains. Salon de 1833*, vol.

Prices from sales around 1800 for *The Willows* by Potter, or *A Village Fête* by Teniers, or *The Ham Eater* by the same artist, bear witness to this evolution. Later it was romantic travellers who transposed Winckelmann's logic to works by painters from the Netherlands. Winckelmann had celebrated the perfection of the Greek and the Italian climate that gave an air of noblesse to the most destitute folk. Lacking sun, soft breezes and a clear blue sky, these travellers found paintings at every street corner and became exalted like Thoré in Ghent, 'where the daughters of common people walk like princesses' and where 'Rubens found the type for his saintly women and the noble ladies in waiting of Marie de Medicis'.[15] In 1824 the editor of the *Globe* had already dubbed Raphael and Adrian Brouwer as belonging to the same art: 'Everything that belongs to the universe, from the highest to the lowest object, from the heavenly Sistine Madonna to Flemish drunkards, is worthy of being depicted in his works.'[16] Here they founded a certain sociological republicanism of art, marking the conjunction between the life animating the pictorial surface and the equality of all subjects, which would be embodied in France by one man: Etienne Joseph Théophile Thoré, revolutionary deputy of the Second Republic, who, under the penname of Wilhelm Bürger, contributed to the glory of two artists still obscure in Hegel's time: Franz Hals and Jan Vermeer. For Thoré, the equal attention that the older masters, Van Eyck, Memling or Roger Van der Weyden paid to 'the landscape and its thousand accidents, to the blade of grass and rose branch or oak boughs, to the bird and the lion, to the cottage and the finest architecture', was the sign of 'a kind of pantheism, a naturalism, a realism, if you will', characteristic of the Flemish or Dutch schools: 'All classes of people, all the particularities of domestic life, all the manifestations of nature are accepted and glorified there.'[17] In favour

II (Paris: A. Mesnier, 1833), pp. 116–17. In the margins of a commentary about a Decamps painting, Lenormant opposes the 'passionate attention' that genre paintings by a Metsu or a Mieris spark in the auctions to the icy reception reserved for historical paintings, which used to be considered timeless.

15 Théophile Thoré, 'Rubens en Flandre', *L'Artiste*, 4th series (1841–46), vol. V, p. 218ff., quoted in Van der Tuin, *Les Vieux Peintres des Pays-Bas*, p. 34.

16 *Le Globe*, 17 September 1824, quoted in ibid., p. 61.

17 Théophile Thoré, 'Musée d'Anvers' (Brussels: C. Murquardt, 1862), pp. 34–5.

of the art of their time, the French contributing editors of *L'Artiste* began to develop this alliance between the freedom of art and the equality of subjects that makes genre painting the true historical painting. In the vibrations of the coloured surface it expressed the larger and deeper history of mores, the chronicle of ordinary people and everyday life that followed the hollow grandeurs of yesteryear. Nonetheless, this art would not be the art of the Second Republic in 1848. Instead, Joseph Chenavard was ordered to decorate the Panthéon with grand humanitarian frescoes. The rapid return of reactionary forces to power blocked the execution of these frescoes, but Chenavard's sketches at least allowed the person who remains the French literature textbook inventor of *l'art pour l'art*, Théophile Gautier, to reveal himself as the most eloquent champion of programmatic humanitarian art.[18]

Hegel, for one, was invested in thinking exactly what art for art's sake and art as the expression of a society had in common. He takes up the problem where revolutionary museographers set it aside: How is one to think through this 'ideal' that defines the excellence of painting, once it has been separated from criteria of academic excellence, from social grandeurs, or from its value as moral illustration? For the museographers of the new Louvre, the organization of the exhibition itself had to manifest the paintings' belonging to the patrimony of freedom. Hegel wants to make this belonging appear on the very surface of the paintings, and especially on the prosaic works of genre painters scorned in the name of the demands of great art. This is precisely where one can best reveal the constitution of the Ideal that now makes up beauty. This is where its essential animating tension can be made manifest. This tension can be summarized simply: on the one hand, the freedom of the work signifies its indifference to its represented content. This freedom can thus appear purely negative: it relies only on the status of the works in museums where they are separated from their primary destination. Religious scenes or royal portraits, mythological compositions or domestic scenes, the paintings that yesterday were used to illustrate the truths of faith, to figure the grandeur of princes or to adorn aristocratic life, are offered in the same way to the gaze of anonymous

18 The seven articles Gautier devoted to Chenavard's project in *La Presse* from 5 to 11 September 1848 were reprinted in his collection, *L'Art Moderne* (Paris: M. Lévy Frères, 1856), pp. 1–94.

visitors, ever less attentive to the meaning and the destination of the paintings. This indifference could mean that, from now on, painting is a simple matter of shapes and light, lines and colours. At first sight, the praise for Murillo's little beggars or the Dutch or Flemish genre scenes seems to illustrate this idea. One must not misconstrue the 'realism' of the representation of the little beggar boys. It is itself the result of a process of abstraction. The child who lets himself be deloused is not simply the representation of everyday life in Seville. He is first a figure detached from another kind of painting, where he had a defined function: to illustrate the works of charity. On a painting hung on the walls of the Caridad hospital, the same Murillo depicted a very similar child. But it is Saint Isabella of Hungary who is busy cleaning his scabby forehead, while an old woman, like the attentive mother, appears as another patient in the hospital. The autonomy of painting is first and foremost the autonomy of its figures in relation to histories and allegories in which they had their place and their function. The representation of the destitute, people who have no importance on their own, allows for the upheaval of the illustration of subjects towards the pure potential of appearance. On the gallery walls, the light of the pictorial works shines indifferently on the quality of what it illuminates: 'servants, old women, peasants blowing smoke from cutty pipes, the glitter of wine in transparent glass, chaps in dirty jackets playing old cards'.[19] It is not the representation of these ordinary objects that makes for the value of the painting, but the glimmerings and reflections that animate its surface, 'the pure appearance which is wholly without the sort of interest that the subject has'.[20]

This absence of interest is obviously not invoked by accident. It is the key word of the Kantian theory of aesthetic judgment. Hegel intends to show that this disinterestedness is not only the subjective property of judgment, but also the very content of painting, and especially the content of painting as such. Painting, in effect, is the art that does not merely describe things, as poets do, but makes them visible. But it is also the art that no longer concerns itself with filling space with volumes, analogous to the bodies it figures, as sculpture does. Rather, it uses its surface as the means to repudiate them: to mock their consistent solidity by making them appear

19 Hegel, *Aesthetics*, p. 162.
20 Ibid. p. 598.

through artificial means, but also illuminating their most evanescent aspect, closest to their shining and glittering surfaces, to the passing instant and the changing light. And it is also the art that manages to prove itself fully once it no longer serves any faith nor celebrates any self-perpetuating greatness: a village scene is something in which no social power seeks its image, it is thus what we look at for the pure 'disinterested' pleasure of enjoying the play of appearances. And it is this play of appearances that is the very realization of freedom of mind.

But a problem arises here: if the freedom of the painting consisted in this play alone, it would simply be identified with the virtuosity of the artist capable of transfiguring any profane reality. The Dutch painting would be privileged, since the very mediocrity of its subject shows that the virtuoso art of the maker of appearances is the only real content of painting, whatever its subject may be. But the relation between freedom of art and the indifference of subject does not allow itself to be resolved so easily; nor does the relation between profane life and artistic singularity. The freedom manifested by the *insouciance* of the characters depicted cannot simply be reduced to the freedom of indifference. The new concept of art demands – as a famous work by Kandinsky recalled in the next century – that it be the realization of content, of an inner necessary freedom. Hegel had already insisted as much: what is seen on the canvas is neither the life of the Golden Age peasant nor the dexterity of Teniers, Steen or Metsu. The play of appearances, light effects, and the jauntiness of the canvas must not arrive on top of the painting independently of the subject. They must reveal its true subject. The freedom incarnated on the canvas does not belong to the artist, but to the people able to domesticate hostile nature, end foreign domination, and gain religious freedom. Greek freedom was signified by indifference in the impassivity of the stone god. Dutch freedom was signified as the indifferent treatment of appearances in relation to the vulgarity of subjects. But this 'indifferent' treatment makes the non-vulgar, spiritual content of these subjects visible: the freedom of a people that gave itself its own way of life and prosperity, that can rejoice with 'insouciance' about the setting it gives itself after great pains, and rejoice in a disinterested way at the image of this universe, created by artifice, in the same way the child revels in the skipping of a stone skilfully thrown across the water's surface. Hegel

considers the child who throws pebbles to transform the natural landscape into the appearance of its own freedom as the originary figure of the artistic gesture, a figure itself inherited from the freedom that Winckelmann saw expressed in the indifferent movement of the waves. But the freedom of the child throwing stones is also the freedom that shaped him – that gave itself its own world by taming the sea and chasing the invader. Dutch liberty expresses itself in the modern art of painting which paints the reflection of light and water upon popular works and entertainments, as Greek freedom in classical art fashioned the serenity of gods.

Yet it not that easy to distinguish the joyful insouciance that characterizes the paintings of free Holland from the kind that spreads across the genre scenes of the Flemish people still under Spanish domination. It is even less simple to understand how the freedom of the heroic and industrious Dutch can be conferred upon the young beggars of Seville, these children of servitude, these children of the land of monarchy and superstition that had placed the Netherlands under its tutelage. It was necessary that they somehow find themselves in the Antwerp market, at the crossroads of Dutch freedom and Spanish servitude, integrated into the art of the people, in order to acquire their exemplarity. But on a deeper level, it was necessary that Dutch freedom, the freedom of an active people reflected on the polished surface of domestic objects represented by its painters, be identified with another freedom that could however seem to be its precise negation: that of the Olympic gods, that of the goddess celebrated by Schiller in his *Letters on the Aesthetic Education of Man*. Like the *Juno Ludovisi*, the little beggars enjoy the beatitude of those who have neither worry nor will, those who remain at rest, without any desire to speak or act. The Greek people attributed this absence of worry to their gods, the poet wrote, because it was the very essence of *its* liberty. He was probably thinking of the famous speech Thucydides attributed to Pericles, affirming that the military heroism of the Athenians had its source in their carefree lives. But the identity of hard work and heroic action with the absence of all worry had been affirmed by Winckelmann, who found its supreme embodiment in a Hercules at rest, lacking a head able to will and limbs able to act. If the insouciance with which the little Sevillian beggars eat their melon, play cards, or let themselves be picked for lice while munching bread, can express the artistic Ideal, it is

because it comprises both the freedom of the modern people that gives itself a world through will power and that of the antique god who neither wants nor does anything. This idea of Greek freedom as the conjunction of supreme activity and perfect idleness, shaped by the shoemaker's son Winckelmann, would later, as we know, during the French affirmation of collective will and great communitarian festivities, nourish the idea of a true revolution for young people, named Hegel, Schelling and Hölderlin – a revolution that would abolish the cold mechanics of the State and unite a philosophy that had become poetry and mythology with the sensible life of the people.

The author of the *Lectures on Aesthetics* stands on the other edge of the great revolutionary upheaval, when both the antique reconstitutions of the French revolutionaries and the dreams the revolution sparked in these young German philosophers and poets, now back to their senses, had subsided. And a few years earlier, in the same university, Professor Hegel, in his courses devoted to the philosophy of right, praised the formative influence of work and discipline, which left no room for reveries on the divine insouciance of these little beggars. But there are many kinds of wisdom, and Hegel's wisdom does not celebrate the return to older values and traditions. Rather, in the forms and institutions of re-established order it shows the effective becoming-world of the liberty and equality carried yesterday by the cannons of republican armies and the dreams of a new Greece. Art and aesthetics are precisely two of these forms: an ensemble of places, institutions and forms of knowledge that welcome, make visible and intelligible the freedom inscribed in stone and on painted canvases, and especially on those paintings that incarnate the distinctly modern political liberty in the insouciance of their subjects: the freedom of the insurgent, protestant bourgeois of Holland rather than those belonging to the revolutionaries influenced by antiquity. This political liberty once it has passed onto the canvas, and been forgotten as an anecdote, provides the frame that allows us to see the freedom of painting present in the little lousy urchins of Seville, and in the dreaming young man of 'Raphael', this young man whose social identity is indefinable: What status could be denoted by this beret and this supple black dress, this nonchalant attitude, and this three-quarter pose that distorts the gaze and denies any intention of

representing the social dignity of a character? Later art historians would conclude that here the artist – Correggio, one claims today – did not depict a client at all, but one of his peers, for fun, who might well be Parmigianino. The portraits that find themselves collected today in the physical and conceptual space of the museum – the free citizen, the oppressed little beggar of the people, and the young man without identity – make up only one single picture in the end: the portrait of the artist by the artist, the portrait of painting by itself.

Only, says Hegel, this being in itself is also a being outside oneself. There is no resemblance between the constitution of a free people and a burst of light on pots and plates. The freedom of painting is realized entirely within this gap, in this 'subject' that imposes itself on the artist, that robs him of the desire to do what he wants, that reduces the pure virtuosity he would like to exhibit to a vain technique. Northern painting falls into decadence when painters become specialists – one in the brilliance of a certain fabric, the other in metallic reflections. And with this, painting in general becomes what it is for us in museums: an art of the past. The heroic age of Dutch painting has passed, like the mythic age of Greek liberty. Painting no longer has its proper subject – that is to say, no improper subject, no subject that puts it outside itself in order to make divine freedom shine upon the foreheads and in the gazes of street children. Painters, from this point onwards, imitate painting. Some imitate scenes of Dutch and Flemish genre painting. But if tavern scenes can be imitated, liberty cannot, and the genre paintings of German painters exhibited at the 1828 salon only show us bitter and mean-looking *petits-bourgeois*. Others want to renew the great tradition of the Ideal incarnated in Raphael's Roman frescoes. But on the walls of the salon, as in the churches they decorate, the 'ideal' turns out to be the absence of flesh, the simple invocation of itself. The true successors of genre painters are not painters any more: they are romantic writers, says Hegel, those who tirelessly animate the prosaic places and episodes that are the theatre of their cock-and-bull stories with the wings of their 'free fantasy'. The freedom shining on the children of the street becomes pure poetic ornament in their prose, the 'whatever' that the artist's empty freedom adds to any reality whatsoever.

Art is thus a thing of the past. As the patrimony of freedom, it finds its own place as part of the décor of a matured and wizened

liberty, realized in a rational world of exchange, administration and knowledge. However, in this well organized past, the professor's reverie introduces a singular call to what is to come. The professor of aesthetics does not merely celebrate the insouciance of these little beggars in his chair where, a few years earlier, the professor of the philosophy of law stigmatized laziness and mocked the ideal of the noble savage, content with the gifts of nature. For this Olympian adolescent that he has composed with the mixed traits of Murillo's little beggar and the enigmatic young man of 'Raphael', he predicts a future that is just as unlimited as it is undetermined: one can expect anything from this young man, anything could come of him. There are many ways of imagining this future. The boy to come might have the features of the kid who accompanies 'liberty guiding the people', gun in hand, after the Parisian revolution of July 1830, on Delacroix's painting. He is more clearly recognizable, no doubt, in the figure of Gavroche, whom Victor Hugo knocks down on the republican barricades, a kid just as insouciant among the bullets whizzing past him as the little kids eating grapes and melon or the young dreamer of the Louvre. But this politicization of the Sevillian kid admired by Hegel is also a prolongation of his meditation. On the walls of the Munich gallery, in the eyes of the philosopher who had been inspired by the French Revolution, the little beggars inherited Dutch freedom. In the prose of the exiled opponent, Victor Hugo, the insouciant child takes on this 'freedom' once more, on literature's account, where the heroism of freedom fighters and the indifference of the little gods of the street are confounded. A century later a filmmaker who was hardly a revolutionary, Robert Bresson, made his child heroine, little Mouchette, an heir to Bara, the child martyr of the French armies of liberty immortalized by David's brush.

The future of the insouciant child thus reopens what philosophy declared closed. The equal insouciance of the Olympic god and the Flemish drinker, of the Sevillian beggar and the young Italian dreamer, is not only preserved in the patrimony of art that is of the past. Art is not condemned to exhaust itself in the will to make art, in fantasy play and demonstrations of virtuosity. The disjunction between art and the beautiful, necessary for the beauty of art, would be found everywhere by the novelists of social comedy and the painters of new urban entertainment and Sunday outings, opening the path for those new artists, who would benefit from an

unprecedented weapon in the quest to realize the union of art with non-art: the mechanical eye that does not know what it is to make of art or beauty. A thoughtless few stigmatized this machine that came to do the work of art. Others praised it, on the contrary, for liberating art from the tasks of resemblance. Perhaps both positions miss the aesthetic heart of the problem. No doubt it would have required the philosopher's gaze on the Sevillian child to understand what the machine would give art: the availability of this non-art without which art could no longer live. The afterlife of the Sevillian child and the young dreamer in the beret is undoubtedly given its most exact formulation by Walter Benjamin, when he is speaking about the photographs of New Haven fishwives by David Octavius Hill: photographs where reality had burnt the image-character, where non-art had pierced a hole that placed it at the heart of what could henceforth be experienced as art.

3. Plebeian Heaven

Paris, 1830

On that day, when Mathilde and Fouqué tried to tell him of certain public rumours very suitable, in their opinion, to raise his hopes, Julien stopped them at the first word.

—Leave me my ideal life. Your little tricks and details from real life, all more or less irritating to me, would drag me out of heaven. One dies as one can; I want to think about death only in my own personal way. What do *other people* matter? My relations with *other people* are going to be severed abruptly. For heaven's sake, don't talk to me of those people any more: it's quite enough if I have to play the swine before the judge and the lawyer.

As a matter of fact, he told me himself, it seems that my fate is to die in a dream. An obscure creature like myself, who is sure to be forgotten in two weeks' time, would be a complete fool to play out the comedy …

Still, it is strange that I have learned the art of enjoying life only since I have seen the end of it so close to me.

He passed these last days walking about the narrow terrace atop his tower, smoking some excellent cigars Mathilde had had brought from Holland by a courier; he never suspected that his appearance was awaited each day by every telescope in town. His thoughts were at Vergy. He never talked about Mme de Rênal with Fouqué, but two or three times his friend told him that she was recovering rapidly, and the phrase reverberated in his heart.[1]

1 Stendhal, *Le Rouge et le Noir*, in *Œuvres romanesques complètes*, vol. I (Paris: Gallimard, 2005), p. 775; *Red and Black*, transl. and ed. Robert M. Adams (New York: W.W. Norton & Co., 1969), pp. 381–2.

When *Red and Black* was published in 1830, critics did not fail to denounce the novel's implausible characters and situations. How could this rather uncouth little peasant become an expert in high-society intrigues so suddenly? How could this child show so much maturity, and how could this cold calculator prove to be the most passionate of lovers?[2] However, no critic noticed the strangest of these inconsistencies: at the end of his long endeavours to escape his condition and rise up in society, Julien Sorel has lost everything. He is waiting to be judged and condemned to death for the shot fired at the woman who denounced him. And it is at this moment, inside the prison walls, that he finally begins to enjoy life. He can only ask the man and woman conspiring to free him not to bother him with the details of real life. A little later, after his condemnation, he will say it to Madame de Rênal: he will never have been as happy as during the days spent beside her in prison.

The little plebeian's paradoxical pleasure in his prison gives Stendhal's novel a conclusion that seems to contradict both its structure and its tone. Indeed the book, in effect, is the work of a man who clearly displays his contempt for stories of sentimental dreamers and lovers of a heavenly ideal. He prefers the tales of Italian chroniclers of the past or picaresque stories like *Tom Jones*, whose situations and characters he imitates occasionally: ladders to boldly climb up to windows, closets to hide in, sudden departures, meeting pretty maids, young dim-witted noblemen, professional intriguers, romantic or pious young women sensitive to the charms of well-built young men. He thus conforms to an old model of novelistic fiction: the story of a character who is placed outside his normal position by some unforeseeable event, and forced to traverse the various circles of society, from princely palaces to port city dens, from farms or country parishes to aristocratic or bourgeois salons. This class disorder – symbolized in the eighteenth century by the

2 'This eighteen-year-old philosopher, with a fixed plan of action, who establishes himself as a master in the middle of a society he does not know, begins by seducing a woman for personal glory, and finds no happiness other than satisfying his own self-love, becomes sensitive, falls madly in love, and becomes animated by the passions of everyone. Another book now begins, in another style.' *Gazette littéraire*, 2 December 1830, in V. del Litto, ed., *Stendhal sous l'oeil de la presse contemporaine, 1817–1843* (Paris: Honoré Champion, 2001) p. 583.

bastard Tom Jones or by Marivaux's 'upstart peasant' – took on a
new meaning after the French Revolution. It was then identified
with the plebeian's hazardous climbing in a society that had not yet
found its new shape, and where the nobility's nostalgia and eccle-
siastical intrigues were mixed with the reign of bourgeois interests.
Stendhal experienced the fever of the Revolution as a child, the wars
of Empire as a young man, and later the plots of the Restoration.
The story of the ambitious young plebeian gave him the opportunity
to exploit the experience he had thus acquired. To show his knowl-
edge of the world and to describe the social intrigues that followed
the revolutionary and imperial epic, he surrounded his heroes with
a multitude of experts: Russian aristocrats, who act as professors of
political diplomacy and romantic strategy; Jansenist priests aware
of all the Jesuit intrigues; Italian conspirators with expert intelli-
gence of state secrets; Parisian academics up to speed on the secrets
of noble families. And he spares us no details about manoeuvres
to obtain a diocese or a position as a tax collector, the conspiracies
led by the Ultras to re-establish the old regime, and the fifty-three
model letters to send in sequence to overpower even the most unas-
sailable virtues. Later, in *Lucien Leuwen*, he explains at length how
to 'run' an election and how to overthrow a cabinet. It is not difficult
to see why an illustrious reader, Erich Auerbach, considered *Red and
Black* to mark a decisive moment in the history of the realist novel.
'Insofar as the serious realism of modern times cannot represent
man otherwise than as embedded in a total reality, political, social,
and economic, which is concrete and constantly evolving – as is
the case today in any novel or film – Stendhal is its founder.'[3] The
circumstances surrounding the book seem to confirm his analysis:
1830, the year the novel appeared, was also the year the people of
Paris expelled the last of the Bourbons in three days. Two years later
Balzac became famous as a writer for *La Peau de chagrin* (*The Wild
Ass's Skin*), in which the banker Taillefer's banquet for journalists
provides a tableau of the bourgeois royalty of opinion, which seems
to respond precisely to the aristocratic and ecclesiastical intrigues
described in *Red and Black*. How could one fail to notice the con-
cordance between the fall of the last monarch of divine right and

3 Erich Auerbach, *Mimesis: The Representation of Reality in Western
Literature*, transl. Willard R. Trask (Princeton: Princeton University Press,
1991 [1953]), p. 463.

the growth of the great novelistic genre, which describes the inner workings of post-revolutionary society and thus takes the place of traditional poetic genres in the new literature? And how could one ignore that this growth begins with the story of the young plebeian setting out to conquer high society?

Yet the promised concordance between the growth of a genre and the rise of a class is immediately muddled. The Revolution of July 1830 had already displaced the narrative of an ambitious plebeian facing a society marked by nostalgia for nobility and Jesuit intrigues. Various critics remarked as much when the book was released: the diplomat–writer's knowledge of the world referred to the world that had just been overthrown.[4] But the rupture created by the July days between the world that had given rise to the book and the one in which it was published is not the most important one. It is in the very heart of the story that the expected concordance between fictional structure, the logic of a character, and the narrative of the workings of the social machine, falls apart. Throughout the novel we see the hero constantly calculating his gestures, words and attitudes. We see representatives from different social circles – the illiterate carpenter hoping to get a little more cash, the grand vicar seeking a diocese, the provincial bourgeois aiming for prebends and distinctions, a young noblewoman dreaming of romantic adventures – multiply calculations of means and ends around him. Finally, we witness the novelist incessantly mixing in his own reflections with the characters' thoughts, and lecturing them in the name of this science of worldly success that he had generously attributed to them. But the instant the shot is fired, all calculation and reflection come to a halt. The letter of denunciation written by an obscure provincial Jesuit has ruined the dreams of Julien, Mathilde and the Marquis de la Mole. A pure succession of acts follows, which has not been announced or motivated by anything, and which takes place in less

4 'Like the Indian cactus, a new civilization has burst open overnight. Now if your artistic imagination lies in a society made of aristocratic pride, financial scheming, injured self-love, either under the feet of the Jesuits, or at the jittery hands of a congregational bureaucracy, what empathy can you expect from an era that no longer knows your models, which has destroyed your painting with a cobblestone, and soiled your colours with July's mud?' *Le Figaro*, 20 December 1830, quoted in del Litto, *Stendhal sous l'oeil de la presse contemporaine*, p. 585.

narrative time than needed until now for one of the lovers to make the slightest gesture toward the other. Julien leaves Mathilde, heads to Verrières, buys a gun, shoots at Madame de Rênal, then remains still and, with no reaction, lets himself be led to the prison, where he will finally enjoy perfect happiness with her, without attempting the slightest explanation of his act. The gunshot undoubtedly has an obvious cause for the reader: the denunciatory letter signed by Madame de Rênal. But at no point is this reflection included in Julien's thoughts and feelings. It is not included simply because it cannot be. In fact, the slightest calculation in which the novelist may have revelled with him until now would have been enough to dissuade the hero from an act that is the most absurd response possible in his situation.

Thus the act, which is the culmination of an entire network of intrigues, also annuls it by ruining every strategy of means and ends, any fictive logic of cause and effect. This act definitively separates the ambitious plebeian from the causal rationality and the very temporality in which his conquering goals were inscribed. Action and the 'real world', Stendhal now tells us, are a matter for 'aristocratic hearts', representatives of the old world. Mathilde, the young aristocrat fascinated by the rebellious lords from the time of the League, takes care of it on her own, even if her noble passion for action only ends up creating a funeral ceremony in bad taste (but the men of action of the new society will not do any better: in Balzac, the pompous burial of Ferragus's daughter will be the greatest success of the Thirteen). Ideal life alone can provide perfect happiness to the obscure beings society only recalls for two weeks if there has been a spectacular crime. Pre-revolutionary society, which considered itself eternal, occasionally liked to enjoy good times – whether erotic or narrative – with parvenu peasants with rosy complexions and rude manners, whom they could always send back to the fields after using them. But the new society could no longer surrender to such innocent games with the slender, effeminate sons of workers who had become Latinists thanks to the priests, and ambitious from hearing tales of Napoleonic feats. The only room it was willing to give them was as short news reports. The plot of *Red and Black* was actually inspired by two brief news items, two singular crimes, taken from the newly founded *Gazette des Tribunaux*, the archive of criminal acts signalling the dangerous energy and intelligence of the children

of the people. This two-week glory is the true end promised to the ambitious plebeian, the glory to which Julien prefers the pure enjoyment of reverie that subtracts him from time. And the book that tells the story of this exemplary fate can only conclude, as Julien does, by dissociating the *faits divers* that capture the attention of society for fifteen days from the pure present of this enjoyment.

But this ending returns to the beginning. In fact, Julien's heart is divided from the very beginning, and the novel along with it. There are the great schemes the young man devises while reading the *Memorial of Saint Helena* and the 'small events' that punctuate life at Monsieur de Rênal's house. Yet, there are two kinds of 'small events': some obey the classic logic of small causes that produce large effects, like refilling a mattress or a dropped pair of scissors, that make Madame de Rênal Julien's accomplice, despite her best intentions. Others are not linked in any chain of causes or effects, means or ends. On the contrary, they suspend these links in favour of the sole happiness of feeling, the sentiment of existence alone: a day in the country, a butterfly hunt, or the pleasure of a summer evening spent in the shade of a linden tree with the soft noise of the wind blowing. In the heterogeneous weaving of small events, the grand schemes find themselves torn between two kinds of logic: there is Julien's *duty* that orders him to take revenge on those who humiliate him, by mastering his master's wife; and there is the pure happiness of a shared sensible moment: a hand that surrenders to another in the mildness of the evening under a tall linden tree. The entire story of Julien's relation with Madame de Rênal is constituted by this tension between such *duty* and such pleasure. But this fictional tension is not simply a matter of individual sentiment. In fact, it opposes two manners of exiting plebeian subjection: through role reversal or through the suspension of the very play of these roles. Julien triumphs the moment he stops fighting, when he simply shares the pure equality of an emotion, crying at Madame de Rênal's knees. This happiness presumes that the conqueror should shed any 'deftness', and the loved 'object' no longer be object to anything – it too must shed all social determination, and be subtracted from the logic of means and ends. Julien experiences such happiness with Madame de Rênal in the countryside retreat at Vergy. He renounces it by heading for Paris and his great expectations. He finds it again in prison, where he has nothing to anticipate except

death. Such happiness can be summarized in a simple formula: to enjoy the quality of sensible experience that one reaches when one stops calculating, wanting and waiting, as soon as one resolves to do nothing.

It is not difficult to recognize the origin of the plebeian heaven that Julien enjoys in his cell and on the prison terrace. It is the same heaven that, seventy years earlier, another artisan's son, Jean-Jacques Rousseau, enjoyed on the other side of Jura, lying all afternoon in his barque on the Lac de Bienne. The plebeian rejected by society had taken refuge there, as if in a welcoming prison:

> Because of the forebodings that troubled me, I wanted to make this refuge a perpetual prison for me, to confine me to it for life, and removing every possibility and hope of getting off it – to forbid me any kind of communication with the mainland so that being unaware of all that went on in the world I might forget its existence and that it might also forget mine.[5]

The 'real' prison in which the fictive assassin is locked up is very similar to the metaphorical prison where the man who considered himself condemned by his fellow beings would have liked to end his life. It is also inside a prison that the young Fabrice del Dongo – whom the reader of *The Charterhouse of Parma* is led to believe is the illegitimate son of one of these children of the people whom the French Revolution turned into generals – tastes happiness, by looking at Clélia's window, that worldly intrigues, success as a preacher, and the possession of women would never equal. The carpenter's son smokes cigars on the terrace, the son of the marquise is busy doing woodwork that will yield his square patch of sky and a view onto the window with the birdcages. This role reversal amounts to the same (in)occupation: thinking of nothing except the present moment, enjoying nothing other than the pure feeling of existence, and maybe the pleasure of sharing it with an *equally* sensible soul. The son of the Geneva watchmaker very precisely designated the content of this enjoyment: 'The precious *far niente* was the first and

5 Jean-Jacques Rousseau, *Rêveries du promeneur solitaire, Cinquième promenade* in *Œuvres complètes*, vol. I (Paris: Gallimard, 1959) p. 1041; *The Reveries of the Solitary Walker*, transl. Charles E. Butterworth (Indianapolis: Hackett, 1992), p. 63.

the principal enjoyment I wanted to savor in all its sweetness, and all I did during my sojourn was in effect only the delicious and necessary occupation of a man who has devoted himself to idleness.'[6]

It is important to grasp the power of subversion of this innocent *far niente*. *Far niente* is not laziness. It is the enjoyment of *otium*. *Otium* is specifically the time when one is expecting nothing, precisely the kind of time that is forbidden to the plebeian, whom the anxiety of emerging from his condition always condemns to waiting for the effect of chance or intrigue. This is not the lack of occupation but the abolition of the hierarchy of occupations. The ancient opposition of patricians and plebeians is in effect firstly a matter of different 'occupations'. An occupation is a way of being for bodies and minds. The patrician occupation is to *act*, to pursue grand designs in which their own success is identified with the destiny of vast communities. Plebeians are bound to *do* – to make useful objects and provide material services to meet the needs of their individual survival. The time that shaped Julien Sorel and Fabrice del Dongo witnessed the upheaval of this ancient hierarchy. Usually we only recall its most visible aspect: the sons of the people who want to *act* and get involved in the great matters of communities at the cost of creating a reign of revolutionary terror. And the responsibility for this terror is readily attributed to the author of the *Social Contract*. The other aspect of the egalitarian revolution is less easily accounted for: the promotion of this quality of sensible experience where one *does nothing*, a quality equally offered to those whom the old order separated into men of pleasure and men of work and that the new order still divides into active and passive citizens. This state of suspension, the sensible state freed from the interests and hierarchies of knowledge and enjoyment, was characterized by Kant as the object of the subjective universality of aesthetic judgment. Schiller made it into the object of a play drive that blurs the old opposition between form and content. The former saw the principle of a new kind of common sense, likely to unite still distant classes, within this universality without concept. The latter opposed the violent revolution of political institutions with an aesthetic education of humanity drawing a new principle of freedom from this sensible equality. But neither of the two concealed the debt owed to the first theoretician

6 Rousseau, *Rêveries du promeneur solitaire*, p. 1042 (Butterworth transl., p. 64).

of this disinterested sensible state. It was Rousseau who had theo-
rized it before them under the name 'reverie'.

Stendhal hardly knew Kant and Schiller. On the other hand, he
felt a youthful passion for the author of the *New Heloise*, followed by
a mature man's aversion for his argumentative lovers and his exalta-
tion of rustic simplicity. And in the author of the *Social Contract*,
he did not despise the supposed inspiration for the sans-culottes,
but the father of a democracy that he identified with the power of
Manhattan shopkeepers and artisans with whom he was obsessed
all the more as he had never had the chance to meet a single one.
But, by rejecting the author of the *Social Contract*, we are not yet rid
of the one who wrote the *Confessions* and the *Reveries of a Solitary
Walker*. Stendhal dismissed the equality of citizens, but only in
order better to identify the sovereign good with another equality,
the equality of that pure enjoyment of existence and of the shared
sensible moment that makes all the intrigues of good society, and
class differences, seem derisive. Julien and Fabrice equally enjoy the
supreme happiness of the plebeian in prison, of Rousseau's joy lying
in his barque – the happiness of expecting nothing from the future,
enjoying a present without gaps, without the bite of a mourned or a
regretted past, or a feared or hoped for future. And it is not difficult
to recognize each one of the steps in the 'conquest' of Madame de
Rênal as so many souvenirs of exceptional sensible moments evoked
by the author of the *Confessions*: a maternal woman, like Madame de
Warens, who welcomes the son of the artisan and the dead woman
at her door; butterfly chases that recall a famous cherry-picking
episode; a hand grasped and kissed, like Mademoiselle Galley's on
the evening of a day spent in the country; tearfully embraced knees
that recall the silent moment of happiness spent in Turin at Madame
Basile's knees … In the same way, one can easily find young Jean-
Jacques's treasured walnut tree in Fabrice's beloved chestnut tree,
and the evenings on the shores of the Lac de Bienne in a certain
evening on the shores of lake Como, where universal silence is only
disturbed at equal intervals by the small waves dying on the shore.

What matters here is clearly not Stendhal's ambivalence as a nov-
elist towards the writer who inspired him in his youth. It is the
textual transfer of the philosopher's childhood memories and rever-
ies into the heart of action novels that tell us about the enterprises
of an admirer of Napoleon and the son of one of his generals. It is

how these narratives bear witness to the twisted relation between the growth of the novelistic form and the rise of plebeians in the new society. One and the other only coincide, in effect, through a singular play of profit and loss. The sensitive plebeian who sets out to conquer society does so at the cost of sacrificing the only happiness that could satisfy him: the abolition of the hierarchy of occupations in the equality found in the pure sharing of a sensation or an emotion. He is condemned, he condemns himself, to the bitterness and the deceptions of the other equality: equality as a form of revenge against humiliation, sought in the network of intertwined intrigues of all those who occupy or strive to occupy some position in society, to exert or strive to exert some influence. The most dim-witted of young gentlemen will always have the means to push the overly gifted plebeian back into the mediocrity of his condition, the slightest Jesuit from some sub-prefecture will always have the power to ruin his audacious enterprises. For they have already sacrificed sensible happiness to social performance. The Russian aristocrats, ridiculous champions of vain success, sum up the entire affair in some praise and a maxim: while congratulating Julien on possessing a naturally cold appearance 'a thousand miles from the sensation of the moment', they invite him to 'always do exactly the contrary of what people expect'.[7] One could hardly give a better definition of the means of never attaining happiness, disguised as an unfailing recipe for success. For happiness only exists in present sensation where there is nothing to wait for and nothing to fake.

It is true that the sorrow of characters normally makes for the happiness of books. This was the case for those great misfortunes that constituted the subject of tragedy for Aristotle. It also applied to the adventures punctuating Don Quixote's quest for feats from another time, as it did to Tom Jones or Jacob profiting from the modern confusion of conditions and sentiments, and even to the non-adventures of Tristram Shandy. The novelist could choose whether to give happiness to his characters at the end of their tribulations. The essence of the matter lay in the agreement between these tribulations and the sinuous line of the novel. In *La Peau de chagrin*, Balzac still laid claim to this sinuous line that placed the adventures of the modern sons of the countryside in continuity with

7 Stendhal, *Le Rouge et le Noir*, p. 599 (Adams transl., p. 222).

those of ancient masters. But only in order to doubt, a few pages later, whether any novel could ever rival the sober genius of a few lines of news in brief: 'Yesterday, at four o'clock, a young woman threw herself into the Seine at the Pont-des-Arts.'[8] But the logic of sorrow does not pose a challenge to the novel alone; happiness does so as well. Concerning the three years of unclouded happiness that Fabrice spends close to the person he does not have the right to see, the author asks for the reader's 'permission to pass, without saying a single word about them, over a gap of three years'.[9] Saying nothing about what constitutes the hero's happiness, on the contrary, means composing the subject-matter of the novel from the chronicle of worldly intrigues alone, which determine his success and failure. The silence about the nights spent with Clélia forces him to say a lot about the calculations of her father, the 'liberal' Conti, just as he must about Mosca's tricks, Ranuce-Ernest's threats, and the conspiracies of the tax officer Rassi. But these divisions of time already disarm the jumble of conspiracies and counter-conspiracies that compose the author's science of society. The plebeian's new happiness, the happiness of doing nothing, splits the novel in two. No need to invoke, like Lukács, a soul in mourning for lost totality. What is lost is the old division, the old hierarchy between two kinds of narrative logic: the noble logic of a chain of actions belonging to the tragic poem, and the vulgar logic of mixed conditions and the cascade of events that made the novel entertaining. In the society of 'material interests' that follows the revolutionary upheaval and the imperial epic, the distinction between forms of causal logic is no longer tenable. This explains why writers from these times, like Victor Hugo, dreamt of a great new genre that would substitute temporal sequences with spatial simultaneity, by holding together on the same stage aristocratic grandeur, the manoeuvres of intriguers, bohemian pleasures and plebeian impulses towards new skies. For them, this new genre was drama, made from a mixture of genres and representing mixed conditions, such as spectacular actions and

8 Honoré de Balzac, *La Peau de chagrin*, in *La Comédie humaine*, vol. X (Paris: Gallimard, 1979), p. 65; *The Wild Ass's Skin*, transl. H. J. Hunt (New York: Penguin Classics, 1977), p. 29.

9 Stendhal, *La Chartreuse de Parme*, in *Œuvres romanesques complètes*, vol. II, (Paris: Gallimard, 1948), p. 488; *The Charterhouse of Parma*, transl. John Sturrock (New York: Penguin, 2007), p. 503.

intimate feelings – in short, 'the mixture on stage of what is mixed in life … a riot there and a romantic conversation here'.[10]

Yet this genre of the future, which was meant to contain everything and instruct the gathered communities, would remain a proclamation. The genre suitable for new society would not take place on the public stage of the theatre. It would later be identified as the novel, the kind of writing that individuals read alone, without one knowing what kind of teaching they draw from it. The novel too was expected to say and represent everything: social stratifications, the characters they shape, the habitats that reflect them, the passions they circulate, and the intrigues that cut across them. But this desire for mastery seems immediately struck by a strange powerlessness. In order to make us cross all the circles of the modern metropolis, Balzac imported an extravagant society of conspirators from the Gothic novel who had 'a foothold in all the salons, their hands in all the strongboxes, elbowroom in all the streets, their head on any pillow'.[11] But the three episodes of the history of the invincible society of the Thirteen are so many failures whose narrative ends in epigrams: the girl with golden eyes 'dies from her chest'; the duchess of Langeais, who was a woman, is no more than a corpse ready to be tossed into the water or a book read long ago; and Ferragus, the chief of the Devorants, becomes a stone statue whose greatest feat is to watch over an ongoing game of *boules*. Behind the repeated failures of an all-powerful society of conspirators, the novelist allows us to see a far more radical logic of inaction: these unknown kings 'having made for themselves wings with which to traverse society from the top to the bottom, disdained to be something in it because they could be all'.[12]

To have the power to do everything, and consequently to do nothing, to head towards nothing: this is the troubling logic laid bare by this literature, which can now take an interest in everything and give equal treatment to the sons of kings and the daughters of

10 Victor Hugo, preface to *Marie Tudor*, in *Théâtre complet*, vol. II (Paris: Gallimard, 1964), p. 414.

11 Balzac, Preface to *Ferragus, chef des Dévorants*, in *La Comédie humaine*, vol. V (Paris: Gallimard, 1977), p. 792; Preface to *Ferragus, Chief of the Devorants. La Duchesse de Langeais*, transl. William Walton (Philadelphia: G.B. & Son, 1896), p. 11.

12 Ibid.

peasants, the great undertakings of powerful men and the minute events that punctuate the slow-paced domestic lives of small provincial towns. Philosophers and critics have privileged an exemplary figure of this abdication, Bartleby the scrivener's 'prefer not to'. But Bartleby's 'choice not to' is nothing but the other side of the irrational action of the other man with a pen and copy, the Marquis de la Mole's secretary. At the decisive moment, Julien acts without choosing: he subtracts himself from the universe where one must always choose, always calculate the consequences of these choices, always copy the right models of political, military or romantic strategy. At the expense of one unreasonable act alone, he goes to the other side, the side of 'ideal life' where it is possible 'to do nothing'. It is not necessary to render Bartleby singular to the degree that he becomes a new Christ, as Deleuze does. The 'prefer not to' is not the singularity of an eccentric attitude bearing a general lesson for the human condition. It is the law of this literature that overthrew the preferences of belles-lettres and the hierarchies on which it depended. No situation, no subject is 'preferable'. Everything can be interesting, it can all happen to anyone, and it can all be copied by the penman. To be sure, this law of new literature depends upon the other novelty: anyone can grab a pen, taste any kind of pleasure, or nourish any ambition whatsoever. The omnipotence of literature – which it lends to these societies of high-flying manipulators it imagines only to foil their intrigues – is the other aspect of manifestos that used to say yesterday that the Third Estate, which was nothing in the social order, must finally become something within it, and tomorrow, would say along with the proletarian song: 'We are nothing, let us be everything.'

This aspiration to everything marks the age of grand narratives, it is readily said. Surely this is the age that offers grand explanations for the order – or the disorder – of society, the teleologies of history, and world-transforming strategies based on the science of evolution. It is also the age of great novelistic cycles that pretend to encompass a society, cross all its strata, and expose the laws of its transformations through an exemplary family or a network of individuals. Yet this solidarity between the socialist political narrative and the 'realist' literary narrative seems to undo itself immediately. Literature that explores this new social world where everything is possible in the name of the omnipotence of writing seems to lead

the grand narrative of an entirely controllable society towards its own nullification. Julien Sorel only finds happiness in the prison that precedes his death, in the definitive ruin of all strategies for social climbing. But his fate, in turn, voids all the conspiracies the novelist revels in describing, in which a society exhausts its energies. This waste of energies will be the common moral of Balzac's *Human Comedy* and Zola's 'natural history of a family during the Second Empire'. At most, the latter would give a derisively positive value to such vanity: in Doctor Pascal's old office, his incestuous son's baby clothes come to replace the notes that scientifically explained the evolution of the family and the fate of all its members. The notes disappear in smoke, and the raised fist of the infant – a new kind of messiah different from Bartleby/Deleuze – celebrates, for all science, the hymn of life obstinately pursuing its own nonsense. Literary fiction has embraced the movement of history described by revolutionary science: the great upheaval of property; the rise of financial moguls, shopkeepers, and sons of upstart peasants; the artificial paradises of the city of trade and pleasure, misery and revolt, rumbling in industrial infernos. But it does so only to replace the future promised by social science and collective action with the pure nonsense of life, the obstinate will that wants nothing. This is not because it enjoys contradicting the socialist science. Rather, it might unveil its flip side: the science of society, bearing a future freedom in its womb and the philosophy of the will-to-live that wants nothing were born on the same ground: the site where old hierarchies of social and narrative order break down.

The year the people of Paris expelled the last king of divine right, Julien Sorel's adventure brought forth this troubling revelation: the plebeian's happiness does not lie in the conquest of society. It lies in doing nothing, in annulling *hic et nunc* the barriers of social hierarchy and the torment of confronting them, in the equality of pure sensation, in the uncalculated sharing of the sensible moment. Twelve years before the storming of the Bastille, this was already the lesson of the author of *The Reveries of the Solitary Walker*. The conflict between the two equalities – the revolutionary dream and plebeian reverie – would merit another study; what matters here is the way in which the great novelistic genre came to the fore gnawed by its opposite, the happiness of doing nothing, the suspension of the moment in which one experiences the feeling of existence alone

'without gaps', without the suffering of past trials or the worry of future calculations. For Julien, this moment comes very close to the end. But the new novel itself is born very close to its end, absorbed by the multiplicity of minute events likely to create a void in the most modest lives, swallowing up any intelligible chain of cause and effect, and any organized narrative of individuals and societies. It is born coupled with two daydreaming genres that will eventually devour its forces. First the prose poem nullified action to spread out the suspended sensation, the little scene that suffices to sum up a world: in Baudelaire, for example, a little old woman in a public garden or the gaze of poor children on the lights of a café terrace. Then came the short story, which conserved action to pierce into the immutable aspect of ordinary life, creating a hole that swallows characters, or that heals only to repeat the cycle. Take the spring walk, in Maupassant, at the end of which a lowly employee, who has changed his routine for once, commits suicide, or the pain of a life, deprived of the love to which it was entitled, that opens up for a brief instant before closing up again.[13] In Chekhov, we have the tears at the memory of a summer evening when love and happiness were within reach, or the moment of revolt when the little slave-girl–maid smothers the child who keeps her from sleeping.[14] The time of the modern novel is cut in half: on the one hand, there is revolutionary upheaval that makes the entire movement of society legible and controllable by thought; on the other, there is the suspension that brings this movement back to the instant and the spot where the equality and inequality of fates hang in the balance. The new novel is born in the gap between these two; it is born as the history of the breach that the great upheaval of social conditions and the minute disorder of plebeian reverie placed at the heart of the logics of action.

13 Cf. Guy de Maupassant, 'Promenade,' in *Contes et nouvelles*, vol. II (Paris: Gallimard, 1979), pp. 127–32; and 'Mademoiselle Perle,' in ibid., pp. 669–84; 'A Little Walk', in Artine Artinian, ed., *The Complete Short Stories of Guy de Maupassant* (Garden City, NY: Hanover House, 1955), pp. 198–202; and 'Mademoiselle Pearl' in ibid., pp. 745–55.

14 Anton Chekhov, 'Sleepy', in *Selected Stories of Anton Chekhov*, transl. Richard Pevear and Larissa Volokhonsky (New York: Bantam Books, 2000), pp. 4–8; 'A Lady's Story', in *The Tales of Chekhov*, vol. IX: *The Schoolmistress and Other Stories*, transl. Constance Garnett (New York: Macmillan, 1921), pp. 87–96.

4. The Poet of the New World

Boston, 1841–New York, 1855

Time and nature yield us many gifts, but not yet the timely man, the new religion, the reconciler, whom all things await. Dante's praise is, that he dared to write his autobiography in colossal cipher, or into universality. We have yet had no genius in America, with tyrannous eye, which knew the value of our incomparable materials, and saw, in the barbarism and materialism of the times, another carnival of the same gods whose picture he so much admires in Homer; then in the middle age; then in Calvinism. Banks and tariffs, the newspaper and caucus, methodism and unitarianism, are flat and dull to dull people, but rest on the same foundations of wonder as the town of Troy, and the temple of Delphos, and are as swiftly passing away. Our logrolling, our stumps and their politics, our fisheries, our Negroes, and Indians, our boasts, and our repudiations, the wrath of rogues and the pusillanimity of honest men, the northern trade, the southern planting, the western clearing, Oregon, and Texas, are yet unsung. Yet America is a poem in our eyes; its ample geography dazzles the imagination, and it will not wait long for metres.[1]

These lines are taken from a text simply titled *The Poet*, drawn from one of the lectures Emerson delivered in December 1841 and January 1842 under the generic title *The Times*. As Emerson

1 Ralph Waldo Emerson, 'The Poet', in Joseph Slater, Alfred R. Ferguson and Jean Ferguson Carr, eds, *The Collected Works of Ralph Waldo Emerson*, vol. III, *Essays, Second Series* (Cambridge, MA: Harvard University Press, 1983), pp. 21–2.

thoroughly modified his text for publication in 1844 in the second series of the *Essays*, it does not seem that the audience assembled under the roof of Boston's Masonic Temple ever heard this profession of faith. We do not know how it would have received this invitation to abandon English encyclopaedias and the relics of Greek and Roman antiquity to go and find new religion and poetry in the fisheries of the East Coast, the pioneers out West, the prose of daily newspapers, electoral jousting or banking. It is true that the former Unitarian pastor was not new to the art of provocation. He had already urged his audiences more than once to reject the conspiracy of centuries past, and to bid farewell to the policed museums of Europe, to Doric columns and gothic ornaments, in order to fully embrace the present. 'I ask not for the great, the remote, the romantic', he had already announced, to the shock of the Harvard fellows, 'what is doing in Italy or Arabia; what is Greek art, or Provencal minstrelsy; I embrace the common, I explore and sit at the feet of the familiar, the low. Give me insight into to-day, and you may have the antique and future worlds.'[2] We must thus take note: it was not in London under the glass-and-steel arcs of the Crystal Palace, nor in the *fin de siècle* Paris of the Eiffel tower, in the New York of skyscrapers or Russia of futurist and constructivist revolutionaries; it was in Boston in 1841, capital of genteel culture, intellectuals and aesthetes enthused by classical philology, French civility, and voyages to Italy for its antique ruins and Renaissance masterpieces, that the modernist ideal, in the strong sense, was first formulated in all its radicalism – the ideal of a new poetry of new man.

But one must also notice where the paradox lies in this declaration. The man who announces it has no personal taste for banking, or electoral stands: he thinks they turn man away from the only worthwhile quest – namely, the accomplishment of his own nature. And if he loves the calm of the countryside, it is so as to be there alone with his thoughts or with kindred spirits, and not in order to get involved with the activities of fishermen or the amusements of lumberjacks. He never travelled to the plantations of the

2 Emerson, 'The American Scholar', in Alfred R. Ferguson, ed., *The Collected Works of Ralph Waldo Emerson*, vol. I, *Essays, First Series*, Introduction and notes by Robert E. Spiller (Cambridge, MA: Belknap Press, 1971), p. 67.

South. And the conquest of the West, or the recent annexations of Texas and Oregon, were only known to him through newspapers. Their evocation here does not at all have to do with a personal passion for the great adventure of a new people and virgin lands. First of all, it defines change in the poetic paradigm: the poetry of the present time breaks with a certain idea of time, one regulated by great events and rhythms inherited from the past. It finds its material no longer in historical succession, but in geographical simultaneity, in the multiplicity of activities distributed in the diverse spaces of a territory. It finds its form no longer in regular meter inherited from tradition, but in the common pulse that links these activities.

But one must not be mistaken: the common pulse that the new poet must make sensible in the material activities of the new world is itself entirely spiritual. The ideal of the new poet can reject refined muses, and the norm of the 'American Scholar' to call for 'the single man [who] plant[s] himself indomitably on his instincts'.[3] However, in these proud proclamations there is nothing that could be attributed to some naive materialist intoxication of the pioneering people of the new continent. Quite the contrary: if the new poet can and must take up the materialities of modern America, it is in order to denounce true materialism, which is embodied by the English empiricist and sensualist tradition. This tradition begins by enclosing material things within the limits of utility and abstractions of ownership, before opposing this vulgar world to the select world of spiritual pleasures. Materialism is the dualism that separates the material from the spiritual by separating particular things from the life of the whole. The task of the American poet is to restore the vulgar materialities of the world of work and everyday life to the life of the mind and the whole. It is to contrast the English sensualist aristocratism with the spiritual revolution carried out, during the time of the French Revolution, by German philosophers. They extricated the spiritual life sealed within any sensible reality, awaiting the thought that must liberate it. The call to sing the prosaicness of American life can thus be translated strictly in these seemingly mystic lines that, however, say exactly the same thing:

3 Ibid., p. 69.

We are symbols, and inhabit symbols; workman, work and tools, words and things, birth and death, all are emblems; but we sympathize with the symbols, and, being infatuated with the economical uses of things, we do not know that they are thoughts. The poet, by an ulterior intellectual perception, gives them a power which makes their old use forgotten, and puts eyes, and a tongue into every dumb and inanimate object. He perceives the independence of the thought on the symbol, the stability of the thought, the accidency and fugacity of the symbol. As the eyes of Lyncæus were said to see through the earth, so the poet turns the world to glass, and shows us all things in their right series and procession. For, through that better perception, he stands one step nearer to things, and sees the flowing or the metamorphosis; perceives that thought is multiform; that within the form of every creature is a force impelling it to ascend into a higher form ... All the facts of the animal economy, sex, nutriment, gestation, birth, growth, are symbols of the passage of the world into the soul of man, to suffer there a change, and reappear a new and higher fact. He uses forms according to the life, and not according to the form.[4]

In a few lines, Emerson gives us the epitome of German idealist philosophy – as Coleridge and Carlyle translated it for the Anglophone world, and as it was adapted to their use by these American 'Transcendentalists' concerned with a new religion of life, breaking the circle of intellectual and social conformity designated by the conjunction between the American spirit of ownership, Calvinist rigour and Lockean empiricism. The layers of the edifice are easily discernible here. First, there is the double distinction carried out by Kantian transcendental philosophy: on the one hand, the separation of phenomena and things in themselves; on the other, the definition of aesthetic judgment in its double opposition to the law of the understanding that makes things knowable and to the particularity of desire that wants to appropriate them. Kant devoted himself to separating the two distinctions. In contrast, his successors strived to reunite them in order to make aesthetic contemplation the path leading from the finite intellectual determination of phenomena to absolute knowing. But he had facilitated the task for them himself in the passage from the *Critique of the Power of Judgment* that mentions the cipher language by which nature speaks to us symbolically

4 Emerson, 'The Poet', pp. 12–13.

through its beautiful forms.[5] This cipher language had found its immediate echo in reflections by Novalis that made everything into encrypted speech and language itself into a vast poem. It had served the young Schelling to confer a strategic position on artistic knowledge in the *System of Transcendental Idealism*, at the price of wedding the tradition of critical idealism with that of neo-platonic metaphysics: 'What we speak of as nature is a poem sealed in a mysterious and wonderful script. Yet the riddle could be unveiled, were we to recognize in it the odyssey of the spirit, which, strangely deluded, seeks itself, and in seeking flies from itself; for the meaning we seek glimmers through the sensible world, as it does through words, and through the dissolving mists which alone reveal the land of fantasy where our desires are headed. Each beautiful painting is born, as it were, when an invisible barrier dividing the real from the ideal world is removed ...'[6]

Breaking this barrier separating two worlds was the very principle of the 'natural supernaturalism' promoted by Carlyle, and it is still the programme attributed by Emerson to the new poet. The poem is a mirror held up to things, to furnish an image of every created thing. No doubt this mirror 'carried through the street'[7] is a metaphor shared by quite diverse minds: one can find it in almost the same form in the least mystic writer of the time, Stendhal, who himself attributes it to Saint-Réal. But we should try to understand its function here. Surely the mirror should not be considered a reflective surface that gives off reflections of things. It is a polished surface, cleansed of any dross so that things of ordinary life can appear in it cleansed of everything that attaches them to utility and propriety, organized according to the divine order of the 'procession' which, according to Plotinus, expresses the supersensible ordering of sensible things. But the opposite is equally true: the ideal world is

5 Immanuel Kant, *Critique of the Power of Judgment*, transl. and ed. Paul Guyer and Eric Matthews (Cambridge: CUP, 2000), § 42, p. 180.

6 Schelling, *System of Transcendental Idealism*, transl. Peter Heath (Virginia: University of Virginia Press, 1993), p. 232. We know the influence this text had on the German romantics, especially through August Schlegel's *Lectures on Art and Literature*. On this point, see Philippe Lacoue-Labarthe and Jean-Luc Nancy, *L'Absolu littéraire* (Paris: Le Seuil, 1978); *The Literary Absolute*, transl. P. Barnard and C. Lester (Albany: SUNY, 1988).

7 Emerson, 'The Poet', p. 23.

not another world; it is the same as the one we live in. This is another lesson of the so-called Idealist philosophers: poetry is not a world of rare sentiments felt by exceptional beings and expressed in specific forms. Poetry is the flowering of a form of life, the expression of a poeticity immanent to the ways of life of a people and its individuals. Poetry exists in poems only if it already exists latently in forms of life. It exists in the 'pre-cantations' offered by forms of nature: sea, mountainous peak, Niagara, or any bed of flowers whose attuned ear hears and understands the poem and tries to put it into words;[8] in the rhymes presented by the knottiness of seashells, the savage ode of the tempest and the epic song of summer and harvests, but just as well in the blade of grass or the drop of water which is 'a little ocean',[9] the meat on the fire, the boiling milk, the shop, the cart and the account book.[10] It exists in the sensations, gestures and attitudes of these peasants, grooms, coachmen, hunters and butchers, who celebrate the symbolic potential of nature 'in the choice of their life, and not in their choice of words'.[11] Finally, it exists in words, of which everyone is a silent poem, the translation of an original relation with those other words that are visible things.

Emerson thus exceeds the thought of the author from whom he borrows his idea of the poet as creator of symbols, namely Carlyle. For the latter, the symbols of the spiritual world present in the natural order were to be found in flags, banners and standards, in works of art, examples of heroic characters and the vestimentary parade of dandies.[12] For Emerson, the symbols of the spiritual world can be found everywhere. The task of the poet is to awaken this potentiality of speech, this potential of common experience of a spiritual world, slumbering in every list of words, as it is in the array of objects, and the deployment of prosaic activities. The poet must reunite words and things, give things the names that express their

8 Ibid., p. 15.
9 Emerson, 'American Scholar', p. 68.
10 Ibid., p. 67.
11 Emerson, 'The Poet', p. 10.
12 See Thomas Carlyle, *Sartor Resartus* (Oxford: Oxford World Classics, 1999). The theory of symbols is notably developed in Book III, Chapters 3 ('Symbols'), 7 ('Organic Filaments') and 10 ('The Dandiacal Body'). Recall that Emerson edited and wrote the Preface for the first book version of Carlyle's text, which first appeared in England as a series of articles.

nature as speech, give words the sensible potential that links them to the movement of life. This task of naming is not a work of art. It is not a matter of happy invention. It is the work of life. The poet names things in the way that things name and symbolize themselves: 'This expression or nomination is not an art; it is a second nature born from the first like a leaf from a tree.'[13]

One might see a paradox here: the thinker lays claim to the creation of an American poetry that breaks with academic canons, the cult of Homer, antique ruins and Doric columns to follow the rhythm of the new world in gestation. But what his discourse opposes to the ruins and reminiscences of classical antiquity is clearly another antiquity, another Greece: the one invented by philosophers and poets of German idealism and romanticism: the Greece of naive Schillerean poetry or the Hegelian epic, which is 'the book of life of a people', the expression of a world that is poetic in itself: a living world from before the division of labour where the song is not separated from worship, religion from civic life, the public world from private life, or the labour of speech from manual labour. The poem of new America is apparently identical to the poem of this Greece recreated by German thinkers and poets. But there is no paradox here. The American poet to come has to solve the problem inaugurated by this German reinvention of antique poetry. To naive poetry, to this poetry of a world where culture was not separated from nature, Schiller opposed the modern destiny of sentimental poetry: for him, this was the poetry of the prosaic world, a world marked by the division of labour and the hierarchy of activities. In this world poetry was also a separate activity: a world of chosen events, thoughts, forms and rhythms, but also an activity torn from the everyday, conscious of its isolation from ordinary life. To this separate destiny Schiller opposed the promise of a poetry to come, an ideal poetry, reconstituting, at the heart of a world of thought, the unity lost in material life. But Hegel opposed his verdict to this promise: ideal poetry thus conceived is a contradiction in terms. The world of thought united with itself only begins where poetry ends. Poetry, like all art, is thought that is still obscure to itself, animating an alien reality with the breath of common life: the architect's or the sculptor's stone, the painter's coloured pigment, the imaged material

13 Emerson, 'The Poet', p. 13.

and the temporal constraint of the poem. Poetry is alive as long as the world has not yet plundered its poeticity, as long as thought has not yet separated the forms of self-knowledge from the world of images, and the rational administration of things from the immediacy of human relations. Faced with the prose of the rationalized world, ideal poetry is condemned to mime its own idea by playing with significations deprived of all substantial content.

The political and poetic nineteenth century may have been nothing but an incessant effort to deny the verdict simultaneously declaring that the long history of poetic forms and the short history of modern revolutionary turmoil were over. Denying this Hegelian verdict means refuting the idea it proposes of the modern world: the idea of a time when thought is finally the conscious contemporary of its world. Our world is not contemporary to its thought: this is the counter-verdict of those who want to confer the task of a necessary revolution on the gathered masses or on the solitary poet. Whoever wants to give a meaning to the word modernity must take this into account: modernism – artistic and political – is not the blissful affirmation of the greatness of work, electricity, cement and speed. It is first of all a counter-affirmation about modernity: it denies that the contemporary world has its own thought and that contemporary thought has its world. In fact, this counter-affirmation contains two theses. The first one is a thesis of separation: the contemporary world is structured by a separation that must be abolished. Here the subjective richness of assembled humanity remains foreign to humans, frozen in dogmas of revealed religion, the mechanics of state administration or the product of work appropriated by capital; the signs of the future are still ciphered there in the fossils of past revolutions or barbarous hieroglyphics of industrial and colonizing innovation. The revolution to come is the conscious reappropriation of this subjective richness fixed in the objective world and the deciphering of these enigmatic signs. 'This is a confession, nothing more', the young Marx wrote to Ruge in a September 1843 letter that fixes the programme of revolutionary modernity at the same time as that of the *Franco-German Annals*. He certainly ignored and would probably always ignore that in the previous year, on the other side of the Atlantic, another student of post-Kantian idealism had fixed the task of the new poet in the same terms:

For all men live by truth, and stand in need of expression. In love, in art, in avarice, in politics, in labour, in games, we study to utter our painful secret. The man is only half himself, the other half is his expression ... For, the experience of each new age requires a new confession, and the world seems always waiting for its poet.[14]

The separation thesis thus doubles as a thesis of non-contemporaneity: the modern world is characterized by a gap between temporalities. It was the young Marx again who determined its political formula in 1843 Germany: the revolution to come finds both its premonition and its task in a double absence of contemporaneity. German philosophy elaborated a theory of human liberation which was already beyond the French political revolution but which did not have – whatever academic Hegelians may say – any correlate in the miserable, feudal and bureaucratic reality of contemporary Germany. The German revolution would thus be able to skip over the French step of political revolutions in order to become a human revolution directly. But it would only be able to do so on one condition: namely, that it would appropriate this energy of the active transformation of the world that the French revolutionary fighters were once able and could still deploy without being able to give it any theoretical formulation at the level of the age and of their action.

By contrast, the Emersonian revolution does not propose any collective emancipation. It entrusts exemplary individuals with the task of giving the meaning and enjoyment of spiritual and sensible wealth to a community. The poet 'stands among partial men for the complete man';[15] he is the one to reattach words to things, and thus inform his contemporaries of a common wealth, that of the universal soul which exteriorizes itself in the material world. But he informs them precisely of their own common wealth, not of his own wealth, nor of his personal artistic talent. His power of naming things is 'the power of resigning himself to the divine aura which breathes through forms, and accompanying that'.[16] He is a complete man only by his capacity to attach each particular sensible form and each word of language to the breath of the whole. And he draws this power only from his ability to nourish himself

14 Ibid., pp. 4–7.
15 Ibid., p. 4.
16 Ibid., p. 15.

with the potential latent in collective experience, to read the hieroglyphics inscribed in the savage and multiform nature of the new continent, but also in the features and gestures of hybrid multitudes that explore and reclaim it. The America of happy lumberjacks and fierce conquerors of virgin lands, where a disparate crowd was summoned not long ago to verbal jousting over these common affairs – which the Founding Fathers had wanted to entrust to enlightened landowners – and where the free spirits of the Bostonian gentry came across slaves fleeing Southern plantations, this land of chaos and contrast indeed offers an image of modernity entirely opposed to the modernity of the Prussian administration defined by Berlin philosophy. Here, more than elsewhere, the contemporary affirms itself as a shock between heterogeneous temporalities, and as a radical gap between spirituality in search of a body and material effervescence in search of thought. Here, more than elsewhere, the task of the new poet can once again find, over the ashes of academic Hellenism, the concrete potency of Homeric poetry, which simultaneously expresses the savage anger of Achilles, the man of war, and the multiplicity of activities represented on his shield. Finally, here more than elsewhere, the task of the poet can be identified with the construction of a community in possession of its own meaning.

The new poet, the modern poet, is the one who can express the spiritual substance present in the barbarity of America in gestation; to express this common spiritual potential is to manifest the symbolic nature of all material reality, as well as any prosaic naming. The symbol is not the figural expression of abstract thought. It is the fragment detached from the whole that carries the potential of the whole, that bears it on the condition that one draw it out of its solitude as a material thing, that one link it to other fragments and that one circulate air – which is the breath of the whole – in between these fragments. Poetry to come could thus be characterized by two seemingly contradictory concepts: one could call it idealist, for it strives to define the spiritual potential hidden in the diversity of things and material activities. One could call it materialist, for it does not concede any world of its own to spirituality – it recognizes it only as the link that unites sensible forms and activities. One could even give it apparently antagonistic names. One could call it symbolist, for in the table of sensible things, it only shows a

copy of a text written in 'the alphabet of the stars'.[17] One could call it unanimist, for it makes clear that something is poetic only if it is attached to the living totality that it expresses. No doubt, the two adjectives express poetic differences. Symbolist poetics singularizes a third element that lends its potency to a series of assembled forms: a 'third, fusible aspect' that suggests, for Mallarmé, 'the exact relation between images';[18] a 'third character', representing the world of the soul, whose presence Maeterlinck underlines in the banal dialogue of certain characters in Ibsen who seem 'to talk about rain and good weather in a dead man's room'.[19] Unanimist poetics, on the contrary, entrusts the multiplicity of words and assembled forms alone with the potential to represent its own infinity. But both one and the other, from the time of Mallarmé to Dziga Vertov, would often mix their forms and their effects for two reasons. First of all, symbolist poetics is an egalitarian poetics: it gives everything and every material relation the power to symbolize what the poetic tradition limited to a few privileged relations. Secondly, both rely on the same idea of poetic capacity – that is, the power to 'explore the double meaning, or, shall I say, the quadruple, or the centuple, or much more manifold meaning, of every sensuous fact',[20] and to find in every sensible form the supersensible potential, the potential for infinitization, which carries it beyond itself. This beyond can be the endless 'procession' of beings equally carried away in the same movement; it can be the 'third fusible aspect' which detaches itself from the relation of elements. But in both cases, the material object is torn from the limits of egotistical usage, made into the bearer of a common potential that is its emblem: the emblem of a community possessing the spirit of its material life or the sensible materiality of its idea. The poem makes everything into more than a thing, but it does so insofar as it is itself more than art – another economy, another circulation established between subjects, words, and things.

17 Stéphane Mallarmé, 'L'action restreinte', in *Divagations*, in *Œuvres complètes*, ed. Bertrand Marchal, vol. II (Paris: Gallimard, 2003), p. 215; 'Restricted action', in *Divagations*, transl. Barbara Johnson (Cambridge, MA: Belknap, 2007), p. 216.

18 Mallarmé, 'Crise de vers', in *Divagations*, in *Œuvres complètes*, p. 210; 'Crisis of verse', in *Divagations*, transl. Johnson, p. 207.

19 Jules Huret, 'Conversation avec M. Maurice Maeterlinck', *Le Figaro*, 17 May 1893.

20 Emerson, 'The Poet', pp. 3–4.

This complicity between symbolist spirituality and unanimism –
whether democratic or communist – had been given its formula by
an attentive reader of Emerson. Its inventor was Walt Whitman,
whose *Leaves of Grass* was hailed in 1855, in a letter from Emerson,
as 'the most extraordinary piece of wit and wisdom that America
has yet contributed'.[21] We know that Emerson's friends and the
Bostonian intelligentsia were moved by the support given by such
a distinguished mind to a work whose vulgarity and 'ithyphallic
audacity' insulted 'what is most sacred and decent among men',[22]
and that Emerson himself did not much appreciate seeing his
letter used to promote the second edition. But this rerouting of a
thank you note is itself only small change in a much more radical
transaction. The work itself seems to have been conceived as the
exact response to the philosopher's call, as an exact embodiment of
the program sketched out by the propositions of the 1841 Boston
lecture, by someone who had only been an inoffensive New York
journalist until then: the programme of the new poet who would
measure up to the immeasurable American people and territory, the
new poet capable of expressing the living poem that they constitute.
Whitman tells us he throws his 'barbaric yawp over the roofs of the
world'. But this barbaric manifesto itself is only the extreme version,
the deliberately 'barbarized' version of an idea of poetry elaborated
by the best philosophical minds and the highest poetic spirits, from
Schiller to Emerson, Schelling, Hegel, Coleridge, and a few others.
Surely, even if the famous description of Achilles' shield serves as a
distant model, no one had ever seen such an extravagant succession
of prosaic activities and tools, this gallery of insignificant, vulgar
or horrible genre scenes, offered up as a poetic work. Thus, in the
first of the poems, the one that will become the *Song of Myself*: the
farmer contemplating his oats, the lunatic carried to the asylum, the
printer with gaunt jaws turning his quid of tobacco, the malformed
limbs of a bloodied body tied to the anatomist's table, the removed
parts falling off into a pail with a horrible sound, the quadroon girl

21 R. W. Emerson, 'Letter to Walt Whitman, 21 July 1855', in Joel
Myerson, ed., *The Selected Letters of Ralph Waldo Emerson* (New York:
Columbia University Press, 1997), p. 383.

22 Anonymous review of the book by the *Christian Examiner*, June
1856, in Graham Clarke, ed., *Walt Whitman: Critical Assessments*, vol. II
(Mountfield: Helm Information, 1995), p. 39.

sold at auction, the drunkard nodding close to a kitchen stove, the mechanist rolling up his sleeves, the express-wagon driver, the wollypates hoeing in the sugar-field, the platform reformer with a nasal voice, the pavingman leaning on his rammer, the drover, the pedlar sweating under his pack, the opium eater, the prostitute with her blackguard oaths, the masons calling for mortar, the pikefisher, the coon seeker, and a few dozen other genre portraits, among which the poet has knowingly dispersed a church contralto, deacons waiting to be ordained, an art connoisseur walking through an exhibition gallery, and the president surrounded by his cabinet. No one had attained the pure enumeration presented by the following poem, the future *Song of Occupations* mixing the slave's ankle-chain and the plates of the forger with grain and manure, marl and clay, bins and mangers, tongs, hammer, jointer and smoothing plane; plumbob, trowel and scaffold; the sailor's compass and stays; powder and shot; the surgeon and the oculist's étui; steam saws, the cotton bale, the working knife of the butcher, the handpress, goods of guttapercha or papier mâché, the veneer and the gluepot, awl and cobbler's kneestrap, billiard sticks, stockings for women, the walking beam of the steam-engine, bonfire of shavings, coffins stored in the sexton's wareroom, beef on the butcher's stall, the milliner's ribbons, dressmakers patterns, wanted ads in penny papers, and hundreds of other items that contain both far more and far less than the price they are evaluated at, and that the poet's soul welcomes without worrying about their price. An auctioneer's catalogue, the disdainful would say. But their disdain falls flat. The poet has anticipated their judgment by identifying himself with the one who puts up the vilest and the noblest merchandise for auction: this black slave, this 'curious creature', this admirable frame of bone and muscle, the gaze full of life and this disconcerting brain whose value no bidder can afford to pay, 'For him the globe lay preparing quintillions of years, without one animal or plant.'[23] And he specified the meaning of his intervention: he made himself the auctioneer's assistant because the latter only knows half his business. He does not know the value of what he exhibits because his very trade obliges him to ignore this supplementary value that each being and each thing possesses, a value that is added to their practical use and subtracts it from the

23 Walt Whitman, *Leaves of Grass* in *Complete Poetry and Prose*, ed. Justin Kaplan (New York: Library of America, 1982), p. 255.

monetary estimations of the market: the value of equality that they get from all being microcosms of the whole, susceptible of being attached to the interminable chain of beings, to the inexhaustible life of the whole.

The 'auctioneer's catalogue' is thus a counter-catalogue that annuls the difference between use and exchange value by returning each thing to its place. This place denies the ancient hierarchy of positions in which each person had to do 'his own business', to take each thing and each act in the great 'procession' of irreducibly material and spiritual realities. The interminable display of vulgar objects and activities is the strict application of the spiritualist principle articulated by Emerson: the symbolic use of nature abolishes distinctions of low and high, honest and vile. 'Small and mean things serve as well as great symbols. The meaner the type by which a law is expressed, the more pungent it is, and the more lasting in the memories of men.'[24] And the same vertigo of common names of common things follows Emerson's indication on the role of the poet as a giver of names, the suggestive value of 'bare lists of words' borrowed from a dictionary for 'an imaginative and excited mind', and the fact that 'what would be base, or even obscene, to the obscene, becomes illustrious, spoken in a new connexion of thought'.[25] The 'catalogue' is the linking, and it is the linking that redeems all ugliness and all vulgarity:

> For, as it is dislocation and detachment from the life of God, that makes things ugly, the poet, who re-attaches things to nature and the Whole … disposes very easily of the most disagreeable facts. Readers of poetry see the factory-village, and the railway, and fancy that the poetry of the landscape is broken up by these; for these works of art are not yet consecrated in their reading; but the poet sees them fall within the great Order not less than the bee-hive, or the spider's geometrical web.[26]

24 Emerson, 'The Poet', p. 11.
25 Ibid. Whitman himself systematizes a theory of the multiplication of names in a text composed after the publication of *Leaves of Grass* – *The American Primer*, ed. Horace Traubel, with an Afterword by Gay Wilson Allen (Wisconsin: Holy Cow! Press, 1987).
26 Emerson, 'The Poet', p. 11.

The infinite multiplication of activities, things and vulgar names is thus the accomplishment of a spiritual task of redemption.

The interminable inventory cannot be relegated to a materialist myopia glued to the immediacy of facts and objects. Nor can the triumphal affirmation of the one who sings himself be relegated to the naive egotism of a proud inhabitant of the new individualistic world. Above all, it is related to the vast redemption of the empirical world proclaimed by German idealism: the redemption of a sensible world where spirit recognizes the exterior form of a divine thought that it knows from now on as its own thought. The initial declaration of the collection expresses this primordial reversal, and not some silly uncouth Yankee arrogance: 'I celebrate myself, and sing myself, / And what I assume you shall assume.'[27] The formula does not simply translate Emerson's formula affirming that 'All men have my blood, and I have all men's.'[28] It puts to work, more profoundly, the Emersonian virtue of 'self-reliance', which is no self-infatuation but the knowledge that 'there is a great responsible Thinker and Actor working wherever a man works'.[29] Also, this self-affirmation goes along with the erasure of the poet's proper name. No author's name appears on the cover of the collection. The name 'Walt Whitman' appears only once in the body of the text – that is to say, at once in its centre and lost within its mass. It is qualified as 'one of the roughs' and 'a kosmos' – that is to say, as a microcosm of the community. Putting oneself at the centre of all things is to thereby affirm this universal intellectual capacity, which most people renounce practising. It is to undo the chains by which things are held in the utilitarian and monetary order and individuals held in the role that society expects of them. In an earlier version, the proud self-affirmation was found in a declaration of emancipation:

27 Whitman, *Leaves of Grass*, p. 51.

28 R. W. Emerson, 'Self-Reliance', in Joseph Slater, Alfred R. Ferguson and Jean Ferguson Carr, eds, *Collected Works of Ralph Waldo Emerson*, vol. II, *Essays, First Series* (Cambridge, MA: Harvard University Press, 1979), p. 41.

29 Ibid., p. 35.

> I am your voice – It was tied in you – In me it begins to talk.
> I celebrate myself to celebrate every man and woman alive;
> I loosen the tongue that was tied in them,
> It begins to talk out of my mouth.[30]

The absolute immanence of the 'I' to all things is also the means of giving the nearest things the beauty and the marvellous character reserved until then for distant things.[31] It is the means for suppressing the very difference between close and far, for bringing the distant closer by rendering what is close infinite. This bringing closer is a matter of breath, of shared respiration. The poem establishes this community from the beginning by linking the emanations of all things to the poet's breathing, and the poem's words to the very breathing of the things it speaks about:

> The smoke of my own breath,
> Echoes, ripples, buzz'd whispers, love-root, silk-thread,
> crotch and vine,
> My respiration and inspiration, the beating of my heart, the
> passing of blood and air through my lungs,
> The sniff of green leaves and dry leaves, and of the shore
> and dark colour'd sea-rocks, and of hay in the barn,
> The sound of the belch'd words of my voice loos'd to the
> eddies of the wind,
> A few light kisses, a few embraces, a reaching around of
> arms …[32]

In one of those anonymous articles where he celebrates his coming, the poet is not mistaken to award himself the praise of being the 'true spiritualist'.[33] The true spiritualist is the one who exactly identifies the manifestation of spirit in the respiration of bodies which takes all things into its cycle and thus delivers the truth – the becoming flesh and spirit – waiting there. He is the one who

30 A draft of a poem quoted by F. Matthiessen, *American Renaissance: Art and Expression in the Age of Emerson and Whitman* (London: OUP, 1968), p. 555.

31 Emerson, 'American Scholar', p. 68.

32 Whitman, *Leaves of Grass*, p. 51.

33 Graham Clarke, ed., *Walt Whitman: Critical Assessments*, vol. II, p. 15.

erases everything that could arrest this continual breath of spirit/ respiration. This is why the collection bears its author's name only as a name uttered by the breath of the poem. This is why the name on the cover page is replaced by a full-length portrait: the portrait of a body well planted on its feet and 'depending on its instincts', able to exchange its health with the health of common things. One of the first commentators underlines the pertinence of this substitution as a transcendental principle: 'As seems very proper in a book of transcendental poetry, the author withholds his name from the title page, and presents his portrait, neatly engraved on steel, instead. This, no doubt, is upon the principle that the name is merely accidental; while the portrait affords an idea of the essential being from whom these utterances proceed.'[34] Following the same logic, the collection is named *Leaves of Grass*. The title not only affirms the poetic thesis that governs it: all things are equal because the most infinitesimal contains the universe: 'I believe a leaf of *grass* is no less than the *journey work* of the *stars*.'[35] It incarnates this egalitarian procession in its very layout: the pages of a book must be considered like the detached leaves of any tree whatsoever, emanations of universal anonymous life. Before Mallarmé, Whitman asks the 'symbolist' question par excellence: How can the book be the sensible reality of its own idea? The 'pure' poet will not find a more subtle means than to imitate the starry sky through the arrangement of lines on the page. The rude Long Island native takes things more at the root: instead of asking printed paper to imitate the subject of the poem, he asks it simply to imitate the potential it expresses: the potential of the continual procession of material realities traversed by their spirit. Strictly speaking, this means the poem neither begins nor ends. The pages of the preface are presented in columns, imitating the layout of daily newspapers. And the preface is not announced as such but starts as the continuation of a speech that has always already begun. If the first letter is capitalized, it is uniquely because it belongs to the proper name that this poem expresses, and that is expressed within it: America. The collection of poems, for one, does not include any division. At most, the time of a deeper breath separates the twelve poems – of extremely varying length, and none

34 Charles Eliot Norton, 'Whitman's *Leaves of Grass*', *Putnam's Monthly*, September 1855, in ibid., p. 6.

35 Whitman, *Leaves of Grass*, p. 109.

of which has a title – from one another. In a single continuous flow of sixty pages, the first poem emits what the future *Song of Myself* would distribute into fifty-two sections. And above all the poet invented an unprecedented verbal form for the great procession of common things and beings. It would be called the 'prose poem', and its precedents were sought here and there: in America, in the morals of the popular *Proverbial Philosophy* by Martin Farquhar Tupper; in France, in the pictorial evocations of Aloysius Bertrand, a supposed precursor of Baudelaire. After Baudelaire, poetized prose expressed the sinuous twists and turns of the big city, and the poetry at work in the prosaic world. But what Whitman invents, for America, is more radical than the flexibility of the serpentine line, dear to the English. As he deploys it, the 'prose poem' is a mode of written speech that refutes the dilemma the philosophy teacher poses to Monsieur Jourdain. Like Molière's stubborn fabric salesman, the poet of plebeian America wants neither 'verse nor prose': neither the account book that maintains things in their commodity value, nor the poetic speech that separates its chosen subjects and rhythms from commonplace occupations. The modernist axiom – at the time it still carries the unwieldy name, 'transcendentalist' – can be summed up here: there is a mode of presenting common things that subtracts them both from the logic of the economic and social order and from the artificiality of poetic exception. In order to guarantee material reality, Whitman breaks both the conventional closure of verse and the continuity ('universal reportage') of ordinary prose. He invents an unprecedented punctuation: these ellipses that the first paragraph of the 'preface' spectacularly imposes and that the poems will continue. The ellipses are the practical punctuation of this 'neither … nor', this 'neither verse nor prose' that claims to express the spiritual truth of things, their belonging to the whole manifested by their ability to create links. This is a suspended linkage: these ellipses disunite the micro-events of ordinary life in order to reunite them in the continuity of the living poem. They are the visible figure of the Idea, the figure of Infinity that reunites by disuniting all vulgar things in its interiority.

The ellipses would disappear in later editions that gave the poems titles and organized them into sections. They nonetheless remain one of the first and most significant attempts at writing and visualizing the poem of 'modern life'. For Whitman's novelty effectively

inaugurates a double legacy: the new poem is the poem brought nearer to life in two ways. On the one hand, it is the interiorized poem: the description of the world's spectacles is repeated in the movement of speech, the movement of speech brought back from the letter towards its living spirit, towards the breath from which it comes. But on the other hand, it is spirit outside itself, made visible in the new arrangement of the page. On the one hand, Whitman's 'free verse' could serve as a model for the symbolist search for rhythm subtracted from the material constraints of traditional verse, apt at expressing the ideality of poetic emotion. Symbolist poets – Vielé-Griffin in France, Balmont in Russia – were among the ranks of Whitman's introducers. But it was the naturalist or unanimist reaction that set the excessively pale symbolist idealities against the poet of flesh, large cities, and teeming life. Later the propagandists of young Soviet Russia widely distributed Korney Chukovsky's translation, to the point of making fliers from it in order to boost the morale of the soldiers of the Russian army and the workers of the industrial reconstruction.[36] But next to these poems transformed into propaganda tracts for combatants, there was the edition published in 1923 in Petrograd, with its futurist cover on which the Cyrillic letters making up Walt Whitman's name danced before a background of sky-scrapers, between the stars of the American flag and the accordion folds of the red flag. The spiritual and materialist poem of modern life is also the poem that abolishes the separation between the signs of speech and graphic images. Hence the Whitmanian legacy, surely an unexpected legacy for Emerson, is not limited to verses adopted by poets in Claudel's time; it can also be found in the paintings, drawings or posters by cubists and futurists, which mix linguistic signs with the outlines of forms to identify them either with the painting of the modern city or with the impulse towards the future of the workers' homeland. This explains why, more than once, the frenetic rhythms of Whitmanian lyricism would contaminate the rigorous constructions of the Soviet avant-garde directors who were working to make cinema the language of the dialectic. Dziga Vertov could accuse Eisenstein of misappropriating montage from the Kino-eye to restore bourgeois

36 On this point, see Stephen Stepanchev, 'Whitman in Russia', in Gay Allen Wilson, ed., *Walt Whitman Abroad* (Syracuse: Syracuse University Press, 1955), pp. 150, 152.

narrative cinema. In turn, Eisenstein could denounce the accumulative, non-dialectical character of Vertovian montage. But one thing is certain: the montage of *Man with a Movie Camera* which sweeps up the manicurist's gestures, magicians' tricks and miners' labour in the same accelerated rhythm owes more to *A Song of Occupations* or to the *Song of the Broad Axe*, than to *Capital*. And the dialectic of *The General Line* receives its demonstrative force only in the torrents of milk or the frenzy of reapers carried away by the Whitmanian rhythm. The production revolution is expressed in the forms of the new poem only if it momentarily forgets the distance separating the revolutionary editorialist of the *Franco-German Annals* from the transcendentalist lecturer of Boston.

5. The Gymnasts of the Impossible

Paris, 1879

Dear reader, savor this book, without losing a single syllable, for it will teach you about the most interesting people that the century has produced; these admirable mimes and gymnasts, the Hanlon Lees who, while everybody bends towards the ground, saying that crawling is good, do not consent to crawl and instead fly towards the azure, towards infinity, towards the stars! They thus console us and redeem us from vile resignation and universal platitude. They do not speak – no just Gods! – due to a lack of thought, but they know that outside daily life, speech must be used only to express heroic and divine things. Admirable mimes, I have said, yes, even after Deburau and even in the country that produced Deburau, because like him they have mobile faces, the rapid idea that transfigures them, the flash of the gaze and the smile, the mute voice that knows how to say it all, and, more than that, they have this agility that enables them to fuse desire and action in one single movement, which frees them from ignoble gravity. Like Jean Gaspard, they have a comedian's face, but it might not be that way; in fact, just as Deburau's grimace gave the impression and the illusion of agility, they too could give the illusion of thought by the rapidity and the rhythmic precision of their movements.

I love them with the strictest bias, because they are entirely allies and accomplices of the poet, and because they pursue the same goal as the poet himself. Originally the human being was triple; he contained three beings within himself: a man, a beast, and a god. To the sociability that made man, he added instinct, running, naive grace, innocence, sharp and perfect senses, the joyful leap, the surety of

animal movements, and also what makes god, the science of super-natural truths and nostalgia for the azure. But he did not take long to kill the beast and the god within himself, and he remained the social animal that we know ... Reviving the beast and the god in the human, such is the task of the poet, having remained instinctive in a world stuffed with commonplaces, and whose thinking soars winged and free above frenetic stupidity. This is also the task of the mime and the gymnast. But what the poet does only figuratively, through his soaring and leaping rhythms, the mime does in reality, literally. He frees his very own flesh from awkwardness, from the painfully acquired heaviness of social man. He has rediscovered the young fawn's startled flight, the cat's gracious jumps, the monkey's terrifying leaps, the panther's dazzling energy, and at the same time this fraternity with the air, with space, with invisible matter, that creates both bird and god.

This is how the poet, Théodore de Banville, introduces the *Mémoires et pantomimes des frères Hanlon Lees* ('Memoirs and Pantomimes of the Hanlon Lees Brothers') compiled by a man of letters, Richard Lesclide.[1] He is not the only writer who was interested in the performances of these acrobat mimes, then at the height of their glory. Émile Zola saw them the same year at the Folies Bergère, and the following year devoted a column to their show at the Variétés. He praised the 'perfect execution' of their stunts and their 'tremendous' gaiety 'revelling in broken limbs and battered bodies, triumphing in the apotheosis of vice and crime in front of outraged morality'.[2] One finds traces of their performance in Huysmans's *Croquis parisiens* (*Parisian Sketches*), as one does in the acrobat and mime characters imagined by Edmond de Goncourt or Jean Richepin.[3] But, while 'naturalist' novelists willingly probed the

1 *Mémoires et pantomimes des frères Hanlon Lees*, with a preface by Théodore de Banville (Paris: 1879). The Preface was reprinted in Théodore de Banville, *Critique littéraire, artistique et musicale choisie*, vol. II, eds Peter J. Edwards and Peter S. Hambly (Paris: Honoré Champion, 2003), pp. 429–36; 'Theodore de Banville and the Hanlon Lees Troupe', transl. R. Southern in *Theatre Notebook*, 1–4 (London: Society for Theatre Research, 1983), p. 160.
2 Émile Zola, *Le Naturalisme au théâtre*, in *Œuvres complètes*, vol. X (Paris: Nouveau Monde, 2004), p. 568.
3 Edmond de Goncourt, *Les Frères Zemganno* (Paris: Charpentier, 1879); Jean Richepin, *Braves gens* (Paris: Dreyfous, 1886).

dark, pathological and nihilistic content of pantomime, the poet of the *Odes funambulesques* focused on the form of the performance and the idea of art one can derive from it. The performance of the Hanlon Lees carries the tradition of 'English pantomime' to its highest point, which accentuates three great features of the pantomime genre to the extreme: the absurdity of situations lacking any motivation; the instant passage from the most absolute immobility to the violent exuberance of gestures that multiply blows in every direction and make bodies fly across space; and finally, the use of all the tricks that allow bodies to appear and disappear at any moment, pass through walls, windows, or mirrors, run beheaded after their heads, and make the missing heads appear in the most unlikely places. The Hanlon Lees put this virtuosity at the service of performances ruining the proper order of plots and the sense of social values. At times, they were Pierrots terrorizing a small English village, throwing an old lady out of her wheelchair to take it for a spin, using the baker's oven to bake his own son, as well as a protesting passerby, finally setting the whole village on fire. At others, Satan himself sent them to earth in order to create panic at the Saint-Cloud fair, where a crazed lady, trying to escape, threw herself on the target, and got shot by a rifle in the behind. Or they drive a Saint-Germain soirée wild, with a painter who dives into a piano and is revived with blows from a broomstick, a head that disappears from a portrait and that the model replaces with his own head, and guests who end up looting the salon. Or they take revenge for a mistreated lover by infiltrating the young girl's family dressed as barbers, where they forcefully shave everyone, dumping buckets of soapy water onto their heads and cutting the throats of the unwilling. In other sequences, they become killers to fill coffins that they build themselves, or they are unruly musicians who rip off the conductor's coattails before tying him with a huge ship's cable, without the inspired maestro noticing.[4] From such exuberant energy, Banville selects two essential features: the first is the

4 In order, *Viande et Farine, Les Cascades du diable, Une soirée en habit noir, Le Frater de village, Pierrot menusier* and *Do, mi, sol, do.* Concerning these pantomimes, in addition to the *Mémoires et pantomimes des frères Hanlon Lees,* see Ernest Coquelin, *La Vie humoristique* (Paris: P. Ollendorf, 1883), pp. 197–227, and John H. Towsen, *Clowns* (New York: E.P. Dutton, 1976).

abolition of gravity, both in the physical and the social sense of the term. The Hanlon Lees are primarily beings that fly, agile animals that soar towards the sky. The animal/social man/god triad clearly recalls trinitarian definitions of man that circulated throughout the nineteenth century, nourishing philosophies of humanity and plans for ideal communities as well as bodily techniques, such as the training methods of the actor François Delsarte, based on the trinity of the vital, the mental, and the psychic.[5] But these definitions were all directed towards an ideal of integration. Thus the study of the Delsartian trinity founded a science of exact expression and, in the following century, the reformers of dance placed Delsarte among the innovators, opposing exact knowledge of the resources of the body and gravity to the pirouettes of dance in point shoes and tutus. Banville undertook the opposite movement. He undid the trinity in order better to contrast social gravity with the identical impulse of the agile animal and the divine creature towards celestial heights.

Soaring towards the ideal is, in fact, what the *poëtes* – Banville, like Mallarmé, still crowned them with a trema – tend to boast about. Yet it is common to set this flight of words to the azure against vulgar circus clowning. Now Banville reverses the perspective: the acrobat clown literally and materially realizes what remains an ideal and a metaphor for the verse-maker. Against terrestrial gravity and the game of social roles, he knows how to mobilize more than the desire of dreaming minds: the instinctive energy of the animal that transforms desire into action, or rather makes them identical to one another. The sentimental distantness of poetry in search of a lost country is cancelled by the immediacy of the setting in motion, the appearances and disappearances of the acrobat mime. It can be strictly identified with the dream, since, along with the distance between the thought and the act, it overcomes the distance from the possible to the impossible:

> Between the adjective *possible* and the adjective *impossible* the mime has made his choice; he has chosen the adjective *impossible*. It is in the impossible that he dwells, the impossible is what he does. He hides where one cannot hide, he goes through openings smaller than his

5 See Alain Porte, ed., *François Delsarte: une anthologie* (Paris: IMPC, 1992).

body, and he balances on supports too weak to sustain his weight. He accomplishes, under the very gaze watching him, absolutely invisible movements, he balances on an umbrella, he disappears effortlessly into a violin-case … [6]

That the realization of the impossible turns out to be a matter of technical artifice proves nothing against the ideality of pantomime. Poetry itself is the ideal artifice that negates the social education in gravity. But the ideality of the Hanlon Lees pantomimes is not simply the victorious battle of bodies and technique against gravity. For aerial grace occurs through the violent encounters of these bodies that 'collide and clash, break, beat and fall upon each other, mount mirrors and slide down, stream from the rooftops, crush themselves flat as golden guineas, rise again in a storm of slaps'.[7] The duality of serene grace and violent agitation can evidently be explained as the expression of conflict between ideal and empirical life. And, in short, Banville tells us, the extravagances of the Hanlon Lees express true realism, 'life with that devouring, senseless intensity without which it would not be itself'. And he gives us an immediate illustration of this:

> rolling, tumbling down, hiding, going to sleep, and being wakened with a start, falling headlong from a carriage, emptying and filling luggage, making perilous leaps to light upon a chair, and then not having the time to sit there, being smitten with unexpected ailments, decorated with inexplicable bumps, caught in folding doors, piled up, crushed, pillaged, beaten, hugged, kissed, quartered, shaken like a dancing doll whose strings are twiddled by ironic hands – that is precisely life as it is.[8]

Yet, it is easy to see why this 'life as it is', illustrated by stunt clowns, is entirely different from ordinary social life, and very similar, on the contrary, to the dream life of creatures soaring in the ideal: because it is aimless and senseless. Whether they defy gravity or collapse onto each other, the Hanlon Lees do so equally without reason, without being forced by any necessity, nor directed by the search for some

6 *Mémoires et pantomimes des frères Hanlon Lees*, p. 9; 'Théodore de Banville and the Hanlon Lees Troupe', transl. R. Southern, p. 160.

7 Ibid., p. 11.

8 Ibid., pp. 12–13.

end for which this would be a means. This is the second feature that characterizes their performance for Banville. The challenge declared to gravity also applies to causal logic, which deduces action from a formulated plan and means used for a chosen end. This challenge is not only declared to the ordinary everyday, but also – and far more – towards what is ordinary in the theatre: tightly knit plots that make unexpected effects emerge from a very simple cause, well-analyzed characters with their complex motives that push them to act, and well-drawn characters like those found in living rooms or in the streets. Pantomime is an anti-theatre, or a theatre cleansed of all the academicism of tragedy as it is of the bourgeois vulgarity of melodrama or the comedy of manners, reduced to its ideal essence, in which the exact materiality of the performance is conflated with spectacular ideality accepted as such.

This particular theatre, already championed by a few poets over half a century ago, was even sought out in places where respectable men of letters, or respectable people in general, hardly ventured. The Théâtre des Funambules was the place where Deburau's admirers gathered after 1830, aficionados of a theatre whose popular character was defined for them by a double feature: first, the proximity of the auditorium to the stage, thanks to which 'the actors and the spectators, who all, moreover, were of the same breed, common people with jobs outside the theatre, could watch and look at each other up close, talking among themselves with lips nearly touching ...'.[9] Then came the multiplicity of the spectacular incidents and visual metamorphoses made possible by the three levels of machinery underneath. This double proximity – of the public and the actors, of the trivial and the spectacular – was embodied in Deburau's Pierrot. For his literary admirers, he embodied the people: the anonymous people as author, 'this great poet, this collective being who has more wit than Voltaire, Beaumarchais or Byron',[10] the actor people that contains a thousand actors within it, a thousand faces, a thousand grimaces and a thousand postures.[11] Their Deburau-people, however, is more material

9 Théodore de Banville, *Mes souvenirs* (Paris: Charpentier, 1882), p. 216.

10 Théophile Gautier, 'Shakespeare aux Funambules', *Revue de Paris*, September 1842, p. 61.

11 Jules Janin, *Deburau. Histoire du théâtre à quatre sous* (Paris: Cercles des Bibliophiles, 1881), p. 77.

and more cynical than the lunar dreamer hopelessly singing his love played by Jean-Louis Barrault in *Les Enfants du paradis* ('*Children of Paradise*'). Instead of raising his hands towards the indifferent muse, he is more prosaically busy in pulling out the bullet that he has mistakenly shot into his master Cassandra's body, even if this involves piercing him with an auger only to see the red ball he thus pulls out explode; he cuts off Harlequin's head with a sword, or turns the handle of the coffee grinder where he is hiding, unless he himself has to evade Harlequin by crashing through a greenhouse, coming out all cut up by pieces of glass.[12] A more violent Deburau-people, thus, but also one more indifferent towards events that occasion the use of such violence. To embody the people, Banville tells us, is to refuse to 'play the hero of the comedy'. This Pierrot-people thus takes a purely 'plastic and decorative' joy at seeing a tree that bears forth a feast, which, even if it were edible, would not be meant for him in any case. He also shows the greatest detachment in pursuit of fleeing lovers, which he engages in because he is forced to do so, but also 'for no reason, because it is worth doing as much as anything else'.[13] This separation between the act and any motive, this identity of contrary attitudes, makes the people-character coincide with the ideal form of art. The quality of the Pierrot, for Théophile Gautier, is this union of opposites, 'fine foolishness and foolish finesse ... blustering cowardice, sceptical credulity, disdainful servility, busy insouciance, idle activity, and all these astonishing contrasts that must be expressed through the wink of an eye, through a turn of the mouth, a frowning eyebrow, with a fugitive gesture'.[14]

Pierrot's mime offers an entirely new answer to the already century-old debate on the power of pantomime. As early as 1719, the Abbé Du Bos had argued for the restoration of Roman pantomime. For him this was an authentic art capable of expressing feelings and thoughts exactly. After him, reformers of dance like Cahusac or Noverre had set the conventional elegance of the ballet against a language of gestures and attitudes, likely to express silently any situation, thought or emotion. But the practical realizations of

12 'Ma Mère l'Oie ou Arlequin et l'oeuf d'or' in ibid., pp. 131–53.

13 Théodore de Banville, *L'Âme de Paris* (Paris: Charpentier, 1890), p. 17.

14 Théophile Gautier, *Histoire de l'art dramatique en France depuis vingt-cinq ans*, vol. IV (Paris: Hetzel, 1859), pp. 320–1.

this ideal language had shown its limits. Johan Jacob Engel uncompromisingly describes the unfortunate attempts of the performer supposed to translate Camille's invective against Rome in *Horace* into the language of pantomime: 'Qu'elle-même sur soi renverse ses murailles / Et de ses propres mains déchire ses entrailles!':[15]

> First the dancer showed the backdrop of the stage (apparently to indicate the place where Rome was meant to be), then she shook her hands at the ground intensely, at which point she suddenly opened, not the mouth of a monster, but her little mouth, and raised her fist to it a few times, as if she meant to swallow it with the greatest voracity. Most of the spectators burst out laughing, while others found themselves at a loss to guess the meaning of this unexpected acting ...[16]

The language of pantomime thus seemed condemned to redundancy or obscurity. Now Gautier reversed the position of the problem. The force of pantomime does not consist in taking the place of speech to express ideas and emotions. Rather, it breaks with the causal logic of plots and the semiotics of the expression of passions. The idea of an entirely motivated language of the senses was yet another antiquarian dream. Popular art has the same formula as the fabulous performance motivated by nothing; the popular character is like the virtuoso performer who carries out a task towards which he remains indifferent. The clowning of the Funambules provides a model of theatrical art rid of ingenious plots and the comedy of characters and manners. In his column on imaginary play, Gautier playfully highlighted the eminently moral character of a pantomime he had invented in which the head of a clothing salesman killed by Pierrot plays the role of Banquo's ghost and ends up dragging his assassin into the grave.[17] But he clearly draws a contrary lesson, a lesson in the indifference of theatrical action to any moral finality, from the performances of the Funambules.

This also explains why the same Gautier has no problem transposing popular pantomime, performed by lamplight in the filthy

15 'Let her knock down her ramparts on herself / And with her own hands rip out her bowels!'

16 Johan Jacob Engel, *Idées sur le geste et l'action théâtrale* (Geneva: Slatkine, 1979), pp. 41–2.

17 Gautier, 'Shakespeare aux Funambules', pp. 60–9.

space of the Funambules, into a dream-like poetic spectacle set in the gardens of an aristocratic château. This is how D'Albert, in *Mademoiselle de Maupin*, opposes the equal boredom of comedy, drama or tragedy with the 'fantastic, extravagant, impossible theatre' where, with the sky, forests, domes, arcades, and ramps with bizarre and unique colours in the background, characters with pointed hats and capes striped in brilliant colours, who have no professions and reside nowhere, 'come and go without our knowing how or why' carrying 'a little box full of diamonds as large as pigeon eggs'. These characters carry on their love affairs with the same detachment as Pierrot faced with Columbine:

> They speak without hurrying, without screaming, like well-bred people who attach little importance to what they do: the lover declares his love to his beloved with the most detached air in the world ... his main concern is to let strings of pearls and bouquets of roses fall from his mouth and to sow poetic gems like a true prodigy ... Everything comes together and falls apart with an admirable insouciance: effects have no cause at all, and causes have no effect whatsoever ... This apparent helter-skelter and disorder, finally, depicts real life in its capricious aspect more precisely than the most intricate moral dramas.[18]

What the poets found in the stunts of the Hanlon Lees in the Folies Bergère was already what Gautier and his friends had discovered in Deburau's pantomime: a dramatic art substituting psychological and social plots, which claimed to imitate the reasons of life through chains of causes and effects, with the extravaganza of exact performance that follows the twists and turns of its lack of reason. But it is not simply a matter of revelling in the unlikely. Rejecting the logic of verisimilitude amounts to a new balance between the performance of the spectacle and that of the spectator. The broken line of pantomime allows what the ingenious assemblage of the drama forbids: that the spectator can embroider his own poem around these patterns. Detractors of the language of gesture deplored the fact that one left it up to the spectator to imagine the meaning of what he saw. But if pantomime was freed from the linguistic

18 Théophile Gautier, *Mademoiselle de Maupin* in *Romans, contes et nouvelles*, vol. I (Paris: Gallimard, 2002), pp. 406–8.

mode, the fault became a virtue. A pantomime is 'like a symphony in which each person follows his dream through the general design', writes Gautier, who would later specify, in terms that Mallarmé borrowed: 'It is the spectator who makes the site and the dreamer the pantomime.'[19] The mime addresses himself to a spectator-poet who is a double figure: he is the people that consents to fiction as such, and the artist who uses his reverie in it. For Banville, he was the ally of poets against bourgeois vaudeville and its king, who had become the king of the Théâtre Français and the Opéra, Eugène Scribe. But this alliance was fragile because, even among those who enjoyed pantomime, some mistook its power and sought to do it a dubious favour: they wanted to establish its theatrical dignity by modernizing it, by drawing it out of its artifice to make it represent not stock types but the social reality of its time. This was the project of an author, Champfleury, who sat at the Funambules next to Gautier or Nerval. He denounced a conception of pantomime in which it is easy to recognize Gautier's own thoughts and words. Some wanted, he tells us, that the

> subject of the play be vague enough for the spectator to view a simple stunt involving Pierrot, the lady Columbine, Harlequin, Punchinello, Leandre and Cassandra. The spectator can think whatever he wants about this chaos and this stunt, building it into his own play. Thus, ten spectators will see ten different plays, even though they are watching the same work. Pantomime, according to such ideas, is nothing more than a kind of music, a symphony; some see setting suns, others birds with red tails.[20]

In this burlesque extravaganza in which, thanks to changes in perspective, traps and various effects, 'the family of Cassandra, Columbine, Harlequin, Punchinello, enters, exits, jumps out of windows, is cut into pieces, comes back to life', it is impossible to recognize 'the *idea* that might have presided over the pile-up of all these facts'.[21] To the 'realism' of the extravaganza without head or tail, praised by Gautier, Champfleury opposes an intrusion into

19 Théophile Gautier, *La Presse*, 26 July 1847, and *Moniteur Universel*, 2–3 November 1856.

20 Champfleury, *Souvenirs des Funambules* (Paris: Michel Lévy, 1859), p. 84.

21 Ibid., p. 86.

social reality that he deems was initiated by Deburau when he took off the Pierrot costume 'to reproduce popular scenes' by dressing like a soldier, an undertaker or a cobbler. He wants to fix this passage of stock types to social characterization in order to make pantomime ready for 'serious comic effects that had been avoided up till now'.[22] This is how he created the realist pantomime *Pierrot marquis* for Deburau's successor, Paul Legrand. Pierrot's whiteness is justified since he is a mill worker; Punchinello's humps, too, for they are hollow hiding places which Pierrot cuts open to discover the old man's gold. After killing him, he takes his place to dictate a will entirely to his own benefit, playing an erudite marquis, like in the *Bourgeois gentilhomme* ('Bourgeois Gentleman'), hiring a rhetoric teacher who is an aficionado of Ponsard's tragedies, before being robbed in turn by Punchinello's son, and finally transformed back into a miller's boy by a fairy.

Gautier was not mistaken about the meaning of this modernized pantomime. Behind conventional praise, his review underscores what he considers the 'protestant' sin against the very spirit of pantomime:

> The ancient faith has disappeared and Monsieur Champfleury is acting as the Luther of pantomime ... In ordinary pantomimes, Pierrot is white because he is white: this paleness is allowed a priori; the poet accepts this type as such from the hands of tradition, and does not ask him for his *raison d'être* ... but in his sophistry, Monsieur Champfleury gives Pierrot's allegorical whiteness an entirely physical reason, the flour from the mill dusts his face and clothes with this wan and melancholic persona. One could hardly find a more plausible means to make this white ghost probable; yet, we prefer this mysterious and unexplained paleness to paleness explained in this way. Later, the author offers an ingenious explanation for Punchinello's gibbosity: we can see the catholic era of pantomime coming to an end, and the era of protestant art beginning. Authority and tradition no longer exist; the doctrine of free examination will bear its fruits; goodbye to naive formulas, byzantine bizarreness, impossible hues; analysis is unsheathing its scalpel and will begin its anatomies.[23]

22 Ibid.
23 Théophile Gautier, *Histoire de l'art dramatique en France depuis vingt-cinq ans*, vol. V (Paris: Hetzel, 1859), p. 150.

The 'modernization' of pantomime, thus conceived, was part of the genre's decline. Gautier and his acolytes followed its manifestations with melancholy in the skilful compositions the mime Paul Legrand developed through his talent for social observation and dramatic expression: Pierrot exchanging his commoner's white clothes for the tight-fitting, shrivelled ones worn by the office worker, subject to working hours, deferential towards his boss and worried about his promotion; Pierrot the medical student, living the happy and broke life of Latin Quarter bohemians; an obliging Pierrot who only kicks his master Cassandra reluctantly, still stealing a little but so honestly – transforming, in short, the fantastic figure into a human character fit to move the spectator.[24] This suspect humanization of pantomime finds a counter-model in the extravagant cruelty of English mimes who painted two patches of red on their white faces – symbols that various critics considered coloured fantasy, alcoholic fever, or blood-thirsty ferocity. Gautier went to applaud the master of the genre, Tom Matthews, and his English colleagues during their disturb-ing 1842 intrusion on the bourgeois stage of Variétés. Many years later, Baudelaire recalled Pierrot's entry, entirely the opposite of Deburau's lunar persona, bursting in like a tempest, falling like a bundle and shaking the hall with his thunderous laughter, and, with a flick of the magic wand that filled everyone with the vertigo of 'the comic absolute', transforming the action into 'a dazzling volley of kicks, punches and slaps which blaze and crash like a battery of artillery'.[25] This hyperbolic, comic absolute, as opposed to the 'sig-nificant comic' of comedies of manners, is for him, one recalls, the mark of the 'satanic' essence of laughter.

Who knows how many of Baudelaire's contemporaries read this interpretation of comic Satanism embodied by English clowns, pub-lished in an ephemeral magazine called *Le Portefeuille*? However, it marks the juncture between the aerial lightness of the 'comic absolute' and the disturbing drama of Pierrot noir that, during the

24 Théophile Gautier, 'Revue Dramatique', *Moniteur Universel*, 28 July 1856, 2–3 November 1856, and 30 August 1858. He respectively comments on *Pierrot employé*, *Les Carabins* and *Le Duel de Pierrot*.

25 Charles Baudelaire, 'De l'essence du rire', in *Œuvres complètes*, vol. II (Paris: Gallimard, 1941), p. 180; J. Mayne, ed., 'The Essence of Laughter', in *The Painter of Modern Life and Other Essays* (London: Phaidon Press, 1995), p. 162.

naturalist and symbolist age, marked the fortune of the Hanlon Lees and the infatuation of literary men for pantomime. In 1867, the year Baudelaire died, Paris discovered black humour in *Le Frater de village* ('The Village Brother'). Partisans of the French tradition of 'fine comedy' saw more in it than competition between impresarios: it was an intellectual symptom. With the brutality of the English clown, a new civilization of overexcited pleasures, nervous illnesses, and pessimist views on the evolution of humanity arrived on the stages of Parisian shows:

> This macabre clown arrived in our land on the steamboats that carried Darwin's books and commentaries by Schopenhauerians. For an hour we espoused the sadness of our neighbours; the black acrobat was well received ... This exotic art overthrew all our ideas of logic; it was in direct opposition to our inner taste for clarity and nuance. Yet, it was enjoyed, for it provoked the only laughter that we might have been capable of at that moment, a convulsive laughter without joy, full of dread.[26]

This commentary, written twenty years later, can seem purely retrospective. But it nonetheless indicates the path that the figure of the 'English clown' took in the minds of artists, critics and all the analysts of contemporary society and soul. The macabre clown became a contemporary of Charcot's hysterics, the 'deranged' – drunkards or priests – in Zola, and Lombroso's – criminal or genius – degenerates. It was by mixing the features of Zola's alcoholics (Coupeau and Macquart) and his painter who sacrificed everything in search of the absolute work (Claude Lantier) that Jean Richepin composed the character of Tombre in *Braves gens* ('Good Folk'). A fervent renovator of pantomime, he imagines Columbine as a personification of death, 'suave, ideal, dancing and winged',[27] swirling around 'a King Lear Pierrot with flowing white locks, eyes stricken with horror, love and ecstasy, with gestures simultaneously expressing the weariness of life, the thirst for death, and the glory of apotheosis'.[28] After the failure of his attempt, Tombre leaves, like the Hanlon Lees,

26 Hugues Le Roux, *Les Jeux du cirque et de la vie foraine* (Paris: Plon, 1889), p. 215.

27 J. Richepin, *Braves Gens*, p. 178.

28 Ibid., pp. 180–1.

for the United States, from where he returns with the pantomime 'Happy Zigzags': set in a closed courtyard that evokes a hospital or a prison, accompanied by two gnomes, one of whom seems to be a centipede and the other 'a large bug fallen from the ceiling', he appears in black dress hermetically buttoned up, with feverishly shining eyes and his mouth trembling with a madman's rictus. All the action consists in singing 'we are the happy zigzags', along with the others, in an obsessive rhythm, and stiffening into painful contractions, as if petrified before hallucinatory images. With the slow melody that becomes diabolical, the grimaces that become frenetic, and the contortions exaggerated to the point of epilepsy, a long shudder of dread rips through the crowd, the audience becomes agitated with these agitators, women let out a loud, hoarse scream and hide their faces in their hands, weeping or laughing maniacally.[29] In one sense, this spectacle is the realization of a new artistic ideal, in which pantomime is reduced to a pure graphic flash: 'This synthesis, this imagery in action through sudden immobilized postures, this précis of pantomime, was absolute art, the supreme outcome of my theories. Zig, zag, bang! Like a blazing drama, shooting past like an express train, emerging like a landscape in the glow of lightning.'[30] But Tombre conceived this idea of absolute art by miming the delirium tremens for cabaret spectators. At the same time he discovered that it was the simple exhibition of the modern sickness of the soul and civilization: 'Nothing but my body, my face, my gesture. And all the alcohol is embodied within! All of modern humanity, neurotic, martyred, demonized, made heavenly by this alcohol, its God.'[31]

This version of epileptic pantomime can be contrasted, to be sure, with the taste of the literary men of the *Cercle funambulesque* who sought to revive pantomime by transferring it from smaller popular venues to the setting of distinguished salons. In this context, these disciples of Champfleury made it oscillate between a comedy of manners and a 'mystical pantomime' corresponding to the 'instinct of synthetic art that seduces our young literary people today'.[32]

29 Ibid., pp. 459–63.
30 Ibid., p. 477.
31 Ibid., p. 478.
32 Félix Larcher and Paul Hugounet, *Les Soirées funambulesques. Notes et documents inédits pour servir à l'histoire de la pantomime* (Paris: Ernest Kolb, 1891), p. 58.

Sometimes the poet Pierrot was busy corrupting Columbine, whose literary education Cassandra had entrusted to him; at others he was cuckolded by the same Columbine, who dreams of a handsome soldier while he dictates the verses of Sully Prudhomme's *Vase brisé* ('Broken Vase') to the Muse; at other times still, in quest of treasure buried in the Sphinx, he wakes the Egyptian Brunhilde, named Hermonthis, from her sleep. To get the sacred lotus, the emblem of infinite joy, from her, he must renounce life and come to her feet 'lying in a hieratic pose and kissing the conquered lotus with his dying lips'.[33] At the same time, some man of letters took to 'dreaming up a series of noble and calm gestures, on a properly decorated stage, an arrangement of harmonious folds in the clothes of characters', while equally praising 'the crazy English jests' and 'the painful and tender reveries that would take place in a garden with softly rustling fountains, for which certain music by Schumann seemed to be composed'.[34]

Faced with this transformation of pantomime into a little salon piece, between the naturalist version of epileptic Pierrot and the symbolist reveries of noble attitudes set among fountains, Banville's text maintains the essential knot of poetic dream and gymnastic performance. The future of this alliance of the poet with the clown and the gymnast was not realized by verse-makers or playwrights, but by two new arts – one born on the theatre stage, the other on the sites of popular attractions. The first was called *mise en scène*, or staging: an art born out of the reversal by which the auxiliary art that was supposed to put drama in tableaux and in movement proved to be the means of renewing it, of giving thought fixed in words the spatial form that suits it. It was particularly in Russia, and notably on the stage of Meyerhold's theatre, that Harlequin and Columbine underwent a decisive metamorphosis, passing from the status of represented characters to being the theoretical and practical agents of a new theatricality. The latter contrasted the accepted convention with naturalist realism, and the play of the mime's juggling with the performance of an actor interpreting a role. Pantomime

33 Larcher and Hugounet, *Les Soirées funambulesques*, p. 62. *La Fin de Pierrot*, summarized here, is a work by Paul Hugounet himself.

34 Léo Rouanet, quoted in Hugounet, *Mimes et pierrots. Notes et documents inédits pour servir à l'histoire de la pantomime* (Paris: Fischbacher, 1889), p. 234.

was no longer a kind of spectacle; it was no longer the popular art on whose facetiousness or acrobatics the aesthetes, fleeing the inanities of bourgeois theatre, could come to embroider their own reveries of art. It was the *organon* of theatre regained, the learning of play as the 'art of freely combining an accumulated technical bodily knowledge'.[35] Technical knowledge involves the acquisition of all the gestural patterns that define scenic action (walking, running, climbing up and down, sliding, tumbling or tap dancing, slapping, using objects, catching and throwing a weight, archery or stabbing ...). The art of freely combining these patterns is the art of gathering or decomposing them in order to construct pantomimic scenarios that foil expectations and unite what is incompatible. Pantomime is thus the work that visualizes thought into plastic performances in space. Also Harlequin, Pierrot and Columbine can shed their white or colourful costumes for the mechanic's blue overalls. They are no longer the immemorial people opposing precise and indifferent gestures to the plots of the powerful. They are workers/gymnasts who espouse the movements and the forms of a new world in construction. Fanciful actions *à la* Hanlon Lees can thus become coded biomechanical exercises and melt into a dream of Taylorized theatrical action. Gautier and Banville contrasted the impromptu triggers and acrobatic leaps of English clowns with tightly knit plots about love affairs and worldly ambition. By staging Crommelynck's *Le Cocu magnifique* (*The Magnificent Cuckold*) in young Soviet Russia, Meyerhold transformed a plot of jealousy and adultery into a collective sporting event, and Lyubov Popova turned the 'scenery' of a windmill into a gymnastic device with a toboggan, stairs and tackles that could be used both to display the actors' virtuosity and to symbolize the flight of a new society in which man is the master of space.

This Marxist marriage of Taylor and Columbine was possible because the popular art that revolutionary stage directors wanted to import followed its path elsewhere and found new forms of presentation. A new art – cinema – offered a new space of visibility to pantomimic performance. The projected image can convey the privilege of the spectator of the Funambules to a large audience, enjoying both the closeness that allows one to follow the

35 Béatrice Picon-Vallin, *Meyerhold* (Paris: CNRS Éditions, 1990), p. 58.

expression of an eyebrow on a white face and the metamorphoses of the stage endlessly produced by the machinery. And the fragmentations, abrupt stops, reprises and vertiginous accelerations of movement find an adequate technical instrument in the cutting and montage of filmic material. In 1922, the *Eccentric Manifesto*, signed by Kozintsev, Trauberg, Yutkevich and Kryzhitskii, sealed the combination between the art of the new world based on the regulated production of nervous shocks and traditional English clowning. The new plastic, theatrical, filmic art of montage was the universalized form of this performance of the impossible that came to be known during the same period by the name *gag*. But this import from the 'eccentric' tradition into the new mechanical Soviet world was possible because this tradition of English clowns had already undergone another transformation, passing in the new American world from the circus stage or the music-hall to the cinema screen. Pierrot's misleadingly indifferent mime, Harlequin's fits of brutality, and the demonic stunts of the Hanlon Lees become the casual and sneaky attacks of Charlie Chaplin, the impassive face and the unpredictable gags of Buster Keaton, or the vertiginous, involuntary acrobatics of Harold Lloyd, before later becoming the frenetic whirling of the Marx Brothers around their prey. Soviet artists wanted to transpose the acrobatics of the Funambules of the Folies Bergères, which made the delicate poets of the last century dream, onto the great stage of production of the new man. The children of the music-hall who went into cinema guaranteed it a better-defined and more lasting lineage.

6. The Dance of Light

Paris, Folies Bergère, 1893

When the curtain rises in a festival hall or any place, there appears, like a snowflake – blown in from where? – miraculous, the Dancer. The floor avoided by her leaps or hard on her points, immediately, acquires a virginity of a site foreign, to every beyond, undreamed of; and such as will be indicated, built and made to flower, by the first isolating Figure. The décor lies future, in the orchestra, latent treasure of imaginations; to come out, in bursts, according to the view dispensed by the representative here and there of the idea on stage. No more! Now this transition from sounds to fabrics (is there anything resembling a veil more than Music!) is, visibly, what Loïe Fuller accomplishes, by instinct, with displayed crescendos, and retreats of skirt or herself, instituting a place. The enchantress creates the ambiance, pulls it out of herself and puts it back in, succinctly; expresses it, in a silence rustling with Chinese silks.

Following this spell and soon to disappear from stage, an imbecility, as in this case, the traditional plantation of stable or opaque stage-sets, so opposed to limpid choreographic mobility. Painted or cardboard vehicles, all this intrusion, now, to the scrap heap; here we find given back to Ballet the authentic atmosphere, or nothing, gusts no sooner known than scattered, time enough to evoke a place. The free stage, to the liking of fiction, exhaled from the flow of a veil with attitudes and gestures, becomes the very pure result.

Originally or out of this use, exercise, studied as invention, carries a feminine intoxication and simultaneously an achievement I will call industrial; the ballerina swoons surely, in the terrible bath of fabrics, supple, radiant, cold, and she illustrates some convoluted

theme, acrobatics of a weft spread far, giant petals and butterflies, conch or unfurling, all of a neat and elementary order. Art springs forth incidentally, sovereign; from life communicated to impersonal eurhythmic surfaces, also from the sense of their exaggeration, for the figurant: and from harmonious delirium.

Nothing astonishing that this prodigy should be born in America, and is Greek. Classic insofar as entirely modern.

This is how Mallarmé praised Loïe Fuller's show to the readers of the *National Observer* on 13 May 1893.[1] He was not the first to do so. For four months already, all the aesthetes of Paris had been rushing to the Folies Bergère: a place that they had disdainfully left until now to a 'vulgar' audience, supposedly aficionados of lascivious poses and steamy semi-nudes; a place where, for this very reason, they saw the exemplary demonstration of an aesthetic rebirth. A respected oracle of the time, Paul Adam, declared as much in his *Entretiens politiques et littéraires* ('Literary and Political Interviews'): 'A new art will clearly be born.'[2] This new art comes from a new body, relieved of the weight of its flesh, reduced to a play of lines and tones, whirling in space. Before Mallarmé, an eminent art critic, Roger Marx, had already saluted the spectacle coming from modern America, yet similar to the noblest forms of Greek sculpture.

In turn, Mallarmé attempted to formulate this new aesthetic around three notions: figure, site and fiction. The figure is the potential that isolates a site and builds this site as a proper place for supporting apparitions, their metamorphoses, and their evaporation. Fiction is the regulated display of these apparitions.

These are the aesthetic principles he draws from the show Loïe Fuller designed and popularized under the name 'serpentine dance'. One should not misunderstand the meaning of the adjective. Serpentine dance is not the dance of a serpent. The 'gyrating themes' that the dancer 'illustrates' have nothing to do with the swaying of

1 Stéphane Mallarmé, 'Considérations sur l'art du ballet et la Loïe Fuller', *National Observer*, 13 May 1893, in *Œuvres complètes*, vol. II, pp. 313–14. Text republished with numerous changes in 'Autre étude de danse. Les fonds dans le ballet', in *Divagations*, in ibid., pp. 174–6; 'Another Study of Dance: The Fundamentals of Ballet', *Divagations*, transl. Johnson, pp. 135–7.

2 Paul Adam, 'Critique des moeurs', *Les Entretiens politiques et littéraires*, 10 February 1893, p. 135.

the chest or belly that one readily identifies with 'oriental' dance. Roger Marx insisted on this point: 'No more contortions, no more hip swaying, no more circular pelvic movements; the chest stays rigid.'[3] And it is not a matter of imitating some reptile. No doubt Loïe Fuller did dot disdain the accessory that the outline of an imitated form might make on a dress: snake, butterfly or flower. But, Roger Marx tells us, 'detail is secondary'.[4] What is not secondary is what the dancer does with the long dress she projects around herself; with it she can draw the shape of a butterfly, a lily, a basket of flowers, a swelling wave, or a wilting rose. But all these drawings are primarily pure spinning: spirals and swirls centred and guided by her body.

The serpentine dance first illustrates a certain idea of the body and what makes for its aesthetic potential: the curved line. The very term 'serpentine line' has a long history. It was established in eighteenth-century England by Hogarth. It summarized everything from the architecture of monuments to that of gardens, which symbolized new English taste, the new alliance of art and nature against the rectilinear perspectives of monarchical French gardens. But the mere opposition of soft curves to sharp right-angles does not exhaust the meaning of the notion. As Burke showed, the privilege of the serpentine signifies something more radical, the rejection of the classical model of beauty, which is that of the well-proportioned body: a Vitruvian house designed according to human forms, akin to Leonardo da Vinci's ideal man, with extended limbs inscribed within the perfect form of the circle. The serpentine is the destruction of the organic as the natural model of beauty. It is opposed to the order of geometric proportion by the perpetual variation of the line whose accidents endlessly merge. But, even more radically, it is nature's inventiveness that scoffs at proportion. The beauties that nature presents to us prove it: roses with large heads disproportionate to their frail stems, minute flowers that adorn the massive branches of apple trees, or peacock tails longer than the bodies they extend.[5]

3 Roger Marx, 'Chorégraphie. Loïe Fuller', *La Revue encyclopédique*, 10 February 1893, p. 107.

4 Ibid.

5 Edmund Burke, *A Philosophical Enquiry into the Origins of our Ideas of the Sublime and Beautiful* (Oxford: OUP, 1990), pp. 87–8.

In a sense, the serpentine dance is the dance that transports this natural beauty into select forms. The calyxes of flowers, the flight of butterflies or the waves it evokes are its manifestation. It is not a question of imitating flowers, waves, or insects. The same aesthetic that takes the curve of a rose or the spirals of a peacock tail as its model refutes the idea of creating beauty by producing a resemblance. 'Nature takes place', says Mallarmé, 'we cannot add to it.' One must not misunderstand this formula: it does not disqualify natural forms. On the contrary, it recommends extricating the elements of a language of forms to invent a new power of artifice. Mallarmé's strictest disciple, Camille Mauclair, summed up the thinking of Armel, the poet's fictional double, as follows: '... the part of his art the ignorant called artificial was this sharper penetration of natural forms, this intuition of analogies between all material and spiritual things. Instead of borrowing older literary forms, Armel chose them in the infinite repertory of life ...'.[6] Loïe Fuller gives an example of this 'elemental' language with the crepe of the dress that Mallarmé chose, not unintentionally, to call a veil. The veil is not only an artifice that enables one to imitate all sorts of forms. It also displays the potential of a body by hiding it. It is the supplement that the body gives itself to change its form and its function. The novelty of Loïe Fuller's art is not the simple charm of the sinuous. It is the invention of a new body: this body is a 'dead centre' in the midst of movement; it engenders forms by placing itself outside itself. Art used to include various kinds of bodily forms, such as the models artists used to create resemblance or those that embodied a play's script or a ballet's libretto on stage. Henceforth, it is a different matter, for which Mallarmé finds no better analogy than music: the body that uses a material instrument to produce a sensible milieu of feeling that does not resemble it in any way.

'Transition from sounds to fabrics.' Mallarmé's phrase does not mean that Loïe Fuller's use of veils transposes any music in particular. Commentators of the serpentine dance do not seem to pay any attention to the music. They occasionally mention the flower girls from *Parsifal* or the flame surrounding Brunhilde, but these Wagnerian references are aesthetic ideas, not musical themes. The movement of the veil does not transpose any musical motifs, but

6 Camille Mauclair, *Le Soleil des morts* (Geneva: Slatkine, 1979), p. 80.

the very idea of music. This idea is of an art which uses a material instrument to produce an immaterial sensible milieu. Mallarmé had probably not read much Schopenhauer. But the latter lent his tone to the aesthetic of the time, and when the poet speaks of 'the rapidity of passions – delight, mourning, anger' that the dancer produces, we hear the voice of the philosopher commenting on Beethovenian symphony, where without speech or images the voice of all passions, all human emotions, speaks: 'joy, sorrow, pain, horror, exaltation, cheerfulness and peace of mind *in themselves*, abstractly, as it were, the essential in all these without anything superfluous, and thus also in the absence of any motives for them'.[7] The veil is music because it is the artifice through which a body extends itself to engender forms into which it disappears. This is what Georges Rodenbach, a poet friend of Mallarmé, later summed up as follows: 'The body delighted by being unlocatable.'[8] This unlocatable body is contrasted with the statue of the nude dancer, the statue without veil or mystery, presented at the salon by Falguière. 'Chastity' is a qualifier often used to describe Loïe Fuller's dance. And Paul Adam had already sung a hymn to the desexualization of the body, commenting on this dance in a section devoted not to art but to the 'critique of morals'. However, moral purity is not the basis of the problem. The unlocatable body exists to organize a play of transformations. It is the body that moves the veil, producing these apparitions in constant metamorphosis, 'the rhythm upon which everything depends yet that hides'.[9] It hides not as startled virtue, but as the concealed architecture of the poem according to Poe, or Flaubert's God, invisible in his creation.

This is what creates the 'intoxication of art': the abstract formula that Mallarmé, rewriting his text, substituted for both the maenad in fury Roger Marx invoked and the simple 'feminine intoxication' mentioned in the *National Observer* article.[10] The 'fury' of the dancer

7 Arthur Schopenhauer, *The World as Will and Representation*, vol. I, transl. and ed. J. Norman, A. Welchman and C. Janaway (Cambridge: CUP, 2010), p. 289.

8 Georges Rodenbach, 'Dancers', *Le Figaro*, 5 May 1896.

9 Ibid.

10 'The exercise, as invention, without being put to use, encompasses an intoxication of art, and, at the same time, an industrial accomplishment.' Mallarmé, 'Autre étude de danse: Les fonds dans le ballet', *Divagations*, p. 174; *Divagations*, transl. Johnson, p. 135.

does not refer to any Dionysian ritual. The intoxication of art only means that a body produces its own space of apparition. The body of the dancer constitutes both the operation of the poem and the surface it is written upon: a 'blank page', Rodenbach said, while Mallarmé insisted, on the contrary, on this body's act that constitutes a space drawn from nothing through its operations. This is also the great innovation of the dancer of the Folies Bergère. She is a self-sufficient apparition; she produces the stage of her transformations from her own transformations. The 'virginity of the site' first abolishes any scenery that could serve as a background to the dancer's trans-formations. The scrapping of pasteboard, on which the set designers worked to represent the scenery of the action, was, at the time, the dream of aesthetes of art theatre. It was a dream shared by a young Appia, imagining an abstract space for the staging of Wagnerian musical drama. The music-hall artist beat them in the realization of this dream. The stage where she appears is entirely draped in black, and she steps out in the dark. It is from this initial night that the 'apparition escapes' and takes form and life 'under the caressing ray of electric light'.[11] Her apparition thus follows the appearance of light itself. And, even more than flowers, birds, or insects, her performance draws the general form of what light makes visible. Mallarmé used to call these forms and elementary relations of forms 'aspects', which he readily metaphorized as the folds and unfolding of a fan, swaying hair, or the foam on the crest of a wave. For him all these aspects symbolize the pure act of appearing and disappear-ing, whose model is provided by the daily sunrise and sunset. Loïe Fuller's veil, whose display is lengthened by rays of light, is both figure and background. It is the surface of its own apparition that negates the eternal monotony of 'space similar to oneself' and rejects it, with the 'nothing' of the atmosphere it creates, into the void. The veil illuminated against a dark background thus gathers the three figures celebrated separately by the poet: the console whose gold is substituted for the expiring sun, the vase whose elongation replaces any real rose, and the lifted lace whose beating takes the place of all marriage beds.[12] Paul Adam expressed this reinvention of the world

11 Roger Marx, 'Choréographie. Loïe Fuller', p. 107.

12 Stéphane Mallarmé, 'Tout Orgueil fume-t-il du soir', 'Surgi de la croupe et du bond', and 'Une dentelle s'abolit', in B. Marchal, ed. *Œuvres complètes*, vol. I (Paris: Gallimard, 1998), pp. 41–3; 'Does pride at evening

with greater cosmogonic emphasis: 'She placed the original form of the planet before a thousand spectators, the way it was before it burned, cooled, covered with rain, sea, land, plants, animals and men. The dullest socialite feels a little shudder before this apparition of the genesis of worlds.'[13]

Miming the act of appearing instead of miming the appearance of characters to whom something happens, or who feel something, is the intoxication of art. The intoxication comes from suppressing the gap between will and its execution, the artist and the work, the work and its space. The dancer with the veil is at once the pen that writes, the water-shoot that rises and falls, the statuette condensing outside itself, 'the late decorative leaps evoking skies, sea, evenings, perfume, and sea foam',[14] and the pure stellar space created by this condensation. This is what the word 'figure' sums up: the figure is two things in one. It is the literal, material presence of a body, and it is the poetic operation of metaphoric condensation and metonymic displacement: the body outside itself condensing the late evening, the body in movement writing the latent poem of the dreamer 'without the apparatus of a scribe'. This is the operating presence that Mallarmé designates as the act of the *'figurante'*. The term usually designates the actor in the background meant to merely remain a background 'figure'. Here, on the contrary, it marks the operation of an autonomous creation. Simply, this autonomy only exists to suppress the personality of the artist. 'Immobile' Loïe, at the centre of the swirls created by her veils, embodies exactly the idea of dance expressed seven years earlier by Mallarmé: the body of the ballet figuring 'the ideal dance of constellations'[15] solely around the central star. The active conjunction of two forms, literal and metaphoric, in the 'figure' thus produces a new idea: the figure is the act that institutes a place, a singular theatre of operations. What is produced in this theatre is called 'fiction'.

always fume'; 'Sprung from the croup and the flight'; 'Lace sweeps itself aside', in Henry Weinfeld, ed., *Collected Poems* (Berkeley: University of California Press, 1994), pp. 78–81.

13 Adam, 'Critique des mœurs', p. 136.

14 Mallarmé, 'Autre étude de danse: Les fonds dans le ballet', in *Divagations*, p. 176; *Divagations*, transl. Johnson, p. 137.

15 Mallarmé, 'Ballets', in *Divagations*, p. 170; 'Ballets' in *Divagations*, transl. Johnson, p. 129.

This word must be given a new meaning. For, traditionally, fiction is two things. Firstly, it is imagination deprived of reality. And it is what lends consistency to this non-reality: the plot or the argument that, since Aristotle, lends its own intelligibility to the inventions of poets. It is not meter but the invention of a plot that makes the poem, the *Poetics* tells us. Only at this cost can fiction be something other than an illusion. This is also the cost at which an artisan's or a gymnast's skill counts as art. Such a rule is codified by the classical age: to know if a bodily performance deserves the name art, one must know whether it tells a story. But a story, in this logic, is not a simple series of events; it is an articulated body, with a beginning, a middle, and an end. In short, the model of the organic body defined not only a plastic ideal, but also the paradigm of fiction. The age of Hogarth and Burke did not tamper with this organicity, despite Sterne and the serpentine line used as a symbol for the pre- and postnatal adventures of Tristram Shandy. This is the line of fantasy whose charm only functions in relation to the straight line it deviates from. The romantic age ceaselessly played with this deviation, from fragmented tales by Tieck or Jean-Paul to the Balzac of *La Peau de chagrin*. But what the art of the serpentine dance illustrates, for Mallarmé, is no longer a deviation in relation to a fictional norm, it is a new idea of fiction: this substitutes the plot with the construction of a play of aspects, elementary forms that offer an analogy to the play of the world. The lily or the butterfly have little importance in fact: the lily does not represent any flower, but presents the elementary form of the chalice through which everything is given in an apparition that is also an elevation towards the sole divinity of light; and the butterfly stands for the relation between fluttering and iridescence. The new fiction is this pure display of a play of forms. These forms can be called abstract because they tell no stories. But if they get rid of stories, they do so in order to serve a higher *mimesis*: through artifice they reinvent the very forms in which sensible events are given to us and assembled to constitute a world. The 'transition' from music to fabric is the recapturing of the power of abstraction, of music's power of muteness, by mimetic gesture itself. The body abstracts from itself, it dissimulates its own form in the display of veils sketching flight rather than the bird, the swirling rather than the wave, the bloom rather than the flower. What is imitated, in each thing, is the event of its apparition.

This is the new fiction: the deployment of appearances as a form of writing. This is the meaning of the word 'symbolism'. Symbolism is not the use of symbols. It is the suppression of the difference between symbolic and direct expression. The classic symbol connected a pictorial representation with an intellectual notion: the lion and courage, the dog and fidelity, the eagle and majesty. But the lilies drawn by Loïe do not symbolize purity any more than butterflies are a figure for lightness, or flames for passion. What they symbolize is their potential for deployment and flight. This symbolic potential is thus no different from the potential used. Movement presents itself in every movement. The symbol, originally, is the part detached from the whole, representing the whole. But the movement of veils is not a part of movement: it is its potential at work. This is the equivalence between the 'elemental' language of forms and the apparent display of things that Mallarmé sought to 'repatriate' into the writing of the poem.

Loïe Fuller, in turn, formalized it into a writing of an entirely different genre: the inventor's patent that she filed a year earlier with the US copyright office in Washington to protect herself from her imitators.[16] There she describes a composition in three tableaus, precisely noting all the movements of the dress and all the variations of light, from the initial shadows to the final darkness, through which she imitates an opening flower, the rolling waves, or a spider in the middle of its web.[17] The stakes of the description and the demand

16 This document is entirely reproduced by Giovanni Lista in his book, *Loïe Fuller. Danseuse de la Belle Époque* (Paris: Stock, 1994), pp. 94–7. Every contemporary study of Loïe Fuller's art is indebted to this magisterial study.

17 An example taken from the first tableau: 'The dancer stands at center, catches up dress at each side towards the bottom, holds it high at each side, and moves hands from right to left, imitating a spiral shape, dancing towards footlights. When reaching footlights, changes straight movement of arms, and, keeping same motion, gives a rounding, swerving movement that causes dress to assume the shape of a large flower; the petals being the dress in motion. Then several quick turns up towards back (dress up on each side), quick run down stage to the center, and followed by several more whirls, and, twining the skirt over both arms, drops on one knee, holding dress up behind head to form background.' Quoted in ibid., p. 92; 'The Serpentine Dance' by Marie Louise Fuller, quoted in 'Fuller v. Bemis', Circuit court S.D. New York, 18 June 1892, *Federal Reporter*, vol. 50. no. 989 (1892), p. 926.

are not insignificant: they try to make it admissible that a punctual series of gestures and forms can constitute a new work, which can be attributed to a proprietary artist and defended against all counterfeiting. It is significant that Roger Marx's article crowning Loïe's art as great art was accompanied in the *Revue encyclopédique* with a text examining the legal titles of serpentine dance as artistic property. It is worth mentioning that the dancer's argument did not find favour with the American judicial system. The New York court dismissed her case against an imitator, with arguments that strictly followed the logic of eighteenth-century 'ars poeticas':

> An examination of the description of the complainant's dance, as filed for copyright, shows that the end sought for and accomplished was solely the devising of a series of graceful movements, combined with an attractive arrangement of drapery, lights, and shadows, telling no story, portraying no character, depicting no emotion. The merely mechanical movements by which effects are produced on the stage are not subjects of copyright where they convey no ideas whose arrangement makes up a dramatic composition. Surely, those described and practiced here convey, and were devised to convey, to the spectator no other idea than that a comely woman is illustrating the poetry of motion in a singularly graceful fashion. Such an idea may be pleasing, but it can hardly be called dramatic.[18]

That says it all: the border between the pleasant and the beautiful that sets the pleasure of aroused sensations against the consistency of a realized idea; the identification of art with the development of a story, the painting of characters, and the expression of feelings. This juridical argumentation precisely corresponds to a poetic code – the one belonging to the representative regime of the arts. And it sheds light on Mallarmé's formula that makes the dancer 'the representative of the idea on stage', thus the representative of a new idea of the idea. It also sheds light on the meaning of the 'axiom', which he had opposed, seven years earlier, to choreographies that told the story of the fairy Viviane or the fable of the *Two Pigeons*, as if in anticipation of the performance that would come to validate it:

18 'Fuller v. Bemis', p. 929.

Namely, that *the dancer is not a woman dancing*, for these juxtaposed reasons: that *she is not a woman*, but a metaphor summing up one of the elementary aspects of our form: knife, goblet, flower, etc., and that *she is not dancing*, but suggesting through the miracle of bends and leaps, a kind of corporal writing, what it would take pages of prose, dialogue and description to express ... [19]

Everything transpires as if Mallarmé were responding in advance to the aesthetic arguments of the American judicial system. The latter sees a comely woman making graceful gestures and concludes that there is no 'dramatic composition'. Mallarmé objects that we are not dealing with a woman making graceful gestures, but with a figure: a body that institutes the place of its becoming metaphorical, its fragmentation into a play of metaphoric forms. It is at this cost that Loïe Fuller's dance is not only an art, but an illustration of a new paradigm of art: it is not a dance anymore, but the performance of an unknown art, or rather a new idea of art: a writing of forms determining the very space of its manifestation. This is the art that Mallarmé wants to fix on the written page instead of expressing the feelings of 'ladies and gentlemen'. Awaiting this 'repatriation' onto the surface of the text, Loïe Fuller symbolizes its potential on stage. Camille Mauclair summed it up a few years later in speaking about her performance in the theatre designed for the 1900 Universal Exposition:

Yes, here we truly have a performance freed from all known aesthetic forms, uniting and destroying them together, and defying all qualification. There is neither a play, nor a song, nor a dance, but there is Art, unnamed, giving the soul, intelligence, and the senses the enjoyment that results from a homogenous and complete place where truth and dream, shadow and light unite to move us in an admirable mixture, at once logical and natural. [20]

Mauclair's text is more precise than its pompous language suggests. The Loïe Fuller event actually concerns Art as the general regime of the arts, and not dance as a particular art. We know the ambiguous

19 Mallarmé, 'Ballets', p. 171; 'Ballets' in *Divagations*, transl. Johnson, p. 130.

20 Camille Mauclair, 'Un exemple de fusion des arts. Sada Yacco et Loïe Fuller', in *Idées vivantes* (Paris: Librairie de l'art ancien et moderne, 1904), pp. 106–7.

place that the creator of the dance of light occupies in genealogies of modern dance. We can certainly say that she inaugurated the path for its reformers. Not only did she give Isadora Duncan the occasion for her first success. On a deeper level, she signalled a break by dismissing stories and sets, by fragmenting the dancing body, redistributing its forces and making it engender forms outside of itself. She thus participated in the rupture through which the new art of dance dismisses the representative art of ballet, which subordinated the force of the body to the illustration of stories. She was a pioneer in a greater undertaking of which 'modern dance' was an autonomous shard: the quest for an art of the body in action that exceeds the classic division of the arts into plastic arts – meant to produce images of bodies – and theatrical art, placing the body at the service of a text to be interpreted. It is within this configuration that the art of Isadora Duncan, aiming to reinvent the authenticity of Greek dance imagined from figures on antique vases and statues, or Mary Wigman's attempt to unleash unconscious, still unsuspected forces of the body, between hymns to the sun and dances of witches or the dead, would be inscribed. But it was not out of mere ingratitude that Isadora Duncan denied any debt towards her. In some sense, Loïe Fuller's art sets itself apart from, if not against, the great exploration of the expressive possibilities of all the body parts from which 'modern dance' is born. Even if Isadora Duncan referred primarily to Greek figures and Whitmanian inspiration, her dance belonged to the great revolution of the system of expression which François Delsarte's disciples brought to the United States, following him in affirming the singular role of 'every little movement' executed by each body part within the great triad of the soul, the mind, and life, materialized in the relations of cohesion and independence between the torso, the head and limbs.[21] No matter what great dramaturgies and mythologies it developed, Mary Wigman's art was first trained

21 *Every Little Movement* (Brooklyn: Dance Horizons, 1968) was the title of a volume by one of the great American disciples of Delsarte and one of the great pioneers of new dance in the United States, Ted Shawn. Delsarte's teaching was systematized by Genevieve Stebbins in *Delsarte System of Expression*, published in 1902. Concerning the development of Delsartism in the United States, see also Nancy Lee Chalfa Ruyter, *The Cultivation of Body and Mind in Nineteenth-Century American Delsartism* (Westport: Greenwood Press, 1999).

in Hellerau, at the school of 'eurhythmics' through which Émile Jacques-Dalcroze sought to train bodies capable of making their own vital rhythm coincide with rhythms invented by musicians. It is within this double lineage, attached to the manifestation of total expression or primordial rhythm, that the modern art of dance affirms its autonomy, even if it involves settling into the tension of this autonomy that signifies both the autonomization of body parts and their particular movements, and the holistic affirmation of a global energy of bodies in movement, eventually identifiable with the forces of the Soviet revolution (Duncan) or the regenerated German people (Wigman). Loïe Fuller remained at a distance from this tension: she did not propose a grammar of bodily movements, nor the expression of the body's primordial rhythm. Her veil functions unlike Isadora's. It does not reveal the body; it renders it 'unlocatable'.[22] It does not express inner energy; it makes it an instrument fit to draw forms in space through movement, forms that the painter's brush left on the canvas in two dimensions and the sculptor's knife fixed in immobile volumes.

Yet it did not suffice for Loïe Fuller to propose new bodily gestures; rather, she sought to remodel all the elements of performance: staging, lighting, even the architecture of the place. What she proposes is thus not a form of the art of movement as 'an independent power creating states of mind frequently stronger than man's will', celebrated by Laban.[23] Rather, it is a formula for Art Nouveau as such. It is no accident that the show Mauclair comments on takes place in a theatre specially designed for it, in the context of a Universal Exposition of the Arts and Industry, a theatre whose very architecture evokes Loïe's flight of veils. It is no accident either that this very flight is reproduced infinitely – not only on posters and drawings by Chéret and Toulouse-Lautrec in Paris, or Koloman Moser in Vienna, but also on many Art Nouveau statuettes, lamps or pottery, before the young art of cinema took Iris's scarf as its emblem, with Abel Gance. It is not simply a matter of the late nineteenth century's infatuation with curved lines and flowers – that eventually proved poisonous. 'Serpentine dance' is not enclosed within Belle Époque imagery. It still figures in a futurist 'visual poem' in 1914 by Severini, where the mixture of

22 Rodenbach, 'Dancers'.
23 Laban, *Modern Educative Dance*, p. 6.

curves and words no longer invokes flower chalices but machine disks and helices. The new art symbolized by serpentine dance is more than a temporary decorative style. Rather, this temporary decorative style is itself a particular form of a much larger idea of Art Nouveau.

Mauclair says what is essential: new art is first an art of the indistinction of the arts – an art of their fusion, as it were. But this art does not combine the resources of the poem, the symphony, plastic arts and choreography. If it is capable of presenting a 'homogenous and complete place', it is, on the contrary, because it negates the supposed specificities of material and processes, because it presents itself as the display of potentials and forms anterior to these specifications. Before dance, there is movement; before painting, gesture and light; before the poem, the tracing of signs and forms: world-gestures, world-patterns. The new art, symbolized by Loïe Fuller's dance, captures the common potential of these patterns through its artifices.

Such was the dream begun by romanticism, and that Mallarmé's contemporary sages – Mockel, Wyzewa and a few others – tried to systematize following Schelling, Coleridge or Emerson: that art, instead of imitating objects of physical nature or the passions of human nature, focuses on following its own potential, which is captured in the Greek notion of *physis*: its pure potential to produce and disappear in its production. This is nature's ideality that the new art wants to materialize in its simplified forms: in the graphic tracing of a poem, the silence of a dialogue, a bursting surface, the movement of a statuette, or the floral decorations of a piece of furniture. Loïe's dance offers its exemplary formula, for the ideality of movement is not hampered either by conventional meanings that spoof the words of the poem, nor by the resistant materiality of wood or bronze. It is pure artifice, a pure encounter between nature and technique – nature unburdened of all the earthly or psychological heavy-handedness that this word can carry; a technique relieved of any associations with the blast furnaces and voracious machines that the notion might invoke. The two converged during these years in the encounter between movement and light. Fuller's art established itself precisely at the point where the helicoidal movement of a body espouses the use of analogical forms with iridescent surfaces intercepting electric light. But she was not content to capture this

marriage in a movement. She constructed the global space of this movement at the same time.

The intoxication of art and industrial accomplishment: the former cannot go without the latter. Loïe Fuller is the artist per se, the artist who makes her body into a means for inventing forms. But she is also indissolubly the inventor who, in the margins of her performances, files patents for inventions that extend, amplify and multiply this invention of forms: the armature of a dress, the stage lighting from below, or the mirror device. The intoxication of art is nature – the passage of the night into forms and the return of forms to the night – recreated by pure artifice. The means of artifice is electric light; more exactly, it is active lighting, the creative lighting of coloured projectors in contrast with traditional lighting, which merely shows an art performance still external to it. Mallarmé did not seem to perceive all its implications. His friend Villiers de L'Isle-Adam, however, made Edison the inventor of a new form of ideality. But it was another admirer of the dancer, Jean Lorrain, who celebrated the meeting of the fantastic and electricity in her art:

> This animated Pompeian fresco, these poses of flower- and butterfly woman already seen on ancient bas-reliefs, yet suddenly resurging from the depth of the ages through artistic will, they were sent to us by America, the 'New World,' the world of telephones, mechanics, and the phonograph, that delegated the 'Old' one this chimerical vision of the world of long ago and beyond, this luminous and spectral female flute player, drawn from the ashes of oblivion by some Edgar Allan Poe crossed with Edison.[24]

Mallarmé, on the other hand, did not lend a great deal of attention to electrical ideality. The veil counted for him more than the light that lit it up. The flight of lace, the 'nudity' of a lock of hair, the 'flame' of a ruby, the 'brilliance' of a console, the facets of a theatre chandelier, the golden mirror frames – all are already the artifices that are substituted for the light of the hidden sun. The virtue of these artifices is that they are limited to their analogical function. But with electricity, analogy becomes immediate fusion. And Mallarmé was resistant to everything that absorbs the potential

24 Jean Lorrain, 'Loïe Fuller', in *Femmes de 1900* (Paris: Éditions de la Madeleine, 1932), pp. 60–1.

of duality, of crafted objects that rhyme with the play of natural forms. And yet, it is electricity that presents itself as the perfect identity between natural energy and artifice. If Villiers imagined a poet Edison, sculpting the model of new beauty, Loïe Fuller went to consult the inventor and attempted to display the aesthetic potential of the electric arc on stage. Electricity was suited to realize the new 'intoxication of art' because it is both the natural force of artifice and the artificial force of nature. On stage, the light rays shaped the deployed veils into stars; they glowed the colours of the rainbow or set them ablaze, completing the disappearance of the body in the whirlwind of forms. In this sense, they became the props of her performance. But they were equally the force that made forms emerge from the night, before disappearing again in order to swallow them once more. Electricity is the technical analogue of light that manifests everything. But it is also the force that makes everything disappear in the pure immaterial play of luminous forms. It is the spiritual form of matter, or the material form of spirituality.

This equivalence lay at the heart of a new dream. The autonomous art that dreamt itself, between the written page, the symphonic score, the theatre of shadows, pantomime, and luminous dance, but also between the optical mixture of colours, the vibration of touch, and the enclosed space of painting – one that would soon be dreamt in between staging, photography and cinema, was not what posterity would fix as doctrine – the resistant work, well installed in the exhibition of its materiality. It was something entirely different: art that denies any specificity of matter and identifies itself with the display of a pure act, entirely material in some sense, for it consists in the assemblage of bodily forms supported by everything that technique can invent; but also entirely spiritual, because it only wants to retain the bodily potential to create a sensible milieu, and because it only exists during a manifestation devoted to its own disappearance. This new art is also the art of the age in which the intoxication of art and industrial accomplishment can be espoused together, because art affirms itself as the pure production of world-events, while industrial novelty is identified with the immateriality of electric current, machines that X-ray bodies, or ones that fix shadows, that enclose the symphony in wax grooves or invent dream automata. Art Nouveau is art that wants to anticipate a society where spirit will become entirely material while matter

will be fully converted into spirit. 'The stage is freed for any fiction, cleared and instated by the play of a veil with attitudes and gestures'; this 'very pure result'[25] is far more than a rendezvous for aesthetes. It is the stage of a new world where art and science come together, where the sensible milieu of existence and the form of community obey one and the same principle.

25 Mallarmé, 'Autre étude de danse', pp. 174–6; 'Another Study of Dance: The Fundamentals of Ballet', in *Divagations*, transl. Johnson, pp. 136–7.

7. The Immobile Theatre

Paris, 1894–95

The Master Builder is a drama almost without action. I mean that it is devoid, or almost devoid, of psychological action. And this is one of the reasons why I find it admirable.

The Master Builder is one of the first among modern dramas which presents to us the gravity and the tragic secret of ordinary and immobile life. Almost all our tragic authors see only the life of olden times ... When I go to the theatre it seems to me that I am for a few hours again among my ancestors who had a conception of life which was simple, dry and brutal, which I hardly recall, and in which I can no longer take part. I see a cuckold kill his wife, a woman who poisons her lover, a son who avenges his father, a father who sacrifices his children, children who cause the death of their father, murdered kings, raped virgins, imprisoned bourgeois ...

I had come in the hope of seeing something of life attached to its sources and to its mysteries by links that I have neither the occasion nor the strength to perceive every day. I had come in the hope of glimpsing for a moment the beauty, the grandeur, and the gravity of my humble quotidian existence. I hoped that there would be shown to me, I know not what presence, what power, or what god, who lives with me in my bedroom. I expected unknown minutes that I had seen without recognizing them during my most miserable hours, and I have most often discovered only a man who explains at length why he is jealous and why he poisons or kills.

I admire Othello, but he does not seem to me to live the august everyday life of a Hamlet, who has the time to live because he does not act. Othello is admirably jealous. But isn't it an old mistake to

think that it is in the moments when such a passion and others of a similar violence take possession of us that we really live? At times it has occurred to me that an old man seated in his armchair, simply waiting under the lamp, listening, without knowing it, to all the eternal laws which reign around his house, interpreting without understanding what there is in the silence of the doors and of the windows and in the small voice of the light, subjected to the presence of his soul and of his destiny, inclining his head a little without suspecting that all the powers of this world intervene in the bedroom, like attentive servants, ignoring that the sun itself sustains above an abyss the little table on which his elbow rests, and that there is not a star in the sky nor a force in the mind indifferent to the movement of an eyelid which closes or a thought which rises – at times, it has occurred to me this immobile old man lived in reality a life more profound, more human, and more general than the lover who strangles his mistress, the captain who wins a victory or the husband who avenges his honour …

Hilde and Solness are, I think, the first heroes who feel they are living, for an instant, in the atmosphere of the soul, and this essential life which they have discovered in themselves beyond their ordinary life, frightens them. Hilde and Solness are two souls who have glimpsed their situation in true life.[1]

These lines are taken from an article that appeared in the 'Premier Paris' section of *Le Figaro* on 2 April 1894, signed Maurice Maeterlinck. They were meant to accompany the premiere of Ibsen's *The Master Builder*, at the Théâtre de l'Oeuvre the next evening, directed by a young actor named Lugné-Poe, with a set designed by a young painter named Édouard Vuillard. Lugné-Poe, who produced two other Ibsen plays that very year, had staged the French premiere of *Pelléas and Mélisande* a year earlier. But Maeterlinck's

1 Maurice Maeterlinck, 'À propos de *Solness le constructeur*', *Le Figaro*, 2 April 1894. This article was included in the collection edited by S. Gross, *Introduction à la psychologie des songes et autres écrits, 1886–1996* (Brussels: Editions Labor, 1985), p. 96–102. Maeterlinck republished a slightly modified version with the title 'Le tragique quotidien' in his 1896 collection *Le Trésor des Humbles* (Brussels: Editions Labor, 1986), pp. 101–10; 'The Tragical in Daily Life', in *The Treasure of the Humble*, transl. A. Sutro (New York: Dodd, Mead & Co., 1913), pp. 95–120. An anonymous English translation of the column also appeared as 'Maeterlinck on the Drama with Ibsen's *Master Builder* as his Text', *New York Times*, 13 May 1894.

article is much more than the payment for a debt owed to his director. It is the manifesto for a new theatre: not a new school of dramatic literature, but a new idea of theatre.

The text sums up this idea in three words: theatre without action. What exactly does that mean? The word action first evokes movement on stage: spectacular feats, the actors' gestures, and the exaggerated expression of feelings. It also evokes the excessive plots that try to stage warlike violence and family dramas, unbridled passion and the tumult of busy life. The columnist opposes this to immobile drama: without any movement on stage or any plot twists. The critic's target and the meaning of the demand seem clear at first. The theatre of the soul that Maeterlinck calls for and that Lugné-Poe intends to promote can be situated within the larger anti-naturalist reaction, which had occupied the forefront of the literary and artistic scene for a few years. The Théâtre de l'Oeuvre was created to respond to Antoine's Théâtre Libre. The latter wanted dramas drawn from contemporary society, acting that imitated the conversation and gestures of everyday life, and a faithful reconstruction of its setting. Antoine was the first to introduce Ibsen on the French stage, following Zola's advice, in a staging of *Ghosts*, a play about heredity that echoed the project of the *Rougon-Macquart* cycle, then *The Wild Duck*. By presenting *Rosmersholm, An Enemy of the People*, and *The Master Builder* in the same year, Lugné-Poe aimed to rescue Ibsen from the naturalist enemy in order to make him the champion of symbolist drama.

But the operation remained problematic. How is one supposed to enlist an author under the banner of antirealism when he writes family dramas combined with dark stories of local bankruptcies, land speculation, fraud, water pollution, the construction of villas, or the management of nursing homes? How is one meant to do this, moreover, when the writer has furnished his plays with stage directions minutely describing the stage scenery and the clothing of his characters, including the decoration of the stoves, the colour of their ties and the glasses of sugar water placed on side tables? Is not this a misunderstanding created by artists who do not know the Norwegian language and the cultural context of Ibsen's plays? Or rather deliberate violence towards the author's intentions? For *The Master Builder*, as for his other stagings of Ibsen, Lugné-Poe imposed scenery with little depth – forcing his actors to project

themselves towards the front of the stage – dim lighting, hieratic gestures, and singing diction. The Parisian Ibsenites, mocked by the critics who described them as young aesthetes with 'Botticelli' hairstyles, savoured the mysterious atmosphere with which they naturally associated the land of fjords and trolls. The partisans of tradition ridiculed these performances whose solemn diction, dark stages and fervent, convinced audiences had already transformed into religious services. They soon received the indirect support of orthodox Ibsenites, who affirmed that there was no mystery in these plays and that they must be performed in the regular tone of conversation, renouncing the monotonous chant imposed by Lugné-Poe and the gestures rising towards the heavens to draw imaginary gothic lancet arches.

However, Lugné-Poe and Maeterlinck's bias is more than the naivety of newcomers or a violent, militant takeover. The music of the soul under the lamp and the tragedy of doors and windows can seem far from Ibsen's precise dialogue and minute stage directions. But this silent music, this minimal scenery and this 'little voice of light' indeed define a transformation in the economy of the dramatic poem and theatrical spectacle. And it is no arbitrary decision to crown Ibsen for this reason. He opposed his own down-to-earth intentions to symbolist interpretations. But what are declarations of intention worth from an author whose characters and plots precisely marked the limits of the old causal logic that deduced actions from intentions? If we can seek unknown music in Ibsen's dialogue and conceive of the stage as a space for this music, it is because this quest for the text's music expresses a break with the traditional model of theatrical action to which Ibsen's plays, however 'realist' their subjects might be, bear exemplary witness.

In order to understand this, one must go a little further into what action or the absence of action might signify. External and realist action is usually contrasted with inner action, the fine analysis of nuances, complications of feelings, and their interactions. At the time, a word designating this inner action imposed itself: 'psychology'. Yet, this is not what drama 'without action' means. Maeterlinck emphasized this immediately: it is not a matter of returning action to the domain of introspection and the minute analysis of feelings. *The Master Builder* is admirable for its absence of psychological action. The inner drama does not consist of tormented consciences

and uncertain feelings expressed in well-honed dialogue. It consists of silent sensations through which any individual whatsoever experiences the silent action of the world. Moreover, the refusal of realist vulgarity generally implies the choice of an exceptional universe, like the universe of rare plants, refined perfumes and decadent Latin literature where Huysmans made the hero of *A Rebours* (*Against Nature*) live. Maeterlinck too objects to this equation. Immobile drama is the drama of ordinary life. The voices of the soul that he wants to rouse do not express themselves in sublime phrases. To those who saw poetic artifice in the repetitions that punctuate the dialogues of his plays, he replied that he simply drew inspiration from the way Flemish peasants spoke. And the voices of the soul do not require the homes of aesthetes as their setting. They make themselves heard in the silence of doors and windows and the little voice of light in any bedroom whatsoever. For him the new theatre must copy the new painting, which set aside the luxuries of history painting to represent 'a house lost in the countryside, an open door at the end of a corridor, a face or hands at rest'.[2]

The reference to painting is essential here: immobile tragic drama is an interiorized one, but this interiority only shows through non-human sensible elements – an armchair, a lamp, a door, windows. Much more than mere furniture, these terms define a relation between silence and noise, movement and immobility, light and darkness, interior and exterior. The more drama is interior, the more it needs to find its analogy in a tone, attitudes, a scansion of time, and a configuration of space that are its own. The classic dramatic poem unfolded on the theatre *stage*. The new drama would increasingly tend to fuse its sensible reality with the material reality of the stage, to bestow light with the force of the drama that it lit, lending the arrangement of doors and windows the dramatic intensity that used to be entrusted to the characters that crossed their threshold to bring messages from the outside. Maeterlinck's plays bear witness to this. The main character in *Interior* is the window through which two observers look in on the gestures of a family, under the lamp, still ignorant of the news that the onlookers already know: the suicide of one of their daughters. The main character in *The Death*

2 Maeterlinck, 'À propos de *Solness le constructeur*'.

of Tintagiles is the door behind which death is lurking, waiting for the child.

The new theatre thus revokes the old logic of theatrical action, whose formula Aristotle had provided, in two opposing ways. The essence of the dramatic poem, he had said, is the plot, the skilful chain of actions that are determined by each other, creating expectations and producing results that thwart them. The play of reversals moves men, whose high birth makes them interesting, from ignorance to knowledge, from happiness to misfortune, or from friendship to enmity. This is the system of action, the causal machine, to which the development of characters and the expression of their thoughts are subordinated. This is what defines the intellectual nature of the tragic poem and commands its sensible effect. The primacy of action thus defines both the thought content of tragedy and the sensible tissue through which it manifests itself. This is the causal machinery of the plot that must make the spectator shudder, says Aristotle. But it is not different from the one that makes the reader shudder. The spectacle, the *opsis*, he concludes, is the least important element of tragedy, the most foreign to art. It is a task for the prop master, not the poet.

The *action* Maeterlinck rejects is precisely this relation between thought and its mode of sensible appearance. Thought, for Aristotle, makes itself sensible through emotions produced by a certain chain of causes. It does so through expectation, surprise and terror. The age of Louis XIV grafted another causality onto the causal framework of action – one of character and expression. It shaped the conflict of characters, ambitions and feelings that lends interest to the unfolding dramatic plot. It also fixed the way that signs, tones, gestures and attitudes demonstrate some character, some thought or some feeling. The theatre of action is a determined mode of manifesting the interior in the exterior, of the subjection of the visible spectacle to thought's own visibility. A logic of feelings and situations is translated into words whose meaning is made explicit and effect increased through a system of intonations, physiognomies and attitudes. The age of Diderot rebelled against classic convention, but it finally reinforced this logic by ordering every gesture and every attitude to be the legible signs of a thought or an emotion. The 'immobile' theatre promoted by Maeterlinck aimed, on the contrary, to paralyze this regime of sensible appearance of thought through

a system of correspondences. If it refutes the mechanics of the plot, it is not in order to privilege the expression of emotional interiority, for the latter still belongs to the same regime. Expressions that sensibly translate movements in thought and nuance of feeling must be replaced by the direct relation between the forces of the soul and a certain number of material elements: the partitions among which individual lives are played out, the light that illuminates them, the doors and windows through which an individual senses the vibrations of the world coming towards it. Thought, then, is no longer the interiority of the subject. It is the law of the exterior that besieges this little life, knocking on its doors and looking through its windows. And the speech that suits this thought is one of sensation, which registers the shock and makes the impersonal soul of the world vibrate in an individual life.

The Master Builder illustrates this new notion of the tragic. The plot certainly has all the appearances of a bourgeois drama, intertwining sentimental conflicts and professional rivalries. The aging architect suffers both the sorrow of a household secretly undone by the fire that killed his two children, and rivalry from young men ready to compete with him. But it is in another form that youth comes to destroy him, in the person of a young girl, Hilde. Not content to upset the matrimonial hearth, she forces Solness to repeat the feat he had accomplished before her eyes as a child, climbing up once again, despite his vertigo, to attach a garland on the tower of his latest building. To be sure, Ibsen had also visualized the scenery and the characters in advance to make them suit the representation of an architect from a small provincial town, his household, and his employees. To locate the model of drama without action here, one must look further in the text for what contradicts the apparent realism of the plot and its staging. Further along this path, one must avoid the false trail, taken by Ibsen's French translator, of transforming dramatic events into so many symbols: the old master builder haunted by the memory of the home that burns down with his children would be Ibsen who has sapped his national traditions; the churches Solness built in his youth are the philosophical dramas where he announced the advent of a new human reign; the family homes to which he devoted himself later, his humanitarian dramas; the young Hilde who pushes him to redo the feat that had astonished the young girl at the cost of his life, the exhilarating and

dangerous power of the imagination.[3] Maeterlinck makes it clear that this is not what matters. Symbolism is not the use of symbols. This use is as old as poetry. And it is entirely included in the old regime of relations between the proper and the figurative, between sense and its sensible appearance. Symbolism, on the contrary, means the upheaval of these relations. What justifies choosing *The Master Builder* as an example of the new drama is not the 'allegorical auto-biography' of the poet, whom young people hold accountable for his old promises of new life. Rather, it is exemplary in its break with the causal system implied by a chain of events and the logic of characters distinct to the theatrical tradition. This is the very core of the drama in *The Master Builder*. In the middle of the prosaic worries of a pro-vincial entrepreneur, surrounded by rivalries and the sadness of his secretly undone household, the meeting between Solness and little Hilde introduces a radically deviant causality. The man who cynically exploited the talent of others sets out seeking death for one reason alone: the reappearance of the thrilled young girl in whose eyes he had once glimpsed his grandeur for a brief instant, and who reminds him of his promise to give her a kingdom. *The Master Builder* is a 'somnambulist drama' that stages the 'powers of the outside', these powers which the hero says must be obeyed, willingly or unwillingly.

Thus an essential relation between a causal system and an economy of visibility comes undone. The drama contrasts the Aristotelian logic of the chain of action and the passage from igno-rance to knowledge with the pure effect of an encounter with the unknown. But this encounter is not a matter of metaphysical revela-tion; it can be summarized in the relation between two gazes alone. The Aristotelian devaluation of spectacle, and the realist overload of ties and pitchers, is opposed to this gaze shared between a child and an adult that leads Solness to the summit of the tower where the fall awaits. This is the extent to which Ibsen's bourgeois drama shares the 'the august everyday life' distinct to Hamlet, 'who has the time to live because he does not act': the story of a man led to death by the gaze of a little girl is close to the tragedy of the one whom Mallarmé called a few years earlier 'our adolescent self, who vanished at the beginnings of life'.[4]

3 See the preface by Count Prozor to the translation, *Solness le constructeur* (Paris: A. Savine, 1893).

4 Stéphane Mallarmé, 'Hamlet', *Divagations* in *Oeuvres complètes*,

But this exchange of glances that overthrows the relations between cause and effect, interior and exterior, only actually exists in Hilde's words. The sensible space of this gaze, which only takes place in the text, has to be constructed. It is clearly not a question of mimicry. The new drama is above all another use of speech: it must no longer comment on the action. Nor does it have to express the motives for jealousy or revenge, but only the weight of these outside forces that make individuals act beyond all rationality of calculated means and ends. The new economy of speech must be given its own visibility, lending form to the sensible presence of thought. The stage must manifest the visibility that is latent in the music of exchanged words, and not the old-fashioned kind playing in Ibsen's head as he imagined his characters' old-fashioned living rooms and their clothing.

Lugné-Poe attempted to do so with the help of painters, like Maurice Denis, who proclaimed that painting was first a harmony of colour palettes on a two-dimensional surface, or like Édouard Vuillard, who used to absorb the volume of the characters into the wallpaper. It was under the foliage of the set designed by the latter that he crushed the actors, cramped on an inclined springboard, contemplating Solness's fall. The compression of space, the chanting readings, and the hieratic gestures were taken by the critics as simple effects meant to hijack the realist drama in order to promote 'symbolism'. And yet, this conversion of one space into another is not merely a circumstantial operation. It is the very distinction of the new aesthetic, since Winckelmann reinvented ancient Greece and Hegel showed Dutch freedom – modern freedom – in kitchen equipment or the vulgarity of a tavern scene. *Aisthesis* loses its simplicity in the aesthetic age, when the noise of speech and the deploying of the visible are no longer governed by expressive codes transcribing the majesty of conditions, deliberations of thought, or nuances of feelings in unequivocal sensible signs. According to Hegel, there are two sensible spaces in Dutch genre painting: the representation of furniture or fabrics that indicate a kind of life, and the play of light that expresses profound life incarnated in this 'kind of life'. This doubling of the pictorial surface now reaches the theatre stage: there is the representation of an interior belonging to

vol. II, p. 166. Mallarmé's text was published in 1886 in the *Revue indépendante*; 'Hamlet', in *Divagations*, transl. Johnson, p. 124.

a prominent resident of a small Norwegian village, and there is the stage manifesting the dark forces of the soul that come to derail the path leading this prominent man towards the goal of his career. But this doubling can be understood in two ways, implying two opposing ideas about the future of drama. One could see it as the onstage call of a power that exceeds it. This is the conclusion that Ibsen's most incisive reader – Andrei Bely – would draw. Ibsen's theatre is indeed symbolist, he said, because behind the logic of unfurling images, it illuminates the logic of the development of experiences that exceeds it. The movement leading the architect Solness to the top of the tower, or the sculptor Rubek into the glaciers and avalanches, announces another force that leads us out of the theatre, passing from artistic creation to man's self-creation in real life.[5] But one can also see discordance in this duality that calls for further innovation in order to lend the latent music of the drama its corresponding sensible reality. This will be the very principle of the art called *mise en scène* or 'staging': to give the music of obscure forces its sensible appearance on stage, to make the silent dialogue that inhabits explicit dialogue audible in modulations and suspensions of speech, to give the scene of the meeting with the Unknown its visible form, its space, its light, its attitudes, and its displacements.

This necessity of giving dramatic music its own space was theorized in a brochure that was published discreetly in Paris nine months after *The Master Builder* was staged. Its author was Adolphe Appia, and it was titled *Staging Wagnerian Drama*. This short text is perhaps the first manifesto of this new art called *mise en scène*. It is worth noting the meaning of this novelty. Surely, scenographic work and the use of machines is as old as theatre itself. And even the term *mise en scène* entered common use in the course of the nineteenth century. Yet it clearly designated a secondary art. In 1885, the author of the *Dictionnaire historique et pittoresque du théâtre* ('Historical and Illustrated Dictionary of Theatre') defined it as follows:

> *Mise en scène* is the art of regulating staged action, considered from every angle, and all aspects, not only dealing with the isolated and combined movements of each one of the characters working

5 Andrei Bely, 'Theatre and Modern Drama', transl. Laurence Senelik, in *Russian Dramatic Theory from Pushkin to the Soviets: An Anthology* (Austin: University of Texas Press, 1981), pp. 158–60.

together to perform the work, nor only the evolution of masses: groups, marches, processions, battles, and so forth, but also everything involved in harmonizing these movements, these changes with the whole and the details of the stage set, furnishings, costumes and props.[6]

Mise en scène thus defines a technique of performance: an extension of the art of the 'prop master' that Aristotle excluded from dramatic art strictly speaking. In the romantic period, the partisans of dramatic purity rose up readily against these invasions, like Léon Halévy denouncing the sumptuous stage sets executed by Cicéri for the Comédie-Française at Baron Taylor's demand:

> En muse du décor travestis Melpomène
> Pour toi la tragédie est de la mise en scène ...
> Du Théâtre-Français, ne fais plus une optique
> Le théâtre est un temple et non une boutique.[7]

The 'boutique' is characterized by an accumulation of superfluous things. Halévy's polemic underscores a conception shared both by partisans and critics of *mise en scène*: it is a technical addition, a supplementary visibility lent to the expressive system of drama by the artisans of the theatre. This logic is reversed when *mise en scène* becomes an art: the new Art's work, first of all, is one of subtraction. However, it is not a matter of reducing the technical means of the stage to the expressivity of the text alone. Instead the division at the heart of this expressivity must be carried over, the visual mode through which the author himself imagined the mimicry of his drama must be set aside, in order to locate the principle of another causal regime within the text, another form of efficiency in speech, a mode of expression breaking established expressive codes. This is the specific regime of causality for which an adequate time

6 Arthur Pougin, *Dictionnaire historique et pittoresque du théâtre* (Paris: Firmin-Didot, 1885), p. 522.

7 'Disguise Melpomene as the muse of scenery / For you tragedy is *mise en scène* ... / Of the *Théâtre Français*, make an optics no more / Theatre is a temple not a store.' Léon Halévy, *Le Théâtre-Français, épître-satire à M. le baron Taylor* (Paris, 1828), p. 18; quoted in Marie-Antoinette Allevy, *La Mise en scène en France dans la première moitié du XIXe siècle* (Geneva: Slatkine Reprints, 1976), p. 87.

and space must be constructed. Lugné-Poe did so by setting aside Ibsen's stage directions, in order to give a stage equivalent to the music of outside forces that take hold of Hilde and Solness. Appia decided to apply it systematically to Wagnerian musical drama. He wanted to rid the Wagnerian stage of painted sets, meant to show us Mime's forge, Hunding's home, Siegfried's forest, or Gunther's palace. He wanted to eliminate the expressive gestures meant to make us feel the rapture of the lovers Siegmund and Sieglinde, the wrath of Hunding the cuckold husband, or Wotan's inner torment upon condemning his daughter Brunhilde, in order to construct the space and the movement on stage demanded by the soul of the drama – that is, music itself.

This, indeed, is the core of Appia's argument. It relies on the Wagnerian theory of drama, but also on Wagner's incapacity to draw out its implications for staging. The Wagnerian idea of drama, developed in 1851 in *Opera and Drama*, relies on a simple principle: it concerns the passage from a language of imagination to one of sensible reality. The old drama relied on the power of ordinary language to realize its thought, the same language used to communicate, describe, compare or explain. It translated the poet's intention into dialogues that commented on the action and expressed feelings. By contrast, it is not enough for the new drama to signify a reality and describe an action. It is action that directly presents this reality to the senses in the language of the senses. The poet's intention must no longer be articulated only in the language of words, used by the understanding to distinguish its objects and by the will to formulate its goals. To become a sensible reality in action, the poet's thought and the language of words must be redeemed from their separate, 'egotistical' condition. They are redeemed in their encounter with the language of sounds, which is the expression of unconscious thought, 'the primal organ-of-utterance of the inner man'.[8] This assumes that this language itself emerges from the solitude in which its very progress threatens to imprison it. Instrumental music in the age of Haydn, Mozart and Beethoven freed itself from playing an auxiliary function to the language of words and being the expressive complement to feelings they described. It explored all the richness of its own harmonic language. But this autonomy

8 Richard Wagner, *Opera and Drama*, transl. W. Ashton Ellis (Lincoln, NE, and London: University of Nebraska Press, 1995), p. 224.

only makes sense if it allows a new encounter between the power of thinking put into words and the power of the sensible fulfilment promised by the harmonic 'ocean'. In order to make its thought a sensible reality, the new poem must realize the union between the spoken language of words that translates the *poet's intention* and the musical language of sounds that translates *the life of the poem itself*, its rootedness in unconscious life, which alone provides origin and fulfilment to conscious intention. Music makes sensible what words try to make visible in vain: the ineffability of sensation, the power of unconscious life. It thus has a vocation to realize itself in plastic form, to found its own visibility. As long as it is not communicated visually, musical drama remains a mutilated art, a 'slave' art that does nothing but want.[9] The destination of art is fulfilled only when will becomes power, when it is entirely realized in a sensible form in which it renounces itself.

For Appia, this vision of art would ground a specific spatialization of musical drama. The life that regulates representation is entirely in the score. It is no less necessary to give it its representative form by manifesting it spatially on stage. And this is where the problem begins. This form cannot be an external addition. It must be strictly prescribed by the content of the musical drama – that is to say, by the unity of musical form and poetic content. The distinction of musical drama is to determine actions not in terms of imitation but in terms of musical duration. Performers no longer draw models of duration from a life to be imitated; music imposes them. But after Wagner, this artifice, which is opposed to ordinary life, no longer concerns vocalizations and *da capo* directions. It is the expression of another life, a life before the conventions of meaningful expression. The 'arbitrary' duration of music is identified with the expressive content of drama. Musical proportion, which merges with dramatic expressivity, must be given its analogue in the visible partition of the scenic space. The construction of this proportion does not rely on any technique. It follows from the work of art and from it alone. It thus rightfully belongs to the dramatist. It is up to him to project the distinct duration that makes the heart of drama into space. Unfortunately, the new dramatist, Richard Wagner, was not

9 Richard Wagner, *The Artwork of the Future and Other Works*, transl. W. Ashton Ellis (Lincoln, NE, and London: University of Nebraska Press, 1993), p. 152.

able to determine this spatial analogy of musical proportion himself. He placed the new expressivity of musical drama in the space of the old spoken drama. He remained faithful to traditional representative means and to painted backgrounds whose mimed reality contradicted the reality of the living body inhabited by the union of speech and sound. For Appia, the reason for this was to be found in the naivety of the Wagnerian conception of painting. Wagner saw modern landscape painting as the terminal point to which evolution had brought pictorial art. Painting participated in the movement that carries all art towards reconciliation with living nature. This movement orders it to abandon the 'egotism' of easel painting to take up its specific role in the total artwork of drama: to make manifest on stage the *'background of Nature* for *living*, no longer counterfeited, *Man*'.[10] According to Appia, this is how the task of giving musical drama its own space is avoided. But perhaps this is not the basic problem. Rather, it is that the notion of the sensible in Wagner consumes those of visibility and space. The union between the male intellectuality of the word and the feminine sentiment belonging to the language of sounds suffices to define the sensible reality of drama. Scenic construction finds itself assigned to its traditional, auxiliary function. Wagner makes the language of sounds mediate between the language of words and that of gestures. The space of the stage, for him, is that of the pantomime, which makes sensible the union of spoken and unspoken thought. But this power of the 'gestures' of thought is already contained in the union of the language of words and the language of sounds. The expressive power of the 'language of gestures' is principally realized by the 'orchestral wave' which carries the boat of verse.[11] The language of sounds already offers the effective spatiality of poetic thought. And when the being of 'flesh and blood' dear to Wagner's first master, Feuerbach, yields his place to the groundlessness of Schopenhauer, this spatiality of the poem becomes invisible by receding into the Bayreuth orchestra pit, leaving the visible stage to traditional forms of set design and the expression of feelings. Directing a performance of *The Ring of*

10 Ibid., p. 181. Appia comments on the formula in 'Musique et mise en scène', in *Œuvres complètes*, vol. II (Lausanne: L'Âge d'homme, 1986), p. 118; B. Hewitt, ed., *Music and the Art of Theatre*, transl. R. W. Corrigan and M. D. Dirks (Florida: University of Miami Press), p. 111.

11 Wagner, *Opera and Drama*, p. 314.

the Nibelung himself in 1876, which became the untouchable Bible for staging Wagnerian drama according to Cosima, the master followed the old logic of representative set design and mimetic expression. One must still wait for the dramaturge of the future capable of giving drama its necessary representative form, making its organic necessity visible on a stage that suits it – one that, like it, should be 'an *opening* on the unknown and the unlimited'.[12]

The task of the stage director is thus to fill this lacuna. One could conclude that *mise en scène* exists as an independent art only in the interregnum that precedes the coming of the new dramatist. But the problem is deeper. Wagner's incapacity to invent the space belonging to his music is perhaps not a circumstantial limit. It refers to the very definition of the new work of art. For in order to determine this organic necessity that alone provides the principle of *mise en scène*, one must be able to distinguish it from the intention that is at the origin of drama. It is necessary that the author be able to forget his idea of the work, which has presided over the choice of musical means, in order to identify his point of view with this work's, which must 'redeem' the original sin of all works: this *intention*, this *will* against which the work's power must be conquered. *Mise en scène* is a paradoxical art from the very beginning. This art relies on the idea of the 'unity of conception' of the work that excludes all external addition. But this conceptual unity, which easily regulated the representative work, has become a contradictory notion in the aesthetic logic in which *conception* is precisely what must disappear for there to be unity. The dramatist must stop 'seeing' his work with the 'eyes of the imagination' that guide gestures and the old stage sets, so that this unity can impose itself, so that another can give this work the spatial unity that flows from its musical unity.

The unity of the work must be split in order to be realized, for another artist to draw from the work 'the guiding principle which, springing as it does from the original intention, inexorably and of necessity dictates the *mise en scène* without being filtered through the will of the dramatist'.[13] The stage director is no longer the regent of the interregnum. He is the second creator who gives the work this

12 Appia, 'Musique et mise en scène', p. 82; Hewitt, *Music and the Art of Theatre*, p. 52.
13 Appia, 'Musique et mise en scène', p. 53; Hewitt, *Music and the Art of Theatre*, p. 17.

full truth that manifests itself in becoming visible. He does so by securing total mastery of the elements of the performance. The first element of this visible event is the singing body. It must be stripped of the illusory royalty of the actor playing parts, to become an organizer of the space of representation of music. The singer no longer has to personify his character, to transmit signs that enable the spectator to imagine his situation and feelings. He must limber up his body, turning it into a dancing body that does not imitate any living scene, but directly translates the life included in the music, vibrating to the rhythm of the orchestral symphony. The 'inanimate painting' must be adapted to the new living body displayed on it. This painting is composed of three elements: the painted stage set, scenery, and lighting. The traditional stage prioritized the first, because painting functioned as the means to signify a place, a situation, or a condition. Now the aim is no longer to signify life, but to accomplish the latent potential of drama. The surface of painted signs must be stripped of its privilege in favour of elements that lend themselves to displaying the drama's intimate movement. These elements are primarily composed of 'practicable props' that configure the stage according to the needs of the singers' movements. The Valkryies' rock was thus no longer designed to limit the space accorded to the singers. Instead it was made of a series of platforms from the summit, close to the sky, where the group stands, and where Wotan would arrive, down to the foreground where Brunhilde chases Sieglinde away, via an intermediary platform where the confrontation between Wotan and his daughter occurs. Thus both the potential of the drama and the music could be deployed.

Light comes next: not, of course, the old lighting of footlights and battens. The latter remains subordinate to mimetic details by allowing spectators to 'clearly see' the set and the action. To give drama its visibility, light must be given primacy over what it illuminates, it must be given a dramatic role, to translate directly what words do not say, and what sounds retain in their own language – the sparks and shadows of drama. The light that intervenes then is active lighting, the lighting of mobile projectors that sculpt the singing body and show what drama does not say, yet that structures it, nonetheless, by separating, for instance, thanks to the play of light and shadows, the god Wotan from the humans whose actions he refuses to direct. Thus the stage no longer reproduces the mimetic details of the story.

It is the artificial space that projectors and practicable props adapt to the performance of bodies that bear the music.

Substituting one sensible element for another, projecting the intimate music of drama into space instead of implanting it with the *mimesis* of feelings and actions – this is the principle of the new art of staging: Appia's projectors and practical props are the technical translation of the 'little voice of light' and the mystery of doors and windows that Maeterlinck evokes. One could say that this translation is far from self-evident. For the silent 'music' of relations between Hilde and Solness, or between Maeterlinck's characters, is only metaphorical music. It is made only of the text's silences; it is, according to Mallarmé's formula, 'what is not said in speech'. For Appia, this silent music of the unsaid precisely lacks what makes staging Wagnerian drama possible – namely, the strictly measured duration that constrains the expression of sounds. It is possible to spatialize the musical arrangement of sounds. Yet how could one spatialize the silence that separates the sentences of Ibsen's dialogue? Appia himself underscores the point: it is only in the work of the poet musician that *mise en scène* becomes a means of expression consubstantial to drama. But we can give a simple response to this apparent aporia: what silences express, in Ibsen or Maeterlinck, is precisely the very essence of musical intensity – that is to say, the potential of impersonal life. Perhaps the silence of spoken drama does not have its own temporal measure. Yet it is equivalent to the measured duration of musical drama, because it too can be strictly defined as 'what is not said in speech', what destroys the signifying organization of speech that comments on action and indicates feelings. Music is primarily the revocation of the 'life' that enclosed this signifying organization of causal relations and expressive forms. Ibsen's spoken drama and Wagner's musical drama carry out this revocation similarly. Solness, climbing to the summit of the tower where a fall awaits him, under Hilde's ecstatic gaze, provides the prosaic version of the god Wotan who lets another youth, Siegfried, unleash the forces that lead to the collapse of Valhalla. Both accomplish the essence of music, which is the renunciation of action, the renunciation of personal life.

This is what Appia allows us to see when he moves from theory to its illustration and presents readers with the principles of staging *The Ring of the Nibelung*. In his notebooks, he had already defined

the movements and lighting for each scene, which could translate the inflections of the musical poem. But all this spatial staging of music is reduced in his text to one principle alone: the transformation of action into inaction. *Mise en scène* does not find unity through the properties of Wagnerian composition, but in the destiny of the central character of the drama, Wotan. 'What makes up the essence of the drama, is that the events provoked by the God turn out to be in conflict with the inner purpose of his activity ... '[14] This 'contradiction' may remind us of the scheme of paradoxical causality at the heart of the Aristotelian theory of tragedy. But the similarity is misleading. For Aristotle, the reversal of effects against intentions translated the finitude of a human creature ignorant of the divine order. In the dramaturgy of *The Ring of the Nibelung*, as analyzed by Appia, it takes the form of the fulfilment of divine will itself. Thus the result of the process can no longer be reduced to the punishment of the imprudent. It is simply the becoming passive of the god, his transformation into a simple spectator of events: the god becomes aware of the contradiction, 'but incapable of stopping or even deflecting the course of events, he renounces any attempt to direct them at all. He thus makes himself, against his wish and well-being, a passive spectator, simply awaiting the unraveling of events, that will eventually bring about his ruin.'[15] This process, according to Appia, divides *The Ring* in two: the first two days are marked by active will, whose realization ends in Brunhilde's pyre. The last two days are of passive will – that is, drama become spectacle. This is the caesura that determines the *mise en scène*.

This dramaturgy seems to contradict Appia's initial project. It bases the staging of *The Ring* not on the temporal structure of the music, but on the fictional structure of the drama. Yet it is noteworthy that the fictional content itself recounts nothing other than the ruin of traditional narrative logic. Music is not here to illustrate the fate of Wotan. Rather, the history of the character expresses music's own operation. That the same idea of music corresponds to the silences of spoken drama and to the content of musical drama

14 Adolphe Appia, *La Mise en scène du drame wagnérien*, in *Œuvres complètes*, vol. I (Lausanne: L'Âge d'homme, 1983), p. 272; *Staging Wagnerian Drama*, transl. with an Introduction by P. Loeffler (Basel: Birkhäuser Verlag, 1982), p. 59.
15 *Staging Wagnerian Drama*, p. 59.

is not a matter of metaphoric approximation. This mobility of the concept reminds us that an art is always more than an art, more than the meeting of specific means of organizing speech, sounds, colours, volumes and movements. It is an idea of what art does. The Wagnerian revolution inaugurates not simply a new way of making music, but an idea of music as an idea of new art. Music is no longer only the art of harmonious sounds; it is the expression of the world before representation.

But, to complicate matters, this world before representation is two things in one: it is the world of instinctive potential, of the collective life of the people, for the young Wagner, a reader of Feuerbach. Feuerbach demanded that men reappropriate for themselves, within everyday sensible life, and primarily in the relation between men and women, the powers of consecration of common life alienated in the abstraction of language and the ideality of the Christian god. It was under his influence that Wagner projected the marriage of the masculine potential of the poem with the feminine potential of music. It is in this context that he imagined the return to the potential of free life, contained in the language of sounds and collective myth. But once Schopenhauer eclipsed Feuerbach, this instinctual potential completely changed its meaning. It took the figure of the will, which is the essence of things hidden under the mirages of representation, the will that wants nothing other than its own negation. Music no longer had its symbol in Siegfried, the liberating hero, the representative of the potential of myth and the people, but in Wotan, the god who renounced his will and saw his world collapse.

Saying that *mise en scène* transforms drama into spectacle, therefore, does not mean that it illustrates fiction. Rather, it comes to concretize the meeting of two antagonistic ideas of music in the same space. On the one hand, *mise en scène* fulfils the essence of music as the language of the senses. It is the sensible exposition of the language that bears the potential of collective life. But, on the other, it fulfils the essence of music as the deaf truth of nonsense that supports the illusory world of actions directed towards a goal and meanings attached to it. Transforming drama into spectacle means carrying its intimate life to a sensible potential that exceeds the power of 'beautiful discourse out of some mouth'.[16] But

16 Stéphane Mallarmé, 'Solennité', in *Divagations*, in *Oeuvres complètes*, vol. II, p. 200; 'Solemnity', in *Divagations*, transl. Johnson, p. 166.

this also fulfils the very essence of music, which transforms action into passivity and dispossesses characters of the illusion of their own existence, and actors of their pretention to embody 'roles'. The essence of music ruins the logic of causal chains, the psychology of characters, the performance of roles, and the mimetic expression of feelings. This 'interiorization' of drama demands a new visual form. It demands that art extract its musical structure – that is to say, the law of its transformation into spectacle – from dramatic action. There is no music in the 'proper' sense of the term in Ibsen. Neither is there any in Maeterlinck. And we know that he was only mildly satisfied with Debussy's score. But the transformation of drama into spectacle is indeed at the heart of their dramaturgy. And it inspired their vision of the stage. It is notably translated, as in Strindberg's 'chamber plays', by the importance of the windows through which characters see events occurring on the other side, in the distance, forming an intimate tragedy transformed into a faraway vision.

Mise en scène is thus born as the unity of two opposing procedures. On the one hand, it responds to a principle of overall sensitization: the theatre must no longer narrate actions, but directly express the potential of life. But this life is precisely so at the cost of abandoning the old logic of will, feelings, actions and ends. The overall sensitization it requires can only be carried out through the rejection of motivated language and expressive forms that serve to translate the will and feelings. This life must be displayed entirely, but for this it must reject not only the representative set design but also traditional expressive language and the whole system of life's appearances. How can this imperceptible life be made sensible? Drama can put it into words. But what sensible form should be given to the force of these words? A first response consists in saying that the very project of conferring the representation of this form upon living bodies is contradictory. The new drama is not capable of being represented. This is not because it is too ideal to be handed over to the vulgarity of material representation. It is because its sensible texture is not compatible with the onstage presence of bodies meant to incarnate it. On the one hand, the power of speech and silence is chained in the words of the poem that tell us about the encounter of any given life with the sources of life. And, on the other hand, the poem is realized by the presence of a human body before us confronted by the same powers. These two poems are incompatible. The latter will always

have more presence. The temptation is thus to save the poem from this excess by leaving it up to the reader to construct the mental theatre of its presence. Mallarmé theorized this before Maeterlinck. But both of them knew that this way of saving the purity of the new poem still entrusted it to the old power of imagination. The drama 'without action', the immobile drama, must have its own sensible forms. But these sensible forms are to be constructed as the result of two opposite forces: one pushes the impersonal powers of life to be embodied in the movement of bodies in action; and the other dehumanizes this movement by sending it back, on the one hand, to the inhumanity of organic matter that it comes from, and, on the other, by pushing it towards technical innovations, where it affirms its power beyond itself.

The destruction of the old expressive system is carried out along these two lines: a theatre where life, freed from mimetic obligation, directly affirms its potential in the energy of bodies; a theatre whose potential for art is manifested, on the contrary, by distancing bodies and grimaces in favour of the lifeless potential of architecture, the statue, line and colour, light and movement. To affirm the autonomy of theatre, Edward Gordon Craig and Adolphe Appia were led to abolish it – one in the pure movement of the stage platform, and the other in the collective gymnastics of bodies. Others, however, would explore the tensions, overlaps and distortions this divergence could produce. More than anyone else, Meyerhold illustrated the experimentations of theatrical art, continually travelling between the attempt to immobilize drama into a painting and the effort to increase its sensible energy. In his wake, the art of *mise en scène* capitalized upon the exploration of opposites in formulae of perpetually renewed reconciliation or rupture, without ever eradicating the suspicion that such success was merely the substitute or mourning for a more radical reform, which should address 'the still more difficult art of living'.[17]

17 Friedrich von Schiller, *On the Aesthetic Education of Man*, transl. R. Snell (Mineola, NY: Dover Books, 2004), p. 80.

8. Decorative Art as Social Art: Temple, House, Factory

Paris–London–Berlin, 1893

His work is a vast temple with profound secrets that no one will ever explore without respect or difficulty. Grace and beauty are merely its external decorations; the flame of spirit burns within the depth of its sanctuary. Examine the monument as a whole with the desire to penetrate its meaning; it appears to be a homage to creation and truth; the joy of living and loving has inspired it. It is the expressive manifestation of a sensibility and intelligence directed towards nature's spectacle and passing time. If the ingenuity of the artist and the dreamer are tenderly displayed here, everyone can discover elements of a regenerated aesthetic and the system of a philosophical doctrine within it. The creation bears the date of an era and the mark of a country; it partakes in modern anxiety and curiosity.

This is how a Parisian lecturer spoke in 1910, commenting on the work of an artist.[1] This celebration of the work as a temple surely belongs to the style of the period. In the 1890s, Mallarmé explained the 'crisis of verse' through the 'rending of the veil in the temple' and dreamt of 'services' celebrating the new splendour, the ordinary magnificence of human artifice, bound to follow the 'shadow of long ago' cast by Catholicism. Ten years later, Isadora Duncan and her family attempted in vain to restore an ancient temple on mount Kopanos in front of Athens. In the 1910s, men of the theatre like

1 Roger Marx, *L'Art social* (Paris: E. Fasquelle, 1913), pp. 112–13.

Adolphe Appia wanted to transform the theatre into a cathedral of the future; later, others followed Rudolf Laban to Monte Verità to found a monastic community of a new kind, devoted to the marriage of nature and art alone; others still became involved with the concrete construction of temples raised for the new religions of humanity, like Rudolf Steiner's Goetheanum. There is thus nothing very astonishing about the recurrence of the temple metaphor in the ornate prose of a speaker who was essentially repeating a talk delivered twenty years earlier, in the context of the Universal Exposition in 1889.

But three elements make this banality more singular. Firstly, the 'monument' evoked in this text is not the work of an architect or a sculptor, nor of a poet or a novelist. The temple builder thus saluted was an 'artisan of earth, glass and wood',[2] a master of the so-called 'decorative arts', Émile Gallé, whose works were essentially furniture pieces and vases. Secondly, it was in front of 'comrades' that the speaker uttered this praise for an artist whose productions we associate more readily with the privileged décor of rich art-lovers. The speaker, Roger Marx, was an art critic more familiar in Edmond de Goncourt's 'attic' than in workmen's circles. But here he was addressing an audience of workers that the association Art et Science convened on Sunday to complete their education. And his lecture glorifying the Lorraine industrialist followed two talks devoted to the apostles of the Arts and Crafts movement and the socialist future, William Morris and Walter Crane. Finally, the text was published in 1913 in a volume titled *L'Art social* ('Social Art'). The other models of social art that came with it were Lalique jewellery, the art of a dancer, Loïe Fuller, and a poster designer, Jules Chéret, associated with the splendours and frivolities of the music-hall. And finally, an 'example of patronage', represented by the sumptuous decoration of a villa on the shores of Lake Geneva by Auguste Bracquemond and Alexandre Charpentier. None of this seems to suit the idea of the temple or the affirmation of a 'regenerated aesthetic', any more than it does 'social' art.

Yet none of these formulas occurs by chance. None of them can be attributed to the excessive rhetoric of a man of letters nourished on Mallarmean reveries and the artistic language of the Goncourts.

2 Ibid., p. 112.

Roger Marx was in fact a militant for aesthetic regeneration, and he illustrated an idea of social art through the ideal landscapes that decorated precious Gallé glassware and pottery, adorned Lalique ornaments, and surrounded the mirrors in the billiard room of the villa Sapinière. Aesthetic regeneration is the restoration of the unity of art, a unity lost since the separation between 'fine arts', meant for the contemplation of museum-goers alone, and so-called decorative arts supposedly made to serve a practical end and integrated into the decoration of a building. Roger Marx was a tireless militant for one idea: the art disparaged as decorative in fact indicates the true finality of art, from which it must draw its principle and its criteria of appreciation. Art is destined to build and to furnish living spaces, whether they house divinity or mere mortals. William Morris summarized the matter precisely: the proper unity of art is the 'dwelling of some group of people, well-built, beautiful, suitable to its purpose, and duly ornamented and furnished so as to express the kind of life which the inmates live'.[3] There is no cause for irony towards the fact that 'social' art is made by luxury artisans for rich art lovers. Social art is not an art for the people; it is art at the service of ends determined by society. But this definition could be read backwards. Social art is not the art of any society whatsoever: it the art of a society where 'men live like men', where one builds to shelter and express life, and not to impose a mirror relation between the distinction of a class and the distinction of art.[4] The 'politics' of social art are to be found here: in the refusal of art's own distinction, and thus also of the distinctions between the noble and non-noble arts. Perhaps only high-society women wear Lalique jewellery. But it places a sign of equality on their ornaments. An artisan made them like pictorial compositions, ignoring the hierarchy between fine and applied arts. These pictorial compositions are not meant, like easel paintings, to decorate the living rooms of elegant ladies; they are made to be incorporated into their life, and to accompany their events. And what gives them value is the part of his own life and thought that the artisan has incorporated into it. But this life itself is made of the feeling that he has felt faced with the impersonal life

3 William Morris, 'The Arts and Crafts of To-day', in *The Collected Works*, vol. XXII (New York: Russell & Russell, 1966), p. 360.

4 John Ruskin, *The Seven Lamps of Architecture* (New York: The Noonday Press, 1974), p. 170.

of flowers, insects and landscapes whose shapes these stones stylize. What glimmers on the bust of the high-society lady is thus this impersonal, egalitarian life, and not the mark of her class. The value of her jewellery is no longer given by the size or the quality of the diamond, but by the singular manifestation of great anonymous life composed by the artisan's thoughts and hands. Thus the latter can also mix his jewellery with 'poor pebbles collected during a walk and mixed with the gravel from his garden'.[5] The elegant woman's ornaments display the equality of the arts and their materials. The only distinction of her ornaments is in the artistic genius that composed it. But the genius of Lalique or Gallé is itself nothing but the manifestation of an extreme sensitivity to the spectacle of nature, the inflorescence of plants, the shapes of insects, or the harmonies of landscapes according to the seasons and the hours. It is nothing but the singular expression of impersonal life. It is this life of the whole, this life of all, that the artist illuminates on the trinkets of elegant women, and that the speaker wants the workers listening to him to feel, in order to awaken their desire to be men 'for whom the visible world exists'.[6]

Life – such is the god who comes to inhabit the deserted temple once again and command the revival of art. This 'aesthetic' revival seems to reverse the conception of art born from the contemplation of the mutilated *Belvedere Hercules* or the *Juno* of the Villa Ludovisi. Winckelmann and Schiller admired the undulations of the body without a head or limbs, or the goddess's gaze without a will, as the expression of a free people. But this expression had entirely gone into the stone; this fullness of life was manifested as the suspension of life, the indifferent movement of waves, the perpetually balanced attraction and withdrawal of aesthetic free play before free appearance. A hasty posterity accused these lovers of free appearances of having invented the fatal cult of a new Greece, the totalitarian passion of art turned into a form of collective life. But the statue without limbs was also a statue without a temple, displaced into museums where the only temples to be found were in the fluted columns from porticos. The reality of the romantic passion for stone was the desertion of this stone: temples abandoned to vegetation and looters, statues turned into museum pieces.

5 Marx, *L'Art social*, p. 181.
6 Ibid., p. 150.

And figures of a new aesthetic of indifference rose from this desertion. It was expressed in the admiration of the philosopher, Hegel, for the little gods of the street, bearing witness to an excellence of painting indifferent to its subject and to its exhibition space; but also in the project of the novelist Flaubert during the period when he was writing *Madame Bovary*: to write the book without a subject, the 'book about nothing', the inverse equivalent of now impossible Greek art, which was the expression of a people and a land. The 'poor pebbles' that Lalique placed on the busts of elegant women, and that Roger Marx included in his idea of 'social art', take on meaning in relation to the rags and grapes of the carefree young beggars, as they do towards the blades of grass and eddies of dust in Emma Bovary's grey life and Flaubert's indifferent sentences. But to understand this relation, one must recall the revolution, somewhat forgotten today, brought about by a book that was published between the *Lectures on Aesthetics*, in the 1830s, and *Madame Bovary* in 1856. This revolution occurred in 1851, the year when the first edition appeared of *The Stones of Venice* by Ruskin. The second volume summarizes the gist of the book in a chapter, 'The Nature of Gothic', destined to become not only a reference text for the conception of decorative art, but also the bible for a new idea of art.

It is worth reconsidering the stakes of the notion of the gothic that Ruskin developed. All too often it is merely reduced to a naive nostalgia for the work of artisans from long ago, masters of their craft, inspired by faith and protected by their guilds. It has been reduced to the desperate will to reject the world of machines and restore a dream-like Middle Ages. At the same time the contributions of the Arts and Crafts movement, which it inspired, were summed up as imitations of *haute époque* furniture, images of knights and noble dames with diaphanous complexions, wallpaper with stylized foliage inspired by *mille fleurs* tapestries, and calligraphy aping medieval manuscripts. By doing so, this movement's influence on nineteenth-century socialist militants, and twentieth-century architects, decorators and designers obsessed with functional modernity, was rendered incomprehensible. One failed to recognize its effect on the idea of art, and the relation between art and society, well beyond the milieu of decorative art. The concept of the gothic, as Ruskin formulated it, is much more than the expression of nostalgia for the lost paradise of popular faith and art. It marks both the

fulfilment and the reversal of the dream of an art of the people that was nourished by the contemplation of Greek statues. To understand this, it is necessary to recall Hegel's argument. The temple and the statue, he showed, are art for us because they were something other than art for those who made them, the expression of the life of their people – a life idealized in the geometric proportion of the temple colonnades, in the perfection of idle life, the indifferent forehead and the empty gaze of their gods. Hegel set this link between a people's freedom, the geometric perfection of volume and the indifferent majesty of form against the excessive volume and the illegibility of the forms of symbolic art, found in pyramids and hieroglyphs. He also contrasted it with the tension of edifices raised to the sky and the multiplicity of figures, belonging to 'romantic' art – that is to say, medieval and Christian art – in which religious interiority experienced the impossibility of finding its full expression in the materiality of stone. The age of Schiller and Hegel had conflated Greek perfection with the freedom of a people that did not recognize the separations and the servitude of the division of labour. The symbolic art that had come before it was the art of an enslaved people. Romantic art, which followed, was the age of the withdrawal of freedom into the interiority of souls, within a world of servitude and corporative divisions.

Ruskin came to brutally overthrow this schema. For him, the formal perfection of straight lines, precisely calculated volume, and the symmetrical proportions of the Greek temple in no way expresses the freedom of a people. On the contrary, such perfect execution signals the subordination of the builders' hands to the thought of an architect whose blueprint is precise and complete enough in itself for its realization to be entrusted to servile labour, which neither adds to nor subtracts anything from the master's drawing. Geometric perfection expresses the rigor of the division of labour; it signals that the work comes from the thought of a man who has nothing more to express through the activity of his hands, and is executed by men who do not have the right to put any of their own thought or their lives into their work; nothing more than their skilled hands following instructions. This division between the work of the artist and the artisan was institutionalized, in mores and minds, through the distinction between the fine arts and the applied arts. It is expressed in the cult of pure art whose idol is the

'portable' work of art; easel painting made to be enjoyed in salons and museums. The only true art, on the contrary, is supposedly applied art, which applies both to the construction *and* the decoration of buildings, art that serves life, serves to shelter *and* express it.

To shelter and express: the conjunction of these two functions is essential because it allows one to reject the simplistic opposition between the useful object and the object of disinterested contemplation. The received opposition between the useful and the beautiful undoes the unity of art and establishes the division of labour and the hierarchy of lives. For Ruskin there is basically only one art: architecture, which builds housing for men, people and gods. But architecture is not simply 'functional' art, the art of 'adherent' beauty to which Kant opposed 'free' beauty. Or, in other words, free beauty does not belong to the separate work, designated as such, and defined by the perfection of form alone. Moreover, Kant's own examples of 'free beauty' were not paintings hanging on the wall or statues in the garden, but the decorative wallpaper that transfers the free allure of birds or foliage onto the walls of homes. Ruskin does not linger over Kant, but he is determined to displace the relation between different ends that is at the centre of the definition of art. He contrasts the formal 'perfection' of art that signifies its servitude in the name of so-called autonomy with its submission to a double law: adaptation to a functional end and the free expression of the imagination. These two laws only seem opposed to one another. For life is subject to both the law of necessity and the law of free expression, to the expansion of the self that takes it beyond immediate satisfaction. Man needs the place where he lives after the workday to offer him not only shelter but also the feeling of life in action, joyous in itself. He thus needs rooms devoted to living together to be decorated with ornaments. On the other hand, he does not need the window of the store where he shops to imitate a Greek temple or be decorated with medieval calligraphy. He does not need the workshop where he earns a living to be designed by a decorator. But he does require the work he does there to allow him to express his own life. There is a true life, which winds through the constraints at the very heart of the useful, grows through them, and leaves behind the fruit of this growth. There is also a false life that uses the appearance of art to hide its subjection to necessity: Corinthian columns used as bait for commercial trickery, fake marble stuck on to hide

machine work, fake flying buttresses that support nothing but make
it impossible to notice the very balance of weight and volume, and
so forth. Fake art hides the reality of work. And it is forced to hide
it because this work is not the manifestation of life, but the servile
work of a machine or of human hands subject to the thought of a
foreign mind.

Thus the same confusion between true and false life produces the
'pure' art one admires in museums and the 'applied' art used to deco-
rate stores. It places its point of honour in the admiration for the
regular forms of the Greek temple and the taste of professors of
aesthetics for genre scenes, like the vicious little vagrants Murillo
picked up in the street. He not only shows us their rags, but also the
disgraceful grin of the boy eating melon, and the sole of the dirty
foot of the one eating grapes, deliberately turned towards us in the
foreground.[7] By attacking Murillo's little beggars, Ruskin may not
have been interested in starting a polemic with Hegel. Yet his charge
marks his distance from the way the latter transferred the virtues
of antique marble and Greek freedom to genre paintings. And it
is not out of a taste for digression either that this bravura passage
on the 'roguery' of the ragged and vicious vagrants is included in a
chapter on the nature of the gothic. The long classification of genres
of painting it is inscribed in is also not a digression. Ruskin dif-
ferentiates between three ranks of artists: the formalist champions
of drawing, the 'sensualist' lovers of facts, and the 'naturalists' who
reconcile the two. Thus, on the one hand, the lovers of lifeless per-
fection, inspired by the servile regularity of the Greek temple; on
the other, the adorers of life without harmony, found in the bour-
geois home and the poor street, the world of shops and factories.
The 'Olympic' serenity of the little beggars is of the same order as
the neo-Greek arrangement of shop-fronts. Ruskin contrasts both
Greek perfection and the trash of the bourgeois world, the work of
the slave obeying the architect and the artist's gaze on the pictur-
esque riffraff of the street with this 'naturalism', this assimilation
of art with the expression of a magnified life for which gothic art
provides the model.

'Naturalism' – that is to say, the translation of emotions felt before
forms of nature, forms that every British subject knows, after Burke,

7 John Ruskin, *The Stones of Venice*, vol. II (London: George Routledge
& Sons, 1907), p. 212.

are never straight – comes in third rank, after the love of change, in Ruskin's articulation of the characteristics of Gothic art. First, and most important, is its 'savagery' or its 'crudeness'. The term is ironically taken from the classical judgment condemning the barbaric art of dark times. But this is done in order to reverse the conception of art and the very opposition between the civilized and the savage. Surely gothic art is an essentially imperfect art: made of rarely symmetrical parts, often added during construction without taking the initial plan into account, adorned with a multitude of little naive or grotesque figures, executed by artisans of unequal talent but all equally keen to leave their mark, like the sculptor of the tiny figure lost in the interstice above the Portail des Libraires at Rouen cathedral.[8] This imperfection can be described in classic terms as a conflict of the faculties: the hand fails to execute thought adequately, while thought hastens to act, rushing the work of the hand. For Hegel this inadequacy characterized symbolic art, which is incapable of imposing the forms of the idea on matter because it is incapable of clarifying this idea itself. But Ruskin reverses this argument: symbolic art is human art par excellence, the art of an anxious creature, impatient to realize his thought even if it means anticipating his capacity for action; the art of an imperfect being, thus constantly in progress, always capable of renouncing initial plans to better respond to the difficulties of the enterprise and to adapt to the function of the building. Above all, it is the art of free men, capable of feeling joy in crafting ornaments according to their own idea, bound to be lost among the abundance of figures.

The praise for the impish little figure on the Rouen portal is part of a tradition of thinking that was already a century old: one that conflates the potential of art with the anonymous expression of collective life. It is in the name of this idea that the eighteenth century stripped Homer of his royalty by transforming the *Iliad* and the *Odyssey* into fragments of a vast and anonymous poem of the people. Hegel objected that the very dignity of a poem of the people demanded that it possess its own voice, the voice of a singular subject. He thus restored the poems to Homer. Ruskin rejected

8 Concerning this tiny figure, see the commentary that appears in Ruskin, *The Seven Lamps of Architecture*, p. 165, and Proust's commentary in 'En mémoire des églises assassinées', *Contre Saint-Beuve* (Paris: Gallimard, 1971), pp. 124–8.

the dilemma entirely. An artist cannot sum up the poem of the people. It is the work of many artists, all singular. It matters little whether we know the name of all those who sculpted the countless sacred or profane figures that adorn the great stone poems of Gothic cathedrals. But it does matter for us to notice these figures as the work of artist–artisans, participating individually in the collective work by inscribing their own mark on this multiple poem. The sculptor of little gothic figures provided a new solution to the problematic status of art since the age of revolutions, of the museum and aesthetics conflated the greatness of antique art with the expressive character of a people, even as it liberated works from their subjection to the expression of social powers: How can an art free to do what it wants regain the power of embodiment of an art expressing the life of a community? How can one intentionally create something equal to an unintentional work of the past? The model of the 'gothic' artist responds to the problem posed by Hegel or Flaubert: while subordinating himself to the collective work, to the function of the building and the constraints of the material, he expresses his own will, and his singular manner within this framework. Ornamental work is the exemplary response to this double demand. And the 'naturalism' of the ornament illustrates this: the man who 'governs' ('man as governing'), the man who freely creates forms, shows himself to be equal to the man who gathers ('man as gathering'), the man who creates forms based on his emotional response to natural appearances.

The Ruskinian concept of the gothic is thus far more than another stone added to the romantic nostalgia for the faith of medieval artisans. It is not simply the concept of a form of historically situated art. It proposes an idea of art equally capable of inspiring the art workers of a secular republic and the rational engineers of modern life. Decorative art is not a utilitarian art whose external finality could be opposed to the autonomous work of art. Nor is it an art meant for consumption by the leisure class. It is art that obeys its concept, by responding to a vital double function: habitation and expression. One can thus establish a strict equivalence between two propositions: all true art is decorative, since it is meant to be integrated into a building. But also, all true art is symbolic, since the buildings it works with are not only destined to provide individual shelter or be the seat of collective functions. They are destined to be

inhabited by individuals, communities and their divinities, whether old or new. Thus, they must express modes of social existence, of individual and collective health. But such expression always exceeds function. It does not have its own form or its own perfection.

The modern destiny of decorative arts is always played out over the question of the expressive supplement. One readily describes the movement that stretches from Arts and Crafts and Art Deco to Bauhaus and Esprit Nouveau as the abandonment of ornamental sinuosity in favour of the pure line matching the function of objects and the rationality of the habitat. But this opposition is far too simple. Behind the battle between the future and the past, the industrial machine and the artisanal tool, rational straightness and the ornamental curve, there lies a far more complex play between function and expression. Ruskinian gothic is a social paradigm of art, not the nostalgia of an historic style. The admirers of the machine agree with the defenders of artisanry in thinking that true art is so-called 'applied' or 'decorative' art – art that adapts to life and expresses it. The entire question is to know which life one must adapt to and which life one must express. The transformations of the concept of decorative art depend on the way in which the joint or disjointed relation between these two lives is interpreted. Defining the tasks and the forms of the decorative arts amounts to defining the style of life that gives art its principle. Everyone agrees: a style is the expression of the life of a people in a time. Everything depends on the way in which the articulation of this double relation is understood.

This is the perspective in which Roger Marx's florid prose takes on meaning. Consider the sentences describing the vegetal effervescence of the furniture for which Gallé provided a décor and fitting names, both to their function and their manifestation of shared life, like the dining table dubbed *Les Herbes potagères* ('Garden Herbs') decorated with the 'exquisite Parmentière flower, globular inflorescences of the onion, spruced garlic stalks, lambrequins of kale, and the seeds of umbelliferous plants',[9] or the décor of the 'small poems', comprised by Lalique's bottles, grinders, lorgnettes, cases or reading lights: ' … a flock of swallows takes flight from the bottom of the gorse bush bent by a gust of wind … ; swans silently crack the frozen

9 Marx, *L'Art social*, p. 137.

enamel of the wave; bats cut across a diamond studded sky; through a hedge of tapered pines, the surface of the swamp sparkles and glitters; a swarm of bees keenly seeks its pasture'.[10] Surely these pieces of furniture, chests and bottles only decorate high society salons and boudoirs, and the style of the speaker that describes them is borrowed from the 'aesthete' descriptions of the Goncourt brothers. But these little poems by botanists or landscapers, evoking the flowering of vegetables or familiar birds, are themselves in harmony with another literature, constituted by the readers, and the object lessons provided in republican primary school, taking care to associate the learning of signs closely with the evocation of animals and plants that make up the everyday background of rustic life. They integrate the furniture and the bibelots of rich art lovers with the global vision of an educational republic. The latter, moreover, does not draw its education exclusively from images of country life. The everyday life of cities also has its colourful flourishing. Hence, Roger Marx associated Chéret, who designed posters for the streets of Paris, with luxury decorators. His 'open air museum', free for all, responds to the pastoral of glasswork, furniture, pottery and jewellery made by Gallé and Lalique. In his drawings of tumbling creatures, as in the vegetal effervescence of their furniture and their bibelots, or in the flying fabric in Loïe Fuller's dance, the 'serpentine line' becomes far more than a style imported from England; it becomes the expression of this 'unanimous' life that must found a new education of the mind and the senses. The equality recognized between artists and artisans is the means of a new art, which borrows the means of educating the men of the Republic from the great democracy of natural forms. It is no accident that Gallé himself referred to the emblematic female figure of the sower – painted by Millet, featured on Larousse dictionaries, or on the coins and stamps of the Republic – likening his own work to that of the sower, whose scattered seeds contribute to the elaboration of the 'decorative style of an era'.[11] This decorative style belongs to a republic whose elite sustains the elements of their refinement through the same 'unanimous life' taught in the academically rigorous object lessons and primary school readers, and reflected in the apparent frivolity of colourful street posters.

This new educational art therefore has its privileged place not

10 Ibid., p. 183.
11 Émile Gallé, quoted in Marx, *L'Art social*, p. 127.

in art exhibitions, no matter how applied, but in the Universal Expositions of Industry. Contrary to the Ruskinian prejudice against machine civilization, the new champions of decorative art sought to reconcile art and industry in one and the same energy, which could serve the needs of life and its freedom of expression. It was thus entirely natural that the theatre built for Loïe Fuller, whose architecture followed the movement of dance, was juxtaposed in the 1900 Exposition to machine galleries or exhibitions of new furniture. Loïe Fuller's serpentine dance emblematized the harmony between the dream flowers drawn by moving veils and the new power of electricity. It was the emblem of art itself intimately entangled with unanimous life, manifestations of which 'proved to hold interest for aesthetics, sociology and political economy at the same time'.[12] Regenerated aesthetics affirms itself as the formative potential of a new society. The educational vocation attributed to the elite meets the worker's ideal of a society of free producers, in which art directly works towards the construction of a common manual and mental culture. The 'social' art conceptualized by Roger Marx has two essential sources: it lays claim to Léon de Laborde, the commissioner of industrial Expositions during the Second Empire, who asked the state to shape the taste of the people by infusing useful objects with the principles of great art, but also to Proudhon, the socialist theorist urging artists to turn towards the splendid future of 36,000 communal homes, schools, workshops, factories, plants and gymnasiums, and 40,000 libraries, observatories, museums, auditoriums, and belvederes to be built, not to mention the transformation of France into a vast garden.[13]

The ideal of decorative art can thus reject the Ruskinian prohibition of machines and distinguished materials when they come to serve the Ruskinian conception of an art controlled by the union between utility and expressivity. Roger Marx pushed this conception to its extreme by intensifying the creative character of decorative artists: they become artists par excellence because they owe nothing to the genre they practise and everything to their own invention.

12 Marx, *L'Art social*, p. 51.

13 Léon de Laborde, *Quelques idées sur la direction des arts et le maintien du goût public* (Paris: Imprimerie Impériale, 1856), p. 26; Pierre-Joseph Proudhon, *Du principe de l'art et de sa destination sociale* (Paris: Garnier Frères, 1865), p. 374.

Any piece of furniture or salon ornament thus becomes a poem, and the equality of all the arts risks being translated into the over-wrought quality of every useful object. Later generations did not fail to count this overwrought aspect as kitsch, contrasting it to the beauty of functional lines. Yet the author of the report on the 1900 Exposition, although a convert to the cause of the decorative arts, was already protesting in the name of art and utility against the 'unhealthy intoxication' that had invaded industries: 'As a result of insisting that all arts were equal, it seemed that there was not one brave worker left whose work aimed to satisfy the basic needs of existence, who did not believe himself to be a sacred artist. There was no longer great art or minor art. This much was clear! This final Bastille had been overthrown.' According to the reporter, this was the source of all sorts of extravagance: the gigantic animated flora, 'the entanglement of overexcited tapeworms and tumultuous noodles, macaronic tentacles', figures of dishevelled women swaying on the beaks or handles of vases and pitchers,

> so that the honest container, so convenient before being elevated to the dignity of the art object, could now no longer pour or be grasped by hand ... If one decided to make a chair, the unfortunate person who decided to sit down on this bizarre, mean and savage-looking furniture was sure to catch his clothes on some spiky point, to tie his feet in the bars shaped like wrought-iron volutes ... And all this full of pretension about usefulness while the imagination could hardly conceive of anything more inconvenient.[14]

The reporter only forgets that this 'inconvenience' has another side: the living room crowded with these indiscreet poems finds itself bound to the exhibition of the unanimous life of nature, shared with the residents of the countryside. And the original artist, above all when like Gallé he is a captain of industry, becomes an educator of the community. The intensified expressivity of ornamental décor is a way of ushering the gothic paradigm into the universe of business, the machine and the modern city, in the new world of distinguished salons and popular streets animated by window displays and posters.

14 *Exposition universelle internationale de 1900 à Paris. Rapports du jury international*, General introduction, vol. 1. 'Rapport Beaux-Arts' by Léonce Bénédite, pp. 818–20.

This programme was ostensibly dismissed when the protagonists of German 'artist colonies' rejected their youthful love for swaying lines and the decorative and symbolic exuberance of Jugendstil. And it was the entire artistic ideal of Ruskin and William Morris that seemed to be symbolically rejected when one of their leaders, Peter Behrens, became the 'artistic adviser' of the German electric company, AEG, and undertook not only the design of its lamps and kettles, its logo and its catalogues, but also agreed to build the monumental steel-and-glass structure of the new factory producing its turbines. The inauguration of the Berlin Turbinenhalle in autumn 1909 seemed to mark the conversion of neo-Greek or neo-gothic dreamers to functional industrial architecture. And these were the terms in which the constructivist age praised it as the first great achievement of modern architecture. Yet contemporaries did not hesitate to recognize it as 'Ruskin's words come true'.[15] In this great hall without partitions or corners, where well-lined working spaces evoked 'the trees in an avenue',[16] they saw the exemplary realization of 'joy at work' promoted by the author of *The Stones of Venice*. More fundamentally, the model factory designed by Behrens expresses a Ruskinian idea of an essential link between three things: a society, a way of working, and a function of art. Like Roger Marx, Peter Behrens and his friends of the Werkbund used Ruskin against Ruskin. But they did so in the opposite way: Roger Marx united art and industry by exalting the individuality of the artist-artisan. If they shared the idea that art expresses and organizes the life of a people, they did so in order to refute the privilege of artistic individuality. And if they rehabilitated the Ruskinian principle of 'sincerity', and especially faithfulness to material, they did so in order to reject the swaying and swirling of the organic line by celebrating the beauty of functional lines and the honesty of the machine. Some have argued that they referred to Ruskin merely to mask the absorption of expression into function. But this misunderstands

15 Adolf Vetter, 'Die staatsbürgerliche Bedeutung der Qualitätsarbeit', quoted in Frederic J. Schwartz, *The Werkbund: Design Theory and Mass Culture before the First World War* (New Haven: Yale University Press, 1996), p. 58

16 Wolf Dohrn, 'Das Vorbild der AEG', quoted in Alan Windsor, *Peter Behrens: Architect and Designer 1868–1940* (New York: Whitney Library of Design, 1981), p. 92.

how, for them, function has two parts: an artist's construction of a functional factory is also the affirmation of a programme to unite art and life. The best symptom of this was Behrens and his supporters' indecision concerning the function of the four corner pillars in cement, whose horizontal blocks clashed with the vertical structure of the Turbinenhalle, and the polygonal pediment adorned with the alveoli of the AEG logo alone. They loudly declared that these cement pillars respected the Ruskinian precept of sincerity, by making it clear that they were not support structures. But the 'artistic' treatment of useful material and the shape of the pediment, which seemed a compromise between the Greek triangle and the gothic arc, blurred the distinction between the useful and the decorative, the functional and the symbolic. This was not a remainder of the Jugendstil idea among the new followers of functionalism. Functional construction is not merely construction adapted to utilitarian ends, but also the artistic affirmation of a society in which these ends are themselves subordinate to an ideal of social harmony.

Indeed, the 'functionalism' of the Werkbund artists and their Bauhaus heirs cannot be reduced to the point of view of a rational engineer, opposed to the individualist vision of the artist. It is primarily an idea about art and its social function. The goal is not to adapt buildings to their use or to tailor products to their consumers. Rather, it is a reform in the very structure linking modes of production and modes of consumption, similar to the one found in Ruskin or Roger Marx. This reform counts as art, since the latter is not merely the production of works through a defined technique. It is the power of ordering forms of individual life and those in which the community expresses itself as such within the same spiritual unity. An ethical function of art is being affirmed here in the strictest sense: its mission is to produce objects best suited to practical needs, but also ones that are most likely to place the symbols of a common way of inhabiting a world within each home, thus educating individuals in common culture. This common culture is based on style. Style is not the manner that signals art or the artist. It is not the artificial form of individualization that fashion offers to those who want to affirm their singularity, or that of their class. Behrens had already insisted on this forcefully during a period when he was not building factories but designing a theatre symbolizing the culture of a people and a time:

The style of a time does not mean particular forms in one or another art; every form is only one of many symbols of inner life, every art only a part of style. Style, however, is the symbol of feeling in common, of the whole conception of the life of a time in its totality, and it only shows itself in the totality formed by all the arts.[17]

Here again, the artist's business is shared in common with the architect and the engineer, but also the sociologist, as he was understood at the time: a committed observer who analyzes individualized forms of life produced by new economic structures and collective forms of life to be promoted in order to harmonize forms of individuality with the demands of the community. Furthermore, artists, sociologists and captains of industry came together in the pages of *Dekorative Kunst*, where the most eminent German sociologist, Georg Simmel, elevated the question of ornamental stylization to one of style expressing collective life:

Where only one style is conceivable, every individual expression grows organically from it; it has no need to search first for its roots; the general and the particular go together without conflict in a work … Finally, style is the aesthetic attempt to solve the great problem of life: how an individual work or behavior, which is closed, a whole, can simultaneously belong to something higher, a unifying encompassing context.[18]

This liberation of the individual will leaves its mark on works and objects produced by the decorative arts, and they transmit it to spectators or consumers.

The fact that style also appeals to the spectator at levels beyond the purely individual, to the broad emotional categories subject to the general laws of life, is the source of the calming effect, the feeling of security and serenity with which the strictly stylized object provides us. From the stimulation points of individuality to which the work

17 Peter Behrens, *Feste des Lebens und der Kunst. Eine Betrachtung der Theaters als höchsten Kultursymbols* (Leipzig: Eugen Diederichs, 1900), p. 10.

18 Georg Simmel, 'Das Problem des Stiles', in *Aufsätze und Abhandlungen, 1901–1908*, vol. II (Frankfurt am Main: Suhrkamp, 1993), pp. 383–4; 'The Problem of Style', transl. Mark Ritter, in *Theory, Culture & Society* 8: 3 (August 1991), pp. 63–71.

of art so often appeals, life rises with respect to the stylized object into more pacified levels, where one no longer feels alone. There – or so at least these unconscious events can be interpreted – the supra-individual law of the objective structure before us finds its counter-part in the feeling that we too are reacting with the supra-individual part of ourselves, which is subject to universal laws. Thus we are saved from absolute responsibility towards ourselves, from balancing on the narrowness of mere individuality.[19]

The style expressing the unity of a people is thus at the greatest distance from the 'manner' of artisans contributing their handiwork or their individual idea to the collective project. First, it implies the renunciation of the individual will. And the design of stylized objects must make this disindividualization enter everyone's consciousness through the habits of everyday life. The proper form of useful stylized objects no longer synthesizes the organic forms of nature, as it does in Ruskin. It is the 'abstract' line through which the will of art is imposed on nature, the 'gothic' line theorized in the same period by an art historian, Worringer, as a response to the anxiety of living. On the clock Behrens designed for AEG, there was only some discreet moulding on the side and a tiny volute at the base softening the rigor of straight lines. When it came to stylizing the life of the greatest number through these purified lines, the adequate form of such aesthetic education was the serial production of objects manufactured for the masses. Industrial 'functionality' thus articulates the 'aesthetic' principle of an art of pure lines with the economic principle of the mass production of useful objects. But it articulates it in the name of an ethical function of art. The most eloquent advocate of *types* within the Werkbund, Hermann Muthesius, clarified the re-educative function of the serial production of normalized objects:

> Applied art now faces a daunting educative task ... It is becoming something more than applied art: it is becoming a means of cultural education. Applied art now has the goal of reeducating all classes of present-day society in the virtues of sound workmanship, truthful-ness, and bourgeois simplicity. If it succeeds, it will profoundly alter our culture, and the consequences will be far-reaching. Not only will

19 Simmel, 'Das Problem des Stiles', p. 380; 'The Problem of Style', Ritter transl., p. 68.

it transform the rooms and buildings in which people live: it will directly influence the character of a generation.[20]

The very virtues of industrial standardization affirmed the unity between function and expression once again. But the problem, solved in sociological terms, allowed the tension to persist on the artist's side. And the Werkbund finally exploded when Henry Van de Velde and his friends set the unalienable rights of artistic individuality against the standardized types Muthesius prescribed. Yet if the claim to artistic sovereignty was opposed to the affirmation of the virtue of standardized types, it was still on the basis of the same fundamental idea: the vocation of art to develop forms that educate a society. The theorist of the house as 'machine for living', Le Corbusier, who went on a pilgrimage to the Turbinenhalle, as others had gone to Bayreuth twenty years earlier, would not stop repeating this in issues of *L'Esprit nouveau* after the First World War: architecture is more than construction, it is the 'masterful, correct, and magnificent play of volumes brought together in light'.[21] Only this 'more' must not appear as such. The same science of lines and volumes responds to the 'typical need' ('*besoin-type*') and gives rise to a 'typical emotion' ('*l'émotion-type*'), the happy gaze of feeling a thought expressed in the prisms created by light.[22] The precise satisfaction of the needs of modern life is also an education for the eye in the harmony of forms, thus an education of minds for a harmonious society, a society 'redeemed' from individualism, purified of the dross it leaves on the surfaces of buildings and objects, which these sickly surfaces transmit to men whose everyday backdrop they constitute. The functional surface also splits in two. On the one hand, its pure functionality already expresses an inner necessity, a form of spirituality. This concept of 'inner necessity' or this 'spirituality' – later championed by Kandinsky and considered the privilege of pure and autonomous art by countless critics – was first put to work by the

20 Hermann Muthesius, 'The Significance of Applied Art', in Isabelle Frank, ed., *The Theory of Decorative Art: An Anthology of European and American Writings, 1750–1940* (New Haven: Yale University Press, 2000), p. 78.
21 Le Corbusier, *Vers une architecture* (Paris: Vincent, Fréal & Cie, 1958), pp. 16ff; *Towards an Architecture*, transl. John Goodman (London: Francis Lincoln), p. 102.
22 Ibid. pp. 165, 84.

'applied' artists, artists who sought to educate society through the form of buildings and useful objects.

Thus, on the one hand, pure adaptation to function bears the expression of a reformed life within itself. But, on the other hand, this reform of sensibility must signal itself. Hence the straight lines curve at the corners of the sidewall of the Turbinenhalle, and contradict their verticality with horizontal stripes copied from the facades of Florentine palaces. This is also the reason the ridgeline fluctuates between a straight line and a curve: hesitation between a Greek temple and a Gothic arch, but also a Wincklemannian fusion of contours. The same play is repeated on the pediment in the simple hexagon where the three letters AEG, designed by Peter Behrens, are spread in the middle of six compartments, just like the inscription TURBINEN FABRIK that appears below it. The turbine factory, well designed to accomplish its function, is also a temple of work. In its own way it fulfils the religious function that Behrens first expected from a theatre-temple, where the stage and the hall communicated in unseparated space, to celebrate the new 'festivals of life and art'. And the logo itself, despite the attempts at typographic simplifications led by Behrens, did not meet a pure objective of legibility. Its six alveoli are not only there to separate the three letters of the logo distinctly. They recall the forms of certain Roman jewels studied by Alois Riegl in *Spätromische Kunstindustrie* ('Late Roman Art Industry'), but also the facets of a diamond. More precisely, they recall the diamond, the symbol of the new life of new souls, celebrated by Georg Fuchs's poem *Das Zeichen* ('The Sign') and solemnly exhibited, like the Grail in *Parsifal*, during the 1901 opening ceremony organized by Peter Behrens for the artist Colony in Darmstadt. This relation between the mystical diamond of an educating art and the workman's labour is expressed in striking shorthand in a musical drama whose text was published in 1911: Schönberg's *Die Glückliche Hand* (*The Lucky Hand*). In the third scene, a man – a poet educator – shows workers bound to their task in a cave recalling Mime's forge, how to proceed to make a culture out of work: 'it can be done more simply', he tells them, by transforming a block of gold into an ornament through a single hammer blow. Here the simplification of forms and procedures that we normally associate with the reign of machines is, on the contrary, associated with art, alone capable of spiritualizing industrial

work and common life. The work of the musician who would be considered the champion of the modernist revolution only makes sense if we draw it closer to the evolution stretching from 'festivals of art' to the construction of model factories. It reminds us that it is in the theorization of 'applied' arts that one must seek the genesis of formulae that would be used to emblematize the autonomy of art.[23]

23 It is understandable that this work caught the attention of Adorno, who wrote a long and suggestive commentary about it. But, by finally reducing the gesture of the hero to a defence of 'the magic of the old mode of production' (*Philosophy of New Music*, transl. Robert Hullot-Kentor [Minnesota: University of Minnesota Press, 2006], p. 40) Adorno fails to recognize the paradoxical genealogy leading from Ruskin to the Werkbund and Bauhaus, and simultaneously the role of debates concerning applied arts in the construction of the categories of artistic modernism.

9. Master of Surfaces

Paris, 1902

Rodin knew well that the most essential element of this work was a thorough understanding of the human body. He explored its surface, searching slowly, until a hand stretched out to meet him, and the form of this outward gesture both determined and was expressive of forces within the body. The further he went on this distant path, the more chance receded, and one law led to another. And in the end this surface became the subject of his study. It consisted of infinite encounters between things and light, and it quickly became clear that each of these encounters was different and all were remarkable. At one point the light seemed to be absorbed, at another light and thing seemed to greet each other cautiously, and then again the two would pass like strangers. There were encounters that seemed endless, and others in which nothing seemed to happen, but there was never one without life and movement …

It was only then that traditional notions of sculpture became worthless for him. There was no longer any pose, group, or composition. Now there was only an endless variety of living planes, there was only life and the means of expression he would find to take him to its source. Now it became a matter of mastering life in all its fullness. Rodin seized upon life as he saw it all around him. He observed it, cleaved to it, and laid hold of its most seemingly minor manifestations. He watched for it at moments of transition and hesitation, he overtook it in flight, and everywhere he found it equally great, equally powerful and enthralling. No part of the body was insignificant or trivial, for even the smallest of them was alive. Life, which appeared on faces with the clarity of a dial, easily read

and full of signs of the times, was greater and more diffuse in bodies, more mysterious and eternal. Here there was no deception. Here indifference appeared as such, and pride was simply pride. Stepping back from the stage provided by the face, the body removed its mask and revealed itself as it really was behind the curtain of costumes. It was here that he found the spirit of the age, just as he had discovered the spirit of the Middle Ages in its cathedrals: gathered around a mysterious darkness, held together by an organism, adapting to it and in its service.

Here is a way of discussing sculpture that seems to go against well-established truths on the subject, beginning with the one that considers it a three-dimensional art. The word 'volume' is absent from these lines, as it is throughout the text that the young poet Rainer Maria Rilke devotes to Rodin's art.[1] The word 'surface', on the contrary, recurs persistently, coupled with a word normally reserved for discourse on painting, and particularly impressionist painting: 'light'. The plastic surface is defined as a series of 'infinite encounters between things and light'. The poet could have left the metaphor of encounter abstract. Instead, he pursues the same vein of images, making light and things into people who greet each other cautiously or pass like strangers. The sculptor thus becomes a hunter waiting for life where it must pass and an athlete running to catch it. It does not suffice for Rilke to smash the plastic form, traditionally associated with the image of the sculptural body. He also transforms sculpture into what, since Lessing, it has been considered incapable of being: an art of time. And in order to completely reverse the Laocoön thesis, he borrows the rhythm and the meter of his writing from this sculpture-time.

One could consider this description to be hyperbole generated by the visitor's emotion and the poet's exalted imagination. But the feverish sentence and the luxuriant metaphor only accentuate ideas that distinctly belong to the sculptor's thought or to the already established criticism about him. The emphasis placed on the surface responds to Rodin's insistence on sculpture as an art of planes, at the cost, it is true, of displacing its meaning: for the sculptor, the plane is 'volume – height, width, depth – respected and exactly rendered

1 Rainer Maria Rilke, *Auguste Rodin*, transl. Daniel Slager, with an introduction by William Gass (New York: Archipelago Books, 2004), pp. 36–7.

on all sides'.[2] Thus the surface is nothing but the protrusion of an inner volume. The poet, on the contrary, emphasizes the 'hand' that externally limits the surface – that is to say, life, organizer of encounters that make something exist as a surface touched by light. Rodin also refuted the prevailing opposition between static sculpture and narrative and dramatic temporality. But the examples he uses to illustrate it, notably by focusing on parts of the body during different moments of the same action in a sculpture by Rude, still belong to the classic idea of action as a will imprinted upon a body. On the contrary, the infinite encounters between things and light celebrated by the poet translate the collapse of this idea and the sensible universe in which it took form. Bodies do not act; from now on, actions constitute bodies. What the poet sees on surfaces in movement thus exceeds the sculptor's purpose. But this excess is not arbitrary. Rilke systematizes the efforts of those who had already tried to think about the novelty that Rodin's œuvre signified. He had clearly read the collection *Auguste Rodin et son œuvre*, which gathered the most important texts devoted to the sculptor by Gustave Geffroy, Octave Mirbeau, Camille Mauclair, Roger Marx, Gustave Kahn and a few others, two years earlier. His text was inspired by the critical tradition established during the two exhibitions, which were the artist's crowning glory: the 1889 Monet–Rodin exhibition, which generated the first major critical recognition for new art in the margins of the Universal Exposition and the splendours of official art, and the Rodin pavilion annexed to the 1900 Universal Exposition, which garnered international glory for the sculptor. This tradition did not limit itself to illustrating the artist's ideas through a description of his works. It made him into an emblem for a new paradigm of art expressing a new idea of thought. His sculpture was not considered the highest achievement of a specific art, but a mode of materialization for thought capable of unveiling the features of this new idea of art and thinking circulating between Wagner's music, Mallarmé's poems, Loïe Fuller's dancing, Monet's 'naturalist' painting, Gauguin's 'synthesist' painting, Maeterlinck's 'symbolist' drama, and Ibsen's 'realist' plays.

2 Judith Clavel, *Auguste Rodin: l'œuvre et l'homme* (Brussels: G. van Oest, 1908), p. 56. I have kept the word 'surface', used by Rilke's French translator, Maurice Betz, for *Fläche* and *Oberfläche*. This translation takes into account the meaning Rilke added to Rodin's 'plane'.

The novelty signalled by Rodin's œuvre could be summarized in an essential reversal, which gives the fragment and incompletion the value of the whole. This reversal is immediately underscored in the text Gustave Geffroy wrote for the catalogue of the 1889 exhibition. Before commenting on the sculptor's works, Geffroy leads us into his workshop, described as a chaos of scattered elements strewn about, meant to be assembled on the *Gates of Hell*, without our seeing how, as yet,

> Everywhere in the vast room, on the saddles, the shelves, the sofa, the chairs, the ground, statuettes of all sizes are spread, raised faces, twisted arms, stiff legs, mixed up randomly, supine or standing, creating the impression of a living cemetery. Behind the *Gate*, six meters high, there is a crowd, a mute and eloquent crowd, where each individual must be seen separately, as one flips through and reads a book, lingering over pages, line breaks, sentences, and words.[3]

The great novelty of the exhibition was in effect meant to be the presentation of a completed version of the *Gates of Hell*, which the sculptor had been working on for many years, at the same time as the *Burghers of Calais*. In the end, there were only plaster fragments. And, as a matter of fact, the critic did not focus on the assemblage of groups, but on the scattered elements insofar as they were scattered. The sculptor is not the one who gives the stone the form of a body or a group in action. He is the one who has to deal with a people, with a crowd of 'individuals' who are gestures, attitudes that should be given their just place. The same year, an American visitor focused on the mass of disparate figures stacked on the doorframe like a 'sea of uneasy souls impossible to keep within the stately authority of an architectural form'.[4] Geffroy, in turn, reversed the criticism the traditionalists addressed to the new artists: according to them, the latter only presented the public with studies, outlines and rough sketches, instead of completed works.

3 Gustave Geffroy, exhibition catalogue, 'Claude Monet, Auguste Rodin', presented in Paris, Galerie Georges Petit, 21 June–August 1889, pp. 56–7; reproduced in facsimile in *Claude Monet–Auguste Rodin: centenaire de l'exposition de 1889* (Paris: Musée Rodin, 1989).

4 Truman Bartlett, in *American Architect and Building News*, quoted in Albert Edward Elsen, *The Gates of Hell* (Stanford: Stanford University Press, 1985), p. 127.

He gave the argument positive value: the sculptor's work is meant to capture and collect the fragments of a whole to come – gestures in plaster destined to be assembled on the plaster gate that will give the public an image of the future bronze. Moreover, he gives these plaster fragments meaningful traits and a name: they are a people of individuals. This people bears the traits of menace and confusion that the bourgeoisie classically attributes to the people: lifted faces, twisted arms, stiff legs, pell-mell. But it is also a people of the dead we browse like a book. No doubt here the militant writer Gustave Geffroy is recalling the words addressed to the historian of republican France by the anonymous shades of Hell: 'We have accepted death for one line by you.'[5] More than Dante, who furnishes the *Gates* with its group of damned lovers, Paolo and Francesca, and Ugolin devouring his children, the metaphor of the book to browse through is addressed to the republican people. But it is more than a metaphor: the sculptures do not receive their visibility from any norms of a well-proportioned body, an impassive line, a pregnant moment of action, or an expressive face. It is the anonymous people of literature: not the Balzacian human comedy, which Rodin would strive to capture in a bodily movement, to the great disappointment of the literati expecting a portrait of the novelist; rather, Flaubert's people, a democratic people of a new genre, not made from popular types but from the mixing of insignificant gestures and mundane moments, captured sentence by sentence like leaves equally tormented by the impersonal breath of infinity. Flaubert opposed this microscopic equality of leaves, all different but equally 'tormented', to that of democratic orators. But between the democratic harangue and the indifferent swaying of leaves in the wind, there is precisely the infinite people of gestures and attitudes, all these movements of which bodies prove capable each day, all those which arrive when two bodies are in contact with one another and that plastic art, with Rodin, finally begins to explore.

This is Rodin's great discovery, according to Geffroy: ' ... new attitudes ... the infinity of possible attitudes, engendering one another through the decomposition and the recomposition of movements, multiplying themselves in fleeting aspects each time the body

5 Jules Michelet, 1869 preface to *Histoire de France – Moyen Âge*, in Paul Viallaneix, ed., *Œuvres complètes*, vol. V (Paris: Flammarion, 1974), p. 24.

shifts'.[6] Classical statuary was condemned to ignore these attitudes out of obedience to the principle that limited the body to expressing a determined feeling or a determined moment of a meaningful action. However, this principle gave art a contradictory norm. This was Lessing's profound lesson in *Laocoön*. The problem was not only that the representation of the screams of the Trojan priest would have contradicted sculptural harmony. The contradiction lay in the very idea of representing the pregnant moment of an action. In its desire to express a given feeling or a precise action exactly, the plastic figure deprives itself of an essential resource of art: the one brought to it by the spectator's imagination. The right solution was thus to reduce the determinateness of the action and the expressive power of the body. Thus, Lessing said, the sculptor had to avoid the climactic moment of Laocoön's pain. This is also why Winckelmann discovered the perfection of art in a mutilated torso, where thought was expressed within the folds of muscles alone, swaying like the sea waves. The perfection of sculpture, the perfection of visual art in general, demanded the limitation of its possibilities. But this limitation held it in an inferior position relative to poetry and its actions, exempt from showing what they resembled. For plastic art to be its equal, it needed to carry out a decisive reversal: to renounce using the organic body as a motor for action; better yet, to undo this body, to dismantle it into multiple unities identical to multiple gestures or scenes.

This is the operation underlined by the critical gaze, which did not begin with the whole, or the monumental group, but focused instead on the multiplicity of individualities that had to be assembled without hierarchy. The scattered statuettes are not parts of the whole constituted by the *Gates*. Each one in itself, like a sentence by Flaubert, Rodin's favourite novelist, is a complete individuality, carrying the potentiality of the whole. And this applies to parts of the body as well as to parts of monuments. If the *Torso* Winckelmann describes had been mutilated by the accidents of history, Rodin deliberately created bodies lacking heads and limbs: *The Walking Man* without a head, *Inner Voice* without arms, *Balzac* with limbs hidden by a dressing gown. Spectators, like the literati who had sponsored the *Balzac*, were astonished or indignant before these

6 Geffroy, 'Claude Monet, Auguste Rodin', p. 60.

incomplete bodies. But this, Rilke objected, was a reaction due to an error that made the unity of a work coincide with that of a body. This held for these bodies without arms as well as the trees cut off by the corners of impressionist paintings. They show us that the very nature of unities has changed. On the monument for Victor Hugo, the body without arms of *Inner Voice* composes a totality lacking nothing: it has an attitude sufficiently individualized through the inclination of the body and the opposite twist of the neck bending the head perpendicular to the chest, both focused on itself, and listening for the distant rumour of life. And these hands, which the artist often enjoyed representing and exposing by themselves, do not lack anything either:

> The artist's task consists of making one thing of many, and a world from the smallest part of a thing. In Rodin's work there are hands, independent little hands, which are alive without belonging to any single body. There are hands that rise up, irritable and angry, and hands whose five bristling fingers seem to bark, like the five throats of a hellhound. There are the hands that walk, hands that sleep and hands that wake; criminal hands weighted with the past, and hands that are tired and want nothing more, hands that lie down in a corner like sick animals who know no one can help them … Hands have their own stories; they even have their own culture and their own particular beauty. We grant them the right to have their own development, their own wishes, feelings, moods, and occupations.[7]

It seems that there is a lot of literary style in these lines, which outdo the text Gustave Kahn had devoted to the same topic in the 1900 collection.[8] But this 'literary' excess is precisely there to undo the evidence that linked forms of sculpture to traditional bodily

7 Rilke, *Auguste Rodin*, p. 45.

8 'Rodin is the sculptor of hands, furious hands, clenched, unruly, damned. Here is one that twists as if to grasp the void, pick it up and knead it, like a ball of snow and bad luck to throw at a lucky passerby. Here is a tremendous one that crawls, violent, furrowed with cracks, with a strained tentacular movement, with a movement like an unnatural beast, crippled, marching towards an invisible enemy on bloody stumps; here is another crushed onto a smooth, empty surface, with deliberate weight, grasping uselessly, fingers sliding over the wave like an argument for innocence in the mind of an executioner.' Gustave Kahn, 'Les mains chez Rodin', in *Auguste Rodin et son œuvre* (Paris: Éditions de La Plume, 1900), pp. 28–9.

representations, from the adjustment of its limbs to the lexicon of its actions and expressions. Undoing this evidence does not entail transforming plastic art into a matter of forms, lines and volumes alone. Those who think they have discovered the formula for the modern and autonomous work in this formal geometry, opposed to the mimetic tradition, forget that it is itself entirely dependent on the representations of the body and ideas of plastic perfection that govern this tradition. It is almost as if literary revolution were defined by the autonomous use of alexandrines, purified of the stories of ambitious princes and jealous princesses. The young poet, just like the sculptor and his critics, knows that the regularity of alexandrines and the jealousy of princesses go together. It is a revolution of an entirely different scope that he sees with them in Rodin's people composed of bodies without arms and hands without bodies. There is no question of the autonomy of the arts, forms or works. It is a question of truth, a question of rendering the thousand manifestations of life autonomous and visible in bodies. This truth is not to be sought on faces that hide it under the features of conventional expression, but in bodies where it becomes diffuse. But in order to find it the body parts must be freed from accepted identities and functions. The poet does not describe hands that sleep or wake, rise, walk or bark according to the whims of his imagination. All these actions are opposed to the functions classically assigned to hands: to take or indicate, through which they accomplish or symbolize the identity and the will of their owner. The classic relation of the part to the whole consists in this relation of appropriation, this affirmation of property. Hands that sleep, wake or bark signify its ruin. Action is a unity in itself. The hand that touches or takes is a hand that detaches itself from all property, all personality. Henceforth, action creates unity, not the acting subject. Thus any part can constitute a body lacking nothing. Inversely, the body can transform itself into its own part, or more precisely, into the action of its own part, or into the action of any thing whatsoever: on the *Gates of Hell*, the *Thinker's* body has entirely become a skull, while others fall thing-like into an abyss, listen like faces, or gather momentum like arms set to throw.[9] The poet's metaphors are here to signify this great metonymy, this great displacement through which any part becomes

9 Rilke, *Auguste Rodin*, p. 50.

a totality and any totality plays the role of a part. Whole and part are actions, manifestations of a totality, nowhere closing into an identity and nowhere enclosing themselves as a property: the large, vibrant surface on which bodies and limbs are nothing but individualized scenes of impersonal life:

> Just as the human body is a whole for Rodin only insofar as all its limbs and powers respond to one common (inner or outer) movement, so do the parts of the various bodies come together of inner necessity to make up a single organism. A hand lying on the shoulder or thigh of another body no longer belongs completely to the one it came from: a new thing arises out of it, and the object it touches or grasps, a thing that has no name and belongs to no one.[10]

A work exists, as a self-sufficient unity, to the extent that the potentiality of an open whole is expressed within it, a whole that exceeds all organic totality. Strictly speaking, there are no forms. There are only attitudes, unities formed by multiple encounters of bodies with light and other bodies. These attitudes could also be called surfaces. For surfaces are something entirely different than combinations of lines; they are the very reality of everything that we perceive and express: 'And as for what we call mind and soul and love; are they not all just a subtle change on the small surface of a nearby face? ... For all happiness that has ever thrilled the heart; all greatness that has nearly destroyed us with its force; every broad, transforming thought – was once nothing but the pursing of lips, the raising of eyebrows, the shadows on a face.'[11] Dramatic action and plastic surface can be reduced to the same reality: the modification of this large, vibrant surface, excited and modified by a unique force called Life.

One should not misunderstand the apparent banality of the word 'life'. The definition of plastic novelty hangs on its interpretation. Rilke saw Rodin's œuvre as the resolution of the perennial tension between three terms: 'body', 'life', and 'action'. Winckelmann and Schiller had recognized the freedom of the Greek people on the torso of Hercules at rest or Juno's face without will. Vanished freedom, Winckelmann had said, that one could only see from a distance, like the grieving lover who sees the vessel carrying the

10 Ibid., p. 45.
11 Ibid., pp. 70–1.

beloved recede forever. Soon after the revolution, which sought to revive this freedom, Hegel had altered the verdict: freedom was not dead, it had changed, and this modern freedom, realized in the prose of science, economics and the state, could no longer be represented as the perfection of a plastic body. His century transformed his verdict into a commonplace: the black, tailored clothes of bourgeois life were incompatible with the plastic beauty of bodies. This was the age of prose. But it is precisely the art of prose that brought a far more troubling revelation: the traditional hierarchies of action which had given their laws to the hierarchies of belles-lettres or fine arts were abolished for the sake of the equality of life. Now this 'equality' of life signified its indifference towards ends that subjects sought to realize. Stendhal's adventurers had to find themselves locked inside prison walls to finally taste the pleasure of existing. Balzac's conspirators manipulated all the workings of the social machine but failed each time they chose a distinct end for themselves. Tolstoy's generals vainly imagined themselves directing battles that were decided by a chance cry for help or an improvised cavalcade. Zola's scientific epic concluded with a newborn's solitary raised fist symbolizing the pursuit of life without reason. This is the lesson writers took from Schopenhauer all the more readily, since they recognized it as the conclusion to their own plots: the will exhausts itself for what it believes to be its goals and what in reality is merely the obstinate march of a life that wants nothing. Once again, this is the nihilistic lesson that Gustave Geffroy, the republican, the admirer of Blanqui, sees inscribed on the *Gates of Hell*:

> ... an entire poor humanity whirling vertiginously, falling into space and crawling on the ground, determined to live and suffer, bruised, wounded in its flesh and saddened in its soul, crying with pain and snickering through tears, chanting its breathless anxieties, its sickly pleasures, its ecstatic pains. Through these stones of chaos, against a fiery background, bodies intertwine, leave each other, rejoin, gripping hands seem ready to tear, inhaling mouths seem ready to bite, women run with heaving breasts, burning behinds, equivocal Desires and desolate Passions that shudder under the invisible whip of animal rut, or decline, distraught, regretting the sterile attitude of a greater pleasure, desired yet unlocatable.[12]

12 Geffroy, 'Claude Monet, Auguste Rodin', p. 59.

This commentary marks the paradoxical intellectual context where the thinking of artistic novelty spreads. Those who fought the academic tradition the most vehemently did so in the name of a 'naturalistic' understanding of artistic novelty. They welcomed the shimmering of light in impressionist painting as the ruin of academic stereotypes, the triumph of the 'open air school' that finally does justice to the reality of the incessantly changing aspects presented by things, according to the hour of the day and the variation of light. This truth linked to time was celebrated in 1889 by the most vigorous of critics, Octave Mirbeau, in the essay on Monet that was a counterpart to Geffroy's essay on Rodin. In the emblematic year of the centenary of the French Revolution, the same Mirbeau signed the vitriolic funeral oration of the last champion of pictorial academicism, Alexandre Cabanel: 'He can be summed up in a word: he hated nature; or rather he remained ignorant of it.'[13] The problem is that this 'nature', glorified by pictorial hymns to light, is the external manifestation of a life that itself is nothing but the vanity of a will determined to pursue meaningless existence. It is such consent to a life without reason, as much as the complacency of Zola and his disciples for the sordid aspects of existence and society, that gave rise in the 1880s to the reaction of young people who wanted to deliver literature and art to the cult of the Idea. The most explicit manifesto is no doubt the article written by the young critic Albert Aurier to celebrate Gauguin's *Vision of the Sermon* in 1891. The painting does not show any priests in the flesh, only the vision provoked by his word in the spirit of his female listeners: Jacob's struggle with the angel, which occupies a band of colour juxtaposed, without perspective, to the circle of Breton women in headdresses. No realism, and certainly no realism in the impressionist mode, but coloured forms that are there not to tell an anecdote, but as symbols expressing ideas; deliberately exaggerated attitudes not meant to signify bodily states, but rather the spiritual impulse that animates them or the ideal they tend towards.[14] Gauguin versus Monet, the Idea

13 Octave Mirbeau, 'Oraison funèbre', *L'Écho de Paris*, 8 February 1889, reprinted in *Combats esthétiques*, vol. I (Paris: Séguier, 1993), p. 353.

14 Albert Aurier, 'Le Symbolisme en peinture', *Le Mercure de France*, March 1891, pp. 155–65. I have discussed this text in my book, *Le Destin des images* (Paris: La Fabrique, 2003), pp. 95–102; *The Future of the Image*, transl. Gregory Elliott (New York and London: Verso, 2009), pp. 83–8.

versus Life, the painting of symbols versus the realist passion for shimmering light: the reflection on artistic novelty develops within this tension. Now Rodin's œuvre seems capable of resolving it. The 'fragments' he models, the bodies reduced to movement that pushes them towards one another, can be read in two ways: as the fruit of untiring observation that captures life at all its crossroads, or as pure symbols of a spiritual impulse. This is the identity of opposites celebrated by Rilke's text. *Inner Voice*, with its long neck perpendicular to the body is, in a sense, an impossible figure. But this impossible figure is not the arbitrary representation of an abstract idea, like the symbolist figures stretching towards their ideal sky mocked by 'naturalists'. It is a representation of movement achieved through the synthesis of multiple observed movements. Rodin, Rilke tells us, does not want to know the body, the face or the hand, but 'all bodies, all faces, all hands'.[15] However, it is not a matter of opposing empirical multiplicity with the unity of the idea. A new ideality must be opposed to the old one: for 'the body', 'the face' and 'the hand' do not exist. These terms are understood as a visual synthesis corresponding to a certain idea of totality, which is subject to the organic model. 'All bodies, all faces, all hands' is an impossible totality. But this impossible totality is the asymptotic unity obtained by the active synthesis of a multiplicity of movements whose subject is not a finished unity, the body, but an infinite multiplicity, Life. Life is no longer the great sombre and suffering depth evoked by Gustave Geffroy before the *Gates of Hell*, or that 'background' music that, for the young Rilke, could alone link beings represented on the theatrical stage.[16] It is an infinite power of invention of forms totally immanent to the movements and meetings of bodies. Geffroy was already correcting the nihilistic vision by insisting on the multiplicity of new attitudes, as numerous for the sculptor as the waves of the sea, grains of sand on the shore, or stars in the sky: 'Life passes before the observer, surrounds him with its agitation, and the slightest shudder, made perceptible, can be fixed into a definitive statue, as a brash and intimate thought can bloom in a lasting sentence,

15 Rilke, *Auguste Rodin*, p. 72.

16 Rilke, 'Notes on the Melody of Things', in *The Inner Sky: Poems, Notes, Dreams*, transl. Damion Searls (Jaffrey, NH: David R. Godine, 2010), pp. 45–64.

forever inscribing a state of humanity'.[17] Rilke makes the conditions explicit: in order to capture this potentiality of life and to give it form, one must renounce setting out from individualities constituted and identified according to the organic model. This is the new meaning that must be given to the word *modelé*. It is work that loses itself in the infinity of vibrating surfaces by renouncing everything that is predetermined by a name. Work that, like Life itself, strives to form

> without knowing what would result, like a worm making its way from place to place in the dark. For who can be uninhibited when confronted by forms with names? Isn't there inevitably some selection involved in calling something a face? But the creative artist has no right to select. The artist's work must be imbued with a spirit of unyielding dutifulness. Forms must pass unembellished through his fingers, like something entrusted to him, in order to be pure and intact in his work.[18]

Like a tireless observer, one must have noted the multiplicity of movements that escape their actors, the multiplicity of life's still unknown 'profiles', to be able to blindly participate in the work that gives a visible and lasting spatial form to this incessant production that no will guides. By revoking the Lessingian opposition between temporal and spatial arts, this idea of plastic work is liberated from the Schopenhauerian musical paradigm that dominated the reflection on art at the end of the nineteenth century. There is no reason to oppose the great murmur of original and unconscious will, expressed by the silent symphony alone, to the beautiful appearance of 'Apollonian' forms of plastic representation. 'Unconscious life' is once again, in a Hegelian mode, a life in search of its own meaning. But this exploration is no longer art's surpassed past. And this life in search of itself is no longer enclosed in the Hegelian opposition between the plastic precision of beautiful forms and the sublime indeterminacy of ideas in search of their matter. Rilke

17 Geffroy, 'Claude Monet, Auguste Rodin', p. 62.

18 Rilke, *Auguste Rodin*, p. 73. In this analysis, one can sense the effect of an attentive reading of the 1900 anthology, and more specifically of the text by the critic Yvanohé Rambosson, 'Le modelé et le mouvement dans les œuvres de Rodin' (in *Auguste Rodin et son œuvre*, pp. 70–3).

sees the classic closure of form and the gothic impulse towards an absent god succeeded by a new plastic form, linked to the discovery of all these gestures, all these 'profiles' that life was able to invent during the entire time that decency had covered up the naked body of classical sculpture. The unconscious to which this new plastic form testifies is not the brute drive of humanity pushed to want without purpose. Nor is it the vitalist impulse the choreographies of Rudolf Laban and Mary Wigman would try to express. It is a multiplicity of gestures not yet perceived, seeking their own meaning, because they are no longer governed by a straight line leading from a point of departure to a point of arrival. 'Countless transitions had intruded between these two simple moments, and it soon became clear that modern life, in its actions and in its inability to act, was to be found precisely in these intermediary states. Grasping had become different, as had waving, releasing and holding. They all were possessed of much more experience, but also much more ignorance.'[19]

The sculptor's 'blind' work can reconcile the contradictory ideals of the fanatics of the real and the champions of the Idea because it dissipates the great shadow of 'life without reason' that hovered over theories of artistic creation. Life is not without reason. It incessantly creates thoughts that are in search of their formulation and gestures that have not yet become singular. Plastic work gives a body to these thoughts by giving a plastic figure to these gestures. The poem of bodies that climb, dive, intertwine or separate on the *Gate* is, in its way, another poem of 'modern life'. These lines by Rilke are like a response to an author he probably had not read but whose thinking had impregnated all the fin-de-siècle reflection on plastic form. Interpreting Hegel in his way, Taine attempted to summarize what separated modern life from the old plastic ideal: it was not simply the black tailored clothes in which the bourgeois century had dressed the beautiful Olympic body. It was the physiological character distinct to modern man: *le nervosisme* (neurasthenia), the disordered agitation of individuals too busy with the tumult of urban life, too harried by the myriad thoughts and sights, too taken by a thousand secondary matters to be able to conceive defined ends and to elaborate the precise gestures tending towards their end – a

19 Rilke, *Auguste Rodin*, p. 49.

discus to throw or an army to plunge into battle – which animated classical statuary. By transcribing new ways of holding and throwing, tightening and waving, by exploring the infinite transitions between action and inaction, Rodin's practice relegated dissertations on modern *nervosisme* and attendant nostalgia about the beautiful body at rest and the body strained by the energy of action to the antique shop. Plastic form no longer preserved any ideal of forms, whether understood in the sense of the pontiffs of the Academy or of the lovers of Greek freedom. From now on it marched at the same rhythm as modern life, which an entire century had made its antithesis. Plastic form was no longer subordinate to the poetic plot, nor did it any longer oppose its own mastery of space to the temporal mastery of the poem. Far from becoming autonomous, one in front of the other, drama and plastic form, coloured surface and sculptural volume found their common principle in movement. During this time, movement again gave a name to a new art of dramatic plastic and visual forms: cinema. The relation of Rodin's kinematics to the arts of mechanical reproduction is decidedly contradictory. To those who rely on photography to condemn the attitude of Géricault's horses, simultaneously raising their forelimbs above and their hind limbs behind, the sculptor opposes the truth of art. But his argument itself is significant: if the painter alone expresses the truth, it is because he paints not a state of movement, but movement itself. He alone is faithful to reality, because 'in reality time does not stop'.[20] The painter is superior to the photographer, but insofar as he is a cinematographer. Henceforth, more than photography, plastic form remains faithful to the ideality of becoming. This is the exact identity of the spiritual impulse and the metamorphoses of matter, which find its most fitting incarnation in the encounters between movement and light. It is no accident that the young Prague poet celebrated it in 1902, the very year when a Secession artist built a pavilion, in his home town, specially dedicated to an exhibition of the master's works, which received a triumphant welcome. Indeed his text marks a time when 'impressionists', 'symbolists', 'expressionists', or artists by any other name – whether they painted the ethereal heights of spiritual life or the dark dramas of unconscious life, designed abstract decorations for elegant homes or extolled

20 Rodin, *L'Art: entretiens réunis par Paul Gsell* (Paris: Grasset, 1911), p. 63.

social struggle in anarchist journals – together, all of them, often close, at times the same, saw this new ideality exactly embodied in Rodin's œuvre.

10. The Temple Staircase

Moscow–Dresden, 1912

The scene supposedly took place in Egypt eight centuries before the common era, and the Greek historian recorded it for us: introduced to the holy of holies of the religion, into the 'House of Visions', he supposedly saw a beautiful dark-skinned queen sitting on a throne resembling a tomb, a beautiful queen whose gestures capture the sacred art of movement which is the true origin of theatre, its principle, entirely forgotten and perverted by the 'theatre plays' of the moderns:

> With so much ease did her rhythms alter as with her movements they passed from limb to limb; with such a show of calm did she unloose for us the thoughts of her breast; so gravely and so beautifully did she linger on the statement of her sorrow, that with us it seemed as if no sorrow could harm her; no distortion of body or feature allowed us to dream that she was conquered; the passion and the pain were continually being caught by her hands, held gently, and viewed calmly. Her arms and hands seemed at one moment like a thin warm fountain of water which rose, then broke and fell with all those sweet pale fingers like spray into her lap. It would have been as a revelation of art to us had I not already seen that the same spirit dwelt in other examples of the art of these Egyptians. This 'Art of Showing and Veiling', as they call it, is so great a spiritual force that it plays the larger part in their religion. We may learn from it somewhat of the power and the grace of courage, for it is impossible

to witness a performance without a sense of physical and spiritual refreshment.[1]

It is useless to look for an account of this initiatory encounter in Herodotus. The scene only ever existed in Edward Gordon Craig's imagination. He included this detour through antique myth to expose the principles of the theatre to come in the second issue of his review *The Mask*, published in London in 1908. The beautiful queen illustrates a myth: the myth of the true origin of theatre. It teaches us that the art of theatre does not consist in the writing of 'plays' that place characters in exemplary narrative situations, and are meant to be played by actors. It consists primarily in movement, in drawings of forms in space. These forms do not trace recognizable expressions of defined feelings. They trace the potential of invisible things, those things that can only be shown veiled – not because priests were busy hiding the truth from the masses under veils of mystery, as the age of the Enlightenment thought, but because the truth of existence itself is in the 'veil of Maya' that makes the stage of individual lives appear against the great backdrop of non-individual life, as the age of Schopenhauer and Nietzsche had discovered. In the Theban 'House of Visions', the queen is seated on a throne that is also a tomb. She holds her pain in her hands, the pain of existing, like a thing that can be calmly looked at and grace-fully played with. Her gestures are not those of a body that carries out orders or shows emotions. They are equivalent to the movement without life, without intention or emotion, of the water fountain that rises, breaks and falls back. They are a hymn to life, but a life that borrows its ornament from its opposite, by clothing itself in the beauty of death.

We are free to lend this goddess of Thebes an immediately contemporary face. The allusion would pay homage to the art of a person who shared Edward Gordon Craig's life for some time: Isadora Duncan. It was no accident that she attached the name of the goddess Isis to her first name, Dora. She worked to redis-cover the secret of the noble attitudes of dance on Greek vases, a

1 Edward Gordon Craig, 'The Actor and the Über-marionette', *The Mask* 1: 2 (London: April 1908). This text was republished in Franc Chamberlain, ed., *On the Art of the Theatre* (New York: Routledge, 2009), p. 40.

dance rid of any narrative plot, identifying the free use of the body with the execution of a sacred ritual. But this thinking that is freely exhaled in the movements of a torso, this calmly contemplated pain, this continual passage of one limb or one muscle to another, these human gestures equivalent to the regular movement of rising and falling water, this grace of movement similar to immobility, and of life adorned with the beauty of death, can be easily traced to its furthest origin: the Egyptian dancing queen is a serene statue of a Greek goddess, copied from Winckelmann but envisioned through a Nietzschean prism; a living statue that would fill space with these waves or water fountains in which Dionysian suffering and Apollonian serenity become equal.

This fusion between Winckelmann's Appollonian and Nietzsche's Dionysian Greece gives art and theatre their founding myth. Art, for Craig, is the ritual that makes one see the invisible, while keeping it veiled. Authentic theatre fulfils this idea of art by organizing space and bodily movements within space. In order to do so, the means of this sensible presentation must obey one and the same idea exactly. But what is commonly referred to as theatre is very far from meeting this demand. It subjects the visible manifestation of the invisible to an intermediary, which is as cumbersome as it is unruly: the body of the actor. In his person, the living body is transformed into an instrument to make it possible to see and feel what the words of the poem say. For this it was necessary to treat these words themselves as the expression of private feelings of characters, which the actor is supposed to perform. The opinion of the audience in a rush to recognize its thoughts and feelings on stage led to an identification of the power of art with the power of expression. But the opposite is true: the expressive gestures of the body are not meant for the artifice of art. The latter demands a material which the artist can use with certainty to express his own thinking. The actor is incapable of such accuracy when expressing the thoughts of another. Yet it is also true that tradition has transformed this lack into a virtue: one praises the actor's always singular performance, his ability to imbue his character's life with his own passing feelings and moods. But this amounts to transforming art into its opposite: the unveiled presentation of chance 'feelings' that mask the profound impulses of being. Expressive gestures are not made for art, but for confession. 'That, then, which the actor gives us, is not a work of art; it is

a series of accidental confessions.'[2] Such theatre must be destroyed if we want to rediscover the religious essence of theatre: the art of showing and veiling, the art of showing the veil, of exhibiting truth in its own form, which is the exposition of the veil.

In order to restore the art of the stage, one must undo the knot which had formed quite naturally around what the art of the poem and the human body had in common – namely, the use of words. Entrusting the expression of the poem's potential to the actor's performance cancels this potential. The poem displays the veil in its way, in its own material. This material is the word and nothing but the word. The latter determines its own sensible space – or its veil – called 'imagination'. The reality of the poem, which it shows and veils at the same time, is made of invisible forces that haunt words; they are the spirits that have no human form, no determinate place or age.[3] In Macbeth's story, spirits take hold of a man and plunge him into a hypnotic state, from which he will only emerge in the last act, seeking the meaning of his dream without understanding anything about the sequence of facts he has before his eyes. In its way, the poem exposes the relation between two sensible worlds, two heterogeneous forms of logic: reality – the relation between characters – that is the veil of Maya, and the dream that translates the truth of the obscure forces. In the order of the imagination, this relation is translated as a conflict of causal chains: behind a story of ambition and murder, there is the work of the obscure force that consumes two human beings in its flames.

This is the force that must be conserved for the poem in order to restore its own force to theatre. For theatre is not an art of the imagination. It is an art of the visible, an art of sensible presence that must use its own means to present the relation between heterogeneous realities. One must thus put an end to the long misunderstanding that entrusted the actor's body with the task of translating the poem into the order of visible presence. For this 'embodiment' of the poem effectively suppresses the tension between two sensible worlds which is its very soul. The living body reduces it, in effect, to its unitary logic, the passions of the soul translated into bodily emotions. We know what the actor's body does with Macbeth's

2 Ibid., p. 29.
3 Edward Gordon Craig, 'On the Ghosts in the Tragedies of Shakespeare', *op. cit.*, pp. 128–6.

hypnosis: it transforms it into the story of a brave soldier perverted by his wife's ambition, who is then struck with guilt and hallucinations. By trying to unite the art of the poem with theatre, the body of the actor annuls them both.

The mediation of the actor-interpreter must thus be banned. To show the weight of these invisible forces on stage, which constitute the soul of the poem, theatre must use its own means of showing the invisible, which the gestures of the goddess of Thebes illustrate. These means were readily reduced to a technical artifice: the 'Übermarionette'. Craig may have borrowed the idea from Maeterlinck, who had already prescribed that the new dramatic poem be entrusted to a novel interpreter, the android, similar to wax figures in museums. The lineage of this idea in twentieth century dramaturgy is well known. The Übermarionette would be the precise theatrical body, entirely subject to the power of the artist, entirely freed from the weight of living bodies and the routines of expressive bodies. But the Übermarionette is precisely not a technical invention. It is not a large marionette that can take the actor's place. There is no point in replacing living bodies with puppets on strings, if they fulfil the same mimetic function. The marionettes of popular theatre, which symbolist aesthetes became infatuated with, present the same degeneration of theatrical art as actors playing 'characters'. The point is not to invent a new accessory to renew the charms of *mimesis*. For some time, Craig undoubtedly pictured the actual creation of an Übermarionette theatre for the 1906 Applied Art exhibition in Dresden. The project was not executed, but above all, the Übermarionette was not, in principle, an artefact of wood or metal, but rather an idea of theatre. It was an attempt to restore the temple-theatre to its origins. The Übermarionette is the heir to the idol of Thebes. It belongs to this reinvented antiquity where certain people sought the features necessary to think a new divinization of terrestrial existence. It was no accident that Craig gave the new figure of this idol a German name: he calls it *Übermarionette*. The Übermarionette is beyond the marionette, like the Nietzschean *Übermensch* is beyond the human-all-too-human. It is the scenic translation of what the Theban goddess illustrates in the mythic order: life covered with the 'beauty of death', the force of the gesture that holds pain in its hands, instead of miming it through bodily expressions.

The Übermarionette is thus an idea more than an accessory. The idea is to undo the body of the expressive actor. The body must be fragmented into many entities. There are various ways of carrying out this division. The simplest assigns the action on stage to a masked dancer. Thus the living performance of the body is separated from the identity represented by the mask – even more so when the same performer can use many. Separation can be multiplied when the masked dancer's performance accompanies the words and the music of an actor and a singer hidden behind the stage.[4] The Übermarionette thus defines a distancing effect more radical than the one Diderot promotes. Diderot subordinated the expression of emotions to the intelligence of a calculating actor supposed to control the character to optimize his expressive powers. For Craig, this unifying function belongs to the stage director alone. He is the one who orders the actor/dancer to manipulate his own image to harmonize it with the architectural totality formed by the theatrical stage. The Übermarionette is the theatrical body brought closer to sculpture and the architectural space where it has its place and its life. For the art of theatre is primarily architectonic. Theatre is a ritual insofar as it is an organization of space. It is made of spatial lines, movements and lighting effects. The impersonal force of words has its equivalent in the moving line. It gives theatrical art its principle. One cannot conclude that this art must not use words or bodies. Yet words and bodies are materials like others, subject to the visual harmony of the moving line. There are no 'plays' in theatre. There are scenes, combinations between architectures, silhouettes, and the play of light that transform and melt into one another.

A famous text by Valéry evoked the young poet's emotion upon holding the proofs of *Un coup de dés* (*A Throw of the Dice*) in his hands. For the first time, he tell us, 'extension spoke, dreamed, gave birth to temporal forms'.[5] However, this dream of extension was limited to visualizing what Mallarmé's poem said. The arrangement

4 These different solutions imagined by Craig are analyzed by Hana Ribi, *Edward Gordon Craig: Figur und Abstraktion* (Basel: Theatrekultur Verlag, 2000), p. 54. See also Irene Eynat-Confino, *Beyond the Mask: Gordon Craig, Movement and the Actor* (Carbondale: Southern Illinois University Press, 1987).

5 Paul Valéry, *Variété*, in *Œuvres*, vol. I (Paris: Gallimard, 1957), p. 624.

of letters on the page, in italics, mimicked the shadow of doubt, when it did not simply imitate the shape of a boat or the Great Bear. Craig had something else in mind: not to use lines to mime what the poem said, but to invent an assemblage of forms, translating the unspoken potential manifested in the poem's words into the language of extension. The stage itself must be treated like a face. This face does not express any feeling hidden behind its surface. It presents successive aspects: spatial dispositions, states of light, and stases of time. Borrowing Maeterlinck's idea of a theatre in which things themselves become the actors of the drama, Craig visually conceptualized a drama in four episodes called *The Steps*.[6] The 'character' of the drama, in fact, is an architectural element bound for great success in twentieth-century scenery: the steps of a staircase. Not the luxurious stairs that were used as backdrops for princely plots involving murder and passion, but a staircase squeezed between two walls, like the ones that separate two levels in working-class neighbourhoods. The staircase is a new kind of character: it does not speak; it has states or moods that Craig translates in four scenes that evoke times of the day and ages of life. The silhouettes that fill space and belong to its moods appear in the following order. First, we see three children playing in the light at the foot of the staircase, similar, he tells us, to the birds perched on hippos in an African river, and uttering words that sound like the small noise rabbits make. Once the staircase falls asleep, a farandole of young people enters twirling, like the fireflies on the upper level, in a movement that is repeated in the foreground by the swaying of the dancing ground. The atmosphere darkens in the third moment, when age seems to weigh on the staircase: the waves of the dancing ground have become a labyrinth where a man is still, desperate to reach the centre, while a woman goes down the staircase, without the dramatist being able to tell us whether or not she is going to meet him and give him the thread leading him out of the labyrinth. What interests him, more than the fate of the human silhouettes, is the fate of the staircase, which, like Maeterlinck's lamps or windows, trembles with a larger and higher life than that of a man and a woman in search of each other. This is what the final nocturnal episode makes us understand. It is divided

6 Edward Gordon Craig, *Towards a New Theatre: 40 Designs for Stage Scenes with Critical Notes by the Inventor* (London–Toronto: Dent & Sons, 1913), pp. 41–7.

into three spaces. On the middle step of the staircase, it singles out a man who is tired of having pursued 'life's paths' in opposite directions, standing still against the wall, between the darkness of the lower platform that vaguely envelops a couple's shadow and the upper balcony, where two fountains of light appear successively, similar to the gestures of the goddess of Thebes.

The Steps, Craig tells us, belongs to the theatre of silence that differs from the theatre of words. This theatre is still to come. The drama is still on the page, contained in four drawings discussed in a few pages. The same collection presents us with a certain number of scenes detached from any particular plot: thus *The Arrival*, where it hardly matters who arrives; or *Study of Movement*, where one sees the silhouette of a man struggling with snow, not without the scenographer questioning: Would it be better to eliminate the snow to emphasize the man's gestures alone? – before objecting that it would be even better only to have movements without the man, and finally to have nothing at all. But the detached scenes of this theatre to come also offer models for the transformation of theatre as it exists, as plays to be performed. Thus Craig's pages interlace the drawing of these scenes with proposals about the staging of repertory works. The bird-children on the back of the hippopotamus recur on a staging planned for *Henry IV*: the staging pushes the tent and the battlefield to the background, to use the foreground for scaffolding on which actors stand, like swallows perched on telephone wires. The distribution of levels around the staircase in *The Steps* was also used in a set design for *Julius Caesar*, in which Marc Antony occupies the steps alone, while the crowd of the Roman people remains behind him on the level above, and the conspirators are assembled at the foot of the staircase. In other sketches, the solitude of man in the labyrinth belongs to Macbeth the murderer, a minute silhouette, crushed by the high towers of the castle and sinking into the maze of a seemingly endless corridor. Forever drawings: not the theatre of the future, but sketches that proposed to adapt his idea to this transitional art of staging responsible for producing theatre plays; but the sketches also piled up in notebooks, as the scenographer never had his own theatre, and theatre directors never lent him theirs.

There were some exceptions, however. Even if no one lent him a theatre, others did propose to use his idea of theatre to perform

repertory works. In Florence, La Duse agreed to perform in a staging of Ibsen's *Rosmersholm*, one of those 'realist' plays that could easily be interpreted as a poem of the invisible. And for his Moscow Art Theatre, Constantin Stanislavsky asked Craig to stage the theatrical work par excellence, *Hamlet*, the drama of the one who 'has the time to live because he does not act'. Staging *Hamlet* first involves bringing this 'inaction' to the stage. Hence, the first principle that the director established, astonishing the actors whom Stanislavsky had trained to take control of their characters, to probe the reasons that made them act, the era they belonged to and the milieu they came from, in order to find everything from the proper intonation and style to the right props to make the truth sensible to spectators. From the outset, Craig explained to these actors that the difficulties of the production 'lay not so much in what to do as in what to leave undone'.[7] What must not be done is to embody Shakespeare's text. As a poem, Shakespeare's text is self-sufficient and has no need to be staged. On stage, on the other hand, the words of the drama are simply materials the artist of the theatre appropriates by combining them with plastic forms, colours, movements and rhythms. However, Craig neither adds nor removes anything from Shakespeare's text. Yet he turns it into a sequence of words to which one must lend a tone, a colour and a movement. One should not simply conclude that the text is indifferent and simply offers a decorative pretext. The point is really to render *Hamlet* present on stage. But Craig agrees with Mallarmé and Maeterlinck that *Hamlet* is not the story of a prince who wants to avenge his father. *Hamlet* is the very sprit of the poem, the ideal life that it sets against ordinary reality. Staging *Hamlet* is staging the reality of the poem and its conflict with the other reality, which corrupt theatre feeds on: made of power and plots, crimes and revenge. 'In *Hamlet* all that is living in

7 Interview notes about the preparation for staging *Hamlet*, Bibliothèque nationale de France (BNF), Bibliothèque des Arts du spectacle (Paris), Ms B 25. A considerable portion of the manuscript was transcribed in Laurence Senelick, *Gordon Craig's Moscow Hamlet: A Reconstruction* (Westport: Greenwood Press, 1982). It is also analyzed in Arkady Ostrovsky, 'Craig monte *Hamlet* à Moscou', in Marie-Christine Autant-Mathieu, ed., *Le Théâtre d'Art de Moscou. Ramifications, voyages* (Paris: CNRS, 2005), pp. 19–61, and Ferruccio Marotti, *Amleto o dell'oxymoron, studi e note sull'estetica della scena moderna* (Rome: M. Bulzoni, 1996).

the theatre is struggling with those dead customs that want to crush the theatre'.[8] This is the reason there should not be the slightest harmony, or the tiniest possibility of reconciliation between Hamlet and the rest of the world. Craig's staging thus builds levels of reality, different sensible worlds, passages or barriers between these worlds. It isolates a figure to make it the measure of all others. This is what the staging of *Rosmersholm* had already done in Florence by isolating the figure of Rebecca West: she was no longer an ambitious woman, nor one mourning under the weight of guilt; she was the figure of life reaching towards the high window that opened onto Rosmer's 'house of shadows', in which 'living beings' lacking all real life moved about; she was a Delphic Sybil announcing great events.[9] In the same way, Hamlet is not an indecisive person. He is the representative of the potential of the poem, and the action is only his confrontation with the illusory reality of plots of power that theatrical plots mimic.

To give this confrontation its visible equivalent, Craig looked elsewhere than in Shakespeare's text for a 'portrait' of Hamlet able to generate theatrical drama. He found it in an anonymous sixteenth-century engraving that represents not the Danish prince but King Solomon. At the centre of the engraving, the king sleeps 'gracefully', crown on his head, under a canopy crowned with two sphinxes. On the left, the same king is shown sitting at his worktable. In the background, before the audience chamber, a couple on one side and a group of three courtesans on the other speak silently, leaving the king in peace, untroubled by the 'thoughtless, extravagant chatter' of characters busy in other rooms, their 'hasty actions' and their 'old fashioned quotations'. Here, he writes, dwells the soul of Hamlet that can leave the *role* of Hamlet to the tumult in the 'next room'.[10] This portrait of a sleeping prince must generate the drama. As Craig

8 Interview notes about the preparation for staging *Hamlet* (BNF).

9 Cf. Isadora Duncan, *My Life* (New York: W.W. Norton & Co., 1955 [1927]), p. 144. Laura Caretti, 'Rosmer's House of Shadows: Craig's Designs for Eleanora Duse', in Beate Burtscher-Bechter, Maria Deppermann, Christiane Mühlegger and Martin Sexl, eds, *Ibsen im europäischen Spannungsfeld zwischen Naturalismus und Symbolismus*, Kongressakten der 8. Internationalen Ibsen-Konferenz (Frankfurt am Main: Peter Lang, 1998), pp. 51–69.

10 Edward Gordon Craig, 'The True Hamlet', in *The Theatre Advancing* (Boston: Little Brown & Co., 1919), p. 270.

conceives it, it could be reduced to the monodrama of a man who divides his time between sleeping, sitting at his desk to study, and daydreaming. As a result, it would be essential that Hamlet always be present on stage as the very indicator of the sensible texture and mode of reality of each character and each scene. In the theatre, the tragedy of Hamlet too must be a moving montage of moods dominated by three tones: the abstract tone of Hamlet's emotions, the semi-realist tone belonging to the events of the plot, and the realist tone of characters who are committed to rationalizing its course – Polonius the wise man, the argumentative officers, and the learned gravediggers. In order better to accentuate Hamlet's isolation from the other 'characters', Craig planned to accompany him with the plastic figure of 'joyful death', the scenic incarnation of the goddess of Thebes, leaning over his shoulder during the famous monologue, which would have been delivered not in a melancholic tone, but in an exalted one. Failing to convince Stanislavsky about the merit of his discoveries, Craig was at least able to impose the visual structure of the conflict between two worlds. The opening scene provides the tone by contrasting the arguing officers with a mobile spectre hardly distinct from the colour of the high grey screens, which were Craig's great scenographic invention: with them, the scenery became an assembly of geometric elements no longer on perches, but simply placed on the ground and adjusted into modifiable arrangements throughout the play.

The following scene shows Hamlet in the position of King Solomon in the engraving: asleep, half-sitting, half-lying on a bench in the foreground. Behind him, the king and queen are sitting on their thrones in front of the screens, covered in golden paper, and arranged in a semicircle. A large coat embroidered in gold falls from their shoulders. It was supposed to wrap the totality of the court. Failing that, the golden hats of the courtiers allow them to be seen as one sole mass of undifferentiated gold, shining in darkness. Between the court and Hamlet, who answers the king and queen without looking at them, and whose words should not be interpreted as more than meaningless music, a barrier built with large cubes separates the two worlds, or the two 'chambers'. In the mass wrapped in gold one can discern the reality of the plots ignored by the supine dreamer. But one can equally see the dream – or the nightmare – of the drowsy prince within it: a dream populated with

fantastic animals. For, around Hamlet, Craig only wanted to see figures from a bestiary: king-crocodile, Polonius-toad, Rosencrantz and Guildenstern as chameleons or snakes … Thus the king must speak like a figure from the prince's nightmare – a half-animal, half-automaton being with enormous claws like arms and jaws that bite the words they utter like metallic sounds or meaningless grunts – before falling into darkness with the entire court, like a vanished dream, leaving Hamlet to wake up alone in a monologue delivered to himself.

For the tension between two worlds is a tension between the uses of language, between a language that is used to reason about situations and one that manifests the sensible texture and reveals gaps between multiple realities. Thus in Act IV, Ophelia's song must prevail like a series of words without meaning, addressed to no one, like slightly dissonant music that mixes into the madrigal sung by court ladies, while the king and Laertes – characters playing characters – absurdly insist on trying to grasp her allusions. In the same way, in the graveyard scene, Hamlet's voice must echo, like Dante's voice in hell, among the two quibbling gravediggers who stumble on the learned words and arguments that they imitate. Hence this scene had to be in a crater at the edge of which Hamlet leans, like the poet at the edge of the pit of the damned.

The poem would thus end up being staged, not as a text embodied by characters, but as a moving architecture of moods, lines, colours and tones. But this staging is opposed to another one, by Stanislavsky himself. He was willing to leave the mood scenery to Craig, but like Laertes or Claudius, he intended to read words as clues to feeling, and demanded his actors embody characters. Thus he refused to have only one true character opposed to an indistinct mass. He was willing to disguise Polonius with a shell taken from Craig's bestiary, but he did not at all intend to direct him as a toad, but as a good family man and a prudent politician. And for him, the king is a manipulative autocrat, not a crocodile; Ophelia, a young lover of high rank, not the street singer Craig imagined her as. The plastic and musical vision that constitutes the drama for Craig can be contrasted with his director's notebook, covered with arrows pointing out the 'invisible radiance of feeling' that the characters emitted or received. No craters, nor 'joyful death', would appear on the stage of the Art Theatre. Only a few scenes would carry the scenographer's

own mark: the high screens of the first scene, the golden mass of the court, the ditch from where Hamlet directs the play meant to trap Claudius, the final vision of Fortinbras as the archangel Michael in front of a forest of spears shaking in the breeze. For the rest, there were actors playing their roles, reducing Craig's role to the use of the screens that, moreover, fell over one hour before the curtains were raised. Craig concluded that the most talented and well-meaning man of 'modern theatre' was still light years away from the theatre to come. After the Moscow *Hamlet*, he only produced a single play, fourteen years later – Ibsen's *The Pretenders*, a work still emblematic of the new theatre, for it opposed two worlds and two men: Haakon, the pretender, who simply wanted to be king and unite his people, because he was 'stupid' enough to believe in the power of the will and its intrigues, and Skule, the pretender who doubted his right, waiting, like Hamlet or Wallenstein, for a decisive sign to act, because he suspected 'that a fixed purpose is little for a man' and instead wished to 'understand and taste the whole of life'.[11] Beyond this disqualification of royal will, the Danish public hardly appreciated seeing a bishop die in the middle of bluish cubes evoking the crates in a dock warehouse, and medieval Norway immersed in the ambiance of an Italian *campo*, decorated with French wall hangings, oriental doors and Japanese lanterns. The director returned to his miniaturized theatre in Florence and to his dream of art uniting 'the three great impersonal arts of the earth'[12] – architecture, music, and movement: a drama that could simply consist of the incessant displacement of projectors playing, like a violin bow, upon the patches of screens capable of moving on their own to any spot on stage; a stage divided into regular squares that became the upper sides of parallelepipeds, which climb up and down to open and close space incessantly, giving birth to steps, platforms, or walls, as required.[13]

Modular space, infinitely transformable through the displacement of combinable elements and the play of light, is at the heart

11 For these notes by Craig on the characters, see Frederic J. Mayer and Lise-Lone Marker, *Edward Gordon Craig and 'The Pretenders': A Production Revisited* (Carbondale: Southern Illinois University Press, 1981), p. 52.

12 Edward Gordon Craig, 'Motion: Being the Preface to the Portfolio of Etchings by Gordon Craig', *The Mask* I: 10 (December 1908), p. 186.

13 On this point, see *Scene* (Oxford: OUP, 1923).

of theatrical reform. This explains why Craig came to a dead halt when, during his winter in Moscow, a Russian benefactor showed him a series of designs, Appia's 'rhythmic spaces': tall pillars made of square blocks whose shadows were projected onto vast levels and platforms; a 'play of hills', made from the terracing of low walls at right-angles, like frozen waves; alleys of cypress trees in black geometric shapes; waterfalls like organ pipes; open spaces that the light transforms into clearings or islands, bathed in the Mediterranean sun or the rays of moonlight, or even inhabited by the solitary shadow of a cypress. At first glance, these are quite close to Craig's own spaces. The two men effectively share the same fundamental idea: theatre is primarily a matter of architecture, movement and light. Yet, on this common basis, two ideas of movement intersect, proceeding in opposite directions. Movement, for Craig, is the movement of the scene itself. It is both the temple of the goddess and the deploying of her gestures. From the Greek friezes that had inspired Isadora Duncan, Craig wanted to return to the temple from where they were taken. The theatrical idea is an idea that is realized in the construction of a space, and it is into this global architecture that these expressive bodies, made to admit weakness and not to realize ideas, must melt, like the thin silhouettes of his drawings. By contrast, Appia's rhythmic spaces are not populated with any silhouettes. But their barren solitudes are platforms on which the moving sculptures of living bodies must be displayed. Appia thus understood the relation between the sculptural frieze and the dancing body in the exact opposite way. In his work, the task of lighting was always to sculpt bodies. Yet the bodies it sculpted were precisely bodies in motion. And it is this movement of bodies that must give concrete form to the interiority of the idea, a plastic form only supported by the architecture of the stage.

For Appia remains faithful to the idea expressed in *Staging Wagnerian Drama*: giving 'music' a visible spatial form. But the formulation of the problem had changed since the 1894 essay. Appia sought to overcome the dilemma encountered in the spatialization of Wagnerian music. He wanted to deduce the principle from the score alone, but, in fact, he found it elsewhere: in the philosophical essence of music, this renunciation of the will, symbolized by Wotan's progressive disinterest. The staging of *The Ring of the Nibelung*, like *Hamlet*, had to be, at its core, the manifestation of a

certain *inactivity*. Thus music and space remained separate in conse-
quence, united only in thought. The art of interiority could not give
itself the unitary formula of its spatial presence. This was hardly a
passing concern. It was a much more general problem that Hegel
had formulated: the sensible form of art cannot be the result of the
pure will to art; it can only be born in the encounter with what is not
art, with forms of education and the life of a community. A reader of
Hegel, often quoted by Appia, Hyppolite Taine, had developed its
consequences by explaining the principle of performance in Greek
art at length in his courses: in one term, *the orchestric*, he summed up
this education of the body given to young Greeks from good fami-
lies, which made them accomplished men in all physical exercises,
such as song and dance, as well as wrestling, capable of ending their
private banquets with 'an intimate opera at home',[14] but also skilled
at the art of leading choruses, dances and processions in honour of
the gods of the city, or capable of heading out for battle at the sound
of flutes. This orchestric or orchestic, which prepared bodies for art
because it prepared them for the luxuries of private life as well as the
duties and pomp of public, religious and military life, was exactly
what dancers, choreographers and decorators were attempting to
rediscover on Greek friezes and urns in museums. But for Appia
it was vain to look to works of art for the secret of this *predisposi-
tion of bodies* to art that made them possible. One could not find
the means of giving space to new music in the immobile lines of
Greek friezes. One had to search outside art, where it was a matter
of simply giving bodies health and a new balance. The new orches-
tric was called 'rhythmic gymnastics', and was based in Geneva in
the school run by Émile Jaques-Dalcroze. The latter was certainly
a musician, but he did not spend time creating works of art, only
bodies capable of feeling the rhythms that inhabit them and giving
them, through the control of each muscle, their exact figure in space.
Thus it was no longer necessary to set the architectural perfection of
light and movement against bodily anarchy, as Craig had done. On
the contrary, the principle for reuniting separate powers, which had
been Wagner's programme, was to be sought in the human body.
The only place where poetry, music and space could reunite was the
living body. It alone was capable of concretely wedding recitation

14 Hippolyte Taine, *Philosophie de l'art*, vol. II (Paris: Hachette, 1918),
p. 173.

and song, musical time and its spatial deployment. It was no longer a matter of simply offering bodies to music, which it used as exact instruments. It was necessary to deny the instrumental relation itself, carrying the cerebral control of the value of each muscular contraction in space and time to the point where this control cancels itself, where thinking is no longer separated from its modes of execution. The body's taking possession of its own rhythm suppressed the external relation between ends and means, between an idea and its execution, an art and its interpreters, an inner rhythm and its spatial translation.

Mise en scène is no longer the name of a new art, accomplishing the synthesis between separate arts of speech, sound and space. Rather, it designates the site of a conversion towards the only haven that lends unity to the forces of art: the living body. Platforms and staircases, made of combinable elements, are not at all meant to symbolize the idea of drama in Shakespeare, Wagner or Ibsen, but are meant to enable the collective deployment of the body's regained potential. In Hellerau, in 1912, the happy shadows and furies of Glück's *Orpheus and Eurydice* would demonstrate as much. Appia's staircases, in Jaques-Dalcroze's scenography, did not seek to solve the problem of the scenic representation of opera, but rather to use the scenes taken from the opera to show the potential of a new art – namely, the new union of art and life: a performance symbolizing the collective potential of bodies that have discovered their capabilities, by abandoning the passive attitude of those who watch shows in a theatre, or who gaze at works in a museum or luxury goods in a display window.

For, even if rows of spectators seated on benches faced the movements of the shadows and the furies that welcomed Orpheus, the place where they moved was not a theatre. It was an institution, specially built for Jaques-Dalcroze to put his teaching into practice and occasionally show its results. And it was no accident that this institute was located in the suburbs of Dresden. Hellerau was the seat of the Dresdner Werkstätten für Handwerkskunst, a workshop producing furniture and household instruments that was a factory like no other. Its founder, Karl Schmidt, was actually one of the founding members of the Deutscher Werkbund, the group of architects and designers who gave their art a social and spiritual goal at the same time: to give the décor and the objects of everyday

life a style, opposed to the anarchic multiplicity of styles created by the vanity of artists who sign their products to satisfy the vanity of clients trying to display their wealth or be admired for their taste. Styling the objects of everyday life seeks to rid them of design intended to signal artistic mastery or social rank; it gives them pure forms that suit their well-defined functions. Thus, they made useful objects into the formative elements of a new culture. These workshops where modern industry is allied with the artisanal tradition did not merely produce household goods, then. They also wanted to create the forms of a new life. Thus, Schmidt also had the first German garden city built for his workers designed by a Werkbund architect, Richard Rimerschmied. It was in this context that another member of the Werkbund, the philanthropist Wolf Dohrn, offered Jaques-Dalcroze a place that resembled what another founder of the association, Theodor Fischer, had already dreamt about: '... *a house* not to live in alone or as a family, but *for all*; not to learn and become intelligent, but *to be content*; not to pray following such and such religious conviction, but *for reflection and inner life*. Thus, not a school, nor a museum … And yet a bit of all that, *with something else added*.'[15] The architectural concepts of the Werkbund theorists coincide exactly with the plastic conceptions of Jaques-Dalcroze and Appia, adapting the architectural lines of buildings to the only activities meant to take place within them. Now, an educational institution is not an entertainment centre. It is a place devoted to two kinds of activity: first the courses addressed partly to paying amateurs, partly to the children of workers, admitted free; then come the meetings and festivals that gather the community of those concerned by this educative scheme and by its larger social calling. Thus, there was no theatre auditorium at the Hellerau institute, but a large common hall: a long, continuous rectangle where nothing demarcated a theatrical stage in front of the benches. The acting space was defined only by lines of markers, used for the curved movements of the rhythmicians, who were barefoot, wearing overalls or pleated dresses that showed their attitudes, to the sound of a visible piano or a hidden orchestra.

Those seated on the benches were not – should not have been

15 Wolf Dohrn, *Die Gartenstadt Hellerau* (Jena: Diedericks, 1908), p. 27, quoted by Marie-Laure Bablet-Hahn in her preface to Appia, *Œuvres complètes*, vol. III, p. 95.

– spectators watching a play, but men committed to the performance before them, equally responsible for the development of collective bodily potential. For the living art on display in the hall is antithetical to the very idea of an art that could be merely watched as a show. If the synthesis of thinking, music and space resides in the body of the rhythmician alone, the new art consists in the deployment of this synthesis for itself. This is what Appia sums up in a manifesto of the new art, the 'living' art of the future:

> our body is the dramatic author. The work of dramatic art is the only one that is truly identified with its author. It is the only art whose existence is certain *without spectators*. Poetry must be read; painting and sculpture, contemplated; architecture, surveyed; music, heard. A work of dramatic art is lived. It is the dramatic author who lives it. A spectator comes to be moved or convinced; therein is the limit of his role. The work lives of itself – without the spectator.[16]

The living work of art cannot be an object of representation. It is performed and shared. Thus a mixed crowd of residents from Hellerau and cosmopolitan aesthetes were not invited to a theatrical show in late June, early July 1912, but to an end-of-the-year celebration showing the work of the institute. They were invited to 'convince themselves' about the potential of art that can be deployed by those who have abandoned the position where they remained confined, those who have learned to 'overcome *the public*' within themselves.[17] The 'public', in short, attended its own defeat. It came – it had to come – not to watch a performance, but to disavow the position of the spectator: 'everyone basically felt that they did not have the right to watch the living drama before them, and that they were being done a remarkable favour, and that in order to be worthy of it they had to take part in the action itself, in the tears and the songs of the performers'.[18]

It came in solidarity with the expression of this life that had

16 Adolphe Appia, *L'Œuvre d'art vivant*, in *Œuvres complètes*, vol. III, p. 387; *The Work of Living Art: A Theory of Theatre*, transl. H. Darkes Albright (Coral Gables, FL: University of Miami Press, 1960), p. 54.

17 Adolphe Appia, 'Style et solidarité', in ibid., p. 72; 'Style and solidarity' in Richard Beacham, ed., *Adolphe Appia: Texts on Theatre* (London–New York: Routledge, 1993), p. 82.

18 H. C. Bonifas, article in *La Semaine littéraire*, 26 July 1913, in ibid., p. 220.

conquered its style, to countersign this nascent collective writing, which was the manifesto of a new aesthetic pact. The hall at Hellerau was not a modernized theatre; it was the prefiguration of a new bond. This place was just called the *Hall*, and would be the 'cathedral of the future, which in a vast, open and changeable space will welcome the most varied expressions of our social and artistic life, where dramatic art will flourish, *with or without spectators*'.[19] 'Just the hall' revoked any space separating the stage and the hall, the work of the artists and the lives of those watching. 'Aesthetic conversion' consists in 'taking oneself as work and tool, and then in passing on feelings, and the convictions that follow, to one's brothers'.[20] It is within the very heart of aesthetic religion that this faith is affirmed which will find its application in the heroic times of the Soviet revolution.

But it was not yet this future work of art that filled the hall of the Hellerau institute in 1912 and 1913. No doubt, Appia's system was loudly proclaimed there, but it was present above all through his staircases. Jaques-Dalcroze was logically responsible for directing actors, understood as conducting the work of the rhythmicians. But someone else was made responsible for the lighting effects. He sacrificed the active light of the projectors, essential according to Appia to build the relation between living bodies and inanimate space. He had favoured atmospheric lighting with changing colours, transforming the singers into figures from a pre-Raphaelite painting. As in Moscow, the winter before, the role of the artisan of the new theatre was reduced to the conception of set design. But, unlike Craig, Appia was no longer there to witness the disfiguration of his larger project. A fit of anger concerning the colourful costumes designers had proposed at one point made him abandon the stage where his vision was supposedly being put to work. And after the wartime silence, in the 1920s, he staged the only true *mise en scène* of his entire career on the opera stage: *Tristan and Isolde* at La Scala in 1923, denounced by critics as a 'Calvinization' of Wagnerian drama; the *Ring* in 1925 in Basel, interrupted by the cabal after two episodes.

19 Appia, 'L'avenir du drama et de la mise en scène', in *Œuvres complètes*, vol. III, p. 337; Beacham, *Adolphe Appia: Texts on Theatre*, p. 115.

20 Appia, *L'Œuvre d'art vivant*, in *Œuvres complètes*, vol. III, p. 394; *The Work of Living Art*, p. 67.

Impossible compromises, in a sense. More precisely, impossible to put to work for the inventors of the new stage. For others would be able to do so all too well. While Craig and Appia were sent back to their drawings or their marionettes, their platforms and their stair-cases would become emblematic elements of the stylized scenery of the new stage. At the reopening of Bayreuth in the early 1950s, they would even be the symbol of the denazification of Wagnerian opera. Yet the stairs would be there precisely without the temple whose steps they were: without the living stage, rid of human presence, whose effectiveness Craig had mimicked in front of the miniature Florence stage; without Appia's great dream temple of collective life, halfway between the celebrations of the Vevey winegrowers and the Soviet re-enactment of the storming of the Winter Palace. The temple of immobile theatre and the living body both exceeded, in opposite directions, the apparatus of the theatrical scene. They demanded that one cancel the theatre to realize its finally revealed or rediscovered spatial essence, in either the play of machines or the collective impulse of bodies. The two great renovators of theatre carried the logic of renovation to the extreme point where it signalled the death of spectacle performed on stage by actors for spectators. The realization of a true essence of theatre thus led to its suppression. Yet it was at the juncture of these impossible realizations – at the meeting point between the fusion of parasite bodies in the space of the stage made absolute and the over-presence of bodies denying the artifice of the stage – that the modern art of *mise en scène* would find its principles and its strategies.

11. The Machine and Its Shadow

Hollywood, 1916

Chaplin is undoubtedly the most cinematic actor of all. His scripts are not written; they are created during the shooting. He is nearly the only movie actor who originates from the material itself.

Chaplin's gestures and films are conceived not in words, nor in the drawing, but in the flicker of the gray-and-black shadow. Chaplin has broken with the theatre once and for all, so, of course, he deserves the title – the first movie actor ... In his films, Chaplin does not speak – he moves. He works with cinematic material instead of translating himself from theatrical into screen language.[1]

This judgment by Victor Shklovsky summarizes Chaplin's privileged status in the avant-garde thought of the 1920s quite well. However, this identification between the new actor's performance and the art of cinematic shadows was opposed by the judgment of one of the filmmakers who theorized the new art of cinema most intensely: Jean Epstein. He certainly admired the inventor of the Tramp, pictured on the cover of his pamphlet, *Bonjour Cinéma*. But for him Chaplin 'brought nothing to cinema itself', and must be studied 'as a phenomenon evolving in very narrow limits entirely at the margins of cinema, using the lens only with extreme caution, even suspicion, to record a pantomime born in the English music-hall,

1 Victor Shklovsky, *Literatur i Kinematograf* (Berlin: Helikon, 1923), p. 53; *Literature and Cinematography*, transl. Irina Masinovsky (Normal, IL: Dalkey Archive Press, 2008), p. 65.

only broadened by all the horizons of the screen, and yet meticulously admirable'.[2]

These two judgments do not only express the particular points of view of their authors. Rather, they reflect the ambiguous status of Chaplin's figure: on the one hand, it is entirely assimilated into the unfolding potentialities of cinematic art; on the other, it is relegated to the margins of this art, identified with a performance, which cinema is merely the means of recording, and fixed in a myth that became his emblem. These two contradictory arguments are based on the same principle: the new art of visual forms in motion is opposed to the art of representation – that is to say, to art based on the passive reproduction of a pre-existing given. It is a performance without mediation, without a copied model or an interpreted text, without opposition between an active and a passive part. Shklovsky and Epstein simply draw opposite consequences from this. The former tells us that Chaplin's pantomime breaks with the very essence of theatre: the subjection of an actor's performance to the interpretation of a plot. Chaplin does not create a visual equivalent for words; he gives ideas an immediately plastic form. Epstein admits that Chaplin's art is one of autonomous movement, liberated from the theatrical mediation of story and text. But this autonomous movement is not that of cinema. It is not produced by the cinematic machine's own distinct resources. It belongs to a traditional and popular genre of silent theatre. Faced with this pantomime, the camera serves as a simple recording device. It is thus as passive, as subject to outside data, as the actor was to the text.

The same idea of cinematic modernity thus gives way to two divergent accounts. Each one places the emphasis on an aspect of this modernity. Shklovsky privileges the rejection of plot in favour of an immediate motor and plastic performance. But the rejection of the traditional theatrical relation between text and interpreter cannot suffice to define cinematic novelty. Even less so, since from Appia, Gordon Craig and Meyerhold onwards, theatre had already begun to make this break. Moreover, Meyerhold developed the idea of movement that Shklovsky applies to Chaplin here: a succession of passages, each one of which is punctuated with a pause. Epstein thus has some ground both to deny that Chaplin's œuvre is purely

2 Jean Epstein, *Écrits sur le cinéma* (Paris: Seghers, 1974), pp. 243, 239.

cinematic and to lay claim to a specificity of cinema linked to its own instrument. But, inversely, cinema could hardly be defined as art by the mere fact of 'using lenses' for themselves or making them the sole performers of artistic intention. Cinema is not the art of the movie camera – it is the art of forms in movement, the art of movement written in black-and-white forms on a surface. Shklovsky's argument now regains its force. Charlie Chaplin's performances take place in front of a camera. But the movements 'Charlot'[3] traces on screen nevertheless create an unprecedented writing: a way of inscribing signs on a white surface that is no longer the transcription of words; a way of filling space with forms and movements, which are no longer the expression of definite feelings. The art of moving images cannot be reduced to that of the camera's movements. The 'medium' of cinematic art cannot be identified with the instrumental paraphernalia that captures movements, gathers and projects moving images. A medium is neither a basis, nor an instrument, nor a specific material. It is the perceptible milieu of their coexistence. The 'movements' of cinema define an art insofar as they transform distances and modes of perception, forms of development, and the very feeling of time. These perceptual distortions are not made possible by the camera's resources and montage tricks alone. These tricks remain technical performances that impose the artist's skills onto the machine's capacity. For there to be art, there must be an aesthetic scheme that holds together the two kinds of savoir-faire – the material they act upon and the one they produce – and that makes them contribute to the production of a new sensible fabric.

This is how the 'medium' of art always exceeds the distinct resources of an art. Cinema cannot simply become an art through its own material and instruments. Rather, it must rely on its capacity to adapt them to the new distribution of the sensible, at a time when a new art seeks to define itself through the discoveries of poets, choreographers, painters and theatre directors. Chaplin could use the film lens sparingly. But it is not without reason that his image adorned the pamphlet with which Jean Epstein saluted the new art of cinema. Epstein even gave us a reason for it himself: 'He is far

3 Translator's note: In French, Chaplin's 'Tramp' is called 'Charlot', which is also used as a moniker for Chaplin himself.

more alive than cinema.'[4] He lives, we are told, the legendary and impersonal life of Cinderella and Puss-in-Boots. But this explanation falls short. Epstein must have known that the artists of his time were not merely interested in characters from fairy tales and fables for their imaginary power. The simplicity of these characters and their stories lent themselves well to new attempts in art to recompose living figures based on abstract forms, and to replace plots with the mechanics of basic movements. Indeed, the little man with the jerky walk lives the same life that animates the prose of the filmmaker's friend and inspiration, the poet Blaise Cendrars, whose phrases for saluting the 'profound today' can readily be reduced to one word alone, bursting like the electricity of a synaptic charge. And his gait recalling a broken puppet, with a hat too small and shoes too big, a jacket too tight and trousers too baggy, shares a life with the characters made of rectangles and cylinders by his other friend, the painter Fernand Léger. Léger never made his film *Charlot Cubiste* ('The Cubist Tramp'), where Charlot had to pick up pieces of his pictorial body upon waking, and put them away at night. But he made Charlot the 'presenter' of the *Ballet mécanique*, the final episode of which consisted in the little man dividing himself into independent pieces in order to better salute the imaginary audience of the ballet mixing abstract forms, fleshy lips, mechanical parts and kitchen utensils.

Charlot's 'life' is thus nothing other than the very life of new art, an art that crosses the borders separating the different arts, as it crosses the ones that separate art from prosaic life and live performance from mechanical movement. The very conjunction of the word 'ballet' and the adjective 'mechanical' helps us understand the link between Charlot's performance and the becoming-art of cinema. For the art of the camera to be recognized as art, the frontier between the artistic and the mechanical had to disappear. For it did not simply oppose the inventions of art with the automatism of the machine. More deeply, it separated two types of bodies and two ways of using one's body. A 'mechanic' in the old sense of the term was not a man working on machines. He was a man enclosed in the circle of needs and services. The gestures of the 'mechanic' were as different from the man of action as everyday life was from nobility. For the moviemaker to become an artist, the gap between

4 Ibid., p. 240.

the two kinds of gestures had to be filled in. And it was more than affectation that made Chaplin's admirers make so many prestigious allusions about him, invoking everything from Shakespearean farce and Isadora Duncan's leaps to Watteau's Pierrots and Aubrey Beardsley's arabesques. In fact, Chaplin's fate as an artist and cinema's fate as an art supposed that the gestures of the little man and the movements of the camera be inscribed together in a continuum between popular art and great art, which would also be a continuum between pantomime and graphic line. Already in 1918, an American journalist had rebutted those who pointed out Charlot's 'vulgarity' by discovering a 'truly Shakespearean … note of tragedy' in the episode in *The Bank* where he picks up a bouquet scorned by his beloved.[5] Two years later, one of his colleagues sees 'a Puck, a Hamlet, an Ariel' in Charlot.[6] Adding to this Shakespearean allusion, Élie Faure invoked Watteau's gallant scenes and Corot's landscapes, while Aragon assimilated the vagabond to Picasso's harlequins. Quattrocento painting, modern-style graphic art and neo-Hellenic choreography were invoked together by Louis Delluc to celebrate the countryside ballet from *Sunnyside*, in which a cactus needle to the behind transforms Charlot into a faun, led in a dance by four nymphs with a Duncan-style tunic: 'Rhythmic gymnastics, Dalcroze, Duncan, Botticelli, Aubrey Beardsley, hang yourselves. The rhythm of the plastic line has a new master … Charlie Chaplin is a choreographer equal to Fokin, Nijinksy, Massine, and – do understand me – Loïe Fuller.'[7] The reference to Loïe Fuller should probably be 'understood' as the alliance between the veil, an ancient accessory of dance reinvented, and electric projection technology. A supplement to the issue that *Le Disque Vert* dedicated to him summarizes this identification of Charlie's figure with everything that new art expects from the conjunction of the décor of the Greek

5 Julian Johnson, *Photoplay* 14 (September 1918), quoted in Charles J. Maland, *Chaplin and American Culture: The Evolution of a Star Image* (Princeton: Princeton University Press, 1989), p. 49.

6 Benjamin de Casseres, 'The Hamlet-Like Nature of Charlie Chaplin', *New York Times*, 12 December 1920, quoted in Maland, *Chaplin and American Culture*, p. 63.

7 Louis Delluc, 'Une idylle aux champs', *Paris-Midi*, 17 December 1919, and 'Charlot brocanteur', *Paris-Midi*, 28 January 1920, both reprinted in *Écrits cinématographiques, vol. II: Le Cinéma au quotidien* (Paris: Cahiers du Cinéma, 1990), pp. 139, 151.

urn, Shakespearean enchantment, pictorial fragmentation, new choreography, and electric lighting: 'Charlie is a course in modern art. He is sudden. Neither circumlocution, nor introduction. He is immediate.'[8]

Immediacy is what the art of projected moving shadows demands. Since this art is deprived of living flesh, of the stage's depth and theatre's words, its instant performance must be identified with the tracing of a writing of forms. New art removes distance: the distance separating the idea from the form, the text from its interpretation, living performance from situations, thoughts and feelings that must be recognized there, and projected shadows from a story with a beginning, a middle and an end. Mallarmé summed it up once and for all: 'Modern man disdains the imagination, but, expert at making use of the arts, waits until each one carries him up to the point where a special power of illusion gleams out, then consents.'[9]

A special power of illusion denies the separation between the author, the work and the interpreter, and along with it the hierarchy of ends and means, of the active idea and the passive execution. But this suppression of mediation can be understood in two opposing ways. On the one hand, the author of the illusionist performance is the representative of the Wagnerian dream of total art, where the conceiver of the idea is also the one in control of its sensible execution in every detail. In this sense, Chaplin adapts the dream of total art to cinema's own means: the projection of a dramatic performance exactly identical to a plastic realization onto a flat surface. The cinematic-plastician Chaplin who 'does not play a role' but 'conceives the universe as a whole and translates it through the means of cinema' is, for Élie Faure, the new expressive instrument meant to animate 'the cinematic-plastic drama where the action does not illustrate a fiction or a moralizing intention but makes up a monumental whole'.[10] He uses the lens sparingly, but this very thrift enters into the conception of total art in which the same artist

8 *Le Disque Vert*, 2nd year, 3rd series, nos 4–5 (Paris–Brussels, 1923), p. 73.

9 Stéphane Mallarmé, 'Richard Wagner. Rêverie d'un poète français', in *Divigations*, p. 170; 'Richard Wagner: The Reverie of a French Poet', in *Divagations*, transl. Johnson, pp. 108–9.

10 Élie Faure, 'Charlot', in *Oeuvres complètes*, vol. III (Paris: Jean-Jacques Pauvert, 1964), p. 309.

produces the idea of a sensible figure and transmits it through the means of recording. This is what Louis Delluc summarizes in the painter's self-portrait: 'he is his own painter. He is the work and the author at once. He does what is only possible in the cinema – may dandyism pardon me! – that is to say: paint, model, and sculpt with his very own flesh and face, a transposition of art.'[11]

But the poet of the self is not the dandy who displays himself as a work of art. He is an artist who disappears into his creation – that is to say, in this case, into his own body, whose expressive possibilities he reduces to a few simplified poses and movements. The special power of illusion replaces the science of plots, represented characters, and embodied feelings with the immediacy of mute figures – figures that have an effect by melting into an outline, or singling themselves out through a few gestures and rudimentary attitudes. Charlot's panto-mime arrives at the right time to synthesize the two great virtues of simplification that poets, dramatists and directors sought to borrow from the art of fairground theatre, for over twenty years, in order to revive great art. On the one hand, pantomime is theatre placed at a distance, freed from the weight of bodies incorporating thoughts and feelings, the 'pure milieu of fiction' celebrated by Mallarmé, where the mime proceeds by 'perpetual allusion without breaking the mirror'.[12] Hence it responds to the dream of writing forms in space, where the poem could deploy its arabesque choreography on a blank surface. On the other hand, it is, inversely, the art of popular conventional characters, jokes and tricks, inherited from fairground theatre and the *commedia dell'arte*, and renewed by the new kinds of circus and music-hall. There seems to be a great distance between the quarrelsome harlequins favoured by some and the pale faraway princesses in the golden background imagined by others. However, fairground harlequins and dream princesses arise from the same concept: both are *types*, moving figures that dispense with the repre-sentation of characters and the embodiment of feelings. Thus, since the 1890s, the same renovators of theatre were able successively to look into both sides of the formula of new art. One man, one of the inventors of theatrical *mise en scène*, Vselovod Meyerhold was

11 Louis Delluc, 'Charlot' (1921) in *Écrits cinématographiques*, vol. I, *Le Cinéma et les cinéastes* (Paris: La Cinémathèque française, 1985), p. 84.
12 Mallarmé, 'Mimique', in *Divagations*, p. 179; 'Mimesis' in *Divagations*, transl. Johnson, p. 140.

able to summarize this double movement. A basic principle animates his work: 'Words in the theatre are only embellishments on the design of movements.'[13] In order to validate the stylization of theatrical movement, against Stanislavski's psychological realism, he first sought to deny the depth of the stage, and to group characters into collective frescoes inspired by Renaissance paintings. This is how he fused semi-mute figures from Maeterlinck's dramas, as if into a single painting; but only to oppose the 'mystery' dear to symbolist poets and aesthetes of *Monde de l'art* with an entirely different form of anti-psychology, a stylization of movement, borrowed from the stiffness of marionettes and the baton blows of fairground theatre. Finally, he did so in order to discover within the 'grotesque' the synthesis of pantomime that 'shuts up rhetoric', capriciousness that makes the everyday extraordinary through the assembly of heterogeneous elements, and the stylization that subordinates characters to an ornamental goal. When Charlot was playing his first pranks for Mack Sennett, Meyerhold still opposed the virtues of popular conventional theatre to the realist platitude to which mechanical recording seemed to reduce cinema. But the features he chose to celebrate this fairground theatre – summed up by the silly, cynical Harlequin, able to draw tears and laughter in the space of a few seconds – are exactly the ones that went on to make up Charlot's glory.

What made for his glory, more precisely, was the conjunction of two *types* on the screen's flat surface: the popular role whose physical performance, both silly and sneaky, dispenses with the incarnation of emotional states, and the pure graphic line denying all bodily gravity. What is seductive at first are the gestures of the fake blunderer, whose head is humbly hunched into his shoulders, but whose leg is always ready to swing back for a swift kick to the first passing behind. These are the gestures of a starving man whose beaten-dog look instantly transforms itself into a predator's glance, expert at pilfering pâtés or sausages from the butcher's display, making a sandwich from the neighbour's meat, or at crudely downing other people's glasses in fancy soirées that he infiltrates through mistaken identity. This 'vulgarity' is consonant with the liquidation of the

13 Vsevolod Emilevich Meyerhold, 'Fairground Theatre', in Edward Braun, ed., *Meyerhold on Theatre* (Reading: Methuen Drama, 1998 [1969]), p. 116.

'sentimentalism' despised by the artists and critics of the new age. Sentimental characters are indeed laughable in Charlot's films, from consumers literally crying rivers at hearing a sad song (*A Dog's Life*) to the falsely mourning widower who ends up selling the watch of his beloved deceased spouse as a last resort, and steps away from the exchange, putting away the five dollars into an enormous stack of bills (*The Pawnshop*). But, more broadly, the repudiation of sentimentalism is the rejection of the expression supposed to translate the intensity of feeling. The black triangle of his moustache and his fake bushy eyebrows are there first of all to block this invasion of feeling onto his face. The romantic situation thus has to be expressed by a shrugging of the shoulders. Even this gesture still tends to ambiguity. And the entire traditional expressive system itself seems to be annulled by the scene in *The Idle Class* in which the shoulders of an alcoholic husband abandoned by his wife are shaken by the trembling that traditionally expresses a body invaded by sadness, but turns out to be the functional movement of preparing a celebratory cocktail. The vagabond's hiccup that interrupts the tenor's romance in *City Lights* sums up the opposition between these two systems even more brutally.

Some sought to give this vulgarity its stamp of cultural nobility. As early as 1916, in *Harper's Weekly*, a theatre star inscribed Charlot's tricks into the lineage of Aristophanes, Plautus, Shakespeare and Rabelais.[14] On the contrary, others opposed his provocation to the ceremonial of great culture. The Russian authors of the Eccentrism manifesto put it bluntly: 'We prefer Charlie's ass to Eleonara Duse's hands.'[15] But the little man's mobile behind is perhaps not as far as they thought from the model of movement offered by the actress's open hands. The play of the high and the low, useful for provocative manifestos, should not hide what is essential: the opposition of type to character. First of all, this means the opposition of gesture to speech. This is what the pantomime of David and Goliath

14 Minnie Maddern Fiske, 'The Art of Charles Chaplin', *Harper's Weekly*, 6 May 1916, reprinted in Richard Schikel, ed., *The Essential Chaplin: Perspectives on the Life and Art of the Great Comedian* (Chicago: Ivan R. Dee, 2006), p. 98.

15 Grigori Kozintsev, Leonid Trauberg, Sergeï Yutkevitch and Georgi Kryzhitsky, 'Eccentrism', in Richard Taylor and Ian Christie, eds, *The Film Factory: Russian and Soviet Cinema in Documents, 1896–1939* (London: Routledge, 1988), p. 59.

symbolizes, used by the false pastor in the *Pilgrim* as every sermon
for his audience. But mime is not only to be opposed to edifying
chatter. Its pure functionality also ruins the dramatic model of
action that pursues its ends and obeys its motivations. This is how
Charlot's vulgar gestures are close to La Duse's noble poses. The
actress's ample gestures in *Rosmersholm*, directed by Gordon Craig,
rejected the psychological interpretation of actions and attitudes of
her character, Rebecca West. They transformed the young intriguer
into an antique Sybil. The 'vulgarity' of the impenitent predator of
sandwiches and cocktails neutralizes, for one, the sentimental effect
of the social theme of misery. It brings them back to simple gestures
of survival. To make people laugh using the hungry man's hunger
is the performance that Chaplin always bragged about. But these
gestures of survival are not satisfied with the double-blow that takes
revenge for the oppressed while dismissing sordid realism. They also
entail the radical negation of narrative action and dramatic charac-
ters. To respond to all stimuli is to put oneself in the situation of the
mobile trapped by a revolving door in an endless loop (*The Cure*).
Chaplin made this gag the structure of an entire film – *The Circus*
– which is simultaneously a metaphor for his art: the comic nature
of the little man's tricks takes on an entirely involuntary character
there. In order to flee the police at his heels, he rushes onto a circus
track, getting stuck in a circular motion giving a mad rhythm to
the hackneyed mechanics of circus tricks. When he is ordered to be
funny, however, he seems pathetic. The perfect mechanism of gags
only works in the fictional narrative that turns them into pure reac-
tions to external stimuli. But the success of this 'pure reaction' relies
on the total indeterminacy of its effect. The spring of Chaplinesque
comedy cannot simply be equated with the Bergsonian blueprint
of mechanical reaction superimposed on a situation demanding the
adapted response of a living organism. The soldier in *Shoulder's Arms*
surely follows an irrelevant habit, when he draws a blanket to warm
himself, even though it, like him, is underwater. On the other hand,
he invents a well-adapted response to the situation by transforming
the horn of the gramophone into a tuba. One is left wondering, of
course, what the gramophone is doing there in the first place. The
partier of *Pay Day* shows a perfect sense of adaptation to circum-
stances by climbing onto the shoulders of passengers in order to
get onto the bus, except the very pressure of the human torrent that

allowed him to enter at the back throws him out again inevitably through the front door. And the 'functional' response of escape, for someone who frequently gets out of prison and puts himself in the position of having to go back, also has to do with a double effect: the Tramp cleverly escapes from the cop chasing him only to run into two others at the next corner, who are running in opposite directions, and whose collision allows him to go hide in a pipe, where he falls into the hands of a fourth cop, on duty at the other end (*The Adventurer*).

It is through this perfect equality of the functional response and its unforeseeable consequences that the exact gestures of the popular mime transform themselves into the pure plastic forms deployed on screen. This, rather than any graphic ideal, is what Chaplin's choreography is based upon. We must understand what choreography means here. No doubt it is the farmhand's dance in *Sunnyside*, with the four nymphs wearing garlands, coming out of Isadora Duncan's Greek dreams, that inspires the choreographic references to Louis Delluc and Élie Faure. Meeting Nijinsky is said to have inspired the filmmaker. But this ballet, like the one with the angels in *The Kid*, or the little bread buns in *The Gold Rush*, is a dream sequence. The true choreography of *Sunnyside* resides elsewhere. It can be found in the play of simulated and foiled actions that mark the beginning of the film: the valet humbly holds out his behind so that his master – who instead of hitting him, has accidentally struck the bars of the bed – can repair his error, and then finds himself brutally thrown outside, only to re-enter just as quickly through the window to begin lazing about again without being disturbed. The explicit and parodic ballet with the nymphs is less meaningful than this or that implicit choreography, executed with the very elements of forced labour or everyday vulgarity: in *Behind the Screen* the extraordinary pile-up of chairs on the Tramp's shoulders seem to anticipate Oskar Schlemmer's baton dance; in *Work*, climbing up and coming down the same slope with the cart, carrying his boss, equipment and ladders, which the Tramp desperately tries to counterbalance at the cost of transforming the assemblage into a strange, amphibious animal; in *Pay Day*, the virtuoso catching bricks backwards, on the scaffolding, with his hands and feet, and knowingly stacking them in staggered rows, at the cost of letting a brick fall without fail on the head of the foreman, whose imperious whistle has just signalled a break.

At the exact juncture of vulgar reaction with ideal choreography, there is a mechanical precision of movement. Charlot's triumphant years are also those that witness the triumph of the dream of a new humanity, marching to the rhythm of the machine. Meyerhold finally discovered the synthesis of pure visual form and carnival gestures in biomechanics, and one could easily apply his remarks on the art of the actor to Chaplin:

> The actor embodies in himself both the organizer and that which is organized (i.e. the artist and his material) ... Insofar as the task of the actor is the realization of a specific objective, his means of expression must be economical in order to ensure that precision of movement which will facilitate the quickest possible realization of the objective ... Since the art of the actor is the art of plastic forms in space, he must study the mechanics of his body.[16]

The actor is identified as the engineer of his own mechanics. Another commentator, Franz Hellens, pushed the reasoning even further by inventing a fictional character named Loucharlochi. He was presented as the master of movement in whose school

> each person practises imitating decomposed movement. The human body made of adjusted parts moves according to a general plan where each part has its role and carries it out without worrying about the others ... For every action of the body there is one formula alone. The words to express desires and will have the same sounds as those of the body beaten by the hammering of steps, and the same rhythm as gesture ... No more ornaments, cries, exclamations or poses; nothing but movements, breaks, repetitions with the identical return of adequate expressions for each pose and for each idea. All things, like all men, are equal; things differ only by their force of movement.[17]

Nonetheless, Loucharlochi could only present this teaching of movement by masking it in the performance of a comic actor:

16 V. E. Meyerhold, 'Biomechanics', in Brown, *Meyerhold on Theatre*, pp. 198–9.

17 Franz Hellens, 'L'École du mouvement', *Le Disque vert*, 2nd year, 3rd series, nos 4–5 (Paris–Bruxelles, 1923), pp. 89–90. (This text is taken from chapter fourteen of his novel *Mélusine*, published in 1920. It does not appear in the final version of the novel, published in 1952 under the title *Mélusine, ou la robe de saphir*).

The reason for my clothing and some of my gestures that make you laugh and that I could call *hors d'œuvre* is extremely simple. To teach my contemporaries, I became an actor myself. Our era calls for great feats; but it wants agility to hide in grotesque, shabby appearances ... I am considered awkward and clumsy. I bump into things, I stumble, and I pick myself up. Through laughter, astonishment begins to make way. I am followed; I put my flexibility to work. Each pass is applauded. I produce speed and laughter at the same time.[18]

But the theory of the actor as pretext is based on a simplistic opposition between mechanical precision and dramatic sentimentality. This is what obsessed Charlot's avant-garde admirers, constantly anxious at seeing the biomechanical comic perverted by some unfortunate emotion towards some stray dog, foundling child, ill-treated waiter or blind florist. They identify the perfection of art with obedient mechanics. But there is precisely no art where mechanics obey. Art occurs when mechanics fall out of order, when the relation between the order and its execution is blurred, just like the relation between the living and the mechanical, the active and the passive. This blurring of established oppositions is summed up in *The Pawnshop* by the famous alarm-clock gag, where Charlot listens to it with a stethoscope before opening it with a can-opener, pulling out all its springs and putting them back haphazardly into the box. Technical agility does not have to hide under the appearances of clumsiness. The machine functions as art as long as its success, and that of its users, is also a glitch, as long as its functionality constantly turns against itself. In the drawings that Varvara Stepanova did for the special issue of *Kino-Fot*, a clumsy Charlot falling on all fours into the air ends up transforming himself into airplane propellers, then into a mechanic. The text by the artist's husband, Aleksandr Rodchenko, promotes the clown with the automaton's gestures into a hero of the new mechanical world, somewhere between Lenin and Edison. But the opposite is also true: the beautiful machine only works through its glitches. The little man with the cane and the bowler hat is no more a sentimental type hidden under the guise of an automaton than he is a bio-mechanic masked behind the appearance of a simple-minded comedian. His gestures as a virtuoso goof who fails

18 Ibid., p. 88.

every time he succeeds, and succeeds every time he fails, make him an exemplary inhabitant of a new sensible universe belonging to the age of machines that carry out and negate the will and its ends at the same time; for they only lend themselves to his enterprises at the cost of imposing the stubborn repetition of a movement whose own perfection is to want nothing on its own.

This is the anti-acting actor's own contribution to cinema: he brings a paradoxical virtue into the machine age, and projects it onto the moving screen – a virtue already celebrated by Winckelmann in front of the *Belvedere Torso*, or by Hegel before Murillo's little beggar boys: the virtue of doing nothing. He puts inertia into perpetual motion, caught both in the immediate efficiency of the reaction and in the uselessness of the mechanism that always returns to its original position. He makes this continual excess and lack of efficiency into the distinct art of moving shadows projected onto a depthless surface. His performance as an anti-acting actor is above all a perversion of the very logic of the agent. Thus a French critic, better known as a biographer of Balzac, Dickens and Shelley, sums up the logic of his incessant gestures: 'I must be the cause of nothing. Events in the course of the film must fall upon me like a kind of avalanche, but none of them must have a voluntary act on my part as a point of departure.'[19] And another shows the consequence of this 'inaction' in terms of form:

> He lives as such an indifferent disenchanted figure that if events did not follow throughout a film and if there were nothing, *he would cross the stretch of the film reel from one side to the other without doing anything* ... Others have adventures, behaviours, social positions, a home. Charlot has nothing. The world is reduced to the proportions of the screen.[20]

It is surely a strange metonymy that speaks of a character that 'crosses the stretch of the film reel from one end to another'. But this metonymy is the metonymy of the 'medium' itself, which does not limit itself to an instrument and to a distinct material, but exists

19 André Maurois, 'La poésie du cinéma', *Art cinématographique* 3 (1927), p. 14 (reprinted in 1970 by Arno Press/*New York Times*).

20 André Beucler, 'Le comique et l'humour', *L'Art cinématographique* 1 (1926), pp. 51–2 (my emphasis).

only through the unpredictable displacements it is forced into by forms and moving objects from elsewhere. The character turned into a type is the 'actor' denied, a creator who has become inseparable from his creation. But the form that this identity takes on – evocative of dreams of the total work of art – is, on the contrary, entirely pure form in motion on a white surface, the anti-character that is the cause of nothing. Charlot 'crosses the film reel' and occupies the screen with a movement of inertia incessantly thwarted and re-established. The popular type, where the will of the author and the mediation of the actor evaporate, reduces the character to a graphic type, a form that draws arabesques on a white rectangle. But the knowledgeable movement of shadows on a white rectangle suddenly reveals itself as a metaphor for a singular way of living in the new world of great enterprises of the will and machine performances. The artists constructing the future vainly sought to discern in the little man's gestures a symbol of an art synchronized with the great epic of the mass-producing machine, Taylorized work, and men with precise gestures. In vain did they despair at seeing him flee the beautiful universe of machines and leave with his bundle of belongings on the highway. What his gestures put to work is the exact identity of mechanical precision and the struggle against windmills, the infallible trick and certain failure, stubborn doggedness and the abandonment to chance. The frenzy of pantomime and the immobility of the camera go together like the virtuosity of the brick builder and the impotence of the driver shot down by his cart to the bottom of the slope. There is no doubt a little too much Nietzschean pathos in Élie Faure's pages celebrating the victory of pessimism over itself in Chaplin's choreography: 'man dancing, drunk with intelligence, over the peaks of despair'.[21] Eisenstein would meanly mock his tendency to insert 'superfluous metaphysics into the tap-dance of Chaplin's boots'.[22] But this excess of metaphysics is also a way of reversing the great faith in the new language of the machine and the identification of the operations of king-montage with the new mechanical world's will to plan. Through Chaplinesque pantomime, cinema expresses the secret nihilism that accompanies the great mechanical faith, likening the demiurgical

21 Élie Faure, 'Charlot', in *Oeuvres complètes*, vol. III, p. 310.
22 S. M. Eisenstein, 'Charlie the Kid', in Jay Leyda, ed., *Film Essays and a Lecture* (London: Dennis Dobson, 1968), p. 136.

potential of machines to the shadow play on the walls of the cave, at the cost perhaps that these shadows turn out to be more exact and clearer than the plans of the engineers of the future.

12. The Majesty of the Moment

New York, 1921

For the man who out of the black box and the bath of chemicals produced these cool dynamic prints, there seems to be scarcely anything, any object, in all the world without high import, scarcely anything that is not in some fashion related to himself. The humblest objects appear to be, for him, instinct with marvelous life. The dirt of an unwashed window pane, a brick wall, a piece of tattered matting, the worn shawls of immigrant women, horses steaming in the smudged snow of a New York thoroughfare, feet bruised and deformed by long encasement in bad modern shoes, seem, for this man who has shoved the nozzle of his camera so close to them, as wonderful, as germane to his spirit, as the visage of a glorious woman ... So, out of the brief sudden smile or fixation of the gaze, out of the restless play of the hand, Stieglitz has made something that looks out over the ages, questioningly, wistfully, pityingly. Out of a regard of weariness and kindness and gentle chiding laughter, he has made a sort of epilogue to the relations of women and men. Sphinxes look on the world again. Indeed, perhaps these arrested movements are nothing but every woman speaking to every man.

Never, indeed, has there been such another affirmation of the majesty of the moment. No doubt, such witness to the wonder of the here, the now, was what the impressionist painters were striving to bear. But their instrument was not sufficiently swift, sufficiently pliable, the momentary effects of light they wished to record escaped them while they were busy analyzing it. Their 'impression' is usually a series of superimposed impressions. For such immediate response, a machine of the nature of the camera was required. And yet, with

the exception of Stieglitz, not a one of the photographers has used the camera to do what alone the photographer can do, fix the visual moments, register what lies between himself and the object before his lens at a given moment of time. All have been concerned not so much with the object, with the moment, as they have with the making of an 'artistic photograph', and so failed to use their instrument properly.

These lines are taken from a long article devoted to the Alfred Stieglitz photography exhibit in 1921 by an art critic, Paul Rosenfeld, whose usual speciality was music.[1] If they deserve our attention, it is for the way they display the great divide within which photography earned its status as an art. Stieglitz, the critic tells us, is first among the photographers because he is the first to use the distinct means of the camera. His colleagues desperately attempted to imitate painters, choosing subjects, lenses, paper and development techniques to produce 'prints' that resembled a Degas, a Whistler or a Böcklin. He understood that the photographer did not have to erase the work of the machine to imitate the effects of painting. On the contrary, he must seize what the machine alone offers him, the possibility of realizing the impossible dream of painters: to directly record the momentary play of light and its glorious effect on a back yard or a dirty windowpane, as fully as on the curves of a woman's body or the enigmatic depth of a gaze. Stieglitz is the first photographer because he is the first to accept being only a photographer.

The problem is not to judge the contest, but to reflect on the criterion that grounds it, on the privilege given by the critic to the fact of being 'only' a photographer. Indeed, such a judgment considerably alters the usual meaning of words. For, in common usage, being only a photographer is the fate of those who practice photography professionally: those who have a studio and take portraits of the little and the great people of this world, against a more or less 'artistic' backdrop. But precisely, their portraits, however carefully composed they might be, do not count as works of art, which, on the contrary, include photographs of trains, carriages, ferries, brick

1 Paul Rosenfeld, 'Stieglitz', *The Dial* 70: 4 (April 1941), reprinted in Beaumont Newhall, *Photography: Essays and Images: Illustrated Readings in the History of Photography* (New York: Museum of Modern Art, 1980), pp. 209–18.

walls or bruised feet taken by Stieglitz. One must give a different meaning to the fact of being only a photographer, and understand the artistic value of photographs that result from it differently. These are art for two reasons that belong to different kinds of logic. They are art firstly according to the old representative logic, because their author is an amateur who practises photography for its own sake: not to earn a living, but out of love for its expressive possibilities, thus because he practises this art, 'mechanical' in its means, as a 'liberal' art in its ends. Secondarily, they are art according to the aesthetic logic, because they do not owe anything either to the quality of their subject or to any artistic addition meant to raise them from their mediocrity. They owe it only to themselves. They are the testimony of a glance directed at the right time at the right spot to catch what is in front of it: 'life', Rosenfeld tells us, that the photographer himself evoked in the 'Statement' that accompanied the exhibition: 'The Exhibition is photographic throughout. My teachers have been life – work – continuous experiment.'[2] This is the experimentation that Rosenfeld describes at work to catch the life without quality, the life of skin pores, a moist lip, the insignificant motion of hands sewing or peeling apples, fleeting facial expressions of joy or pain: any life whatever, comments the critic, life that is both the enigma, and the suffering of not knowing the answer, and the similar suffering of knowing it, of knowing the absence of reason that is its fate. Rosenfeld's text lingers over this for some time, and any reader even slightly familiar with philosophy will recognize the source of the notions that underwrite his analysis: the reference to this 'pity' towards life, which is also a consenting to its absence of meaning, comes from Schopenhauer. The great and joyous affirmation of pain, in which Rosenfeld sees the essence of the photographer's art, is an allusion to Nietzsche. No doubt the same reader will ask how these references, inherited from the romantic vision of Greek tragedy, are suitable to define the specificity of the photographic act in 1921.

However, one must not hastily denounce this as a simple affectation of a critic seeking to elevate his subject through a few prestigious philosophic references. This leap between the click of the photographic snapshot and the eternal affirmation of life measures the space of paradoxical thinking well – the great divide in

2 Alfred Stieglitz, 'A Statement', in Newhall, *Photography*, p. 217.

which photography was recognized as a new art. It could be that some philosophic supplement is always necessary when it comes to defining the specificity of an artistic practice as a practical *and* artistic specificity. For what we call *an* art is two things in one. It is a way of doing, the use of a proper technique that becomes individual in distinction to others. And it is the negation of what constitutes the specificity of any technique – that is to say, to be a means placed at the service of an external end. It states that this technique is able to do what recognized arts do: negate the technical specificity that destines them to particular uses.

An art based on mechanical reproduction is surely more hard-pressed than any other to affirm that it is indeed an art. But it is also better placed to generalize the problem and reverse the argument against those who want to exclude it. Rosenfeld's argument expands a debate started early by photographers themselves, when – once the age of admiration for the miracle of fixing shadows and the denunciation of an art good for immortalizing shopkeepers had passed – they undertook a justification of their claim to artistic dignity. 'A man might be a good painter or a good photographer without being an artist at all. A man who paints is not an artist because he paints, or a photographer an artist because he photographs. Both are artists when they can produce fine art with either paint or chemicals, or any other materials.'[3] The author of these lines, written in 1888, Henry Peach Robinson, is remembered above all for the method he found to make photography an art: joining multiple negatives through combination printing to compose a single image. But the problem was not formulated differently by his most tenacious rival – not only the defender of 'photographic naturalism', but also the president of the jury which would award young Stieglitz his first prize, Peter Henry Emerson: 'Versifying, Prose-writing, Music, Sculpture, Painting, Photography, Etching, Engraving, and Acting, are all arts, but none is in itself a fine art, yet each and all can be raised to the dignity of a fine art when an artist by any of these methods of expression so raises his art by his intellect to be a fine art.'[4] Emerson's disciples mocked Robinson's

3 Henry Peach Robinson, *Letters on Landscape Photography* (London: Piper & Carter, 1888), p. 11.

4 Peter Henry Emerson, *Naturalistic Photography for the Students of Art* (London: S. Low, Marston, Searle & Rivingston, 1889), p. 19.

kitsch montage. But they could not help subscribing to his 'dictum' for recognizing a 'fine art': 'Art is the result, in the first place, of seeing rightly, and in the second place of feeling rightly, about what is seen.'[5] And anyone who remarked that there is a long way from this 'seeing rightly' to the artificial composition of *tableaux vivants* made of assembled images, would still have to admire how the most famous work composed according to this procedure, *Fading Away*, was a painting of the 'pain of existence', as it was conceived of at the time: the death of a young consumptive in a white dress in a salon with heavy drapes, assisted by two resigned figures, while a man, with his back turned, contemplates clouds at dusk through the large window. The becoming-art of photography tells the story of how such Victorian pictorial pain folded its tableau until it was lodged in the pores of a woman's skin, or even in the dirty smoke of a New York train or steamboat.

Concerning the conditions of this becoming-art, at least two points seem to be givens for all. The first is the one that literature and painting had already made acceptable: the dignity of art does not depend on the dignity of its subjects. There is no longer high art and low art, unless, Emerson remarked ironically, one uses these terms to distinguish art suspended from the ceiling from art spread on the floor.[6] Nor does it lie in the dignity of the instrument or the material. Photographers incessantly insist on the distinction between the work of art and the instrument of its execution: 'That the recording factor is an instrument, a machine, if you will, no more compels mechanicalness than a piano makes a Beethoven sonata mechanical because it is only audible through its agency; it is neither the piano or the camera that really matters, it is what is done by them.'[7] Emerson had already developed the argument: the poem does not change if it is typed rather than written on parchment. What counts is what the poet has to say; and it is no different for the photographer, painter, or etcher.[8]

The argument is obviously weak: the parchment and the typewriter, like the performer's piano, are surfaces and instruments that

5 Robinson, *Letters on Landscape Photography*, p. 11.

6 Emerson, *Naturalistic Photography*, p. 20.

7 Frederick H. Evans, 'Personality in Photography – with a Word on Colour', *Camera Work* 25 (1909), p. 37.

8 Emerson, *Naturalistic Photography*, p. 285.

make visible or audible a work that exists independently of them. But the photographic image is not like a musical score; it cannot be isolated from the instrument that fixed it on a negative. It must be compared not to the written text of the poem or the pianist's performance, but to the image formed by the painter's hand.

It is thus a twisted dialectic that is used to say how the photographic image is art, *like* painting. 'Like painting' primarily means: just as much as it. But this proof of equal dignity immediately splits into deviating arguments: it is a matter of proving that photography is art for three different, if not contradictory reasons. First because, despite the handicap of being a mechanical art, it sets to work the same principles as the new painting; next, because, thanks to machine aid, it can realize the ideal of painting better than painting itself; and finally, because it gives up being an art that imitates painting. All these games of resemblance and difference depend, it is true, on a shared certainty: the force of art can no longer be derived from either the quality of its objects or artisanal skill. What makes the artist is the capacity to transcribe a vision. For photography, however, the argument is a double-edged sword. On the one hand, it nullifies the hierarchy of 'instruments'. The painter's hand is an instrument like the camera. In this sense, it is not superior to it by nature. Is the skilled hand, usually opposed to the stupidity of mechanical recording, anything more than the use of a few 'conventional absurdities' meant to provide the equivalent of perception, whose true organization is unknown?[9] But the argument can be reversed immediately: if true originality is found in the vision and not the instrument that transcribes it, how can one make art with an instrument that automatically transcribes what is before it, without leaving room for any interpretive originality? Vision, moreover, is an ambiguous word. It is understood as grasping the spectacle of the world, and the impressionists largely popularized this idea of an art capturing the unique, vibrating instant of things and beings in an always different light. But this word is also understood as the way in which artists reconstruct the spectacle of the world according to their ideas, composing a plastic equivalent of their inner perception. No doubt the gap between these two visions allows itself to be forgotten through the ambiguity of another keyword from the time,

9 Robinson, *Letters on Landscape Photography*, p. 14.

namely suggestion: the spectacle of the world only touches the artist in the form of a suggestion, whose expression is at the same time the liberation of a personal vision. But the moment that photography tries to consider itself art is the period when these two 'visions' are separating, when impressionism, Emerson's model, is accused of submission to the real, and criticized in the name of a 'synthetism' or a 'symbolism' that sees paintings by Gauguin or Émile Bernard as the graphic expression of pure ideas.[10] No doubt Emerson and his contemporaries stuck to a sober 'impressionism' represented by Bastien-Lepage more than Monet or Whistler. But the artists and the critics that Alfred Stieglitz united fifteen years later in *Camera Work* found themselves directly confronted with these two traditions of pictorial modernity: one that privileges catching an instant of the world and another that opposes it with the free construction of lines and colours expressing the artist's inner vision.

It is thus a matter of proving that the photographer is an artist because he sees, and because he interprets. This last word is omnipresent in the texts. It is apparently the talisman that opens the gates to the fortress of great art. The whole question is to know when in the process and in what form one should consider this interpretation. Deciding on this point is also to decide the relations between the work of the camera and the artist. The first response is articulated as a clear division of tasks: the artist makes art, once the machine has done its work; and he does so by suppressing everything in this work that is mechanical, thus un-artistic. This position is summarized in a few lines by the champions of French photographic pictorialism, Demachy and Puyo:

> The proof furnished by the negative can be correct from a documentary point of view. It will lack the constitutive qualities of the work of art until the photographer knows how to put them there. This means—we dare to affirm—that the definitive artistic image obtained photographically will owe its artistic charm to nothing but the way in which the author can transform it. We gratefully accept the correct picture that an appropriately chosen and well-directed lens can offer. All our efforts are directed to preserve its integrity. Yet, all means are valid for us to simplify the minute useless information

10 See Albert Aurier, *Le Symbolisme en peinture: Van Gogh, Gauguin et quelques autres* (Caen: L'Échoppe, 1991).

with which this precision instrument still garrulously supplies us. Thus we prefer the development method that best allows synthesis through the suppression of useless details ... Perhaps we will be accused of thus erasing *the photographic character?* This, indeed, is our intention, for we know from experience what this established term gives rise to in the minds of artists.[11]

This text poses the problem clearly. Art begins where technics ends. It begins when technics has developed enough for its intrinsic limit to become evident: not its insufficiency, but on the contrary its excessive perfection – such minutiae make it 'docile and reliable for scientists', but 'surly and unfaithful to artists', whose capacity to see and interpret is diminished by it.[12] This indicates the direction in which the artist's interpretation must proceed. Contrary to the first artists of photography, concerned with adding to photography by combining many shots or by enhancing them with gouache, it seeks to eliminate the excessive 'minuteness' of the 'picture' taken by the camera in order to allow the artist's vision to emerge. Hence the care taken to 'clear' the image, with the help of various instruments, to suppress or lessen elements that draw attention away from the centre of this vision. The authors used the example of a photograph of a woman seated at a table where the white spot of a tea towel and the black spot of a chair were erased, while a vase and its bouquet were blurred into grey in order to make her head appear more prominent. This artist's vision must be transmitted to an audience, which is composed not of photographers but of art lovers, through beautiful design, which requires rich material. This is where the resources of a process, widely used from the 1890s to the 1910s to signal the artistic character of photography, come in: gum-bichromatic printing. The work of erasing, and the use of gum bichromate and stock paper are meant to lend the artist's vision a density of medium and plunge figures into the blurry background. The combination of these effects defines the softness that, by erasing the sharpness of its angles, redeems the mechanical character of straight photography, making its product pass through the ideality of art. The emblem of this conception of art was Frank Eugene's

11 Robert Demachy and Constant Puyo, *Les Procédés d'art en photographie* (Paris: Photo-Club de Paris, 1906), pp. 1–2.
12 Ibid., p. ii.

Nirvana, in which scraping successfully transformed a woman lying on a sofa in the artist's studio into Ophelia floating on the immemorial waters.

Some, it is true, rejected these procedures that attributed the artistic character of photography to everything it was not, and especially to the treatment of printing paper. Emerson thus mocked the 'gum splodgers'.[13] And after a short period of enthusiasm, Stieglitz, following the example of a few other masters of the art like Frederick Evans, affirmed his hostility to gum bichromate. Photography would not become a 'pictorial' art by imitating the work of hand on matter. On the contrary, it would do so by affirming the privilege of the seeing eye over the instrument – whether hand or camera – that executes. This privilege is shared by photography over painting. This much was shown by a writer enthusiastic about this new art, Bernard Shaw. Painting mistakenly brags, he said, about the superiority of its technique. In fact it depends on the hand, on 'incurably mechanical' handwork, to transcribe an equivalent to its vision. The camera frees the artist from this manual labour. Hence photography is 'far less hampered, far more responsive to the artist's feeling' than the painter's design. It alone 'evades the clumsy tyranny of the hand, and so eliminates that curious element of monstrosity which we call the style or the mannerism of the painter'.[14] The supposedly mechanical quality of photography, on the contrary, frees the potential of seeing from the mechanical servitude of the hand. It enables the suggestiveness of things offered to the gaze and the artist's inner subjective vision to coincide directly.

The form of this conjunction, as well as the way in which the eye of the camera can translate the vision of the artist photographer, remains to be thought. The first solution demands a technical way of making the camera bend to the artist's vision. Such technique must erase the dryness of the photographic image, its simple documentary character, and produce images that unite the two visions, or as one readily said at the time, 'interpretive' images. This can

13 Peter Henry Emerson, quoted in Helmut Gernsheim, *Creative Photography: Aesthetic Trends 1839–1860* (London: Faber & Faber, 1962), p. 126.

14 George Bernard Shaw, 'The Unmechanicalness of Photography', *Camera Work* 14 (April 1906), pp. 18–19; originally published in *The Amateur Photographer* in October 1902.

be done in two ways: by extending the exposure time or by using lenses to round the edges. It was the first process that was radicalized by a photograph that became an icon of 'art photography'. With a simple pinhole camera, in 1890, George Davison obtained the combined effect of material density and reduced contrast in a homogenous atmosphere that made his *Onion Field* famous. But his colleagues did not look towards the asceticism of the pierced tube to find ways of erasing the straightness of mechanical recording. On the contrary, they turned to technical improvement, capable of inventing lenses that met the artist's need to blur silhouettes. The spherical aberration of soft-focus lenses would, in fact, be the basis of photographic pictorialism. It allowed these blurring effects with which Edward Steichen, Clarence White, Gertrude Käsebier, Alvin Langdon Coburn or George Seeley transformed any urban setting into a dreamlike landscape, and familial scenes in the countryside or studio model photography into age-old mythological symbols. These images filled the pages of *Camera Work*, the journal Alfred Stieglitz founded in 1903 and which, for the next ten years, would be the rallying point for all those who claimed a place for photography in art. Yet, from the beginning, the critical discourse that accompanied them, coming more often from generalist art critics than from photography specialists, took its distance and sought models for photographic 'interpretation' elsewhere than in the symbolist blurring of contours. The commentary in the 1904 issue on Alvin Langdon Coburn's photographs by Charles Caffin – one of the recognized theorists of the journal and the author of *Photography as a Fine Art* – bears witness to it. Coburn, he said, sacrificed too much to the search for an overall effect. This search for homogeneity forced him to repress the unforeseen events that constitute the value of photography: 'the nuances of nature have been sacrificed to force a robust and striking pictorial arrangement' and photography had lost 'those delicate surprises of effect which in nature, whether animate or inanimate, are so full of beauty'.[15] And Frederick H. Evans, the great English elder who lent his authority to the young Turks of the American Photo-Secession, did not refrain from criticizing certain works that they sent to the London exhibitions, these 'formless and textureless' greys, these exercises in black and white, ignorant

15 Charles Caffin, 'Some Prints by Alvin Langdon Coburn', *Camera Work* 6 (April 1904), pp. 18–19.

of the nuances of light, whose subjects end up becoming pure mysteries.[16]

Thus the problem is not to mimic the work of pictorial touch in development or to rely on irregular lenses to expose artistic vision. The artistic vision must be the vision of the artist. What matters is to define how this vision coincides with art's own gesture. The photographer's own intervention occurs behind the camera, in an idea 'thought out and vividly realized before the camera was set in place'.[17] It is executed through the choice of the spectacle to fix and the moment the shutter release is activated. But this relation of place to the moment is itself the theatre for the tension between two ideas of art. Artists and critics surely agreed to make 'composition' the criterion for the artistic quality of an image, to extract general laws of composition that must be learned from the old masters in order to train the photographic gaze. Invited to write an article on the 'simplicity of composition', Stieglitz described it in classic terms as unity in diversity: it consisted in impressing 'the beholder so directly and forcibly with the central or dominant idea of the picture that everything else, even though covering a goodly portion of the picture area, is so subordinated as to appear of but little moment'.[18] To do so he recommends studying the best pictures in different media, analyzing them endlessly to incorporate them so well into one's being that they form the 'style', that is to say the gaze, of the photographer. This opinion was shared widely enough that a photographer concerned with social testimony like Lewis Hine took his students from the Ethical school of Culture to the Metropolitan Museum, for them to learn the art of drawing from Raphael. What composition means exactly remains to be determined. The work by Stieglitz that he and his admirers chose as a model, *Gossip-Katwyk*, stands out less for the centred architecture of the scene than for the empty space it negotiates between the yard and the sail of a boat,

16 Frederick H. Evans, 'The Photographic Salon, London 1904. As Seen Through English Eyes', *Camera Work* 9 (January 1905), p. 38.

17 Charles Caffin, *Photography as a Fine Art: The Achievements and Possibilities of Photographic Art in America* (New York: Doubleday, 1901), p. 45; originally published as 'Photography as Fine Art, II: Alfred Stieglitz and His Work', *Everybody's Magazine* 4 (April 1901), p. 371.

18 Alfred Stieglitz, 'Simplicity in Composition', in Richard Whelan, ed., *Stieglitz on Photography: His Selected Essays and Notes* (New York: Aperture, 2000), p. 183.

cast to the left on the far side of the frame, and, on the right, two isolated women facing the waves, shot from far enough away for their facial expressions to remain indiscernible. Those who wanted photography to learn from painting were also aware that the current law of painting was not the architecture of the Greek line but the 'nervous' drawing of Japanese prints that raised a few chance figures on a schematic landscape. One of the theorists of *Camera Work* took note of this displacement: 'Modern art has discarded the classic purity of the Greek line and substituted the rugged, picturesque line of the Japanese, which vibrates with the nervous touch of the artist's hand.'[19] 'Composition' thus took on a singular aspect. According to Stieglitz, one must choose one's subject regardless of figures, by carefully studying the lines and lighting. Once you have decided on them, observe the passing figures and wait for the moment when everything is in balance.[20] One must thus compose everything and wait for the right moment when the figures put themselves into place. Preliminary study, waiting, and patience are continually praised as the photographer's cardinal virtues. It took Stieglitz two years to be able to take a spontaneous portrait of Mr Randolph, Caffin assures us.[21] And the hours it was necessary to wait in the cold before being able to capture the coachman in the snowstorm of *Winter, Fifth Avenue* are the stuff of the photographer's legend. This insistence on the time of study and waiting is not only an emphatic response to those who reduced photography to pushing a button. If the photographer refuses to imitate artificially the 'nervous' gesture of the print painter, if he cannot follow the modern painter, Whistler, in whose work 'the figure is, so to speak, invented in the character of the colour arrangement',[22] then he must find a way to make his practice coincide with the capture of singular emergences that constitutes modern art, even if he must once again discover the model elsewhere. The critics of *Camera Work* applauded Steichen's photograph of a half-erased Rodin, between the black mass of the *Thinker*

19 Sidney Allan (Sadakichi Hartmann), 'The Value of the Apparently Meaningless and Inaccurate', *Camera Work* 3 (July 1903), p. 18.

20 Alfred Stieglitz, 'The Hand Camera: Its Present Importance', in Whelan, *Stieglitz on Photography*, p. 68.

21 Caffin, *Photography as Fine Art*, p. 46.

22 Sadakichi Hartmann, 'White Chrysanthemums', *Camera Work* 5 (January 1904), p. 20.

and the bust of Victor Hugo that he was preparing. But they turned to the sculptor rather than his portraitist for the proper principles to guide photographic art. The galleries of Photo-Secession thus exhibited Rodin sketches in spring 1908, 'notes for the clay' done in two minutes, 'by a mere gallop of the hand over paper'[23] with hasty lines that 'speak eloquently of life ... the essence of art expression that has here been flashed upon a piece of paper'.[24] But the analogy between the gesture of drawing and taking the shot marks the gap between the two processes. The sculptor's work can be broken down into a gaze that seizes its object, the speed of the hand that notes it in shorthand, and the slowness of the hand that kneads the clay. But in photography, no clay work follows the shorthand. The gaze alone must be responsible for every function, before conferring its vision to the shorthand of the camera. Photography is a distinct art – and a distinctly modern art – because it affirms the privilege of the gaze over the hand. It can affirm its immateriality not by blurring out-lines, but by appropriating time as its object and material. Its work is identified with the mastery of time that settles the framework within which singularity can emerge. Photographic composition is the composition of time. The art of photography is an art of the time-form more than of the disposition of figures in space.

But this art is not simply one of waiting for the right moment. The photographic act is defined by the coordination of three times: there is the waiting time that delimits the frame for a possible emergence, and a time when this emergence becomes the singular expression of a figure in the light; but there is also the time of the world and the people that this figure crystallizes. This is what Stieglitz's favourite photograph – showing a Dutch fisherman's wife repairing a net – illustrates: a lone figure, this time, on a background of dunes, where the blurry outline of the woman seated in profile is justified by the need to emphasize her attention to work, and the entire universe of life and thought concentrated within it: 'every stitch in the mending of the fishing net, the very rudiment of her existence, brings forth a torrent of thoughts in those who watch her sit there on the vast and seemingly endless dunes ... All her hopes are concentrated in

23 Arthur Symons, 'Studies in Seven Arts', quoted in 'The Rodin Drawings at the Photo-Secession Galleries', *Camera Work* 22 (April 1908), p. 35.
24 John Nilsen Laurvik, article in *The Times*, quoted in ibid., p. 36.

this occupation – it is her life.'[25] Waiting is thus the condition to make the patiently awaited singular flash of light coincide with worldly and social time. The photographer's work thus, in its own way, rejoins the lesson of a friend of the arts who hated photography, as he hated all technical perfection – John Ruskin. Photography is worthless, he said, because unlike painting it cannot 'condemn itself', before adding: 'Not with the skill of an hour, nor of a life, nor of a century, but with the help of numberless souls, a beautiful thing must be done.'[26]

Mechanical precision is not 'redeemed' by the manipulation of film, aberrant lenses, or the science of lines. Rather, the redemption resides in photography's capacity to 'condemn itself' through the use of what is proper to it, namely time. The capacity to fail – and thus also to succeed – at making the time of the gaze, the time of the machine, and the time of the world coincide.

Thus photography would find its proper place not in steamy nudes, faces floating in shadows, dream gardens, naked adolescents playing pan flute, flames reflected on the long white dresses of virgins, or naked women playing the spirits of old trees that adorn *Camera Work*, but rather in the metropolis, its ports, train stations, construction sites, workers and pedestrians. Photography is an art of the gaze par excellence. But the art of the gaze primarily consists in the art of choosing, and it is best when, instead of relying on the limited repertoire of 'artistic' scenes, the gaze is exposed to the risk of getting lost in the largest profusion of spectacles – even apparently indifferent, inartistic ones. The modern art of the gaze, in this sense, is linked to the modern spectacle of the city. But the modern city – especially if it is a port city – is also the place of time: the place marking all the accelerations whose symbol is of course the *Flatiron*, which Stieglitz photographed early on. Yet these accelerations are expressed differently by the dirty smoke of the railway or the steamers that bears witness to the speed with which yesterday's novelties are covered by a layer of banality and wear. It is the place where ages and rhythms are mixed together, where the exuberance of speed and

25 Alfred Stieglitz, 'My Favourite Picture', in Whelan, *Stieglitz on Photography*, p. 61.

26 John Ruskin, *The Laws of Fésole: A Familiar Treatise on the Elementary Principles of the Practice of Drawing and Painting, as Determined by the Tuscan Masters*, vol. I (Orpington: George Allen, 1879), p. 4.

technology finds itself covered at times by the timelessness of an icy night or a snowstorm, where bodies differently bear traces of urban speed and the slower rhythms of the lands where they come from. It is no accident that, in the statement that accompanied the 1921 retrospective, the photographer of German origin, who studied in Munich and captured the labour of German peasants from Gutach and the life of Dutch fishermen in Katwyk, recalls that he is an American born in Hoboken, New Jersey – a few cable lengths from Walt Whitman's Long Island.

This future of photography truly remains indistinct in the photographs Stieglitz published in *Camera Work*: New York crowds form a black mass on a ferry boat, the shawls of emigrants are more visible than their history, and train smoke organizes vision more than the dynamic machinery celebrated by Soviet artists. The director of *Camera Work*, moreover, avoids using himself as an example or using the pages of his journal view to indicate the path of the photographic future. Meanwhile, photographs increasingly give way to reproductions of drawings, paintings and sculptures. The visual portfolio of spring 1911 is emblematic: the dark and theatrical photographs where Steichen transformed Balzac's statue into a commander's nocturnal shadow yielded to colour collotypes of Rodin's drawings. And the issue begins with a hymn to the pagan and Dionysian art of sculpture that makes everything into a 'perpetually miraculous epiphany'.[27] In the next issue, a cubist silhouette of a Picasso nude followed the emaciated silhouette of the tree in *Spring Showers*, which closed the portfolio on Stieglitz, as his own graphic ideal – the ideal of an abstract graphic design that could accommodate the rhythm of the city and modern lives. After Picasso, Matisse, Cezanne, Braque, Picabia and a few others invaded the portfolio of images and the critical discourse of the journal. There was undoubtedly an empirical reason for this. They were the artists Stieglitz exhibited in his galleries. Yet they were exhibited as representatives of artistic modernity defining the framework in which photography must find its place, which no photography could actualize. Some would not hesitate to theorize this divorce. The new theorist of the review, Marius de Zayas, expressed it brutally in the January 1913

27 Benjamin de Casseres, 'Rodin and the Eternity of Pagan Soul', *Camera Work* 34/35 (April 1911), p. 13.

issue: 'Photography is not art. It is not even an art.'[28] This exclusion was immediately turned into an advantage, following a very Hegelian dialectic that gave photography the task of representing the modern, material reality of forms, while until now art had translated the inexactitude of thoughts and feelings in inexact forms.

This calling of photography seemed to triumph in June 1917, when Alfred Stieglitz devoted the last issue of *Camera Work* to the œuvre of the only photographer he deemed worthy of being exhibited in his gallery: Paul Strand. He clearly presented this election as the death certificate of pictorialist photography, a farewell to the past materially symbolized by the omission of the Japanese fabric that used to cover – and used to iconize – the journal's photogravures. This œuvre, he said, was 'brutally direct. Devoid of all flim-flam; devoid of trickery and of any "ism"; devoid of any attempt to mystify an ignorant public, including the photographers themselves. These photographs are the direct expression of today.'[29] And he left it up to Strand himself, paying homage to the elders nonetheless, to lay claim to the upheaval of perspective that made photography admissible among the arts. Photographic art receives its possibilities from the feature distinguishing it from all other arts – the total objectivity of its medium. Its excellence is linked to the purest use of this medium, to the knowledge of its limits as well as to the respect for the object placed before it. It is linked to the organization of objectivity according to the differing logics of the expression of causes through effects, or of simple emotion before the abstraction of forms – two kinds of logic likely to unite, on another level, in the same direction towards 'the common goal, which is Life'.[30] These photographs bore witness to this double direction between brutal close-ups of beggars and passers-by in the streets, taken with a hidden lateral lens, and abstract settings with rays of light, close-ups of fence slats or bowls, which Paul Strand would later say he had photographed to understand the pictorial methods of Braque or Picasso. Such objectivity, linked to the purity of the medium, was thus suspended between two lessons equally

28 Marius de Zayas, 'Photography', *Camera Work* 41 (January 1913), p. 17.

29 Alfred Stieglitz, 'Our Illustrations', *Camera Work* 49/50 (June 1917), p. 36.

30 Paul Strand, 'Photography', *Camera Work* 49/50 (June 1917), p. 3.

inclined to liquidate pictorial prettiness, at which the young Strand himself had tried his hand: the cubist lesson of the abstraction of forms learnt at the gallery run by Stieglitz, and the pragmatic and socially involved lesson taken from his education at the Ethical Culture Society, where Lewis Hine taught him photography by taking him, along with his students, to photograph emigrants arriving on Ellis Island.

The objectivity that dispelled pictorialist fog back into the pre-history of photographic art was itself constructed on an ambiguity of its own – or a plasticity of its own. There is thus nothing astonishing about the fact that the death and birth certificates Stieglitz awarded Paul Strand in 1917 should have been produced once again by Rosenfeld, in honour of Stieglitz, during the 1921 exhibition. Stieglitz, he said, was the first photographer to be truly an artist, because he was the first to be truly and only a photographer. However, such photographic authenticity remains relatively indistinct, considering the works gathered in the exhibition. These can be divided into three categories. First, there is an anthology of photos that made up the photographer's legend: Dutch scenes or urban New York landscapes executed between 1892 and 1911. Then there is the series of close-up studies of Georgia O'Keeffe's face, breasts, hands and feet. Finally, there is a long series of portraits of friends, artists and critics, which possessed neither the novelty of Strand's secret portraits nor the documentary value of Lewis Hine's photographs of children. What this disparate ensemble and Strand's apparently more novel photographs share is the clear affirmation of 'straightness'. But can this only be defined as a refusal of the artifices of soft-focus and gum bichromate? Rejecting any addition to the pure relation between the camera and what is before it at a given moment still leaves this relation itself indeterminate. Respecting the light that sculpts two hands on a window frame or the individuality of two feet on a stool leaves the question of the choice of the subject entirely open. 'Straightness' only defines an artistic process if these long hands of the artist-model and these deformed feet are taken to condense the conquest and suffering of a civilization that has shaped the limbs of individuals according to their occupations, routes and rhythms, as it has raised sky-scrapers in cities, and mixed clouds of smoke from trains and steamers with the clouds in the sky. The Americanism to which Stieglitz lays claim and the

Schopenhauerian pity evoked by his commentator are thus not irrelevant. The objectivity of the camera is only linked to the arbitrariness of the subject the photographer chooses by identifying this subject with the metonymy of a world, at a singular moment that condenses its speed and its slowness. The objectivity of photography is the regime of thought, perception and sensation that makes the love of pure forms coincide with the apprehension of the inexhaustible historicity found at every street corner, in every skin fold, and at every moment of time.

13. Seeing Things Through Things

Moscow, 1926

And it is not only in its formal achievements, not only because *A Sixth Part of the World* is a new word in cinema, the victory of fact over invention, that this film is valuable.

It has managed, perhaps for the first time, to show all at once the whole sixth part of the world; it has found the words to force us to be amazed, to feel the whole power, and strength, and unity; it has managed to infect the viewer too with lofty emotion, to throw him onto the screen.

In the dusty steppes there are herds of goats. In the polar snow, where you find no traces of people for hundreds of miles, the Zyriane graze herds of deer. In the towns there is the noise of machines, thousands and thousands of machines, and the fires of the illuminated advertisements burn. In the Far North, at Matochkin Shar, Samoyeds sit on the shore and look at the sea. Once a year, the steamer of the State Trading Organization comes here, bringing dogs, building materials, cloth and the news of the world of the Soviets and Lenin, and takes away furs …

Along the rails of the thousand-kilometre-long lines, trains take the goods; ice-breakers cut through the frozen ice of the Baltic Sea with their breasts.

And all of this is like some fantastical phenomenon – one thing dissolves into another; you see all things and through things; you see sands, and through sands, polar owls and a single skier going off into the snows; you see yourself, sitting in the cinema watching people in the North eating raw venison, dipping it into still steaming-warm blood.

Was this not a miracle! You shave every other day, you go to the theatre, you ride on a bus – you stand on the other end of the cultural ladder – and *A Sixth Part of the World* has somehow managed distinctly and indisputably to link you with these people eating raw meat in the North. It is almost like a phantasmagoria. To look through things, and to see the iron logic, the connection of such things – the common character of which cannot be proved by any demonstration ...

There is no plot in the film, but you sense your emotion growing, you feel yourself becoming more and more enthralled by the unfolding of the concept of 'a sixth part of the world,' being thrown onto the screen, to the Lapps, Uzbeks, and lathes (*stankam*); you feel all this coming down from the screen, into the auditorium and into the town, and becoming close, becoming yours.[1]

Such is the miracle that the critic Ismail Urazov attributed to Dziga Vertov's film in the booklet that accompanied its release. This booklet was clearly made with particular care. Aleksandr Rodchenko was in charge of graphic design. He framed or cut the text with strictly straight horizontal or vertical lines, while leaving space for photographs that show us a Siberian camp, a well-bundled-up nomad, a troupe of black dancers or an indolent woman smoking. What relation is there between the constructivist rigour of the lines geometrically cutting across the page and these representations of primitive ways of life or bourgeois pastimes? This question of formatting is linked, of course, to the basic question: How are we to understand the 'phantasmagoria' displayed here and the 'iron logic' that is affirmed in between images of skiers and reindeer in the snow, Samoyeds watching the sea or hunters poaching in the woods? The perplexity only grows if we know that this film was commissioned by the Central State Trading Organization and had a specific goal: to make the Soviet Foreign Trade Organization known abroad – that is to say, in capitalist countries. No images of this organization's services and the workers involved appear in the film; no explanation is given of its workings. Indeed, the film does

1 Ismail Urazov, 'Shestaia chast mira' (1926); 'A Sixth Part of the World,' transl. Julian Graffy, in Yuri Tsivian, ed., *Lines of Resistance: Dziga Vertov and the Twenties* (Pordenone: Le Giornate del Cinema Muto, 2004), p. 185. Most of the texts used in this chapter are taken from this masterful anthology.

show products prepared for export and their routing methods. But the fruits of the Crimean – sheep's wool from the Asiatic steppes and Siberian furs – hardly leave us with a grandiose image of Soviet production. And when it comes to means of transportation, dog sleds and caravans appear as often as trains or cargo ships.

And yet, the filmmaker does not feel he has undermined the commission in order to serve artistic intentions. On the contrary, he thinks he has given it full impact by showing not the services of a state agency but the living whole of which it is an organ. Urazov emphasizes this further: the filmmaker wanted to show 'the country as a whole, a sixth part of the world, a real living body, a single organism, and not only a political unit'.[2] But he wanted to show it *in the language of cinema*. This language, Vertov would specify discussing his next film, has three characteristics: it is the language of the eye, designed to be perceived and thought about visually; it is the language of documentary, the language of facts noted down on film; and it is the language of socialism, the language of the 'Communist deciphering of the seen world'.[3] One must fully understand what 'language' means here. Cinematic language is not a tool available to illustrate an idea with images or to translate a message into sensible forms. Vertov does not intend to illustrate the slogans of Soviet economic policies for the use of a defined public. He intends to show the sixth part of the world to itself, and thus to constitute it as a whole. But this does not mean showing Soviets images of Soviet life. This means: extending the living fact of their connection through all their activities. Cinema is a language in the sense that it puts elements into communication. But these elements are facts and actions. And it can do so to the extent that it is itself an autonomous practice, working with the sensible facts of Soviet life, treating them like materials that it organizes to construct forms of perception for a new sensible world.

'Seeing things through things': the idea of a new form of communication is linked to the credo that dominated the politico-artistic avant-garde of the Russian revolution: the time has passed for works of art, for dramatists who told stories, and painters who represented characters or landscapes intended for a public for whom

2 'A Sixth Part of the World', p. 185.
3 'Speech at a Discussion of the Film *The Eleventh Year* at the ARK', in *Lines of Resistance*, p. 290.

the misfortunes of princesses or the labours of peasants were so many embodiments of beauty. Breaking with this world of art does not entail representing 'new life' by illustrating the slogans of Soviet power and by substituting heroic workers for the sentimental heroes of yesterday. It means no more representation. But this does not imply that one has to produce abstract painting. Portraits of heroic workers or abstract portraits are still paintings. And the problem is how no longer to make any, no longer to create objects meant for a specific sphere of production and consumption named 'art'. Revolutionary artists do not make revolutionary art. They do not make art at all. This does not mean there is no art in what they do. They use their art – that is to say, their consciousness of the new goals of life and their practical savoir-faire – to develop materials to make things, material elements of the new life. This is the credo that was particularly developed by the artists named constructivists, who furnished Vertov with a few of his main ideas, and for some time believed they had found in him the filmmaker capable of carrying their flag. A film is not a matter of putting a story into images meant to move hearts or to satisfy artistic sense. It is primarily a thing, and a thing made with materials that are worthwhile on their own. This is the principle Vertov adopts: no acted cinema, not even – certainly not – cinema where actors would replace the sentimental heroes of yesterday with revolutionaries or builders of the new world to exalt new proletarian energies, instead of old bourgeois emotions. Only a cinema of the fact. But neither is this a cinema that represents the real. If constructivists include Vertov's *Kino-journal*, Tatlin's architecture, Popova and Stepanova's printed fabrics, or posters by Mayakovski and Rodchenko among the *things* that must now replace works and images of yesterday, this is because Vertov does not simply want to film facts. He wants to organize them into a film-thing that itself contributes to constructing the fact of the new life. He reverses the common opinion that treats the newsreel as a simple tool of information about brute reality or propaganda at the service of external ends, as opposed to the autonomy and inventive potential of the art film. It is in supposedly autonomous art that procedures of artistic construction become pure means. The art film, the film with a script, meant for the pleasure of aficionados or the emotion of sensitive souls, makes the camera into a mere instrument at the service of an external end. It effectively subordinates the

montage of shots and sequences to the illustrative needs of the plot. On the other hand, 'the newsreel ceases to be illustrative material reflecting this or that place in our many-sided contemporary life, and becomes contemporary life as such, outside of territories, time, or individual significance'.[4] The camera gains its autonomy when it plunges into the middle of facts to make them its own thing, and to make this thing an element of social construction. The choice is not between two kinds of art. It is between two sensible worlds: the old one in which art was the name by which writers, artists, sculptors or filmmakers put their practice at the service of a particular consumption, and the new one by which they make things that enter directly into production in common, which is the production of common life.

Film thus organizes facts. It organizes them in the form of a proper language, a language of the visible that puts them in communication. But the application of constructivist principles to the cinema soon proved ambiguous. The generative image of constructivism remained, in effect, the raw material that production transformed into an object, be it an abstract 'counter-relief', a printed fabric, a public monument or the equipment of a workers' club. The promotion of productive action implies the depreciation of an art devoted solely to the production of visual forms. But cinema has no raw material other than the image. *A Sixth Part of the World* does not work the wool or linen, but 'organizes' images of sheep herds that farmers bathe in a river, linen spinners, or machine turbines filmed by cameramen sent to the different parts of the young Union of Soviet Republics. Its material is composed of facts recorded in the form of visual images. Its organizing work consists in connecting images that represent heterogeneous material activities: wheat-threshing, the pistons of machines, a ship breaking through the ice, reindeer pulling sleds in the snow, a record turning on a phonograph, a moving train, rowers on a river, spectators in a cinema, and thousands of other activities. But this sensible connection cannot be an illustrated explanation of the organization of Soviet trade. It must be the sensible conjunction of all activities into a directly given whole. In this sense, it is essential for the film that these activities be as distant as possible from each other – distant in their materiality,

4 Aleksei Gan, 'The Tenth Kino-Pravda', *Kino-fot* 4 (1922), in *Lines of Resistance*, p. 55.

their location, and their very temporality: the reindeer breeders who eat raw flesh, Samoyeds who see the ship dock once a year to pick up furs, or the caravans at the borders of China must be immediately and visibly united to the metal workers or the pedestrians of Nevsky prospect.

Making the community visible means exposing two of its main features: one is the relatedness of all activity to all others; the other, their similarity. These two features do not necessarily go together. An economy can be shown as the global unity of heterogeneous activities. This is what the film does when it follows the paths that go from the breeders in the steppes and the Siberian hunters to the Leipzig fairs, via the ports of the Black Sea or the Arctic Ocean and the icebreaker that clears the way for ships. But the sensible interconnection of activities is primarily the relation of their visible manifestations. The old pedagogy of schoolbooks followed the route of wheat or wool from sowing or pasture to table or clothing. By contrast, here a product's journey from its origin to its final destination counts less than the link established by the montage of activities unconnected by any logic of cause and effect: the sirens of the steamers that announce the loading of wheat sacks and the *zurna* that announces village dances, the herds crossing rivers and the lemons that stack themselves in a crate, whose cover magically closes, before it jumps to the top of the pile on its own. What unites these activities is their shared capacity to be reduced to fragments in order to be intertwined with one another. This is what the Stenberg brothers' poster for *Man with a Movie Camera* symbolizes: this dancer whose ease at projecting herself into space is due to the very separation of her limbs. The fragmentation of montage can resemble a Taylorist division of labour from afar. But this is a *trompe-l'oeil* analogy. The principle of Vertovian montage is not the fracturing of tasks into *n* number of complementary operations. It is the simultaneous presentation of normally incompossible activities. It is, in this sense, faithful to the cubist and futurist explosion of surfaces that presents not only different sides of the same object, but the dynamism of collective forms that cuts across any particular activity.

The unity of a collective dynamism can be expressed by the double exposure that puts labour, sowing and harvest on the same screen, or projects an aerial view of Leningrad on the sidewalk of Nevsky

Prospect. It does so more commonly through the speed of montage that cuts documentary material into as many fragments as it is necessary to unite and sweep away all these elements in a shared rhythm: the feet dancing to the rhythm of the *zurna* and those stomping laundry clean; the hands of peasants bundling linen into sheaves and the hunter's hands drawing his bow; the breeder's movement bathing his sheep in the waves and the spectators applauding his image. Even when Vertov follows the order that goes from the wheat harvest to the loading of grain on ships, the sequence of complementary activities counts less than the equivalence given to the rhythm of the reaping machine and the hands handling pitchforks, and to the sacks that slide down ramps, are loaded on dockworkers' backs and carried onto ships. The same dynamism drives the spinning machines and the effort of the Kalmyk fishermen pulling their nets, the wheels of the freight trains, the camel or reindeer caravans across the steppes or the tundra, the wheat falling into the ship holds, a flock of seagulls above the Black Sea, the swirling current of the sea, or the waterfall that feeds an electric power station on the Volga. The principle of montage is to establish a community of equivalent movements. Each sequence presents bodies in motion. Among his projects, Vertov had planned a film about hands: 127 possible hand gestures, from the most trivial to the most meaningful. The film was never made, but it is this principle of equivalence between forms and visible movements that governs the 'language' of montage, and not any linguistic articulation of differences.

The problem is that all gestures whose intertwining constitutes human societies in general are thus susceptible to being rendered equivalent. A critic emphasized this: with this device, nothing would be easier than representing the American nation as the land of communism in action. The similarity of gestures is communist only if it is set against a difference. The first section of *A Sixth Part of the World* strives to create this difference by showing the capitalist world in decline. But how can one show this decline through the activity of Krupp factories? The intertitles involuntarily betray the aporia of the attempt: 'more and more machines', they tell us before adding, 'but it is not less hard for the worker'. Unfortunately, nothing distinguishes the image of capitalist machines from Soviet machines, nor the work of a German metalworker from that of a Ukrainian metalworker. To mark the difference between the two systems, one has

to show the relation between the old world and its shadowy under-belly: on the one hand, a group of the leisure class filmed in a salon where they smoke, drink tea, toy with a necklace, or dance to the sound of a record player; on the other, their black 'slaves' who work in the plantations or are drafted into colonial troops – the immediate visual contrast of inside and outside, costume and semi-nudity, leisure and forced labour. But the opposition is blurred when the idle put on their furs to go and see the show performed by the black dancers. A close-up on a trombone slide introduces the rhythm of an orchestra and a dance that carries along the gestures of the idle in the equality of their exact movements. The musicians' virtuosity even annuls the aggressive kitsch of the Negro costumes. And the montage erases the difference it was supposed to accentuate. Thus the words of the intertitles must show the difference, which is not expressed by the simple visible fact or the rhythm of organized facts. The enlargement of an intertitle occupying the entire screen thus comes to attest to the added difficulty of the workers' labour, and the underlined word *verge* visualizes the fact that Capital is on the verge of collapse. Just as images must stop being representations of things to figure the dynamism of their movement, words must stop naming and describing. They must act as conductors of movements themselves.

The use of words as visual elements corresponds to the 'cubo-futurist' tradition from which Vertov's former constructivist friends borrowed this element. In 1922, their theoretician Aleksei Gan celebrated the innovation that he attributed to Rodchenko: the introduction of dynamic intertitles in *Kino-Pravda* number 13, such as a LENIN occupying the whole screen: a screen-word he said, a word stretched like 'an electric cord, like a conductor through which the screen feeds on shining reality'.[5] *A Sixth Part of the World* is composed of 272 cords of this kind, stretched across the screen according to various spatial distributions, gaps and sizes. From the beginning, there is an enormous VIZHU ('I see') that fills the screen and commands, with the inventory of ethnic groups and their activities, the incessant address to a YOU, a YOU ALL and an ALL called to collectively recognize themselves as owners of ALL the shared richness, until the very images are interrupted, leaving room

5 Aleksei Gan, 'The Thirteenth Experiment', *Kino-fot* 5 (10 December 1922), in *Lines of Resistance*, p. 56.

for the crescendo of words, each of which occupies an entire screen, to affirm that all are together masters of the Soviet land (VY/VSE/ KHOZYAYEVA/SOVETSKOY/ZEMLI) – a declaration saluted by the hands of enthusiastic spectators, immediately followed by a new visual crescendo, in four shots and enormous letters, affirming that the hands of all hold a sixth part of the world. The 'main cord' of filmic materiality, which binds hands to hands in order to link each to all, now begins to split into two functions. First, it identifies with the graphic movement of letters. They behave as visual forms to fuse their movements with the waves and turbines, ships and crowds; but also, and above all, to insist on the difference that the latter cannot express: no close-up will ever contain a marching crowd, but a close-up can contain the three fully radiant letters in BCE ('all') or the four in MIRA ('world'). But, at the same time, the visual dynamism of the letters takes on the role of the voice, which at times accompanies images with its obsessive refrain. At others, the voice swells to affirm the power, in four cymbal blows, of what the images show without ever sufficiently saying it: the spiritual power that animates the whole.

Thus the letters must provide the force of the link for which the montage, which links fragments into a whole, does not suffice. They do so at the price of being both material forms – visual facts taken up in the movement of all the visual facts gathered by the camera – and the voice that comes to give these visual facts their 'organization' – that is to say, primarily, their tone and their rhythm. But this double nature of words only creates heterogeneity in the similarity of facts and movements to reinforce the double doubt, to which the idea of the language of facts is vulnerable: an impressionistic lyricism that wants to follow the unitary music of facts to the detriment of their articulated meaning; and an artifice that transforms their material reality into symbolic language. Vertov built his enterprise on a simple alternative: either one has the art film, the 'acted drama' imitating the theatre of the past, or else the organization of documentary facts. Critics did not take long to reply that his alternative was untenable and led to an incessant oscillation between two poles. Either facts without art – that is, without organization – or else art, in the sense of artifice: montage tricks forcefully imposed on facts. And they were not hard-pressed to prove that both paths, the fetishism of facts and montage, led to a particular form of

the same sin against the new civilization: aestheticism, or art for art's sake.

On the first side, the critical tone was soon given by the one who represented the antithesis of the Vertovian project in cinema, the former theatre director become Soviet propagandist, Sergei Eisenstein. Eisenstein had not hesitated to use actors to play 1905 strikers or revolutionaries, going so far as using slaughterhouse scenes in *The Strike* to compensate for the inability of his extras actually to get killed by the bullets of the Tsarist police. Vertov and his partisans considered the skilful montage of *The Strike* or *Battleship Potemkin* to have been borrowed from their methods, and thus to confirm their thesis: if he wanted to encompass the problems of Soviet Russia instead of transposing theatre techniques to the screen, Eisenstein had to borrow the forms of the film-thing developed by *Kino-Pravda* – the composition of a distinctly visual sense through the montage of independent fragments, the use of close-ups and intertitles as dynamic visual elements. Eisenstein's response was simple: he did not at all attempt to organize facts visually; he wanted to organize the emotions that the assemblage of visual elements was meant to arouse in the spectators. The camera is not a means to realize the unanimist dream, 'the combined vision of millions of eyes'; it is, according to the formula he repeats tirelessly, 'a tractor ploughing over the audience's psyche in a particular class context'.[6] The plot of yesterday must not be followed by the language of facts, but rather by the montage of attractions – namely, the elements calculated to produce effects on minds directly, which used to pass through the representation of the actions and emotions of fictional characters. It is not a matter of escaping art, but of rationalizing it as the exact calculation of emotions to be produced and the means for producing them. Soviet cinema does not need a *Kino-eye* but a *Kino-fist*. By rejecting 'artistic cinema', Vertov and his 'Kinoc' friends rejected the basis of all art that is the calculation of ends and the adaptation of means to these ends. From this point of view, the problem is not to film 'real facts' rather than invented ones, or the present realities of industry rather than the facts of yesterday:

6 S. M. Eisenstein, 'The Problem of the Materialist Approach to Film', in *Selected Works*, vol. I, *Writings 1922–1934*, transl. and ed. Richard Taylor (Bloomington: Indiana University Press, 1987), p. 62.

What will be decisive today *for emotional purposes* – extra aesthetic machines … or the nightingale of our grandmothers – this is purely a question of the calendar. If today the strongest response in the audience is aroused by symbols and comparisons with machines, we film the 'heartbeats' in the machine room of the battleship, but if, tomorrow, the day before yesterday's false nose and rouge come back to replace them, we shall go over to the rouge and false noses.[7]

Eisenstein thus reverses the alternative. To denounce artistic work that focuses on producing impressions as old-fashioned bourgeois trash is to condemn oneself to producing the most bourgeois art – the art of artists who note their impressions and translate their emotions. The Kinocs following the shepherds of Kyrgyzstan or the Siberian hunters clearly wanted to compete with the cinematic poems that Robert Flaherty devoted to *Nanook* the Eskimo, or the Polynesians of *Moana*. But their practice also recalls a distinctly Russian tradition – that of the so-called ambulant painters who, in the last century, travelled across the deep countryside with their easels and their sketchbooks to capture the life of the people as they passed by. In lieu of organizing facts, they only propose pantheistic surrender before the 'cosmic pressure' of things. The will to express the dynamism shared by multiple manifestations of life leads to a purely aesthetic montage. It merely mixes everything on screen better to leave it intact in real life.

This is the conclusion hammered home by the opponents of a film whose economic and ideological profitability was inversely proportional to its cost of production. They denounced devotion to the facts as the pure aestheticism of art photography:

He films things, the animal and plant world, machines, everything – only in a 'pose' and from an angle from which it looks more beautiful, more interesting and more attractive. This is the admiration of phenomena without purpose. So he shows you a man in the North. Snow. And against this background a figure in black, walking off somewhere into the endless lyrical distance … The man and his shadow in the snow. Is this not a shot from a good feature film?[8]

7 S. M. Eisenstein, 'Letter to the editor of *Film Technik*', 26 February 1927, in *Lines of Resistance*, p. 146.

8 P. Krasnov, *Uchitelskaia gazeta*, 5 February 1927, in *Lines of Resistance*, p. 208.

This aesthetic tailism towards phenomena is clearly worsened by the giant intertitles that give the film the tone of a Whitmanian prose poem or a 'Hamsunesque' hymn to nature: 'These exclamatory addresses to the sea, to the steppes, to wild animals, as if they were good comrades, sound "Hamsunesque", false in relation to the principles by which the film itself has been constructed ... The point is not "good relations" with nature, but using it, subduing it through enormous human energy.'[9] The aesthetic mistake is a political mistake: the will to show the Soviet Union as a real living body attracted attention to the geographic dispersion of ethnicities, and their ways of life, more than to the economic unity of work forces and means of production. Above all it led to a privileging of immemorial nature – vast snowy banks, deserted Siberian shores, taiga or the endless steppe, herds of reindeer and buffalo – and to an age-old population – hunters in the snow, nomad breeders, yurt-dwellers, caravan drivers, but also men eating raw flesh, veiled women, men prostrated in mosques, shamans and sorcerers in the throes of exorcism dances ... How are we supposed to admit the grandiloquent intertitles telling these men who play polo with goat carcasses and bow before divinity that they are the owners of the Soviet land? How are we to render equal all the activities scattered across the territory when it falls upon the organized proletariat and their Party to impose the economic reality of communism through socialist education in state companies and cooperatives? Communism is not a matter of sheep, reindeer and pigs, and it is not made with the servants of old religious idols.

Vertov thought he had responded to the criticism in his next film, *The Eleventh Year*, with a double manoeuvre: he reduced the intertitles to the modest and uniform size of simple information. And he left behind the sled teams of the Far North and the spectacular *contre-jour* on the infinite waves to celebrate the colossal work on the Dnieper hydro-electric station, the electrification of the countryside, mines and blast furnaces, power plants, metal factories or battleships, and the crowds gathered in Red Square. But the criticism shifted almost immediately: composing visual poems to the glory of machines was still the fetishism of aesthetes. Machines do not need to be admired, only used. And the first step is knowing what they are

9 Osip Beskin, 'Shestaia chast mira', *Sovetskoe kino* 6/7 (1926), in *Lines of Resistance*, p. 205.

used for. Now the alternation between group and detail shots, the superimpositions that expose the machines' inner workings on the worker's attentive face – or the contrary – teach us nothing about this. This applies as much to the turbines of power plants and blast furnaces as it does to dog sled teams or flocks of seagulls. The camera still celebrates them as things, as phenomena without purpose, uniting them as equivalent, abstract movements. It must show not the inner working of machines, but the people that make them work, the 'living people, authentic builders of the new life',[10] these concrete men of flesh and blood, with their effort and their problems, that official doctrine would soon promote in order to silence the bothersome avant-garde artists, abstract lovers of machines, and inventors of new languages incomprehensible to Soviet workers.

Here is the other pendant of criticism. The passivity that records the sled races of the Far North and the turbines of electric stations with equal pantheist exaltation goes with 'formalist' artifice, which fragments images to its liking to compose an extravagant symphony of gestures or machines. The artifice is already present in the presentation of these facts supposedly recorded by the objectivity of the camera-eye. Indeed, according to critics, it is clear that the bourgeois dancing the fox-trot who illustrate the old capitalist mode were not surprised by the camera in the privacy of their apartment. These are not facts recorded by a Kino-eye, but scenes of fiction specially acted before the camera for the needs of visual demonstration. But even when the author is content to combine the documentary material filmed by Kinocs, his montage compromises its reality. What about this peasant's wife we see with the exact same grin in the Ukranian countryside watching an electrician install a wire, and in Red Square in a counter-shot to an official speech? Or the pianist's hands interlaced with dancers' legs and machine levers? Or the harbour crane or the reindeer convoy that change, without leaving us any time to know how, into scissors shearing sheep's wool, immediately transformed into fruit crates, which fade into steamers cutting through waves? 'Organized' facts are facts made dubious, absorbed by montage *tricks* which work as sleights of hand. The law of *either ... or ...* cannot fail to apply to the spectator who has seen the lemons pile themselves into crates:

10 Anonymous, 'Odinnadtsatyi', *Molot*, 26 June 1928, in *Lines of Resistance*, p. 307.

Either the viewer will seriously believe that in our country fruit pack themselves in some miraculous way without the intervention of hands or machines. Or, guessing that this is a joke, the viewer will ask himself: but the loading of cows onto a steamship with a crane – is that not a joke? And all those Eskimos, Dagestanis, and so forth – are they not film actors in disguises and make-up? Let's have one thing: either a race by Kino-Eye through real life, or the tricks of animation.[11]

But the followers of popular common sense are not the only ones who invoke the 'fiction or reality' alternative to protect the defence-less spectator. Vertov's former avant-gardist and constructivist allies themselves cast doubt on the very principle of organization of facts through montage. Osip Brik presented the objection in its most rigorous form: a documentary fact is an individual fact that takes place once and once alone, at a given date and time. Its presentation is understandable and complete in itself. This holds, for instance, for the sequence filmed by the cameraman who followed the herd of reindeer. But, in the editing room where material from the four corners of the Soviet land comes together, the reindeer sequence was cut into pieces to be reassembled with other documentary sequences for logical comparison and lyrical intensification. Their images are no longer representations of documentary facts; yet they have not become abstract signs of a language either. Brik draws a conclusion that seems directly drawn from the pages in Hegel on the aporias of symbolic art:

> Instead of a real deer, we get a deer as a symbolic sign with a vague conventional meaning. But since these deer were filmed without any thought about their possible use as conventional signs, their real nature as deer has resisted this turning them into symbols, and as a result we get neither a deer nor a sign, but a blank space.[12]

By wanting to assemble a film from sequences suitable for news-reel, Dziga Vertov fell into the contradiction between documentary material and the art film's own montage methods. Facts became

11 L. Sosnovsky, 'Shestaia chast mira', *Rabochaia Gazeta*, 5 January 1927, in *Lines of Resistance*, p. 222.

12 Osip Brik, 'Against Genre Pictures', *Kino*, 5 July 1927, in *Lines of Resistance*, p. 227.

pure symbols whose emblem is decidedly the skier headed towards an icy unknown, who can only signify the disappearance of the old world at the cost of also symbolizing an endless flight into the bad infinity of the 'language of facts'. In turn, these facts can only signify if they are incessantly joined with other facts of the same or contrary nature.

The general scope of this critique of Vertovian 'symbolism' is noteworthy. Before being an image that embodies an idea, a 'symbol' is the fragment of a broken ring, an element that demands to find its complement. It is thus the very sense of montage, fragmentation and assemblage of documentary facts into a constructed whole that criticism puts into question. The contradiction of the film-form with documentary material is the rupture declared within 'factuality' that the innovators opposed to the old art of pictorial images and dramatic plots. One could work and assemble raw materials or articulate linguistic elements insignificant in themselves. One could create a montage of images or words chosen to make sense in a work of fiction. But there is no montage of facts. They are only so, they can only escape the undifferentiated flux of 'life', if they carry a meaning that individualizes them. And this individualization is lost when one tries to fragment them into elements of a language. Materials are gathered, linguistic elements articulated, but 'facts' cannot be gathered and articulated a posteriori in the form of discourse. From this, Brik and Shklovsky simply concluded upon the necessity of a plan presiding over the filming of the materials. But the consequence of their critique went much further. It questioned the very idea of cinematic montage as the exemplary form of art-become-life. It proposed an alternative: either there is the assemblage of raw materials or the montage of fictional elements. Cinematic 'language' must choose between the narration of facts and the composition of plots, even to discover that there are other plots, other ways of designing plots – intricacies of words and images – than the story of individual lives.

No doubt such a radical diagnosis and challenge can explain the no less radical response offered by the film with which Dziga Vertov's name would remain associated, *Man with a Movie Camera*. To prove that the Kino-eye is a language indeed, the film adopts a radical principal: the removal of intertitles. No doubt, this had already been done by Carl Mayer, screenwriter for Lupu Pick and

Friedrich Murnau. But the absence of words in *The Last Man* was compensated for by the legibility of a story of social decline that Carl Mayer had even cut into acts. Like Walter Ruttmann in *Berlin: Symphony of a Metropolis*, Dziga Vertov adopted the minimal thread of a city described throughout one day. But Ruttmann described the life of one city alone in a continuous thread that began with the arrival of a train in the morning and ended with nocturnal pleasures. On the other hand, Vertov's cinematic city immediately rejects the choice between facts and symbols, using parallel montage to take us from the surroundings of the Bolshoi to the shores of the Black Sea. Later it passes through a gallery of mines in Donbass, taking us from an unlocated hair salon to the Moscow traffic of Tverskaya Street. Critics protested that the unity shown by *A Sixth Part of the World* was not economic or social, but simply geographic. The spatio-temporal unity of *Man with a Movie Camera* is not defined by any geographic territory or historical sequence, but by the cinematographic machine alone. The film insistently announces itself as an experience. The camera is first presented in a close-up as the subject of the film. It is made metaphorical, doubling in the next shot, where the cameraman and his tripod climb onto the first camera's back, just as, in *The Eleventh Year*, a giant worker becomes the metaphor for the labour of construction workers, who have become ants at his feet. The cameraman then leads us to the movie theatre where the seats repeat the trick of the lemon crates by automatically folding down when the spectators arrive to see the film. Their unity is made metaphorical by the orchestra, before we finally come to the beginning of the 'day' with a travelling shot towards a window revealing a sleeping woman – none other than the filmmaker's wife and the film editor herself. By the time she wakes up, gets out of bed and washes up, juxtaposed to the water jets washing the city, the camera has had the time to splice the images of the lying body with a restaurant table revealing a close-up of a bottle, a kiosk providing a glimpse of the neo-Greek columns of the Bolshoi in the background, homeless people sleeping on benches that visually rhyme with cribs – setting off a series of visual rhymes between the automaton using a sewing machine in a shop window and an automaton riding a bike, a bus-stop and a carriage, an abacus and an elevator, a typewriter keyboard and a telephone, a smokestack and a car radiator grill, cars driving in the street and pigeons frolicking on the cornice,

the movement of the train and the crank of the cameraman filming them, and many other activities. Among these, at times, there playfully appears a poster for an 'art film', *The Awakening of a Woman*, a fictive awakening that rhymes with nothing but itself. A critic of *A Sixth Part of the World* complained about seeing a speaker appear on stage only to be entirely swallowed by the enormous wheel of an unidentified machine. But in *Man with a Movie Camera*, it is the camera and the editor's scissors that we see incessantly swallowing each sequence of everyday life, in an accelerated rhythm, to join fragments to equivalent fragments of any other activity that the camera has shot in order to give them a new life, a life that is its own work. The complementarity of actions is reduced more than ever to their similarity, and the struggle of new against old is blurred even more radically than in the fox-trot sequence from *A Sixth Part of the World*. No doubt one can recognize a 'Nepwoman' in the joyful woman getting her hair and nails done in a beauty parlour, and oppose her foaming shampoo to the mortar mixed by a worker and a housewife's laundry detergent, just as the sharpening of a lumberjack's axe is contrasted with a barbershop razor. But her smile does not differ from that of the young female worker in the tobacco plant. And the opposition of actions is also their similarity. First, the active hands of the hairdresser or the manicurist are linked to the active hands of the worker and the housewife, or those of a shoe-shiner, before rhyming with the hands of the editor scraping the film, just as the hairdryer does with the cameraman's crank, in a movement that fuses what follows into an accelerated montage: a sowing machine and a dressmaker's hand holding a needle, an abacus, the crank of a cash register, a rotary printer, the hand of a worker folding packing paper on a lathe, a telephone exchange, cigarettes ready to be packed, a telephone, a typewriter and a piano keyboard, the line where cigarettes are packed, a pick-axe attacking the beams of a mine, a horse drawing a wagon in the gallery, the editing table, a blast furnace, metal in fusion, the camera, the waterfall from a dam, the pod that bears the camera into the air above the waterfall, buses driving both ways on a street split by superimposition, a policeman's gesture switching the traffic signals, a horn, and various mechanisms making who knows what, but which simply draw the cameraman and his tripod along in their movement.

The opposition between the elegant 'Nepwoman' and the working woman of the people is thus similar to that between couples who go to the town hall to get married and those who go there to get divorced. It is swept up in the universal dance that makes all activities equal to each other. Cinematographic communism is this generalized and accelerated equivalence of all movements. Hence the filmmaker does not fear provocation: in response to the accusation, repeated a hundred times, of wallowing in magic tricks, he ostensibly allegorized his work in a sequence, taken from an earlier film, that shows us children astonished by a Chinese magician's tricks. Through equally ostentatious tricks, he shows us his cameraman perched on top of a building before making him pop up in a beer mug. Some suspicious 'Nepmen' are the ones drinking that beer. But in the Lenin club, where it goes next, the camera shows the honest pastimes of chess players and newspaper readers, only to switch suddenly to pursue new charms: a man playing music with metal spoons on a pot lid attracts the attention of the joyful spectators, setting off a crescendo of thirty-five shots and reverse-shots in twenty-five seconds before the spoon dance, the hands of a pianist and a spectator's radiant face flash together superimposed, thus preparing the spectators – those watching the film and those it shows us – for the new magic trick that will have the cinema as its theatre: the tripod introduces itself and takes a bow, then the camera emerges from its box and screws itself into place, before ceremoniously saluting the audience it will take on new visual adventures.

This bravura greeting that proclaims the power of the Kino-eye and the montage that assembles images more than ever, undoubtedly ignores the fact that it is also the closing ceremony. Proudly claiming to be a film without a plot, actors or intertitles, *The Man with a Movie Camera* asserts itself as the apex of a decade of work, the crowning experiment in a 'universal language of images', constituting the sensible fabric of a new world. But when the film was released in Moscow in 1929, it had already been a year since the voice of *The Jazz Singer* had put an end to the dream of a universal language of visual forms. No doubt Vertov knew how to adapt to the novelty of sound cinema and proclaim that the combined language of sounds and images was the fulfilment of the search for a new language. *Enthusiasm* made the slogans of the Five-Year Plan and the pledges of elite workers resonate through images. The noise

of felled steeples and radio voices drowning out liturgical chants clearly affirmed the conflict between two worlds, thus erasing any trace of the unanimism of which *A Sixth Part of the World* was accused. But the medium of recorded sound was primarily used, naturally, by those who demanded that the 'formalist' exercises of belated constructivists or surrealists be replaced by films capable of showing the condition and the problems of real, living people who were building the new country, and of distracting them from their efforts. Between the release of *The Eleventh Year* and *Man with a Movie Camera*, the Party Conference, in charge of restoring order to the Babel of Soviet cinema, adopted the watchword that would henceforth assign filmmakers their task: 'the main criterion for evaluating the formal and artistic qualities of films is the requirement that cinema furnish a "form that is intelligible to the millions".'[13] In order to get closer to the masses, whose condition and needs they ignored all too often, filmmakers had carefully to join 'experiences of an intimate and psychological character' to artistic and ideological coherence.[14] With sound film, the 'acted drama' of yesterday was not only well armed to make a comeback, but also to impose itself decisively as the art of those building the socialist future.

13 Party Cinema Conference Resolution (15–21 March 1928), in Taylor and Christie, *Film Factory*, p. 212.
14 Anatoli Lunacharsky, 'Speech to Film Workers', *Zhizn' iskusstva* 4 (24 January 1928), in Taylor and Christie, *Film Factory*, p. 197.

14. The Cruel Radiance of What Is

Hale County, 1936–New York, 1941

The bureau was at some time a definitely middle-class piece of furniture. It is quite wide and very heavy, veneered in gloomy red rich-grained woods, with intricately pierced metal plaques at the handles of the three drawers, and the mirror is at least three feet tall and is framed in machine-carved wood. The veneer has now split and leafed loose in many places from the yellow soft-wood base; the handles of the three drawers are nearly all deranged and two are gone; the drawers do not pull in and out at all easily. The mirror is so far corrupted that it is rashed with gray, iridescent in parts, and in all its reflections a deeply sad thin zinc-to-platinum, giving to its framings an almost incalculably ancient, sweet, frail and piteous beauty, such as may be seen in tintypes of family groups among studio furnishings or heard in nearly exhausted jazz records ... The surface of this bureau is covered with an aged, pebble-grained face towel, too good a fabric to be used in this house for the purpose it was made for. Upon this towel rest these objects: An old black comb, smelling of fungus and dead rubber, nearly all the teeth gone. A white clamshell with brown dust in the bottom and a small white button on it. A small pincushion made of pink imitation silk with the bodiced torso or a henna-wigged china doll sprouting from it, her face and one hand broken off. A cream-colored brown-shaded china rabbit three of four inches tall, with bluish lights in the china, one ear laid awry: he is broken through the back and the pieces have been fitted together to hang, not glued, in delicate balance. A small seated china bull bitch and her litter of three small china pups seated round her in an equilateral triangle, their eyes intersected on her:

they were given to Louise last Christmas and are with one exception her most cherished piece of property. A heavy moist brown Bible, its leaves almost weak as snow, whose cold, obscene, and inexplicable fragrance I found in my first night in this house.[1]

This description in inventory form is dizzying. Yet, it is not the most exhaustive one in James Agee's *Let Us Now Praise Famous Men*. Others are devoted to the wooden partitions, furniture, objects, wall decorations and clothes of the three Alabama families who were the subject of his investigation in the summer of 1936. It comes after the minute description of a trunk, its tarnished nails, its grey-green handles, large daisies that decorate the lining, and its entirely prosaic contents: a soiled cotton slip, a baby's dress, a little boy's cap, a baby's shoe, a pair of cheap socks, a piece of green fabric used as lace, and at the back of the trunk, the wide eyes of a little doll. After the details of the bureau drawers full of carefully folded wrapping paper, comes the inventory of the mantel place in the same room, adorned with white tissue pattern-paper, family photos, advertising calendars, religious images, pages torn from a child's storybook, and a drawing of a large white fish torn from a can of mackerel that decorates the wall. And finally, there are the contents of the table drawer: baby's dresses, a worn-out straw hat with a plaid ribbon and lined with brocade, a box of Dr Peters Rose talcum powder, one child's glove with a hole in it, two parts of a broken button, a small black hook, a scissored hexagon of newsprint, and in a split in the bottom of the drawer, a small needle, decorated with a swan, pointed north. After which the reporter proceeds to the inventory of the rear bedroom, the kitchen, and the storeroom of the Gudger house, before lingering over the wellspring of the Woods's house, whose rope is sectioned together from pieces of sheeting, and the calendar vignettes that adorn the walls of the Ricketts's house.[2]

What literary genre do these minute inventories belong to? They would seem to transpose Balzacian descriptions of provincial bourgeois interiors to the setting of poor life, if they were not marked by a dreamer's gaze, ever ready to focus on some surrealistic

1 James Agee and Walker Evans, *Let Us Now Praise Famous Men* (Boston: Houghton Mifflin, 2001 [1941]), pp. 141–2.

2 I am keeping the pseudonyms that Agee substituted for the real names of the Burroughs, Fields and Tengle families.

incongruity – a broken button, a mutilated doll, a montage of news-
paper cuttings or a needle decorated with a swan. Initially, at least,
the text was responding to a precise order. It was meant to be a
journalistic report in an established genre. *Fortune* magazine, spe-
cializing in long-form photojournalism, sent the young James Agee
to the Alabama sharecroppers. For some time already, Agee had
been used to writing perfectly neutral articles of varied length on
documentary subjects: the great industrial project of the Tennessee
Valley Authority, tourist camps for car drivers, horse-racing season
in Saratoga, cockfights, strawberry and orchid farming. At most,
the freelance writer, anonymous like all the writers in the maga-
zine, occasionally allowed himself to slyly include a biblical allusion,
or two verses from *Ode to a Grecian Urn*, in an article written to
comment on Margaret Bourke-White's photographs of the drought.
The magazine sent him there in the context of a series meant to
show how typical individuals and families in Middle America lived
during the crisis and the New Deal: 'The Life and Circumstances
of … '. This explains the successive presentation of a wealthy Illinois
cattle farmer, a construction worker who had been living off different
subsidies and temporary jobs for four years after losing his job, and
an employee of the New York telephone company. James Agee was
now supposed to focus on the effects of the crisis on a social class
known to be particularly miserable, without its misery being imagi-
nable, as it was too far from New York and the ways of life of the
industrial North: the sharecroppers who worked in the cotton fields
of the South. To this end, he enlisted the services of his friend Walker
Evans, who had only collaborated once before with the magazine,
but was currently working for the large-scale investigation of the
Farm Security Administration among the rural populations devas-
tated by the crisis and the drought. But the two friends soon took a
decision that lent their cooperation unique allure: each one of them
would work alone. Text and photographs would be independent. No
photograph, indeed, would show the reader the cracks in the bureau
or the family of china dogs. Photos would bear no captions. And no
reporter's text would explain the circumstances in which the pho-
tographer gathered certain members of one of the three families.

If photography – which will not be examined here – and the text
are independent, this is because each has the calling to say it all. It
is this 'all' that must be understood. A lazy common opinion, held

by those nostalgic for the belles-lettres and fine arts of yesteryear, then taken up by the champions of a certain modernism, opposes the carefully chosen elements of art to the vulgar inventories of 'universal reportage'. But the opposition is specious. The ordinary art of reportage refrains from saying it all. Its 'universality' is based on facts that check ideas and images whose depicted object is clear. Reportage is a selective genre of literature in principle, because it must provide double proof in a strictly limited space: on the one hand, it has to prove that the reporter was there, and it does so by choosing details whose very insignificance shows that they were not invented (some everyday object lying on a table); on the other, it has, conversely, to capture the most significant features. It has to choose signs that are sufficient to show misery and make it palpable for an audience, which will recognize it without having to see it because it knows what evils the signs are symptoms of, and even which remedies would suit them – whether they come from the domain of religious faith, governmental reforms or proletarian revolution. Reportage, such as it was commonly practised in *Fortune*, was an old-style art that had to use few signs to transmit the feeling that a world had been traversed, and that it was both unimaginable and fitted expectations. It combined the narrative and descriptive forms developed by literature and the visual arts in an average regime of factual presentation and interpretation. In order to expose the life of a social group through an exemplary case, the magazine's investigation thus borrowed procedures made familiar by the realist novel: a beginning *in medias res* that makes one feel the tenor of an existential situation, or the slow approach to a place whose decor captures the life of its inhabitants and carries the traces of their concerns. The report on 'the lives and circumstances' of Middle Americans thus begins by following an employee, William Charles Games Jr, as he steps out of his office lighting his cigar before heading towards Penn Station; it begins on the fateful day Steve Hatalla, a mason, is fired by his company, or describes a car driving across the flat plains and straight Midwestern roads all the way to George Wissmiller's farm. Then the story devotes a paragraph or two to an inventory of the place, before describing the character of the wife and children, and the head of the household's philosophy of life. In the prosperous Illinois landowner's home, it notes the cloth-covered furniture, the photographs of children on the piano, the glass bookcases where

old textbooks are shelved next to religious works, farmer's alma-
nacs, *David Copperfield* and *A Boyscout Patriot*, among other books
rarely opened by the industrious family. At the Hatallas', the broken
washing machine or the out-of-order piano bear witness both to
better days and to the musical culture imported from their native
Hungary. A wedding photo, a religious calendar, and the three
plants in the window are the only ornaments of the household, while
the Magyar Bible is placed next to *Collier's* and *Pictorial Review*,
popular magazines, and a novel by Emily Post. These few details are
enough to confirm the singularity of these lives that sum up many
others. The very principle of restraint that limits description to a
few outlines in lieu of an image forbids photography the shot that
speaks for itself. The photography does not lack captions attesting
that these singular lives reflect a common fate and confirm a well-
established manner of conforming to this fate. This is the case of
the three photos collected on one page, which are enough to ward
off the misery of the Hatalla family: 'Steve still has a white shirt, a
necktie, and a smile'; 'Marie Hatalla still has her God'; 'And Sunday
still means worship at the Magyar Baptist Church'.[3] It is essential
for the art of reportage endlessly to contain this double excess in
which it might get lost: a situation so outlandish that words and
images can no longer render it – signs so trivial that there is no
reason to choose one over another.

And it is precisely this double excess that characterizes the
description of the sharecroppers' bureau, the mantel above the fire-
place, or the closet. In no way does the decision to say everything
amount to the fulfilment of journalistic logic. On the contrary, it
explodes this logic, and along with it a certain logic of art. No doubt
James Agee did so in the name of political radicalism. For him,
the art of selecting and gathering signs that express a condition
belonged to the obscene practice through which a group of human
beings, called a newspaper, drawn together in the end merely for
profit, give themselves the right to go and 'pry intimately into the
lives of an undefended ... group of human beings', 'parading the
nakedness, disadvantage and humiliation of these lives' to acquire
'a reputation for crusading and for unbias' beyond financial gain,

3 *Fortune*, February 1936, p. 68. See issues from August 1935 (for
'The Life and Circumstances of George Wissmiller') and May 1936
(for William Charles Games Jr).

a reputation that is itself exchangeable at the bank for money and for 'votes, job patronage, abelinconism, etc.'[4] The two friends are 'spies' determined to betray such a mission. But we should not misunderstand the meaning of this radicalism. Even though the final formula of the *Communist Manifesto* figures among the epigraphs to the book, the break with journalistic norms also dismisses the kind of facile danger characteristic of so-called scientific, political and revolutionary books. It also exceeds the slightly more serious danger of art or literature to tend towards what lies beyond art, and which could have some distant effect on the situation at hand. Thus it is hastily labelled 'frivolous' or 'pathological'.[5] The 'frivolous' or 'pathological' count of singlets, clothespins, rusted nails, espadrille eyelets, broken buttons and lone socks or gloves in the Gudger house is a way of making these objects useless for any account of the situation of poor farmers given to the – traditional, reformist or revolutionary – doctors of society. This way is precisely, says Agee, the only *serious* attitude, the attitude of the gaze and speech that are not grounded on any authority and do not ground any; the entire state of consciousness that refuses any specialization for itself and must also refuse every right to select what suits its point of view in the surroundings of the destitute sharecroppers, to concentrate instead on the essential fact that each one of these things is part of an existence that is entirely actual, inevitable and unrepeatable. The 'frivolous' inventory of the drawers only fully renders a minute portion of the elements that are gathered in the infinite and unrepeatable intertwining relations between human beings, an environment, events, and things that ends up in the actuality of these few lives. It is only possible to account for these lives and their place in the world, however slightly, by going beyond the significant relation between the particular and the general towards the symbolic relation of the part to the unrepresentable whole that expresses its actuality.

Beyond science and art, beyond the imagined and the revisive, the full state of consciousness that perceives the 'cruel radiance of what is' must still pass through words. No doubt the dream that things themselves could express their excess over words is present: 'If I could do it, I'd do no writing at all here. It would be photographs; the rest would be fragments of cloth, bits of cotton, lumps

4 Agee and Evans, *Let Us Now Praise Famous Men*, p. 5.
5 Ibid., p. 11.

of earth, records of speech, pieces of wood and iron, phials of odors, plates of food and of excrement.' But this book-installation would be an object of consumption for an advanced audience: 'Booksellers would consider it quite a novelty; critics would murmur, yes, but is it art; and I could trust a majority of you to use it as you would a parlor game.'[6] In order to avoid transforming the intermediate art of journalism into a surrealist parlour game, this fantasy of the book as a collage of things must be abandoned. Similarly it could be necessary, even if the author does not breathe a word of it, to set aside discreetly the idea that photography could compensate for the lack of words. The writer's words alone possess the possibility of articulating the indignity of the voyeur's position, the effort to go beyond it by unfolding the fullness of being that inhabits each broken button or each patch on an altered garment, and the proof of their incapacity to accomplish the task. Words must go beyond the compromise of description and imitate this embodiment, which they know is impossible: sentences must expand indefinitely in order to mirror the movement that would link each insignificant detail of impoverished life not to its context or its causes, which are always already known, but to the uncontrollable chain of events that creates a cosmos and a destiny. Thus an art beyond art is defined, a lie accepted, so that truth is not lost in the regulated agreement of shown things and their consumable meaning:

> It seems very possibly true that art's superiority over science and over all other forms of human activity, and its inferiority to them, reside in the identical fact that art accepts the most dangerous and impossible of bargains and makes the best of it, becoming as a result, both nearer the truth and farther from it than those things which, like science and scientific art, merely describe and those things which, like human beings and their creation and the entire state of nature, merely are, the truth.[7]

The movement of words, by linking each sensible state to an infinite series of other states of the world, must imitate the truth that does not speak the language of words. This use of words that exceeds all documentary rationality seems, at first glance, to respond to

6 Ibid., p. 10.
7 Ibid., p. 210.

a given poetics. The nocturnal meditation on the porch or in the 'front bedroom' that tries to capture the light or the smell of the oil lamp, the grain and the scent of the pine planks, the shadows of the attic, and the bodies in the back room breathing 'the held breath of a planet's year'[8] clearly recall another nocturnal dream, in which Walt Whitman mimics the silent erring of a body that imaginatively bends 'with open eyes over the shut eyes of sleepers'.[9] In order to go beyond the journalistic routine of representative description and give dignity to the poor décor of the Gudger house, it seems necessary to borrow the unanimistic poetics of the author of *Leaves of Grass*, which makes all activity and all things into a symbol of everyone's lives. Whitman's influence on Agee's lyric inventories is undeniable, yet also limited. For the Brooklyn poet had made his task a little too simple by using the first person, the verse form and the metaphor of travel to gather together, line after line, the farmer leaning on his fence, the harpooner in his whaler at sea, newly arrived immigrants in Manhattan, the mechanic rolling up his sleeves on some railway line, the Michigan hunter setting his traps in a river, the squaw selling her moccasins, the conductor beating time, or the president surrounded by his secretaries.[10] He had already secured the link between the sheet of paper and the leaf of grass, as he had done between the printer's press and the tools and products of all human activity: the doctor's etui, the cotton bale, the stevedore's hook, the sawyer's saw, the butcher knife, the glazier's implements, the cylinder press, and the steam engine's lever.[11] This poetics is too busy rushing towards new prey to take the time to do justice to the 'cruel radiance' of what is here, given by the patterns of rough-hewn pine in the Gudger house, the vermin in the mattresses, bent forks and broken china animals, the Ricketts children's clothes made from cotton sacks which are mocked at school, the terrifying silence of the starry night, the metallic light and stifling heat of the summer day when one must go and work ten kilometres away under the orders of a black foreman, to add to the meagre

8 Ibid., p. 46.
9 Whitman, *Leaves of Grass*, p. 107. In the final version, this section became the poem 'The Sleepers' (Whitman, *Complete Poetry and Prose*, p. 542).
10 Ibid., pp. 40–1.
11 Ibid., pp. 96–7.

resources of cotton cultivation, already devoured by the very conditions of sharecropping, and the endless shame of never being able to live what one knows is a dignified life. It is there, on the spot, that one has to make sensible the relation between the frail wooden shell enclosing these fragile lives and the weight of the globe that holds them there, the metallic brutality of the light and exploitation, the distant radiance of the stars and other possible lives, the crash of thunder and all those 'javelins' that come careening down, thrown from the end of the world, the immemorial past, and the unknown abyss toward this thin shell. It is at 'any juncture of time, space and consciousness', in the singularity of each sensible event, that the power of the infinite must be captured. The problem is not to link everything to everything else, but to capture the great weight of necessity that crushes human beings, and the art with which they respond to it, in each detail. The problem is to restore each element of the inventory to the dignity of what it is: a response to the violence of a condition, simultaneously the product of an art of living and doing and a scar from a double wound – a wound from being subject to necessity and the pain of knowing that the response will never match the intensity of its violence.

To see each thing as a consecrated object and as a scar: for James Agee, this programme demands description that makes sensible at the same time both the beauty present at the heart of misery and the misery of not being able to perceive this beauty. The descriptions of partition walls or clothes emphasize the first aspect. However, neither of the two ordinary criteria of beautiful housing could apply to the Gudger house. No ornaments decorate the pine boards and planks with which it is made. Yet this nudity is not sufficient to give it the functional beauty of the 'machines for living' celebrated by modernist architects. The beauty of partition walls and wooden struts comes from elsewhere: from a distinctly aesthetic accord between a human need to dwell, the materials man is given by nature, and their chance union. On the surfaces of these boards three qualities of beauty are simultaneously present, reflected in one another:

> one is the streaming killed strength of the grain, infinite, talented, and unrepeatable from inch to inch, the florid genius of nature which is incapable of error: one is the close-set of transverse arcs, dozens to the foot, which are the shadows of the savage breathings and eatings

of the circular saws; little of this lumber has been planed: one is the tone and quality the weather has given it, which is related one way to bone, another to satin, another to unpolished smooth silver.[12]

The *aesthetic* beauty exemplarily achieved here, at the cost of a functional lack, is the beauty of unforeseeable metamorphoses, the conjunction of life's randomness with random vegetation, climate and makeshift instruments. No doubt this is the beauty inextricably shaped by 'economic and human abomination'. But the beauty coerced by this abomination is no less important a part of reality than this abomination itself.[13] The same capturing of necessity in the conjunction of chance and art is illustrated by the description of work overalls that age and use, sweat, sun and laundering, transform into 'realms of fine softness and marvel of draping and velvet plays of light which chamois and silk can only suggest, not touch', and scales of blue only recalled by rare skies and some of Cézanne's blues.[14] The work of time is supplemented by the art of mending, a creator of transformation, celebrated on one of the most lyrical pages of the book:

> This fabric breaks like snow, and is stitched and patched: these break, and again are stitched and patched and ruptured, and stitches and patches are manifolded upon the stitches and patches, and more on these, so that at length, at the shoulders, the shirt contains virtually nothing of the original fabric and a man, George Gudger, I remember so well, and many hundreds of others like him, wears in his work on the power of his shoulders a fabric as intricate and fragile, and as deeply in honor of the reigning sun, as the feather mantle of a Toltec prince.[15]

It is by focusing on each part of the surface of each object, on the quality of each sensible event, that we can grasp this conjunction of art and chance that raises the clothing of the poor, the body wearing it, and the hand that mended it to the height of the sun and the stars. The problem is not to glorify handiwork that testifies to the artfulness of the poor. This art is all too readily acknowledged. Rather,

12 Agee and Evans, *Let Us Now Praise Famous Men*, p. 128.
13 Ibid., p. 178.
14 Ibid., p. 236.
15 Ibid., p. 237.

one must spur the recognition of an art of living in this handiwork: beyond any adaptation of a life to its surrounding circumstances, there is the way in which a life rises up to the height of its destiny. But it is precisely here that fate proves most merciless. In order to sense this beauty, one has to be there accidentally, a spectator coming from elsewhere with eyes and a mind filled with the memory of performances and pages that have already consecrated the relationship between art and chance. This outfit patched together cannot fail to remind us of the joined scraps of paper – the *paperolles* – that make up the Proustian page. And it is from Proust, even more than from surrealism, that James Agee borrowed this poetics committed to unfolding the truth of one hour of the world imprisoned in the triviality of a utensil or a fabric. The robe of a Toltec prince resembles both a page of Proustian writing made of many *paperolles* and the jelly made from countless bits, which it describes. In the end, the night in the front bedroom or under the porch roof takes less from Walt Whitman's imaginary nocturnal stroll than from the sleepless nights and the slow awakenings of the narrator of the *Recherche*. The second meditation, 'on the porch', is exemplary in this sense. It is the place where the poetics that suit the situation are defined: the joy felt upon grasping a truth in one's body and mind, this truth, or at least this illusion of wholeness, that can be given by any chance fact: 'the fracture of sunlight on the façade and traffic of a street; the sleaving up of chimneysmoke; the rich lifting of the voice of a train along the darkness ... the odor of scorched cloth, of a car's exhaust, of a girl'.[16] It is difficult to not recognize the noise of the train heard by the insomniac in the opening pages of *Swann's Way*, cutting across the silent night of the sharecroppers, and the smell of gasoline that the narrator enjoys in bed without knowing that it is the smell of the car in which Albertine is getting away. The 'whole' to which the book aspires is this condensation, in the wholeness of one minute of the world, of all these connections in space and time that make every life vertiginous. It is this inexhaustible totality of every instant that literature, in the age of Proust, Joyce or Virginia Woolf, opposes to the selection of significant details that constitute the art of reportage.

But the very similarity of poetics reveals the merciless sharing of lots. The error of the narrator of the *Recherche* finally turned out

16 Ibid., p. 200.

to be the truth. At the cost of Albertine's disappearance, and the end of love's illusions, the narrator discovers himself finally capable of unravelling the smell of gasoline, the crumpling of a napkin, or a clinking fork into the sensible fabric of true life that is literature. This involves admitting that the latter needs to feed on the injustice of sacrificed lives. But the already tight balance of profit and loss becomes even more bitter when it concerns the relation between a visitor who stays for five weeks and the beauty of the plank walls and overalls of the Gudger, Woods or Ricketts families. For this beauty present everywhere around them, produced by their gestures and inscribed in their living conditions, belongs as such only to the one who has come there to see it. They only know the art of responding to chance by chance as the necessary response to necessity. Habit and education have erased any reason 'to regard anything in terms other than those of need and use'.[17] They have extinguished 'the ability to know, even fractionally the almost annihilating beauty, ambiguity, darkness, and horror which swarm every instant of every consciousness, the ability to try to accept, or the ability to try to defend one's self, or the ability to dare to try to assist others'.[18] In exchange for what is robbed from them, they are only allowed to know the shadow of the beauty of others, these images of the lives of the fortunate with which they cover their walls or fireplaces: calendar beauties that cover the Ricketts walls; snow-bound landscapes and stag-hunting scenes; Indian virgins paddling in the moonlight; beaming blondes in luminous frocks leaning back in swings; rosy babies and blue-eyed infants in pastel clouds; rich landscapes with tractors in the distance; young women in riding-habits lovingly caressing the heads of horses; cars driving at full speed, or young couples admiring a brown-and-brocade davenport; and a hundred other images of luxury, peace and pleasure that we begin to doubt that the visitor truly saw and noted one by one, and to suspect that they in fact traffic other images, taken from the pages of another book. Images of keepsakes, vignettes and azure edges of pious books, painted plates representing the life of a royal mistress, Minerva drawn on the farm wall, and other images sealing the fate of little Emma Rouault, the future Madame Bovary. If his accomplice Walker Evans explicitly borrowed from Flaubert the

17 Ibid., p. 277.
18 Ibid., p. 270.

idea of the impersonal artist, invisible in his work like God in his creation, then James Agee more secretly borrowed his art of using a few images to fix the vortex of aspirations and absolute distress that can hollow out the most ordinary of lives: the decorated plates that feed the dreams of the schoolgirl and the daily lunch plates of the married woman on which all the bitterness of existence seems to be served.

The image of the beauty of others thus becomes a scar from a wound, perhaps summarized in the broken china dolls of the girl whom James Agee no doubt recognizes as the Emma of Hale County, little Louise Gudger – whose real name was Lucille Burroughs – who is ten years old, likes to learn and wants to be a schoolteacher, and who looks at the stars with the visitor and questions him about unknown worlds that extend beyond the county lines. Her dull schoolbooks provoke his indignation at the denial to a category of humans of so many possibilities, from the point of view of their virtual capacities. Of course, he was not able to guess what would happen long after his own death: one day in 1971, Lucille/Louise, like Emma, poisoned herself with arsenic, not because her beautiful teenage dreams had been shattered by reality, but because before her adolescence she had been deprived of the very possibility of having such dreams.[19]

Before this tragic ending came the tortuous path imposed upon the writer's report by the poetic spiral necessary to raise the most humble lives to the height of their destiny. The text James Agee wrote was already bound to exceed the format and explode the guidelines for the column about the 'lives and circumstances' of the representatives of Middle America. The impossible article thus grew into a book meant to break with all the markers of book-length reportage: a nonsensical table of contents that puts the first words of the text in 'Book II'; a disrupted chronology; unending sentences, at times transformed into pure sequences of words joined together; subjective reveries mixed with descriptions of the furniture or the living conditions of the sharecroppers, constantly returning, during the book, to questions about its very possibility; the insertion of elements entirely foreign to its topic; the photographer's notebook,

19 On the end of Lucille Burroughs's life, see Dale Maharidge and Michael Williamson, *And Their Children After Them: The Legacy of 'Let Us Now Praise Famous Men'* (New York: Pantheon Books, 1989).

presented at the beginning, without introduction, captions or com-
ments; a text that continues beyond the announcement that the
last words of the book have been written. This is the impossible
book that was finally published five years later by a New York editor.
Without making the slightest impact. There are plenty of reasons
for this lack of success, starting with the Second World War and US
involvement in it, which directed attention elsewhere and settled
problems of unemployment and poverty in their own way. Moreover,
the bleak years were over and attention drifted away from the fate
of the destitute in the countryside. Incidentally, whatever attention
remained found the forms of reportage and artistic engagement
necessary to satisfy it in the meantime. While Agee was inces-
santly working to expand his text with new digressions, a southern
writer and a photographer a lot more famous than him and Walker
Evans – Erskine Caldwell and Margaret Bourke-White – published
You Have Seen Their Faces. Here the reader could see the arrogant
landowner; the ragged black child; the white child with misaligned,
fang-like teeth; the old black woman hunched over her cornbread
in front of a wall covered with newspaper clippings, feathers in
jars, and celebrity photos; the couple on the porch in front of their
house, one of whose walls was destroyed in a flood; a mother and
her daughters forced to roam the street; outside their house, two old
women with dull eyes, deep wrinkles and withered bodies; the man
with furrowed features and the woman with a painful gaze who sum
up the misery of poor country folk in the South. While the writer
made them speak, the photographer, armed with a remote control,
waited for the right moment to capture them unexpectedly at their
greatest expressivity. In contrast with *Fortune*'s tortured reporter, the
authors simply knew how to combine their own subjectivity with
sociological observation by giving each photograph a caption that
expressed their own view of the feelings of the individuals being
photographed: 'Beat a dog and he'll obey you. They say it's the same
way with the blacks'; 'Little brother began shriveling up eleven years
ago'; 'There comes a time when there's nothing to do except just
sit'; 'I've done the best I knew how all my life, but it didn't amount
to much in the end'; 'A man learns not to expect much after he's
farmed cotton most of his life'.[20]

20 Erskine Caldwell and Margaret Bourke-White, *You Have Seen
Their Faces* (New York: Modern Age Books, 1937).

Around the same time John Steinbeck published *Grapes of Wrath*, and soon after, John Ford's cinema gave a face to the legend of the 'Okie' farmers driven from the cotton fields by the drought into savage exploitation at the hands of the owners of California orange groves. At this stage New Deal culture reached its apotheosis, which was not yet recognized as its swan song. In any case, James Agee remained an outsider. His choice to include in his book an article from the *New York Times* about Margaret Bourke-White's 'enjoying life' without any comment could no doubt be considered symptomatic in this respect. The mockery is veiled here, but James Agee's anger became explicit when he read a cinema magazine in which a Farm Service Agency photographer praised the 'beautiful and stirring accounts of reality' presented in Ford's film:

> I submit that there is quite as much unreality in the *Grapes of Wrath* as in *Gone With the Wind* (sight unseen), and that it is of a far more poisonous order, being both more near the centres of human living, pain and dignity, and therefore far more insulting to them, and being also so successfully disguised as 'reality', that it has deceived even its creators.[21]

Yet the basic problem is not that a few writers, photographers and filmmakers representative of New Deal culture were able to use a few striking formulae to capture the misery and grandeur of the destitute, while James Agee was working on an impossible Whitmano-Proustian and Whitmano-Flaubertian poem which, alone, could inscribe its own impossibility into the homage. During these years, this culture itself was increasingly discredited in James Agee's milieu of radical intellectuals and artists, and, along with it, the entire political and aesthetic tradition, at the heart of which his excess stood out from the norm. Among the most obvious digressions in *Let Us Now Praise Famous Men*, we find the author's vitriolic answer to a survey raising 'some questions which face American writers today', carried out in 1939 by one of the most influential organs of the political and cultural far left, the *Partisan Review*. Is there a place in the present economic system for literature as

21 Michael A. Lofaro and Hugh Davis, eds, *James Agee Rediscovered: The Journals of 'Let Us Now Praise Famous Men' and Other New Manuscripts* (Knoxville: University of Tennessee Press, 2005), p. 141.

a profession, the review asks? For serious criticism, despite the pressures of advertising and propaganda? How should the political tendency of the American literature of the 1930s be judged? Can one sympathize with its uncritical insistence on specifically American elements in culture? And which tradition is it suitable to use? Should one, for example, consider the heritage of Henry James more relevant to the future of American literature than Walt Whitman's?[22] Through all these questions one can sense the Marxist avant-garde's desire to break with the committed Whitmanian culture that drove painters, photographers and writers to cross poor city neighbourhoods and poor country roads to exalt the work of men, gather testimonies of social misery, or photograph the picturesque calendars that decorated the walls of peasant houses. There one can sense the will to reaffirm both the rigor of the Marxist analysis of capitalism and art without concessions.

This tendency would find its explicit manifesto in the sensational article published in the following issue of the same review by Clement Greenberg, 'Avant-garde and Kitsch'. Greenberg immediately framed his analysis in terms of the relation between capitalism and culture. He explained that, since capitalism had begun to destroy the forms of the religious, cultural and stylistic tradition that linked artists to their public, art, forced to turn in on itself, had no way to thrive other than to turn its attention away from the content of common experience and to direct it towards the means of its practice, in order to make its medium into the very subject of art or literature. The exemplary expression of this attempt is abstract painting, whose meaning is developed by Hans Hoffman, an artist from Germany, in his courses and lectures. After a false start in Stieglitz's era, it prepared its second entry to the United States, which would be victorious this time, with the opening of MoMA. But it was still necessary, Greenberg wrote, for a social elite to support this avant-garde art, which had no natural public, and to give it the means to remain itself. For a second effect of capitalism now threatened the autonomy to which the first effect had confined it: the rapid development of 'rear-guard' art, 'that thing to which the Germans give the wonderful name of *Kitsch*: popular, commercial,

22 'The Situation in American Writing', *Partisan Review* VI: 4 (Summer 1939), pp. 25–51. James Agee's reply, announced for the next issue, was not published by the review.

art and literature with their chromeotypes, magazine covers, illustrations, ads, slick and pulp fiction, comics, Tin Pan Alley music, tap dancing, Hollywood movies, etc., etc.'[23] In a sense, this art really is the art of calendars, the refuse of refined culture that decorates the walls of poor farmers and keeps them from recognizing their own art and the expression of their own dignity, their way of responding to the violence of the world and history, in the adjustment of wood planks, patching-up clothes, or the way they arrange cheap objects on towels or tissue paper. All the time James Agee spent writing and rewriting this article, which had turned into a book, was aimed at reversing the play of relations between the art of the poor, elite culture and the trash that the latter exported to the territory of the former. Yet this spiral of the impossible book, comparing the art of the poor with its own dispossession, was itself isolated and annulled in the circle where the brilliant *Partisan Review* critic had situated the place and the role of the political and cultural avant-garde. For him, it was necessary to stop indulging the art of living of the poor. For that is where the root of the evil threatening art lies: in the access of the poor to cultural abilities and aspirations which had never concerned them in the past:

> Kitsch is a product of the industrial revolution which urbanized the masses of Western Europe and America and established what is called universal literacy. Prior to this the only market for formal culture, as distinguished from folk culture, had been among those who, in addition to being able to read and write, could command the leisure and comfort that always goes hand in hand with cultivation of some sort … The peasants who settled in the cities as the proletariat and petty bourgeois learned to read and write for the sake of efficiency, but they did not win the leisure and comfort necessary for the enjoyment of the city's traditional culture. Losing, nevertheless, their taste for folk culture … and discovering a new capacity for boredom at the same time, the new urban masses set up a pressure on society to provide them with a kind of culture fit for their own consumption.[24]

23 Clement Greenberg, 'Avant-Garde and Kitsch', *Partisan Review* VI: 5 (Autumn 1939); reprinted in John O'Brian, ed., *The Collected Essays and Criticism*, vol. 1 (Chicago: University of Chicago Press, 1986), p. 11.

24 Greenberg, 'Avant-Garde and Kitsch', pp. 11–12.

Once the root of evil had been identified, duty became clear. The enemy threatening the very future of art and culture had to be repelled: capitalism, no doubt, but capitalism in its most dangerous version – the sons and daughters of peasants who learned to read and write and got it into their heads in turn to like pretty things, and to include art in the décor of their lives. If it was necessary to hope for the advent of socialism for the redemption of culture, artists and intellectuals aware of the law of capitalism had first to work to close the border dividing serious art, focused on its own materials and procedures, from popular entertainment and interior decoration. The time had passed for artists' and writers' voyages among the people and 'popular culture', forms of art that sought to transcribe the rhythms of industrial society, feats of labour and the struggle of the oppressed, new forms of urban experience and its dissemination in every sphere of society. Clement Greenberg and the 'serious' Marxist intellectuals and artists surrounding him wanted to turn the page on a certain America – the America of itinerant and politically committed art of the New Deal, and more profoundly, of cultural democracy stemming from Whitman. But what they were declaring over was actually historical modernism in general, the idea of a new art attuned to all the vibrations of universal life: an art capable both of matching the accelerated rhythms of industry, society and urban life, and of giving infinite resonance to the most ordinary minutes of everyday life. Ironically, posterity gave the very same name to this will to end as to what it was trying to destroy. It would call it modernism.

Index